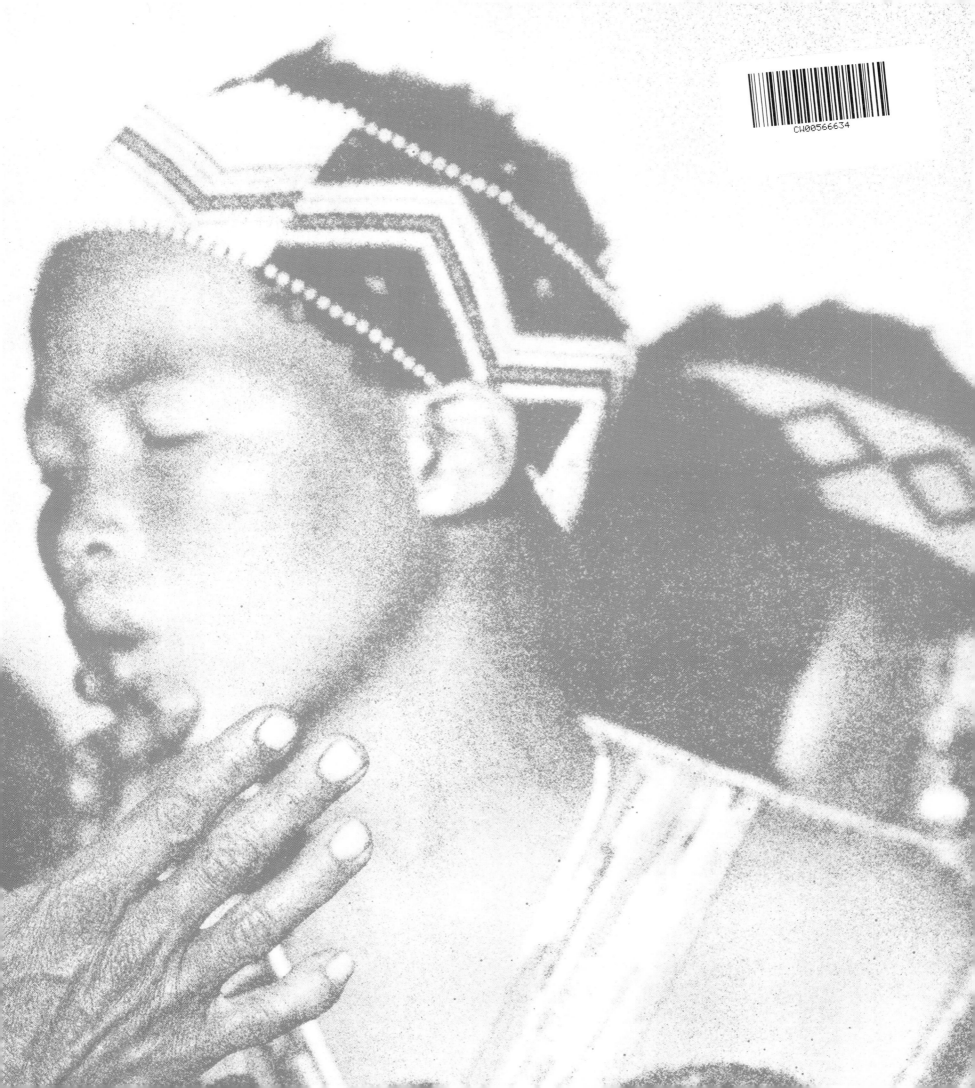

The Miracle Rivers

THE OKAVANGO & CHOBE OF BOTSWANA

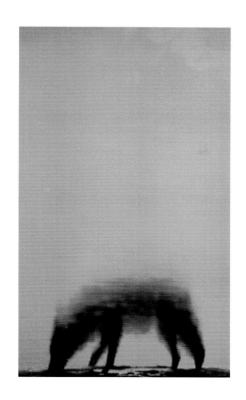

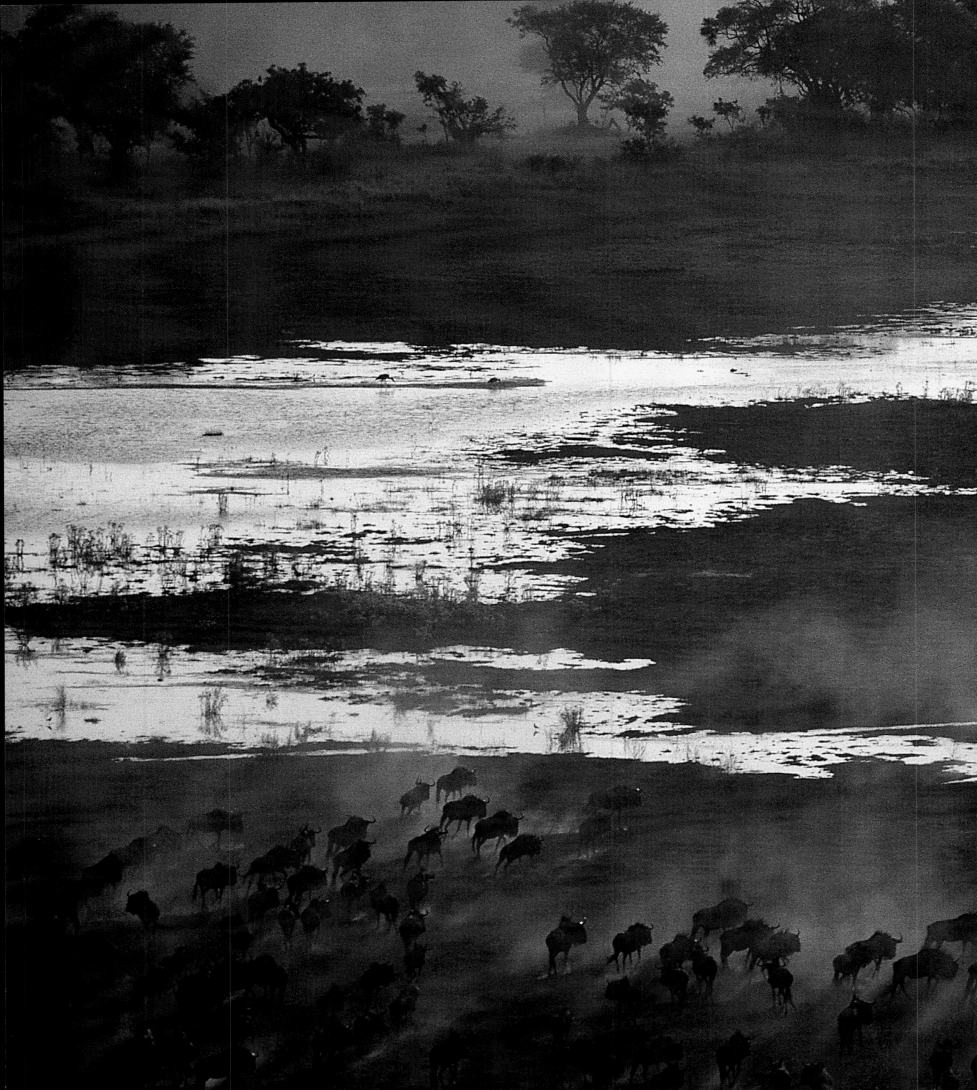

The Miracle Rivers

THE OKAVANGO & CHOBE OF BOTSWANA

PETER AND BEVERLY PICKFORD

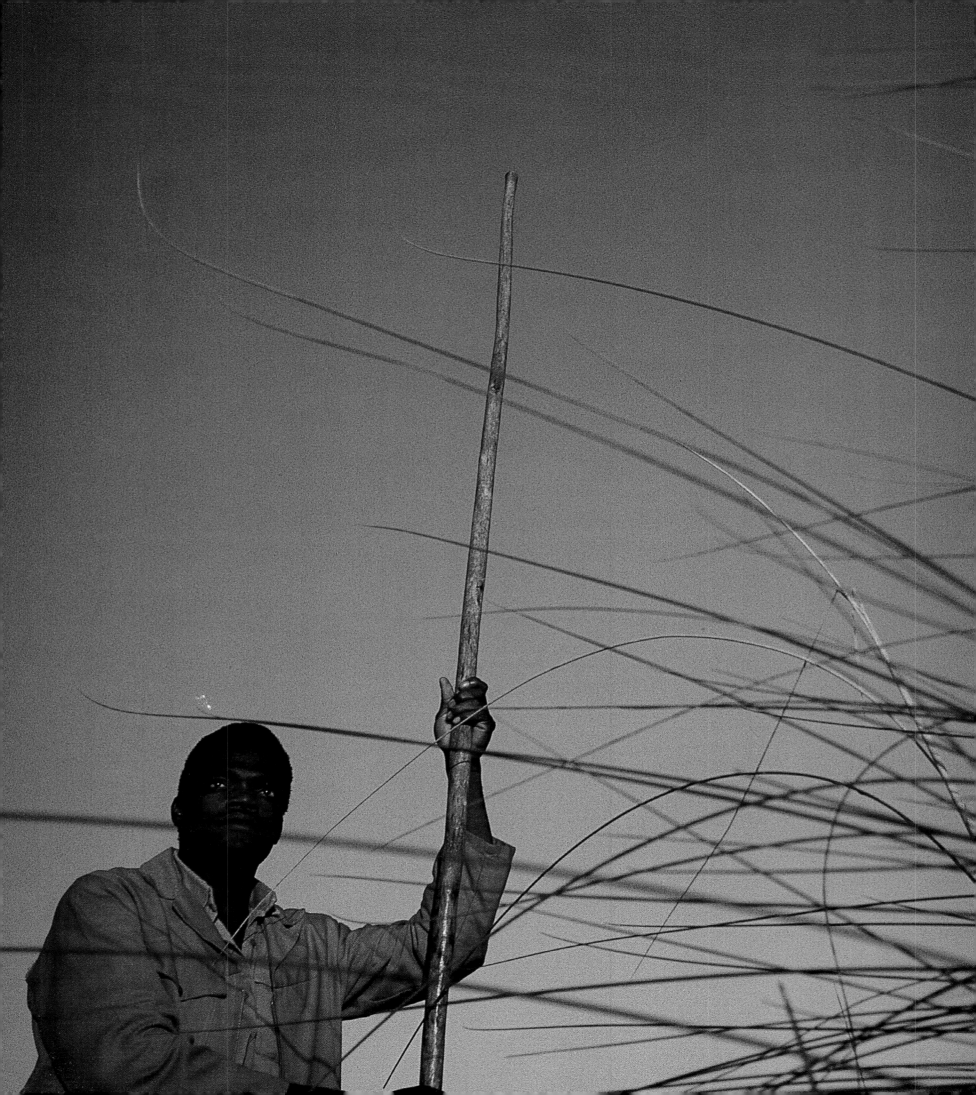

Contents

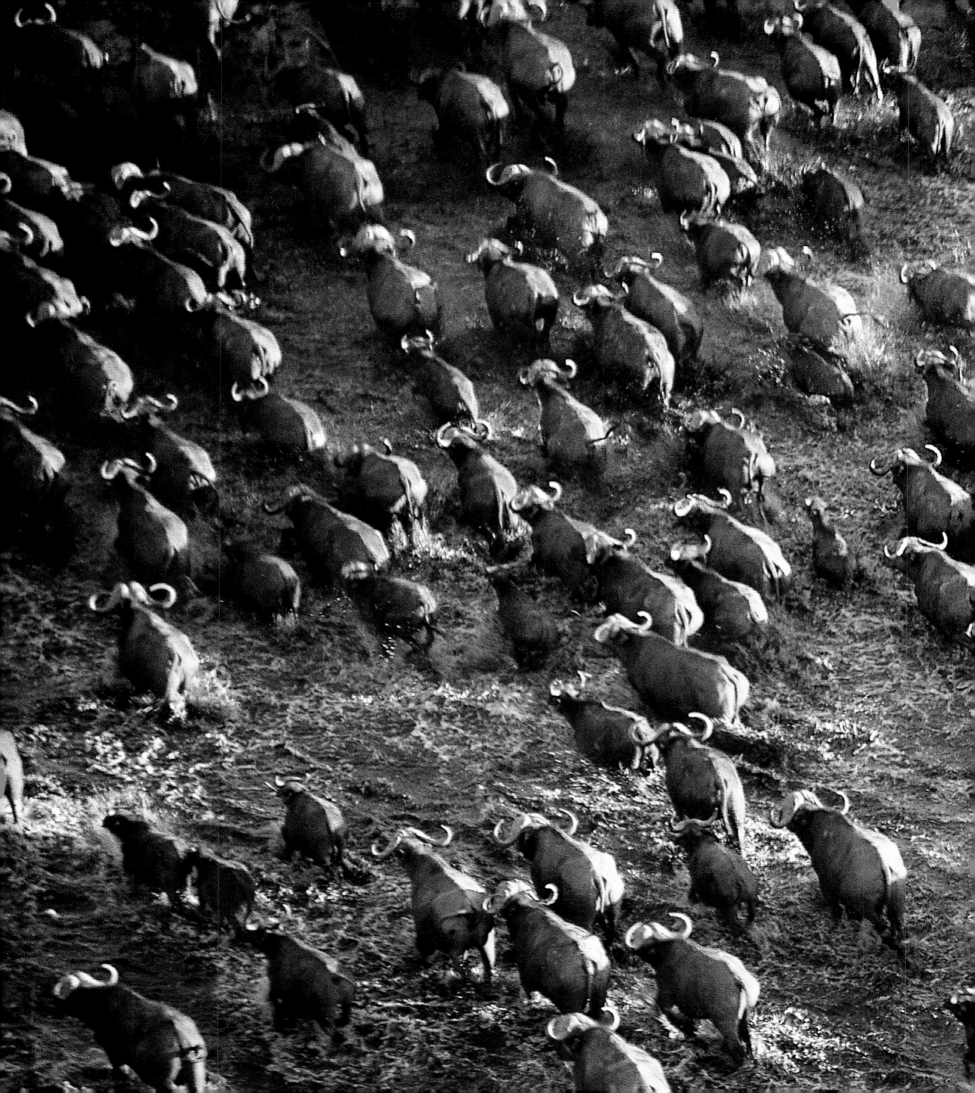

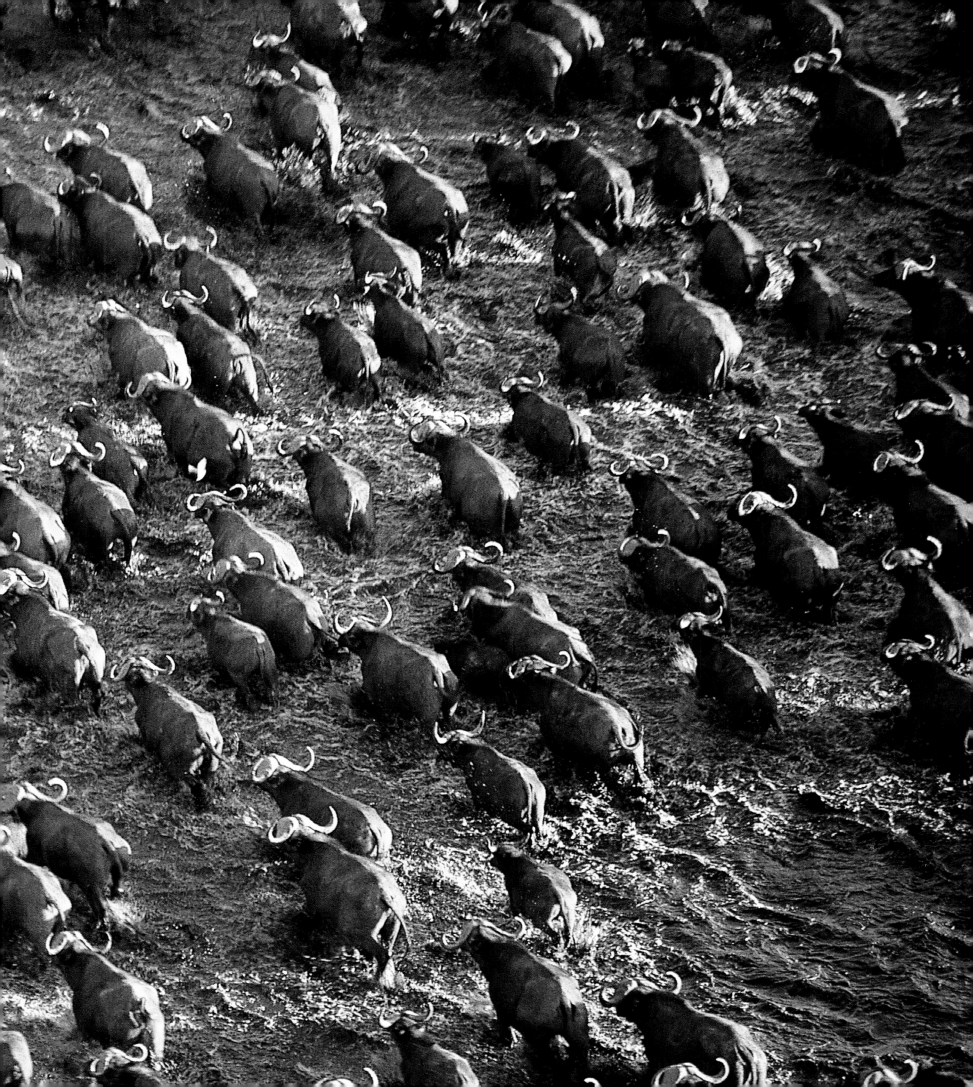

Dedication

It was while looking down into the clarity of a nameless waterway in the Okavango Delta that ourselves and a friend came to talking of fish. He told us then that no great white shark had ever successfully been kept in captivity. Their demise was due not to disease or lack of food or the neglect of their custodians, but a great withering of spirit. For all its formidable bearing, defiant disposition and fierce and singular nature, when the great white shark is removed from the freedom of the open sea it is deprived of an ingredient so vital to its being that there occurs within it a spiritual death which the flesh is helpless but to follow. Despite all efforts, there has never been an exception.

We came across an elephant once that had been spared during a cull; it had chains on its legs. It knew sunshine and rain, green trees, mud holes and the company of other elephants, and yet it was but a shadow of an elephant. It was possessed of a great weariness and its grey, heavy skin hung as parchment on its gaunt frame. Its melancholy was so tangible that we could not come before it, or think of it, without sadness, for it was quite plain that without freedom its spirit had withered to the point where it longed for death.

We have met, too, men and women who have lived by their own rules in the wild places of this earth. In the face of hardship and adversity, the only defeat we have seen them suffer is the curtailment of their freedom by advancing civilization and conformity.

One day we will have driven back all the frontiers of this earth and, with it, all the wild creatures that lived within the freedoms that they offered. Perhaps only then will we realize that the victory of progress will be as nothing, for you cannot conquer what you have killed.

It is therefore to the great white shark and all creatures, both man and beast, to whom a wild freedom is as necessary as the air they breathe, that this book is dedicated.

PETER AND BEVERLY PICKFORD
AUGUST 1998

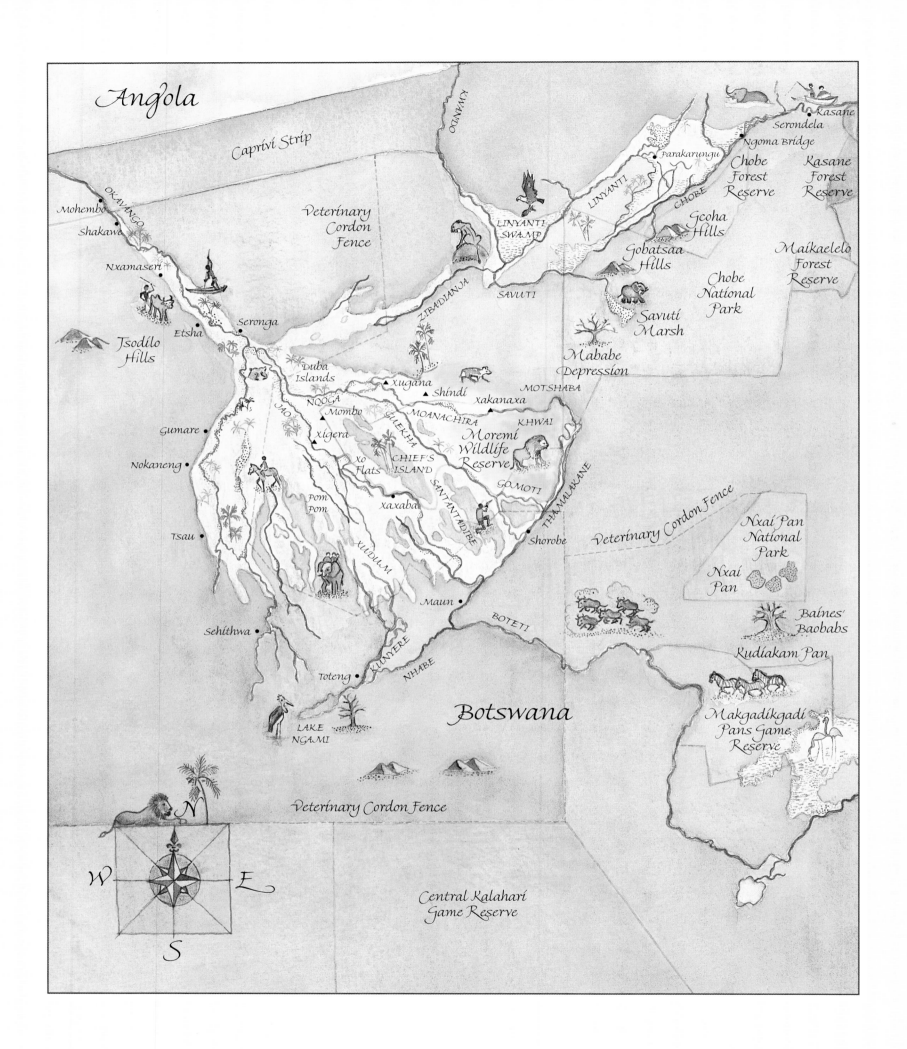

Angola

Caprivi Strip

Kavango

Okavango

Mohembo

Shakawe

Nxamaseri

Veterinary
Cordon
Fence

Linyanti

Linyanti
Swamp

Zibadianja

Savuti

Motshaba

Kwai

Parakarungu

Serondela

Kasane

Ngoma Bridge

Chobe
Forest
Reserve

Kasane
Forest
Reserve

Gcoha
Hills

Gobatsaa
Hills

Chobe

Chobe
National
Park

Maikaelelo
Forest
Reserve

Savuti
Marsh

Mababe
Depression

Etsha

Seronga

Tsodilo
Hills

Duba
Islands

Nqoga

Xugana

Shindi

Xakanaxa

Mombo

Moanachira

Gumare

Xigera

Guekha

Moremi
Wildlife
Reserve

Jao

Chief's
Island

Xo
Flats

Nokaneng

Pom
Pom

Xaxaba

Santantadibe

Gomoti

Thamalakane

Tsau

Xudum

Shorobe

Veterinary Cordon Fence

Nxai Pan
National
Park

Nxai
Pan

Baines'
Baobabs

Maun

Boteti

Kudiakam Pan

Sehithwa

Kunyere

Nhabe

Toteng

Botswana

Makgadikgadi
Pans Game
Reserve

Lake
Ngami

N

W E

S

Veterinary Cordon Fence

Central Kalahari
Game Reserve

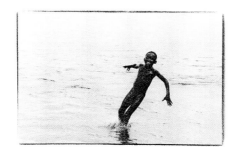

Preamble

Peter Matthiessen notes in *The Tree Where Man was Born*, 'The wild creatures I had come to Africa to see are exhilarating in their multitudes and colours, and I imagined for a time that this glimpse of the earth's morning might account for the anticipation that I felt, the sense of origins, of innocence and mystery, like a marvellous childhood faculty restored. Perhaps it is the consciousness that here in Africa, south of the Sahara, our kind was born. But there was also something else that years ago … had made me restless, the stillness in this ancient continent, the echo of so much that has died away, the imminence of so much as yet unknown. Something has happened here, is happening, will happen – whole landscapes seem alert.'

A journey is two things: a moving away and a moving towards. This journey, for us, was more a moving towards than a moving away – for in moving away there is only what is known, and in moving towards, there is hope. There is, too, in moving forwards to a place that is already known, preconception. In returning, then, to the Okavango, a utopia of my youth, I had not made allowance for change – for change in my utopia and change in myself. The book Beverly and I expected to make will never be, for the paradise we carried in our heads existed in too pure a form to be real, and we found instead a reality quite different – and yet, perhaps, more beguiling still.

In these pages we have tried as much as possible to hold ourselves in reserve and present what is there without judgment or favouritism, for in the years that we lived in Botswana, we came to understand that it is not only the coming of the sun that makes a day, but the heat and the wind and the clouds and the rain, and the evening too.

AUTHORS' NOTE

We have, for the sake of the story, taken some scenes and events out of their chronological order.

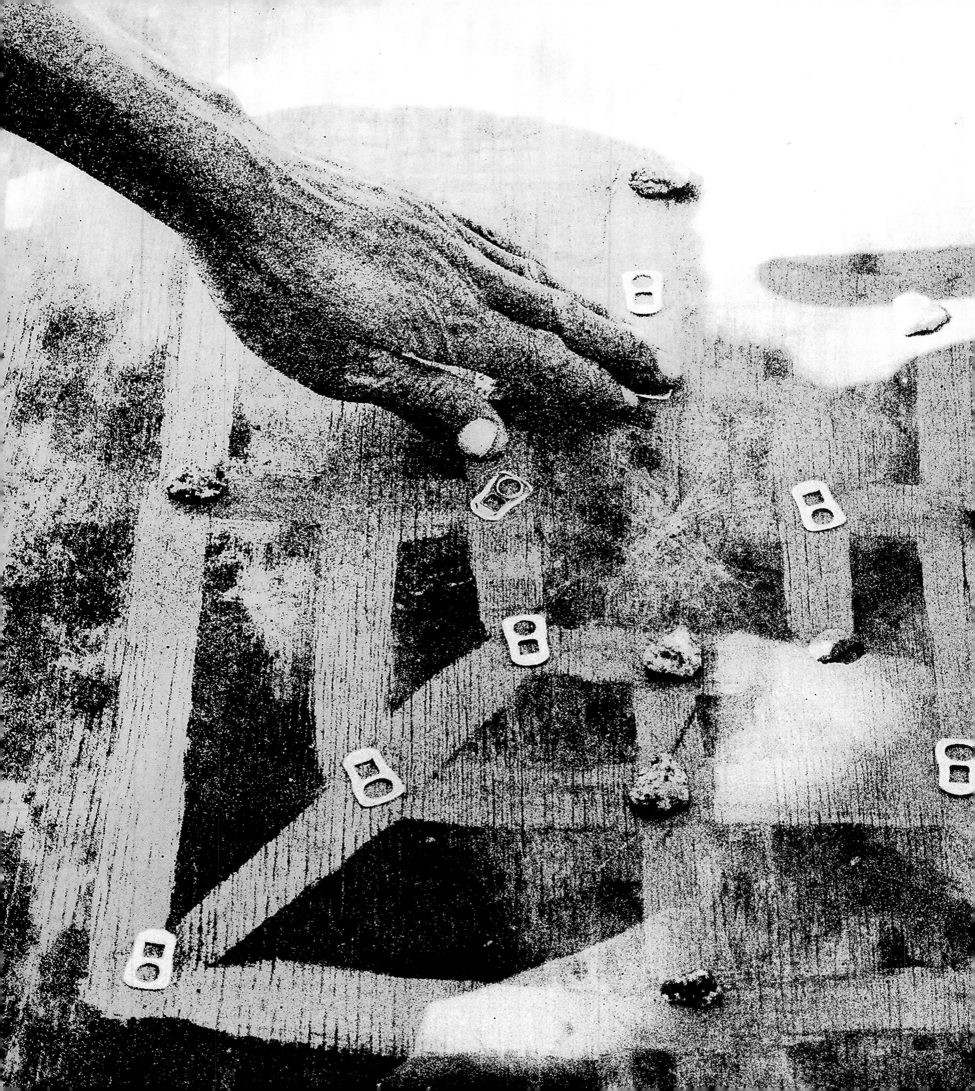

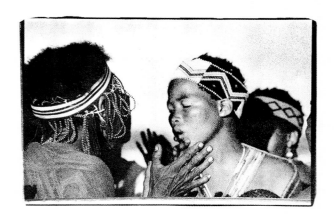

Forewords

Beneath dappled shade, a player makes his move in
an African game, on this occasion pullring versus stone on a
weathered board. Each player brings his own style to the sport –
some are ponderous and calculated, considering their moves
like chess masters; others use flashy, exaggerated hand
movements and slap their pieces loudly onto the board.
So it is with the peoples of the Okavango Delta – each
brings a unique understanding to the place in which he or she
lives. This is the reason why, instead of asking one illustrious or
prominent person – a master of the game, as it were – to
write the foreword to this book, we approached at random
everyday people – the players themselves.

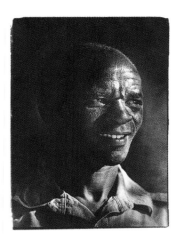

JIMMY K BONTSIBOKAE

Camp assistant at Abu Elephant-Back Safari Camp

'In l955 my grandmother told me that many, many years ago her people left the Tsodilo Hills and came to the Okavango River. They were searching for clay to make handles for the metal of their knives, spades, axes, adzes and blades to shave off their beards. These people had a very great respect for old people and listened to whatever their parents told them. One of these old people, Mokoko Resheku, who lives at Seronga, remembers when the country was still wet.

'This is my belief – that people came from Tsodilo Hills to find the Okavango – and this is my heritage.

'"Okavango" in HaMbukushu means something you were looking for, you have found, and can now be happy.'

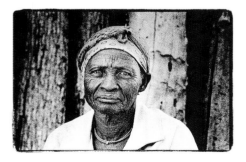

MOTSEWA BOLOT MATIHO

First Lady of the River Bushman village at Khwai

'I was born in Khwai in the Okavango. It has been good here since I was born. This is my usual place and I prefer life here very much.

'If I was told to go I could not. This is my motherland and it would be impossible for me or my family to move. From here to the Dombo Hippo

Pools, where I used to live, is my home. Since I have been here for so long I do not think I could cope with any other kind of life.

'I now eat mealie meal which I buy by threshing thatching grass and selling it, and weaving baskets which I sell to tourists at Khwai. I eat meat which we are permitted to hunt by licence. I have no problems.

'My only sadness is that my people are deprived of their normal way of hunting and gathering.'

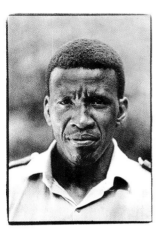

ISHMAIL MOGAMISI

Chief safari guide at Chobe Game Lodge

'I was born in Kachikao, in the Chobe district, in l964.

'All my growing-up years were spent in this area, where I partook in the usual boy hobbies such as fishing and swimming in the Chobe River and hunting birds and small game.

'Many changes have taken place, such as the building of more hotels, an airport, tarred roads, more houses, etcetera. Another change, although a natural one, was the drying up of Lake Liambezi, where locals used to fish a lot.

'Fishing is still carried on in the Chobe River but is now being monitored by the officials to avoid overfishing. People are more aware of the Chobe area now as tourism is being promoted worldwide.

'I am very proud to have grown up here and witnessed the developments that have taken place over the years, mainly within the tourist industry. I am currently a professional guide at Chobe Game Lodge and am very happy to be involved in tourism, as I can share with family and friends the joys of this industry.

'I do sincerely hope that the area does not become overutilized in the future.'

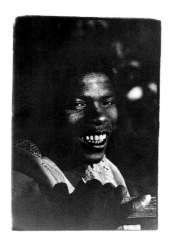

PHURAKI NGORO

Mokoro poler and camp hand at Nxamaseri Fishing Camp

'Okavango is a very beautiful place for the people. When the river flows and when we get the new water, we fish in the river and catch many fish.

'This is the life of the Okavango. It gives me work to do and is a very, very good place to be. We have a very happy life and we like to stay in this place.

'I am very glad to be able to tell you this.'

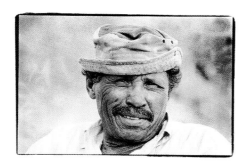

WILLIE PHILLIPS

Professional hunter, naturalist and guide

'I saw the Okavango for the first time in 1955 and I have not left yet. When I first came here the freedom, the cleanliness of the place, the wilderness, deeply impressed me. It's different now, and that is the sad thing. Right here in Maun there used to be herds of buffalo.

'The Delta attracts a certain type – many different nationalities and personalities, but we are all the same type of person. The women in Maun are strong, hard working and fun loving; they are survivors. With the men it's the same thing: a strong, hardy group of characters.

'You have got to be an individual to survive here. When things get tough and you sometimes have days when you are really down, you carry on going and you don't give up.

'You are not just a number in a computer. You are yourself here, and you can be yourself here. Here, we don't introduce people as "Mr" this or "Mr" that – it does not matter where you come from, it is you who counts.

'I can get into my Land Rover and within one or two hours I can be totally alone. I can go out into the wilderness, which is why I will never leave here, and I can be myself and this is freedom.

'Now I need to leave Maun where there is too much plastic as I cannot pick up every piece of plastic alone and people don't care about it any more. I need to move into an area up north, a concession area, where there are people, but fewer people, and keep it clean and look after it to make it look and feel like it was thirty years ago. I need to control hunting in an area, to solely have the right to say who hunts in the area and what they hunt.

'I feel that the only way for an area to be saved is for individuals to take responsibility for an area and utilize only what that area can support.'

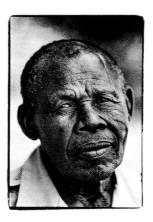

MUNGU SIMATA

River-safari guide at Chobe Game Lodge

'I was born in Zambia in 1940 and came to Botswana in 1955 looking for a job. I liked it here and decided to stay. I married a Motswana girl and became a citizen. I have my wife and children and my business in Kasane.

'Even if my business and family were far away and if I could not move them here, I would still stay in Kasane as I am attached to the Chobe River. I would never feel well to go away. I would have to visit my family and check on my business then return as soon as possible to the Chobe.

'I am particularly attached to the wild animals, and to the water since the animals depend on the water.

'I will never go anywhere else because this is my home.'

ELAINE PRICE

of Shakawe Fishing Camp

'The value of the Okavango Delta to the diversity of life it nourishes is inestimable. Such natural diversity is a precious commodity, and one that is environmentally fragile in this rapidly advancing world.

'During the past 21 years of my life spent in the Panhandle of the Delta, I have discovered it to be an area with its own integrity, rich in peace and wild beauty. It is a rare privilege which has provided me with an opportunity to develop an intimate affinity with nature and, on occasion, to begin to understand the complexity of such an ecosystem.

'It is a pristine environment, and I can only hope that the Okavango will be kept sufficiently unpolluted to provide sustenance for all those who come after us.

'My passion for the Okavango runs too deep to put into words.'

LLOYD WILMOT

of Lloyd's Camp

'The name "Okavango" floods the mind with images and bittersweet memories. Okavango is a name, a place, an experience – a physical aberration in a world of sand. It is a natural wonder of surpassing beauty whose life-giving waters sustain a delicate web of life.

'Few people have come away from the Okavango without being moved, elevated or inspired by its beauty. The Okavango is an enrichment of the soul that stirs man's deepest instincts of an Eden we left at the beginning of time.

'Memories of Okavango leap in the mind: palm fronds in the wind, the tinkle of frogs, a heron's cry at night. I remember, too, voices at sunset, the glow of embers, the smell of wood-fire smoke mingling with the heavy damp of swamp.

'No-one could forget the crystal-clear streams, the fragrance of water lilies, sunsets like none other and rain dropping from the leaves.

'In remembering the Okavango it is my deepest wish that it be preserved forever to give others what it gave to me.'

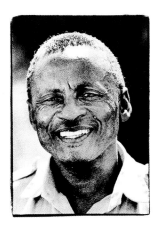

MELEKO SETSWALO

otherwise known as 'Alec', safari guide at Chobe Chilwero

'It seems like the Okavango is dying. When I see such big rivers, like in Francistown, with no water, the Shashe and so forth, I am always getting worried that the Okavango is going to be like that.

'When I was a child in Shakawe, Mark Kariakou and me, we grew together. We used to play with an engine boat, going right to the middle of the Okavango River, and going straight to the bottom of it, but you couldn't touch.

'At the moment this place is an island. Now the sand is piling, piling, piling … there is no water.

'I remember at a certain stage at Nxamaseri, the primary school was under water. What you saw there was crocodiles swimming in the classrooms, getting some fish.

'I am so concerned about the wildlife in the future, as now there is no water. Here in Chobe, all the animals are crowded together as this is the only water. If the government takes some water there will be no water left for the wildlife.

'Myself, I am so worried. I am looking forward to the education of the children, so that they can be having more interest in wildlife. The reason is that when we grew up, I did not know that wildlife is worthy.

'Maybe it is because at the moment I am Christian, and that means to have that sympathy with wildlife.

'When I grew up I didn't know better than destroying this bird's nest, that chick and so forth. I was enjoying that. But at the moment when I see a child doing that I am not feeling happy, or even someone telling me that he shot a buffalo or a lion – especially the lion.

'We had four lions here at Chobe. Two of them have been shot. Really, I didn't like it because of that spirit of, you can say, friendship between the animals, especially the lions. It took me a month not feeling well. Can you imagine: how can you shoot a lion, two metres from you? I even asked the wildlife people, "Can't you think of something better?"

'In Shakawe at my home there is no wildlife. Mostly, I am staying with the Bushmen there. We hunted everything: that gemsbok, this roan, sables, kudu… Now even the kudu have turned nocturnal; they come at night. You only see them at night because we shot them all.

'At the time when we were still in primary school in l963, I was attending school in Tsau. There was a mass of buffaloes between Nokaneng and Gumare, a mass of animals there, large numbers of buffaloes. At that time there was no limit to shooting. Even in the truck you just shoot them unnumbered, just like that. At the moment if you go there, there is nothing, nothing left.

'If you go between Tsau and Nokaneng, all the trees are dead – the camelthorns, *Acacia erioloba* – because they were ringbarking them, trying to control the tsetse. Because of this all the animals moved from there; all the buffalo moved towards the east, into the Delta.

'Most of we Batswana, we do not see that all these things are disappearing – completely they are disappearing but we don't take notice. Most of them, they don't take notice, they are after shooting, eating, that's it. For example, at my cattle post there are only common duiker left; that is the only animal, but people are shooting them.

'My father, he was one of the hunters. Some years back he could sit under the big tree, in the shade, and there were coming some kudu and he could say to a child, "Bring my gun and bring a bullet," and just like that, there in the village was a meal.

'Educating children is much better because if they are with their parents they can say something. At least, if we and our government can do something, like teaching the children about wildlife in schools, primary schools, I think that will be good.

'You see, we Batswana, mostly, like myself and my relatives at home, all of them, they believe in whatever they see they want to eat. They don't see those things as worthy. Even my children, I stop them using a sling, taking a stone and trying to kill something. I don't like it.

'Because they don't look forward they don't see that all the wildlife is disappearing. It comes to my mind that it can be better so I am trying to find a way to help children, that they can have that interest in wildlife.

'Can you imagine, when you ask them, "What is the national animal of Botswana?" they don't know? Even the teachers themselves, no-one can give me an answer.

'Such things!'

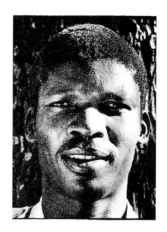

JOMO BONTSHETSE

Assistant game warden of Moremi Wildlife Reserve

'The Okavango Delta in northern Botswana is unique as, unlike other deltas, it flows through an arid country.

'Because Botswana is not densely populated, the Okavango has little human interference and this should be upheld for its future existence. Being a tourist attraction because of the variety of wildlife found there, the whole Okavango area should be incorporated into the existing protected areas and made a World Heritage Site.'

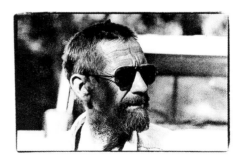

PJ BESTELINK

of The Okavango Horse Safari and Nxamaseri Fishing Lodge

'The way of life here in the Okavango revolves around the level of the water. Every aspect of life comes into its own at a particular level of water. Every year is different, an unending jigsaw of nature in which man should not play a part at all.

'My strongest wish is for the Okavango to become a World Heritage Site, which should protect it from all threats of the future.'

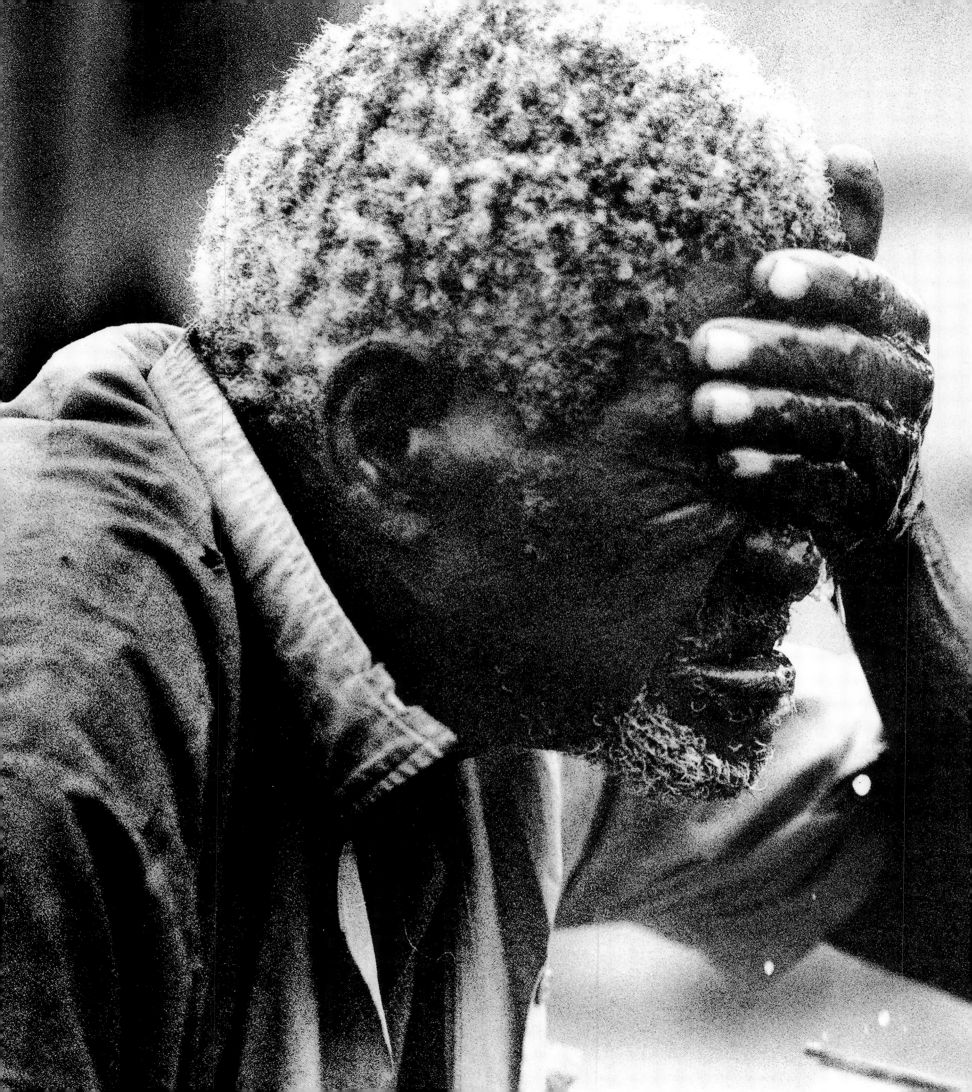

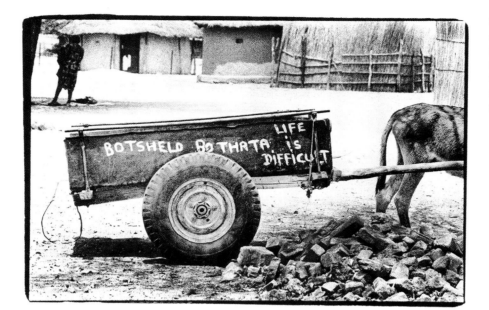

Left: *We saw this
donkey cart from time to
time and it always left
us in a reflective mood.*
Opposite: *An old man
washes with a little
water from a tin cup.*

The Road up

Our papers processed, we were soon on our way again. The earth here was red. Beyond the wire of the border post a group of people sat on old school benches, their backs resting against the lidless desks. A dog, its fur the colour of the soil, lay in the shade of a scrawny thorn tree. Set back from the road, a trading store stood on some open ground at the mercy of the sun. It was still.

A short way down the road a yellow boom blocked our path: a veterinary cordon control. The attendant swung the boom open at our approach and, without stopping, we passed with a rattle over the metal grid. Although he looked at the car, he did not see us, and in the rear-view mirror I watched him swing the boom closed and return to his low stool under some trees.

The road was new, mostly straight and quiet. Only occasionally did a truck pass in the other direction, rocking the car in its wake. We passed a temporary shelter beside the road, a few bent sticks with a checkered blanket thrown over the top. It looked deserted. Farther on we passed a slightly bigger group of shelters. There were some children there, using leafy twigs to flush grasshoppers from the new, green grass at the roadside. An oddment of clothes hung neatly from the barbed wire of the fence. The children knocked the grasshoppers down in their flight, pinched them to death and dropped them into a shiny tin.

I noticed a few caterpillars on the road and then, quite suddenly, there were hundreds crawling across the tarmac.

'Mopane worms,' I observed.

We saw many temporary shelters beside the road after that, where women sat with

their legs outstretched as they placed squeezed mopane worms on blankets or sun-faded bolts of cloth to dry.

Some time after dark we stopped and slept between the silent trees. As I lay with my eyes closed, I tried to imagine those temporary shelters, now far behind, and what it was like to sleep among your food – crawling past you, crawling over you, the unceasing shuffling through the grass, soft but heightened in the darkness.

'I'm trying to remember,' said Beverly the next morning, as we drove into the dawn, 'what all the things were that seemed so important only a few days ago – those things that had me worried and were making me toss in my sleep – and you know, I can't recall.'

'Yes, it's quite a wonderful release,' I agreed, for I had been feeling the same way. 'Given the opportunity or the space to think, the details and the pettiness are really of little consequence, and they fade in the face of the big picture, the major occurrences.'

'It seems so silly,' said Beverly. 'We really were so busy, and now I can't remember with what.'

'"Busy" seems to be becoming a watchword,' I observed. '"Busy" means that you're more than just needed, that you're important.

Previous pages:
The brightly coloured mopane worms feed exclusively on the waxy leaves of the mopane tree and occur briefly in such extraordinary numbers as to leave whole stands of trees leafless in their wake.

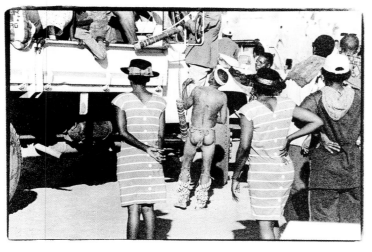

"Busy" is translated as being a success. What a peculiar notion.'

Beside the road a youth watched, unmoving, from where he reclined against the bent post of a sign. 'Bus Stop' was written in broad, white letters on the piece of corrugated iron above the youth's head. There were a great number of these self-proclaimed 'bus stops' along the road. The buses I had seen stoically ignored them, even when people stumbling through the soft sand from beside a sign tried frantically to stop them. Some of the signs bore the name of the proprietor: 'Bus Stop, Mr Magadisu, Cattle Post'. I concluded that 'bus stop' was intended not only in its literal translation, but also as a sign of some importance and gravity, and indicated a village or settlement obscured by trees or distance from the road.

At Nata we left the main road north and turned west. This, our previous trips to the Delta had taught us, was the last, arduous leg of the journey. From Nata to Maun the road crossed a vast, flat wilderness, following the edge of the expansive Makgadikgadi Pans before entering a featureless, arid thornscrub that shrank the horizon. The bright-white surface of the road was pitted with corrugations for its entire 300 kilometres, and in places concealed potholes big enough to tear an axle from its mountings.

Fifteen minutes out of Nata I turned to Beverly. 'It's still tar,' I said in apprehension.

'I know,' she replied and paused before adding, 'I hope we haven't come too late.'

As the tar stretched on and on, a small panic rose in me. A tar road: to look at, rather dull and uninspiring; no monument. If you hadn't known the road before, you probably would not pay it much mind – seemingly insignificant, this long black finger of progress. But to us it felt strange to be travelling down the length of this harbinger of change. So small a difference really, just a physical alteration; so much remained, and yet everything had changed.

In Maun a black and brown goat stood on its hind legs, nibbling at the base of a poster tacked to the thick posts of a sign. School children waited to cross the road, their red and white uniforms

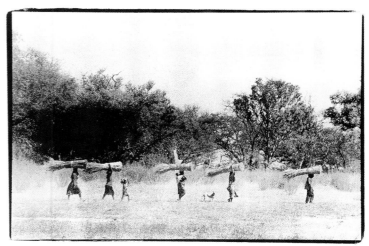

emphasizing the blackness of their skin. The wide expanse of the Thamalakane River had been spanned by a double-lane bridge. Beside it the carcass of a cow lay festering half in, half out of a stagnant pool in the dry river bed, two dogs and some vultures in attendance.

There were some new buildings and more tar road than I remembered, and for a moment I was disoriented. A German tourist with short-cropped blond hair and a red backpack smiled at me on my second circumnavigation of the traffic circle.

Up ahead was a whole block of new buildings, and more under construction. As I turned the corner I noticed that even the barber had upgraded. Outside his stall, a small generator coughed blue smoke – he had dispensed with mechanical hand shears and was using electric barber's shears. A battered yellow board depicted his new styles: 'Straight Up', 'Punk', 'Flat Top', 'Mr Cool' and 'Stars and Stripes'. He had painted all the faces pink. Something else was new, too: across the road he had competition.

I waited for a hobbled donkey to hop out of the road. The cuts in its ankles dripped bright red onto the black of the new tar. A short distance on I pulled up in some shade and killed the motor. I got out and stretched, easing the distance from my limbs. Across the road stood the Duck Inn.

The Duck was what every establishment aspires to be – it was 'the' place. If you wanted a drink, if you needed a meal, if you were waiting to meet someone or just back from the bush, if you wanted to know if the Xudum Pontoon was working again – in fact, just if you were in town – you went to The Duck. It was small and squat, with a low roof over the verandah out front. Its two rooms were overcrowded with tables and invariably short of chairs. The few wall decorations were limp and tired. There was a short bar without any bottles – the liquor was kept in a small anteroom, where the clients could not reach over and help themselves. On the door to the anteroom hung a T-shirt for sale; 'I survived the Duck Inn' read the front; 'The Duck didn't' was written across the back.

An eclectic assemblage of vehicles stood outside, most of them four-wheel-drives with heavy-lug tyres, the bumpers wound with rope and cable or supporting high-lift jacks, raised bench seats in the back, gun racks, bedrolls resting atop white packets marked in blue with 'sukiri' ('sugar'), a chassis buckled here and there, scratches hidden beneath coatings of dust. Between them were a few new cars, sedans mostly, the contrast between them and the bush vehicles harsh, like painted lips in a haggard old face.

At the bar I ordered a beer for myself and tea for Beverly. Jimmy handed me my beer and disappeared between the warren of crates and cases to make the tea. Jimmy had been there forever – or so it seemed. He'd seen and heard it all, and yet maintained a quiet grace.

It is the great privilege of many native Africans to have known a rural home. They are attached to this land, anchored to its ancient soil, held in its mystery and relentless turning. They are beyond the frantic strivings of westernized man, possessed of a peace that, if we searched half our lives, we could not come to know as fully. It is their history, their culture, their belief, at the very centre of their soul, that their only fastness is themselves and the land. They let life come to them, unlike those of us who are constantly yearning, digging, searching for some richness and reward, and in doing so distancing ourselves from a state of grace.

'Hey, Peter,' said Map, leaning on the bar beside me, as if the last time he had seen me was yesterday and not almost two years back.

'Hey, Map. What happened to Maun while I was gone?'

'Little yellow men brought big yellow machines and changed it.' He grinned at his joke, but there was no humour in his eyes.

Jimmy brought Beverly's tea and I carried it outside. There, I recognized PJ from behind by his short-cropped black hair and slender, sunburnt neck. His hand absently scratched the top of his head; he was puzzling over something. His long-haired companion was pointing at some papers before him.

'Tell me, PJ, are German tourists still the only ones who wear short white socks and Birkenstocks in Africa?' I asked as I set the tea down on the table. He gave his distinctive cackle.

'Mister P,' said his companion, standing up.

'Mister M.' Ian Michler embraced me across the table.

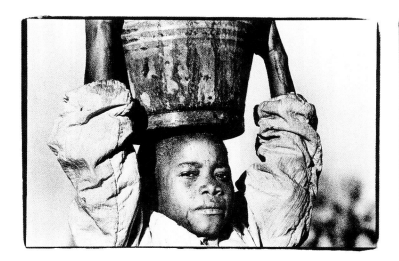

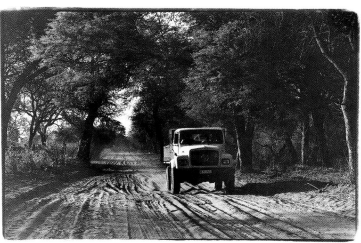

From far left:
In the white sand beside the Thamalakane River; tradition and fashion in Maun; returning home with thatching grass and water; the old road to Shakawe.

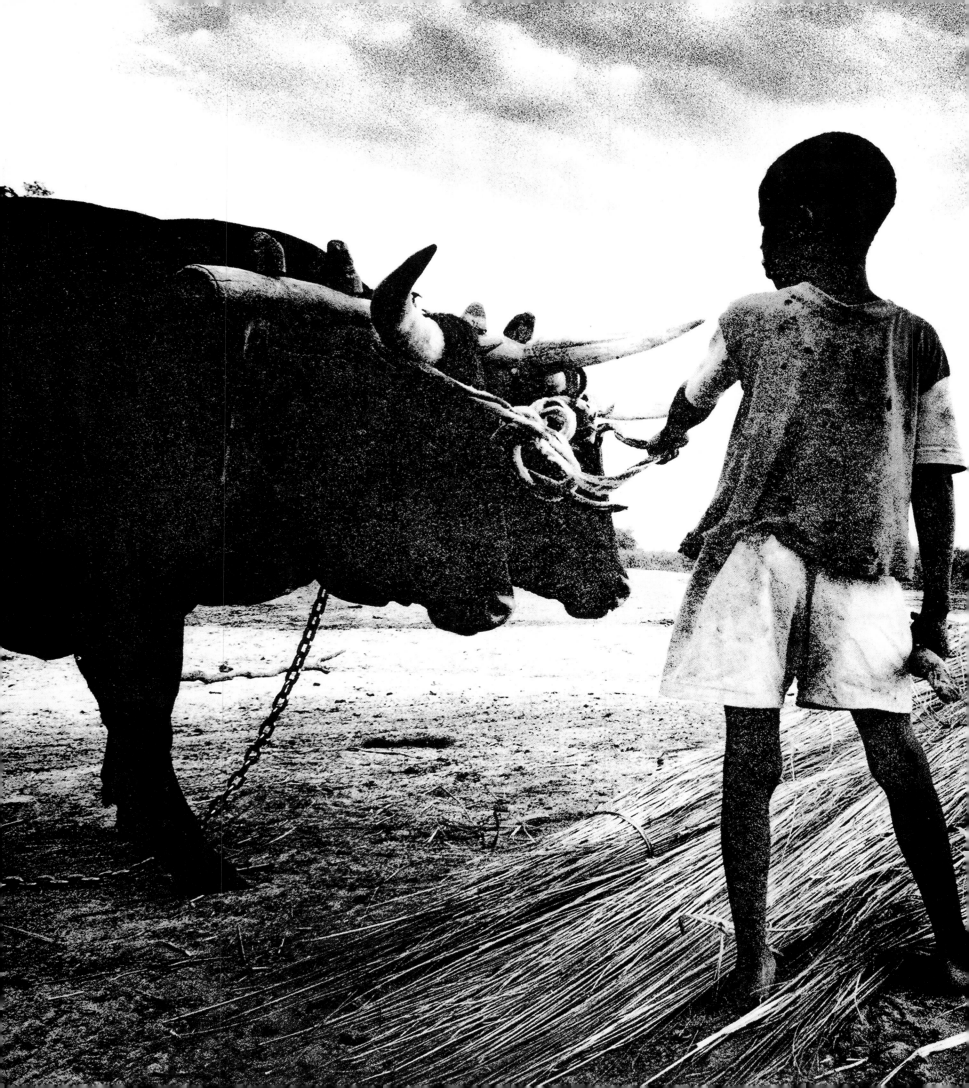

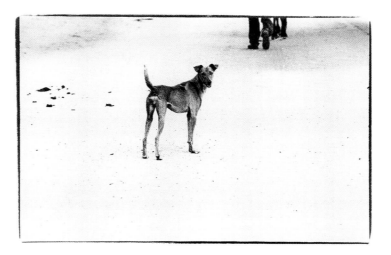

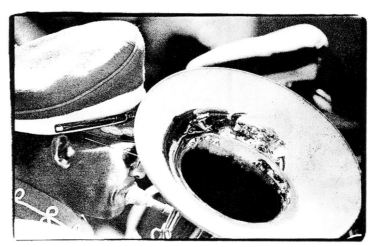

Far left: *In Shakawe, a young boy and his oxen wait to load reeds onto a sled.*
Above left: *A dog follows its master home.*
Left: *A marching band in Maun.*

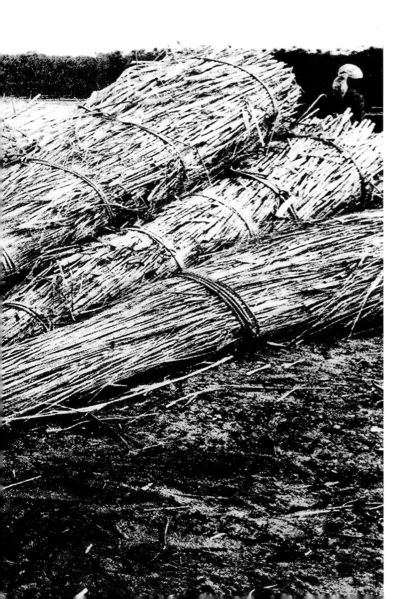

There was an official form on the table in front of PJ.

'What's this?' I asked.

'They grounded his plane,' said Ian, laughing.

'The buggers,' muttered PJ under his breath.

It seemed that PJ had found a bulldozer busy grading a strip that he had wanted to land on, and had decided to buzz it from behind for a little fun, at the same time letting the dozer driver know that he wanted to land. What PJ had not seen was a six-metre aerial, sticking out of the dozer's top, which he then inadvertently shortened by a few metres. The prop was fine, PJ told us, and there was just a small hole where it had gone through the windshield and instrument panel; it didn't hit anything important and, after giving back the piece of aerial and sticking some tape over the holes, PJ had flown on.

Some days later the hyenas had found a way through a thorn branch enclosure that PJ had dragged round his plane and had chewed its tail. Some more tape and PJ was on his way again.

A week or so later he had flown to Lanseria outside Johannesburg in South Africa, and that was where he had promptly been grounded.

'The buggers,' he muttered again. 'And now I've got to fill out this "Please Explain!"' he said, banging his hand down on the form.

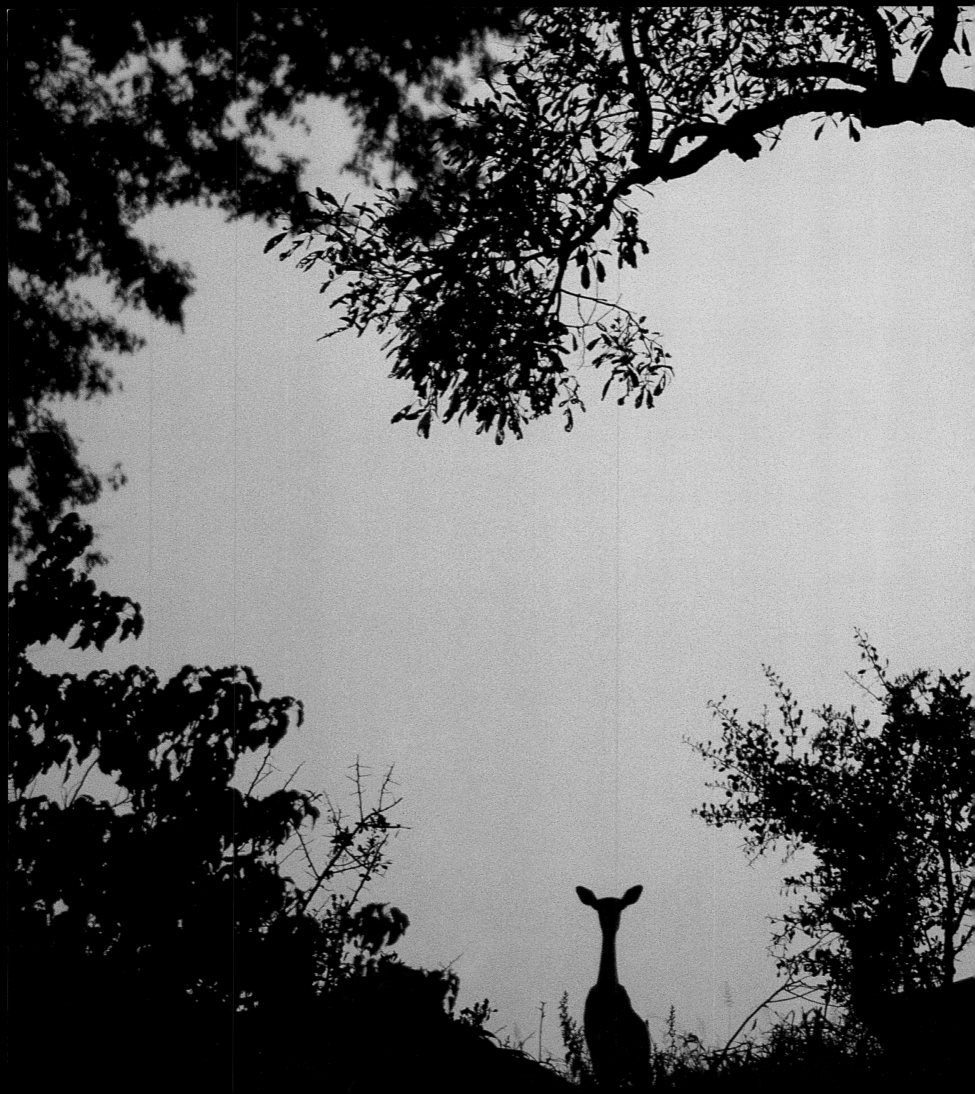

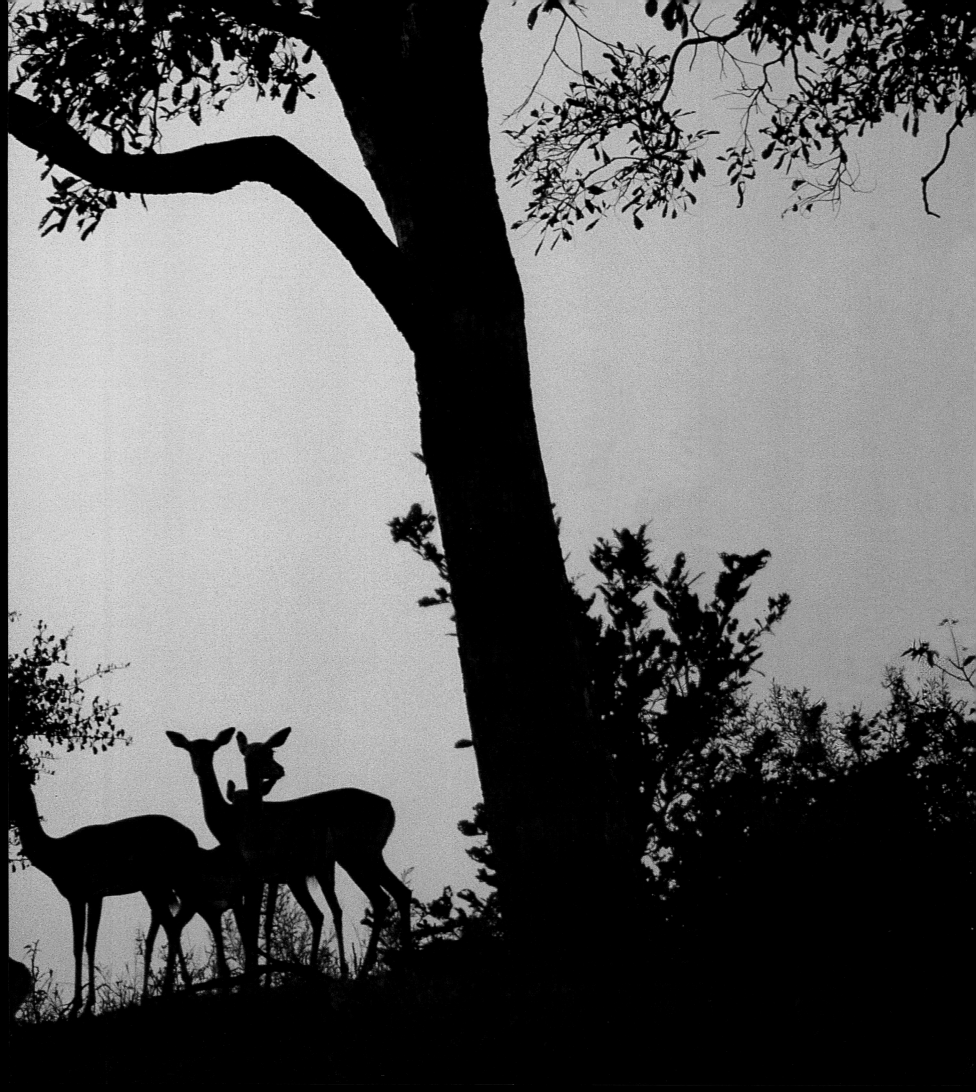

We ordered a meal. The chicken was tough and the peri-peri hot. My beer tasted good. While I waited for the others to finish I leaned back in my chair and looked about. A few tables away a couple ate in earnest, their conversation sporadic and sparse.

'Jimmy, more beer!' shouted a barrel-chested, big-bellied man, expansively throwing open his arms.

'Jimmy can't hear you when you shout,' retorted a female voice from inside. Behind the bar Jimmy smiled.

'Jimmy, more beer please,' rejoined the corpulent man in a hoarse stage whisper.

A well-dressed couple shook the hand of an elderly, silver-haired gentleman with gold-rimmed spectacles and stood up to leave. A dust-coated black youth in tattered shorts peered over the low wall from outside the restaurant, and was about to put out his hand when the couple, also black, shooed him vehemently away.

It has always surprised me that some of the blacks of Africa who

Previous pages:
Impala stand alert in
the twilight beneath
a rain tree.

attempt to understand the town, their cold modernity a slap in the face, a reminder of another world far from here, both in spirit and in place. And, between the two, the 'Smart Centre'.

'**Smart** *adj.* Astute; clever; impertinent; well dressed; fashionable; causing stinging pain.' I found the name fitting in its ambiguity. In the window a pale, flesh-toned mannequin was robed in some evening finery, its hands placed as if receiving guests. Beyond the glass a goat nuzzled at a packet in the dust.

Some of the government buildings retained their turquoise, black and white hues – the colours of the flag – while those more recently painted were a more practical creamy beige. The old Riley's Hotel had long given way to new buildings, the grandeur of which led to expectations that were not always met. Riley's Garage was, however, my deepest shock. The plain-sided, barnlike building was gone, and from the dust a modern counterpart was rising up to take its place, all glass and polished finishes.

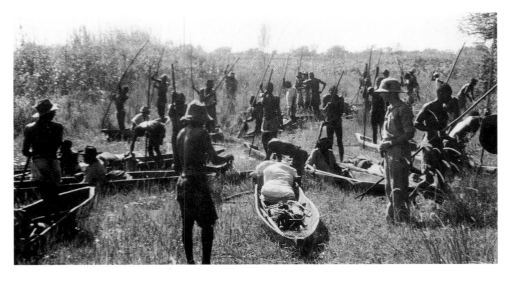

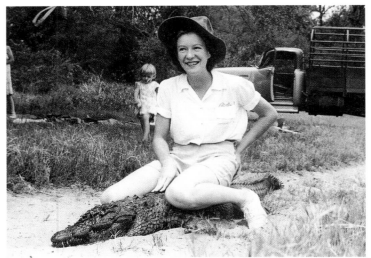

have taken to western ways are apt to treat their rural contemporaries so harshly. The west has hidden its insatiable greed behind the banner of progress and passed it off as the right to the enlightenment of every being. In the wake of westernization natives have been severed from their roots and it will take a native African to stand up and point to the richness and value that the African cultures possess and from which the west could learn so much.

As the youth ran away I found myself hoping that Africans, at least, would not follow in the footsteps of many of the native peoples of other continents, that when the realization dawned that their beliefs, their culture and their ways were both valuable and sacred, and that in them lay their individuality and their identity, it would not come as a retrospective yearning for something that was lost.

I drove slowly down Maun's main road. Most of the development was centred near the airport – two shopping complexes and a line of stores bearing testimony to the fact that the architects had made no

One of the most vivid memories of my youth came from here. Sweating and dusty, clad only in sandals and shorts, I had sat atop a 220-litre fuel drum in the back of a pick-up, filling it up beneath the hot sun in preparation for a safari – the root of a passion that burns bright in me still. Riley's forecourt was dust then – the road too – and on still days the people driving their flocks of goats past would leave a cloud of fine white dust lingering behind. It would mingle with the diesel exhaust fumes and you could taste it on your tongue. Above the clank-clank of the fuel pump you could hear Mr Kays talking in fluent Setswana as he held a part up to the sun, or the murmurings of the conversation between the men who sat in the shade of the tall white walls. It seemed somehow more essential then, more African, and it drew you to its breast and gave you an identity and a sense of place.

The colonial era was decried as the 'exploitation of Africa and the African' – and indeed it was, but the exploitation has not stopped. It continues unabated; it is just its masters who have changed. Perhaps,

at some date long in the future, when history has been written and our actions judged, this era will, in retrospect, be considered worse. We Africans have forgotten who we are and, in playing follow-my-leader to the western world, we have denied ourselves a richness, a uniqueness and a mystery that we will not be able to recreate.

In trying to create a wealth both fickle and transient, we have destroyed another. The colonialists exploited Africa, but in doing so they became African themselves. We stand in their stead, with every single trait that they possessed, except that one. And at the hands of our progress it is the lot of the rural black – the one person who remains truly African – that steadily deteriorates.

In the Herero quarter – a village within a village – the mud huts came to right beside the road. A woman walked towards us. Beneath her bosom her dress was gathered tightly at the waist and then, just above the hips, blossomed out in a spreading, bell-shaped dome, given volume by petticoat upon petticoat until the spreading circle of the hem caressed the surface of the sand. The material was deep red with paisley whorls of gold. Upon her head she had wrapped the same material, bonnet like, in the style of the Hereros' traditional headdress, and fastened it in front with a brooch. She was wearing gold earrings and her lips were boldly red. She was a figure of poise, accurately emulating the bygone era from which her style of dress was borrowed, and a solace to me.

Tsau, Nokaneng, Gumare … the names came more quickly than before; this road, too, was tar. Diverted off the new blacktop by a wildly gesticulating man (without a flag), we continued more slowly on the old road, a wide swath of sand cutting straight through the trees.

A steenbok bounded away from the road at our approach, a quick, red flash in the yellow grass. Some distance on, a Landcruiser was stopped at the side of the road and a short, ruddy-faced man, with a beard every bit as red as his hair, flagged us down. Talking in a broad Scottish accent, he told us he had stopped to relieve himself and then found that his vehicle would not start again. He had been unable to push-start it by himself, he said.

I turned the key and there was no response.

'I did hit a bump rather hard a little farther back,' he said as I opened the bonnet. His battery was, quite literally, flat – he had hit the bump so hard that the battery had concertinaed in on itself, compacting down to half its size.

Briefly, I inspected the vehicle for other damage, fully expecting to find the front wheels looking like an overloaded Volkswagen Beetle from behind. Although the one wheel stood a little skew, it was not badly damaged enough to prevent him from driving. Surprisingly, there was still sufficient current to work the gauges.

We push-started the vehicle. 'Drive a little slower for now,' I shouted, unheard, after him as he accelerated hard through first gear.

For a long time we had the road entirely to ourselves. Two ostriches ran, high-stepping across the soft sand. They raced off into the bush as we drew level, their heads remaining perfectly still as their bodies swayed and wove between the shrubs. A bateleur drifted back and forth across the road on fixed wings before disappearing over the tops of the trees.

At Sepupa a few people stood beside the road. A group of young boys with catapults stalked through the trees. A dry field cut into the forest beside which a group of bony-hipped cattle plodded in single file, their heads hanging low, ignoring the dust raised by their hooves. Through my open window I heard the passing tinkling of a cow bell.

Finally we reached Nxamaseri, quaint beneath the tall trees – Nxamaseri is one of the few exceptions I have seen where huts have been built beneath a tree. I have never understood why the rural African chooses to build his hut out in the sun. Regardless of what trees grow close at hand, the huts will be built on a bare piece of ground and the people who live in them will spend most of their days outside in the shade of the trees. Even when, rudely, I have questioned them directly about this, I have never received a plain reply.

But that is the nature of the African: as much as is revealed, there is always more that remains concealed. I have lived beside them and among them, and although I am familiar with them I have never come to know them, for they keep their mystery to themselves. Perhaps it is in this jealous seclusion that the salvation of Africa lies, for if we cannot touch the mystery, we cannot cut it out, analyze it and break it down. As much as I would relish the privilege of knowing his soul, it is my preference to know that that part of the heart of this continent will remain uncontaminated, dark and obscure.

I drove slowly past Nxamaseri, looking about. It was much the same as I remembered. A child ran before us pushing a spokeless bicycle rim with a piece of wire. Tiring, he collapsed laughing in the sand while the bicycle rim rolled on. Some women sat talking on an upturned dugout canoe. Behind them a young girl pounded millet with a heavy pestle in a deep wooden mortar. The huts were hidden from view behind the compound walls of new, yellow reeds. A mongrel dog with blue eyes yapped at our passing.

Opposite and above:
The Okavango has long been a magnet to all manner of adventurers.

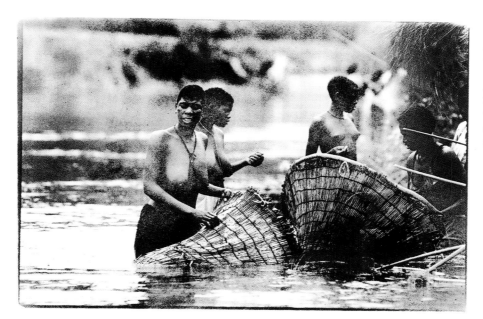

The River Down

*A*t the wooden pole bridge we left the road and followed the edge of the dry Nxamaseri Channel. It was narrow at first, hemmed in by trees, but soon it opened into a wide valley. The grass had been cropped short by the cattle and horses that grazed everywhere. Beyond the grass, white sand traced the edge, and thereafter came the trees. The spaghetti-like strands of the paths that emerged from the trees twisted together, worn by passing feet.

It was not long before we came upon the water, and it shrunk the edges of the valley until at times there were no more than a few metres between the water and the trees. There was a great fluttering of birds along this narrow band. A woman and a child followed a path towards us, carrying buckets of water on their heads, their arms hanging loosely at their sides, the peculiar undulation of their swaying bodies and the carriage of their motionless heads an elegant African pas de deux.

We passed beneath a spreading jackalberry tree. A flock of green pigeons fell from the branches like ripe fruit, to fly fast away. A cow standing knee-deep in the water dunked its muzzle below the surface to pluck the fresh green shoots. In the middle of an open stretch of water, hemmed by blue and white lilies, young boys fished with slender, fly-rod-like branches from a short *mokoro*. Closer to the shore, a great white egret kept motionless vigil.

We crossed a shallow flood plain, pushing a small wave of white water ahead of us for a hundred metres or more, to reach a wide, low, sandy island with short, spiky grass. On the far side we found Ian waiting for us, dozing in the bow of a battered green boat in the shade of a tree.

We loaded the boat, squishing through the shallows. The water was shallow, the boat heavy. Leaning low against the transom, we pushed until it floated free. We used the long, slender *ingushi*, a springy pole with a forked tip, to push us farther out. Ian and I punted in unison, our conversation punctuated by the grunts of our efforts.

The pointed bow parted the thick vegetation of the shallows: water lilies, their flowers bright with yellow centres, the pads of their leaves emerald green on top, maroon below; a forest of single-stemmed, pulpy reeds, dark green and tapering to a bluntish point, their dragging against the hull a soft sigh that kept time with the punts. They closed behind us, erasing any trace of our passage.

In deep water Ian started the motor and brought us quickly onto a plane. I sat looking over the side, dragging my hand through the water and then holding it up to let the drops fall into my mouth.

We rounded a bend in the channel and came upon a wide, shallow place of yellow sand where the cattle crossed. The narrow lengths of *mekoro* were drawn up on the shore. Some children played naked in the shallows, their bodies slick and shiny. On the island stood tall, spreading trees beneath whose dense canopy a shadowed cathedral

Below: An elephant creates a filigree of water.

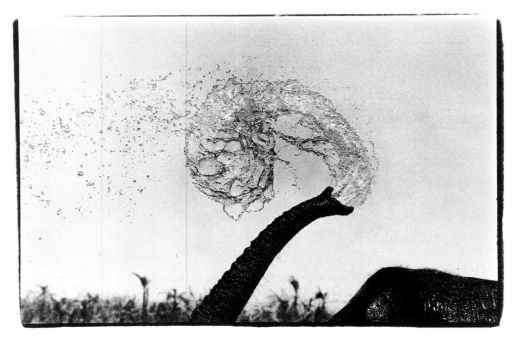

like a cavern faced its dark maw towards the crossing. In the shadows women cleaned freshly cut reeds, bundles of which were stacked against the trees. The butterflied carcasses of fish hung drying on lines between the branches. A man with his back to us repaired a net strung between two posts.

'What's that?' I asked Ian, pointing to what appeared to be a gas freezer deep in the shadows.

'Commercial net fisherman,' he answered, his distaste plain.

I remembered the occasion I had innocently broached the subject of nets with PJ. His brow had furrowed and he had jutted his goateed chin. It seems that some European country had first given nets to

Botswana as part of an aid programme for drought relief – nets instead of money, to provide protein. The drought had broken and the aid had stopped but the nets had stayed. Their devastating efficiency compared to traditional fish traps or hook-and-line fishing had ensured their survival.

There had been only one law instigated regarding nets, that you could not string them across a channel, but in areas where motorboats did not operate this was, for the most part, disregarded. There was no open or closed season; no restricted species; no minimum size of fish; no maximum length of net; no minimum size of mesh; no licence required; no research; no policing. The result was unprecedented, wholesale slaughter.

The channel grew deeper and the current slowed. The paths of hippopotamus showed clear on the riverbed. A pied kingfisher on a dry papyrus head made as if to fly off, changed its mind, and then, as we came closer, flew away with a twitter. The channel opened into quiet lagoons dotted with vast beds of water lilies fringed by stands of papyrus and bulrushes. Whitebacked ducks and, startled from among the lilies, a pair of pygmy geese took fright, their piping whistle continuing even when they were out of sight. A procession of *mekoro* passed us, going the other way. Each was laden with bundles of reeds, weighing them down so that only a few centimetres of their dark wooden sides stood free of the water.

We spent the remainder of the afternoon at a lodge beneath tall trees, preparing the boat that PJ had lent us to do the river trip, an open fibreglass vessel of about 5,5 metres, white, with pleasing, sweeping lines and a wide body. A 220-litre drum of fuel stood in the centre of the deck; smaller containers lined the sides. Coolboxes of food, camping gear and a toolbox occupied the centre, piled high, topped with foam cushions for sitting and sleeping on. Clothes, sleeping bags and cameras were safely stowed in a sealed hatch in the bow. A bright yellow beach umbrella was tied with a stretch cord to the fuel drum.

We left the following afternoon. PJ had drawn us a map on a piece of foolscap paper. We did not know where we were going, how long our journey would take or when we would be back.

At the mouth of the Nxamaseri Channel, the clear water mixed with the opaque-green flow of the main Okavango River, reminiscent on a small scale of the Río Negro and the Amazon in Brazil. We turned downstream. The current caught the boat and we moved swiftly. The river here was wide, a smooth highway between avenues of dense green papyrus, the horizon close. There were not many birds; a single darter dropped with a splash into the water from the branches of a wispy tree. We passed an island dotted with acacia trees, its base dense with slender, long-fringed palms.

We followed the inside curves of the river. A small crocodile, caught dozing on a smooth sandbank, ran into the water. The opposite bank was a flat flood plain with some cattle paths that pointed towards the river, a shallow drinking place that shelved off into deep water. Thorn branches had been thrown onto the edge of the drop-off to deter the

crocodiles. A bank of tall reeds with feathery heads, rattling softly, provided the backdrop for little bee-eaters that hawked insects over the water, the meagre weight of their bodies lightly bending the reeds to which they returned. A hippo path cut deep into the bank, revealing a short passage pressed in upon by the multitude of stems.

Shortly before sunset we came upon an island that I knew to be the last for quite some distance down the river. We pulled in beside a luxuriant waterberry tree. Wild date palms leaned out over the water, sweeping the surface with the tips of their fronds. A fish splashed out in the current and I heard the distant snorting of a hippopotamus.

We slept on the ground beneath our mosquito net, the light of our fire dancing silently on the trees.

The air was still and cold as we motored out. Dawn found us down a side channel, photographing a darter colony crowded on a single waterberry, white with droppings. A pair of fish eagles hovered in constant vigilance, eager for an unattended nest. Below the tree a squacco heron risked becoming whiter still as it foraged among the exposed roots, stabbing at the plenitude of small fish that came to feed on the richness that fell into the water. I caught a small bream, wriggling green, with a gaping mouth and bright orange spots on its fins. Stopping at a small island farther on, we ate it for breakfast, sizzling hot from the pan, sitting on a weathered log beside the fire.

The river between Sepupa and Seronga was busy. There is no road between them; the river is the highway. A small, speeding motorboat with four passengers slowed to cross our wake. A long, deep, aluminium barge churned the water up behind it, progressing slowly against the current. A police boat passed, its rows of seats empty behind tinted Perspex.

On a particular bend in the river we counted 23 immature fish eagles flying overhead or perched on low trees. They flew frequent sorties, snatching small, dead catfish from the surface, squabbling over perches or the meagre prizes. It was a strange phenomenon, the dead catfish, and we subsequently established that they had suffocated, caught in the oxygen-depleted, still water from the lagoons, pushed downstream ahead of the new flood.

Beyond Seronga the river traffic receded and we were on our own again. From PJ's map I knew that we were coming upon a long stretch of the river without islands. We decided to spend the night on the boat, and towards sunset I killed the motor. Our pace slackened, the silence settled and, twisting gently at its whim, we became part of the river's relentless march.

I fell asleep against the gunwale and woke in the dawn with a stiff neck. We stopped on an island for breakfast. There we found an old fire, baboon droppings on the ground and vervet monkeys in the trees and, after breakfast, walking out the back of the island, a pair of red lechwe hidden behind the fronds of palms.

Between the banks of papyrus the river meandered back and forth upon itself, like the coils of a shiny, slithering snake, and at a wide pool the river split and a channel led off to the west. The pool was

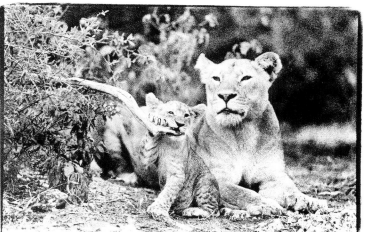

Above: *Traditional witches in Botswana have been known to take on the body of a hyena to perform their more clandestine and devilish deeds.*
Left: *A cub tests the mettle of its claws.*

presided over by a fearsome denizen of the river, its rows of teeth narrowly agape as it watched us with unblinking eyes from a low bank. We consulted our hand-drawn map and turned to the west. The channel was only two or three boat-widths wide and grew constantly narrower, pressed in by the ever-present banks of papyrus; the water moved swiftly.

Two boats filled with tourists – fortunately on a straight stretch where we could see them in advance – passed, cameras pointed at us, clicking; only the guides waved in greeting. The brief encounter left me moody and disquieted for, even though they were innocent of crime, they had robbed me of my peace and isolation and tarnished my adventure, making it common, known and plain.

An hour on we came upon an archway of trees over the channel. Two tiny islands – little more than large termite mounds raised above the river's surface – lay on either side. We stopped to make tea beneath the arch, the current rippling against the hull.

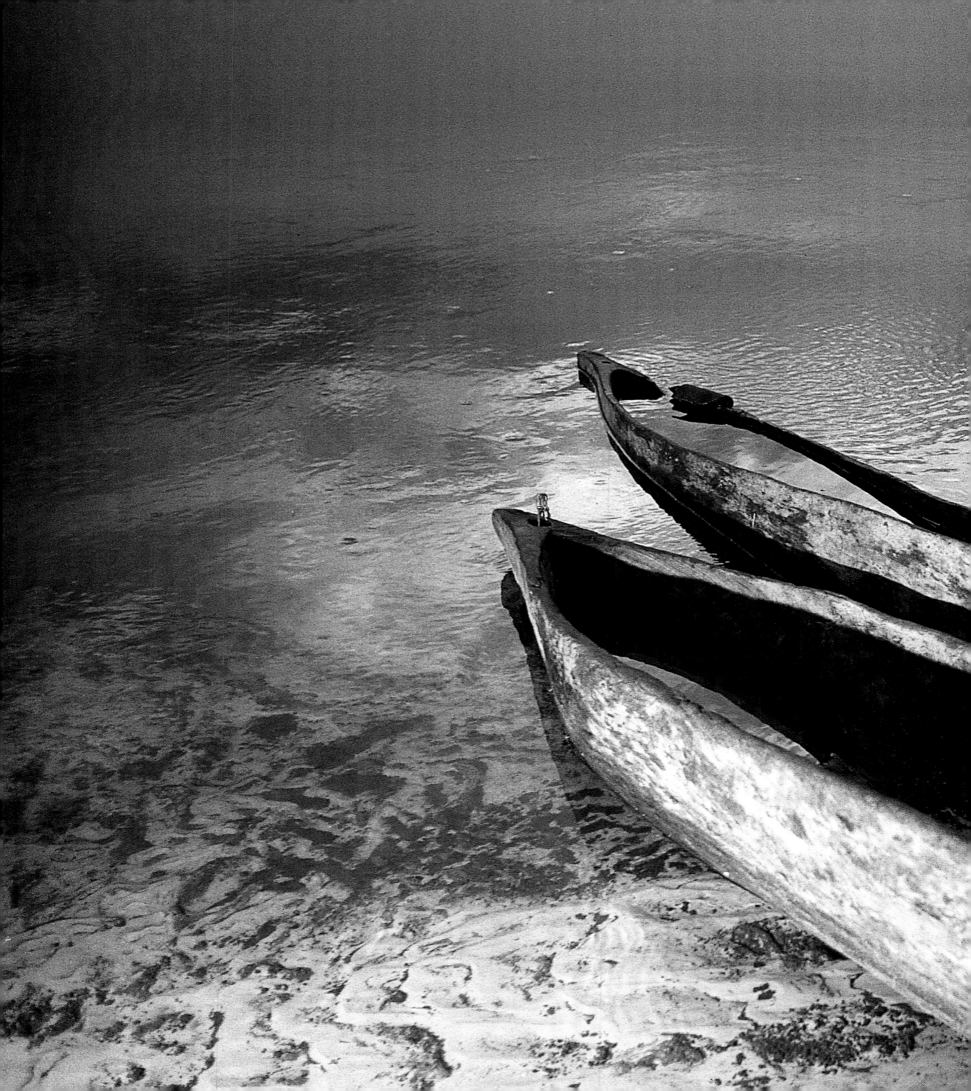

Right and below: *Aggression: hippopotamus and black-backed jackals.*

We spent a night in a place where two lone islands shouldered into the channel. When the moon had yet to drive the darkness from the sky, an elephant approached the place where we slept on a low island of damp ground. I banged two bowls together to drive it off and, although at first it retreated, it returned once again. Eventually we were forced to climb a tree, a giant strangler fig whose convoluted contortions provided easy handholds. We were soon high above the ground; we couldn't see the elephant but we followed its progress by the sound of its crashing through the undergrowth.

Eventually we came to a place where the channel offered us no reprieve, holding us in the grasp of its narrowness, and often we were forced to use the *ingushi* to help us make the turns, or to push the bow out of the papyrus where it had become lodged. And then, quite suddenly – as if created by someone who relished a surprise – the channel emerged from the walls of clinging green to burst forth upon an expanse of open water. I motored slowly forward. Having been slave to the narrows of the channel for so many days, I found myself reluctant to accept that its chains had so abruptly been broken.

A vast, many-stranded necklace of lagoons spread out downstream from the main, threaded by waterways and channels, encrusted with islands and all about a hinted presence, but unseen, of game.

PJ's map could help us no further; any of a myriad channels could have been the way out. We tracked the course of other boats by the propeller cuts in the reeds but their path brought us to places of deep water which forked and then forked again. The urge to explore was finally curtailed by prudence, for our fuel was running low. We opted to remain in the system of lagoons and return the way we had come.

One morning, quite unexpectedly – for the prevailing wind carried the sound away – we heard a boat. It was the Department of Water Affairs, and two days later they led us through the maze.

It seemed that the driver knew only two speeds: stationery or flat-out. At every fork he waited for us to reappear before speeding off again. They finally stopped a last time, to tell us that the channel was now plain. The Xo Flats lay ahead, they said, before they finally sped away. PJ's map bore no such name.

A meandering channel cut deep into the flat surface of a wide flood plain. The sand on the bottom was swept smooth and clean by the swift passage of the stream. The water, still higher than the banks, was receding, leaving as its legacy a flush of new grass to the herds of attendant game. Three giraffe watched us from over the tops of short, thorny trees. A herd of lechwe splashed through the shallows and then leapt high over the channel, the water streaming from their hooves. A group of rams, resting in the open, rose stiffly to their feet at our approach, to walk a few paces away; two young males jousted briefly before lying down once again.

Everywhere was green. Through the short grass of the plain rose a plenitude of tiny islands obscured below a burgeoning of palms. A herd of wildebeest turned their heads towards us, alert. The bull, a few paces out in front, tossed his head and snorted. Some shy kudu

Previous pages: Mekoro *after a rain storm.* **Opposite:** *Wild dogs often hunt along the shallow rims of the flood plains.*

We entered then a most isolated realm, a mosaic of land and water threaded tenuously together, each giving way to the other so that there was no continuance, only the whole. Under the influence of the place, the days too rolled into one. The channel we followed became extremely narrow, at times no more than a hippo trail, with the beam of the boat pushing down the papyrus on the sides. We deviated often from its path, the mouth of a lagoon leading us away to a small piece of quiet water and then, following a clear channel farther still, coming quite suddenly upon a vast lake set about by islands, the sanctuary of birds. We walked the narrow footpaths of elephants, beneath forests of tall, straight palms and, stripping naked, swam in the shallows of wide sandbars. We skirted around pods of hippopotamus, startled shy sitatunga with our approach and, as we rested beneath some spreading shade, watched the birds that fretted above us.

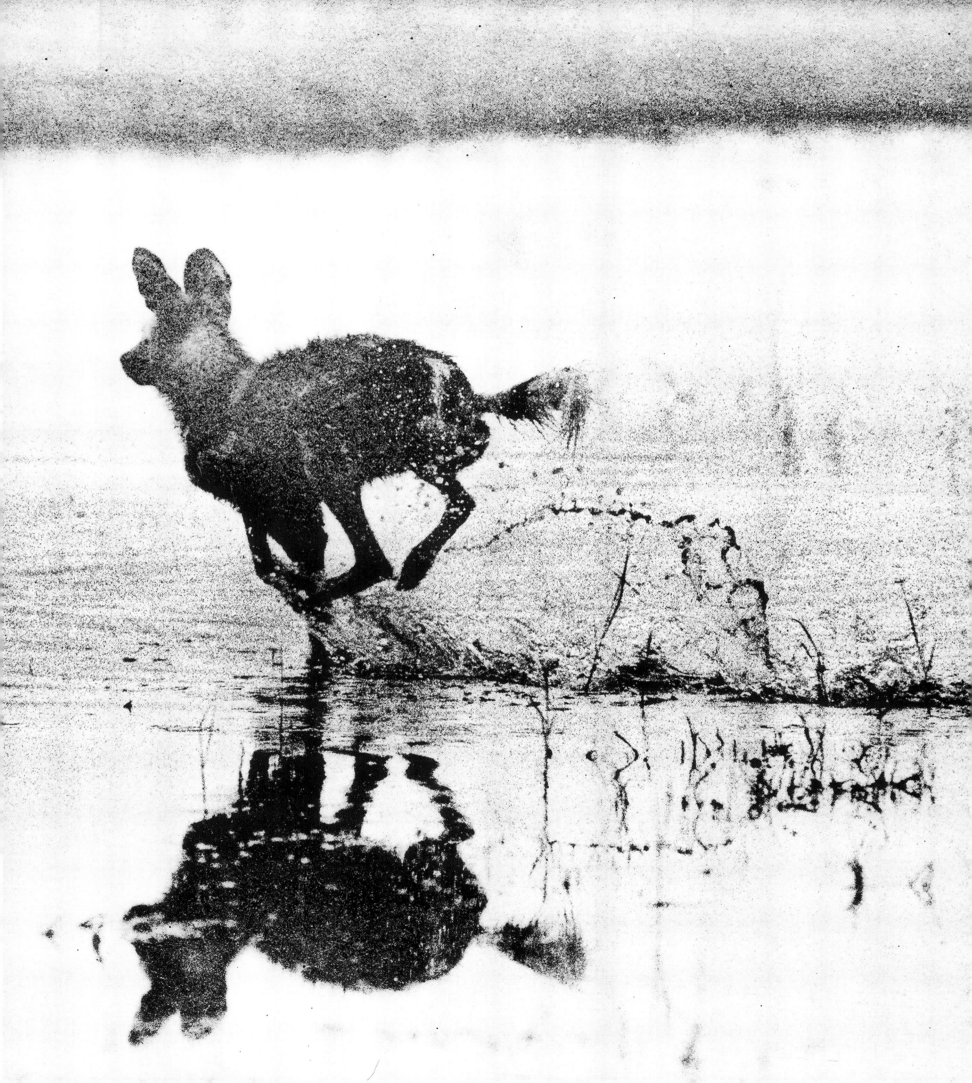

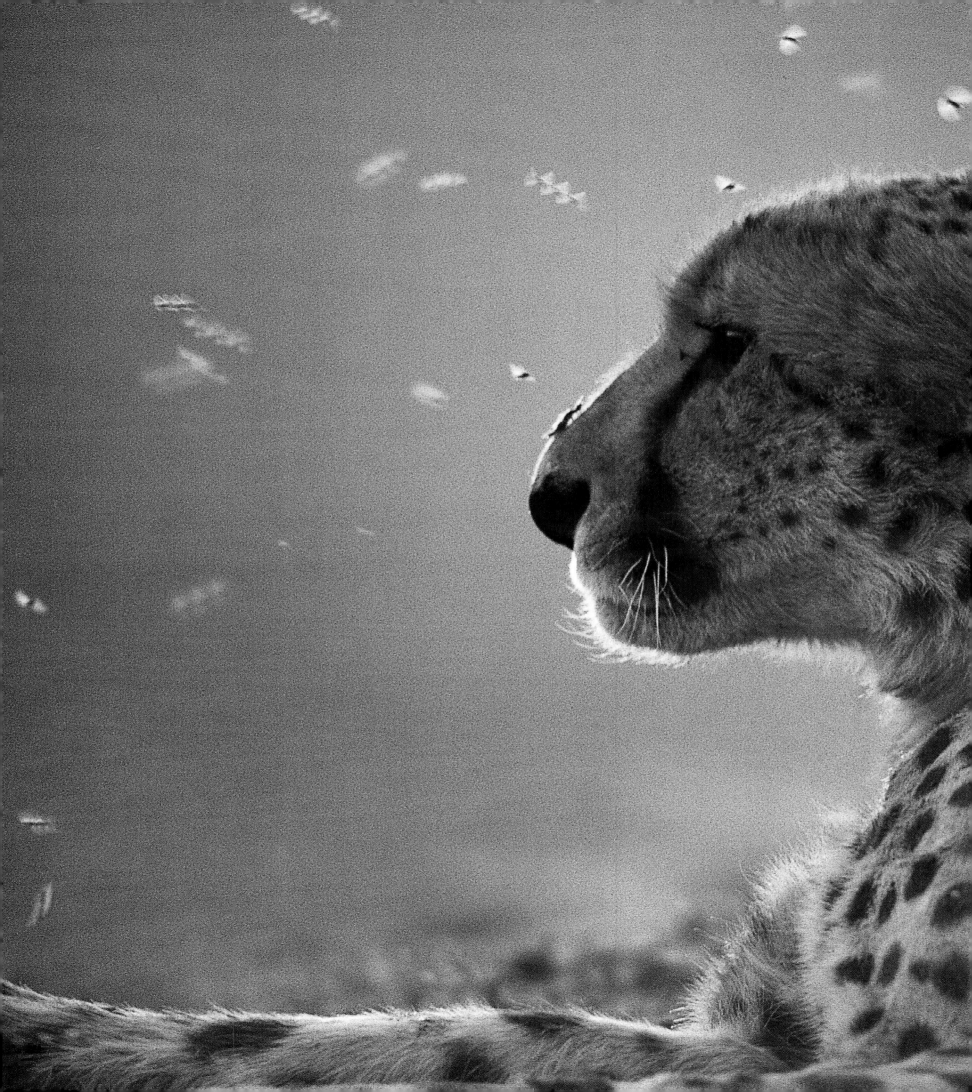

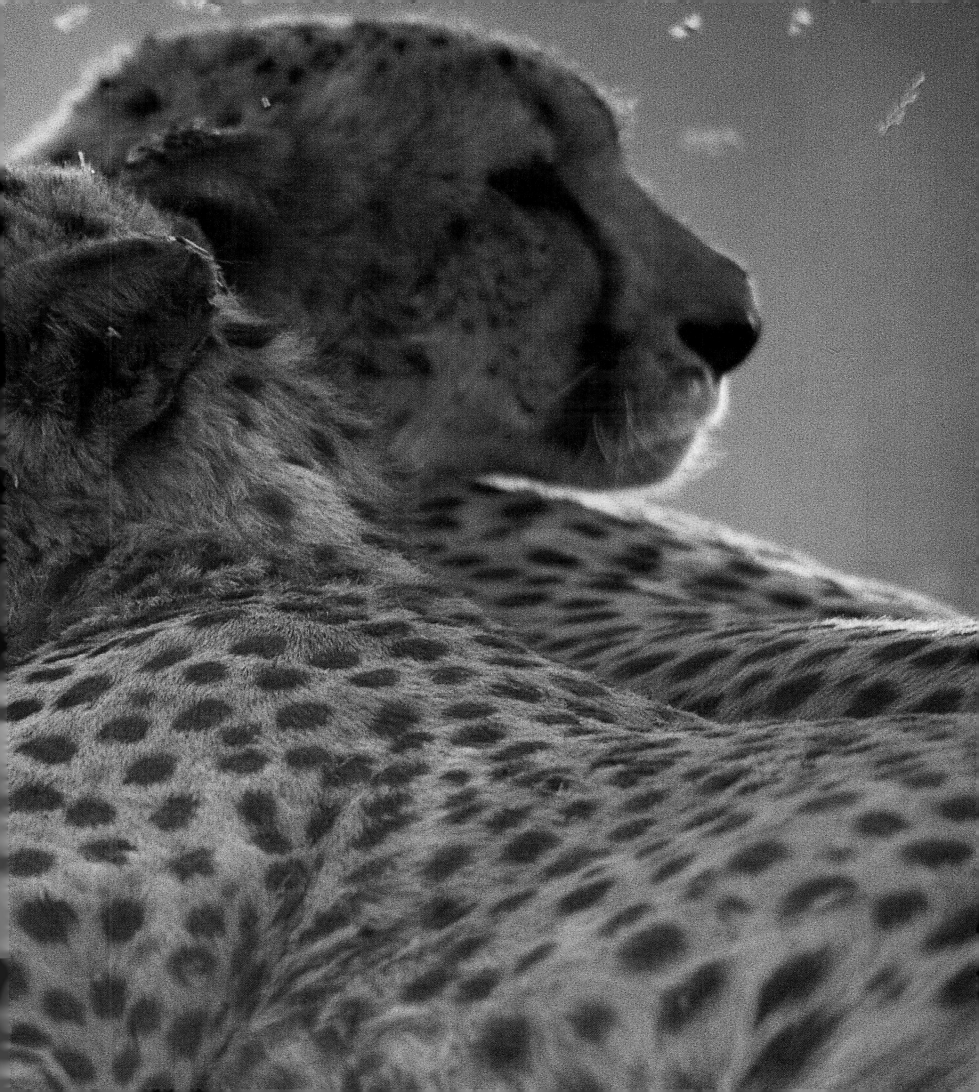

does peered from the safety of a stand of trees, the pink inner ear of one accentuated by sunlight from behind. A small crocodile slid into the water, momentarily gone, then clear, sitting motionless on the bottom beneath the boat. The flow drew us on.

Beside a single waterberry we found a sandbank and swam in its shallows, while in the distance a herd of buffalo stood spread out over the plain. The channel led into tall reeds and once again the horizon was drawn close about us. A tiny malachite kingfisher whirred away on frantic wings.

Where the reed walls petered out, the channel grew wider and constantly shallower. Eventually we could use the motor no more. The *ingushi* brought us to a wide, shallow place where we had to man-handle the boat over the sand, in places digging a path for the keel with our hands. The water seemed to flow from everywhere, as if all

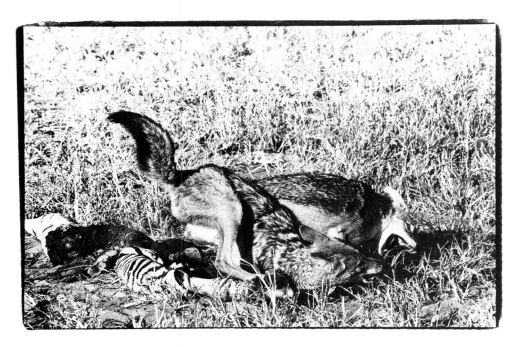

Previous pages: *Two cheetah ignore the persistent buzzing of the biting flies.* **Above:** *With wealth comes squabbling; two jackals in dispute.*

the channels, paths and streams were veins that led to this heart. On the other side the water grew deep and, motoring on, it was some time before it dawned on us that we were on a river once again.

The water here was quick and dark, the banks wide, the shallows reaching into flood plains that stretched beyond view. The islands rose large from the plains of green or the encircling water. On the rises of the islands, where the water had not reached, the tall grass stood bent over, a static sea, dry and brittle yellow. Groves of palms, pale topped, stood straight and tall, their ordered ranks blending into a dark mass where they retreated into the distance.

Each island was cloaked with trees. Old and young, they stood side by side, behemoths all. Great girths reached upwards from the earth with gnarled rough branches of black and grey or smooth and yellow-green. I had read somewhere that trees were like frozen music. In this place it was quite so: this was a symphony of trees.

The music of the silence shattered into a thousand pieces as an aircraft passed mere metres above our heads. The pilot waggled the wings in greeting and then continued his game flight, coursing low over the river.

We saw an island that looked like it might provide a good camping place, but closer inspection revealed a red dome tent. Two people stood on the edge of the island gazing out, while their *mokoro* poler sat in the prow of his beached dugout, fishing. They waved in greeting. In a sheltered lee of the same island, a black skin smeared with streaks of shining white revealed itself to be a *mokoro* poler bathing. Unembarrassed, he waved too.

All about the river were small groups of lechwe. Only those nearest to the edge moved nonchalantly away. A pair of wattled cranes walked closely side by side, immersing the whole of their heads beneath the water to probe into the mud; withdrawing, the water streamed down off the points of their beaks. Two elephants walked through the trees. We stopped and they came to drink not far from us, slurping the water from the surface. They sprayed their backs and their bellies when they were done, and then ambled to a clear patch of fine sand. They dusted it over their bodies with their trunks and it clung to the wetness, patches of white against the grey.

A pair of hippopotamus in a pool off to the side revealed themselves by the raised ridges of their spines low above the water, the soft sighing as they breathed; a wagtail hunted about their backs and heads. In the trees behind, an ear twitched and, looking closer, we saw a pack of African wild dogs resting in the shade.

A boat approached on a plane. In the back a young man stood with his legs apart, his hand on the tiller, a bandana knotted at his throat. A crocodile rushed from a sandbank into the water. 'Croc!' shouted the young man, but it was already beneath the boat. One of his passengers moved to raise his hand in greeting but was forced to grab the gunwale instead as the boat banked away.

I'd met young men like him before, who, like the evening boulevard cruisers, seem to translate the flagrant power of the throttle directly to themselves, and would appear incapable of understanding the power that lies in peace. Their pursuit of wilderness lay in its endorsement of machismo, its association with 'tough' and 'real' men. But that breed is rare and in most of these imitators the lie showed through; they stayed a while and then were gone.

Another aeroplane flew overhead. We decided to return later to watch the wild dogs; for the moment we needed a quieter place. We turned up a side channel, a wide sheet of water with the current at its centre. We motored slowly past a single tree with a fish eagle, a thin screen of reeds, some people fishing. The water was a broad canvas against the blue of the sky, the channel discernible only by the swirling of the current. A black snake crossed the sand of a small island; birds fussed about it, hovering and twittering over its head.

A vehicle track disappeared into the water and led away on the far side. We left the channel not far beyond it and poled ourselves through an area of low reeds to an island with dense shade. The

island rose sharply up at one end, to a small level place with a vista all around. Two men approached us, walking. They asked if we might give them a lift to their lodge; later would be fine, they were in no rush. They walked off and went to sleep beneath some trees. We went for a long walk in the yellow grass and saw a cheetah standing high on a termite mound. We returned to rest within the shade.

With the two men we returned whence we had come. Down a side channel, we found the lodge landing, motor boats and *mekoro* with plastic seats. A silver fuel drum lay in the sun. A path close with palms opened into a treeless arena baked hot by the sun. The path, neatly swept, led beneath the grove of towering trunks, the undergrowth cleared away, reeded buildings dwarfed by the canopy above.

Exclamations of surprise – some people that we knew. We accepted their offer of tea and signed the book put into our hands. A young woman, all thighs and buttocks beneath frayed shorts, offered chocolate cake and drinks from behind the bar. We retreated to the radio room, received our messages, said our thanks and left. That night I sat alone beside the fire while Beverly slept beside me beneath the net.

I had come here in excitement, with preconceptions built on past experience, and, I suppose, something close to hope. Now my hope was all but gone. I recalled a passage from Karen Blixen's *Out of Africa* in which she describes her experience as that of a person who had come from a rushed and noisy world into a still place. Here, I felt quite the reverse.

I had long wondered if nature conservation still actually exists. Conservationists had seen fit to justify the existence of wilderness and natural realms as economically viable and, in doing so, had committed wilderness to the annals of history and dedicated themselves to an endless series of battles in a war that was lost at the outset.

We have made a business of wilderness. We will now, continually – forever – have to justify the business of wilderness per se against those businesses that seek to utilize wilderness for some other purpose. In the Okavango Delta the business is cattle, water and diamonds, the justification for its continued existence reflected in the figures on the bottom line.

With each battle that conservationists win, I realized, we guarantee nothing – only the grant of a temporary stay of time. In winning those battles we have also lost, for in making a business of wilderness, we have committed ourselves to its utilization. To utilize means people – people to fish, people to cut grass and trees, people to hunt with cameras and with guns – and thus we make of a still country a rushed and noisy place. Wilderness as a product must be sold, and in the way we have presented wilderness as a commodity, we have altered people's thinking. We have made of it an African spectacle, little more than a gigantic zoo, denying its spirit and its soul.

Essentially, man is faced with a choice between two values: material worth and spiritual worth. Material worth is fickle, transient, unenduring; it is also discriminatory, offering privilege to the few while keeping opportunity from the many. Matters of the spirit are

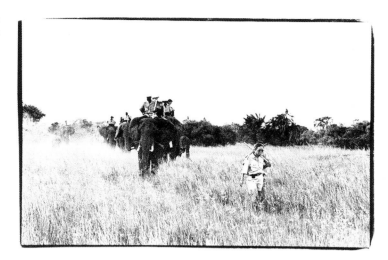

Left: *To walk beside an elephant for days is to know that they possess a benign wisdom, one we have either forgotten or have yet to learn.*

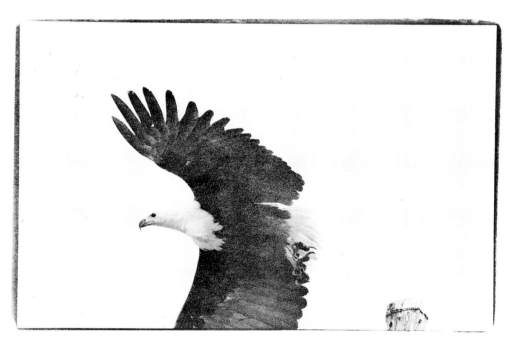

known to every single human being, the very pivot at the heart.

In placing only a material worth on wilderness, we have severed man's final alliance with the earth. We have denied ourselves as part of all creatures and all things, and have committed ourselves to a path of great loneliness. In holding ourselves separate and aloof, we have subjected all that of which we are not a part to condescension, and have made of ourselves masters. The progression thence is to assume the work of God or evolution, and in doing so we will make of ourselves a creature too hideous to love.

If we cannot use our reason to hold ourselves in humility, and accept with grace our partnership with all the earth, then we will not be able to perceive that man, like the dinosaur, is expendable. Ultimately, in the vastness of time, man is on trial here, not only as a species, but also as a vehicle to determine whether reason was an advance or a tragic evolutionary mistake.

Above: *An old man with watering eyes told me of his wish to be reincarnated as an African fish eagle.*

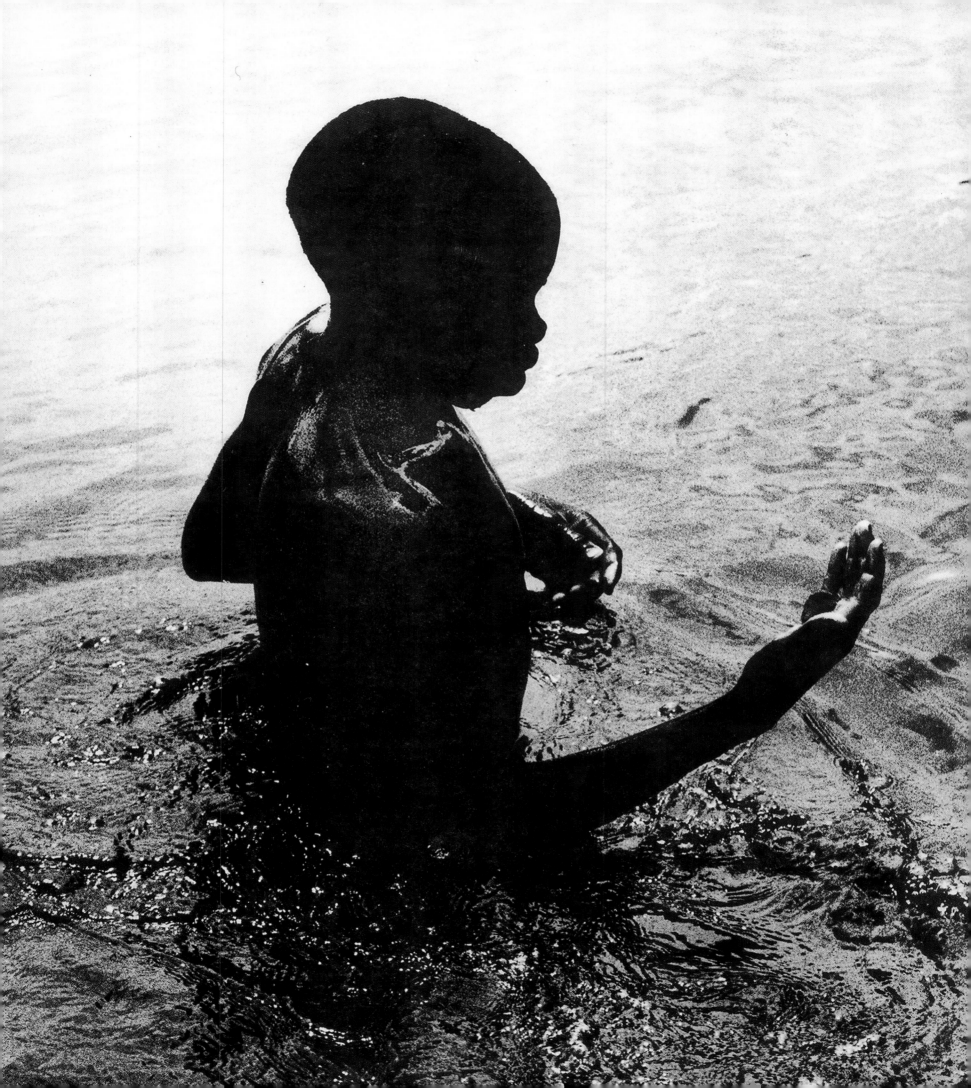

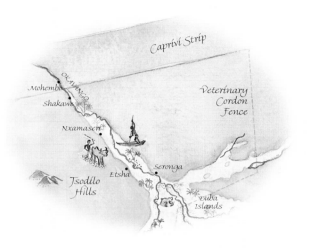

The Web
OF THE
Water Snake

'When the fifth veil falls and with it the illusion
of financial worth, individuals might recognize themselves
again, might find themselves standing, as if naked, among
ancient values in a long-lost landscape.'

Tom Robbins, *Skinny Legs and All*

Between the Namibian border in the north and Jedibe in the
south, where the waters of the Okavango finally encounter flat
ground and begin to spread out, the river is confined by the rise of
the land to a comparatively narrow passage. It may be likened to a
python whose blue-black coils twist and writhe against constraint.
As it gorges and swells on the summer rains from the north, it
creates a legacy of wealth that draws the people to it. Its grip is fast
upon their lives, but rather than savage, it appears benign, its
only cruelty a mocking disdain for attempts at mastery.

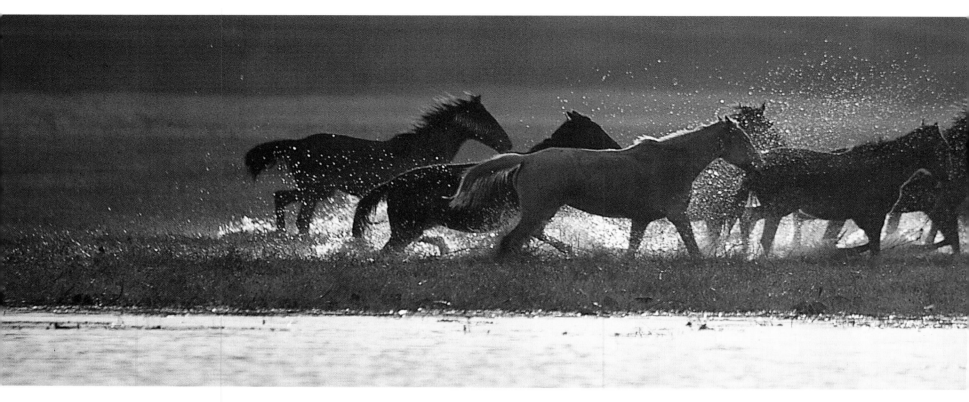

You have the choice in Botswana for civil disputes or criminal charges of recourse to either tribal or judicial courts. The tribal court is outwardly a less formal affair, the custom, formality and ritual little perceived by the unfamiliar eye. In such a gathering of older men – whose outward appearance offers no clue as to the status each holds – long discourses ensue which to the casual observer can lead to some confusion as to who is judge and jury and who is witness and accused. Each who wishes to talk may do so and his utterances may be considered with anything from ridicule to great gravity by all present – including children. No punishment is fixed and its terms are often unique and inventive.

The tribal court seems the most common choice for both complainant and defendant for, unlike in contemporary western courts, with their clever parlance and haranguing over technical details, it does not often fall short of a fair and reasonable judgment. Perhaps this is because in a tribal court, those present and their personal circumstance are often known to their peers, for they are part of a smallish community, a group of villages connected by footpaths and the river.

In this northern panhandle of the Delta, although a road exists, it is mostly a medium for visitors, government business or those from elsewhere who have settled along the river. To most locals here, a ride in a bus or in the back of a government pick-up represents a red-letter day, and it is rather the soft, white, sand pathways and the smooth, green, shiny coils of the meandering river that string village to village and tie each person inexorably to the life force of the water, making of the fragments a whole.

The villages, the huts in which are made of reeds and roofed with grass and the compounds of which are often screened by high walls of new yellow or old grey reeds, are set far away from the river, in the dry country, beyond the reach of the annual flood.

From the air the twisted, silver body of the river is plain to see. Turning upon itself again and again, it seems to lie motionless among the wind-stirred swath of the reeds. Where, over time, the river has changed its course, it has left in its wake all manner of lagoons. Some are like strands of round, silver pearls, severed by thin stands of reeds or laced together by hippo paths. Others are wide and long, with their surfaces freckled by water lilies. Where water

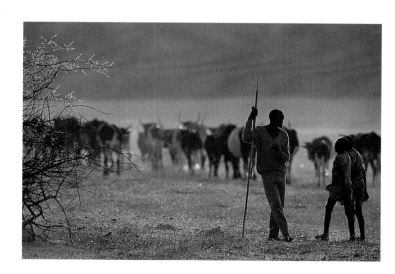

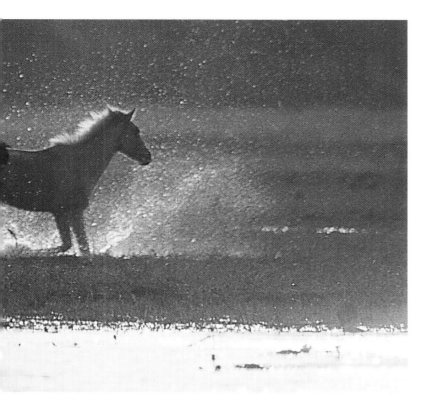

From behind the obscuring papyrus a man may appear in his *mokoro*, returning home with his catch strung on a thin, fleshy, green reed. Behind you an old man may rise from where he has been sleeping in the deep shade and return to mending his net, hung up on thin poles beneath the trees; or there may be women sitting straight-legged on the ground, cleaning fresh-cut reeds or crushing them with heavy, hourglass-shaped wooden mallets.

If, when you arrive, you find only silence, and a few *mekoro* drawn up on the shore with, perhaps – if you are lucky – a pied kingfisher sitting still on one of the prows, wait and they will come. Sooner or later, the long-legged, bony, multi-hued cattle will come to drink, before returning to the villages where their calves are held in small, wooden-pole kraals.

If you choose not to follow the cattle on the dusty path home and slip instead from the shore in one of the *mekoro*, then you will immediately realize the depth of deception that had been your view from the air, for the river is no single body. Each bend and straight, its horizon shrunk by papyrus or reeds, becomes drawn in upon itself and holds you in a world isolated and on its own. The greasy green surface is roiled by the current or the wind or the rain and the constant sound of life – a fish sucking at the surface, birds calling on a small island, the distant snort of a hippopotamus.

Most of the lagoons, so plain from the air, remain hidden for the earth-bound. Only in those leading off the main river or joined to it by narrow, sandy-bottomed channels can you sit in silence between the green-topped lily pads, in the company of ducks, geese, kingfishers, bee-eaters, herons, egrets and fish eagles.

Returning to the landing, you may be unsettled by the demure but inquisitive gaze of the quiet people, but during your time on the river, you may have been touched by the calm that lies in its relentless, steady passage – and, in having done so, understand, however briefly, the tranquil acceptance of fate that lies in the depths of these people's eyes and know that, at night when the drums sound, there is no shackle that could fetter the spirit in this African place.

meets land, green canopies of trees cluster closely about the shore. But this view is a deception.

On the ground, the emerald canopy is held high above head height by the girths of great trees. Close by the edge of the water their ranks stand pressed upon each other and a host of birds frets and flutters between them, their soft songs joining the single, clear note of a goat or cow bell. The smell of fresh dung seems never far away.

The river is a magnet to all the paths, and where they draw together, like veins to the heart, you will find the people. There may be only one or two, there may be many, but they will come and go quietly, like the river.

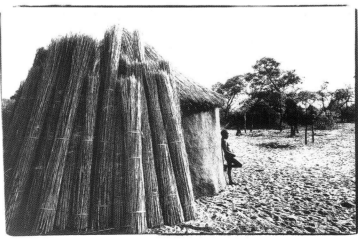

In the Okavango Panhandle wealth and water run hand in hand, for water means grass and crops and fat stock, while in the river it brings a flush of reeds and fish.

45

Wild Things

'There are some who can live without wild things, and some who cannot. Like winds and sunsets, wild things were taken for granted until progress began to do away with them. Now we face the question whether a still higher "standard of living" is worth its cost in things natural, wild and free.

'These wild things, I admit, had little human value until mechanization assured us of a good breakfast, and until science disclosed the drama of where they come from and how they live. The whole conflict thus boils down to a question of degree. The minority sees a law of diminishing returns in progress; most do not.

'Conservation is getting nowhere because it is incompatible with our Abrahamic concept of land. We abuse land because we regard it as a commodity belonging to us. When we see land as a community to which we belong, we may begin to use it with love and respect.

'That land is a community is the basic concept of ecology, but that land is to be loved and respected is an extension of ethics. That land yields a cultural harvest is a fact long known, but latterly often forgotten.'

Aldo Leopold, from *A Sand County Almanac*

Water is a binding force drawing together all manner of lives and things, creating an inexorable flow.

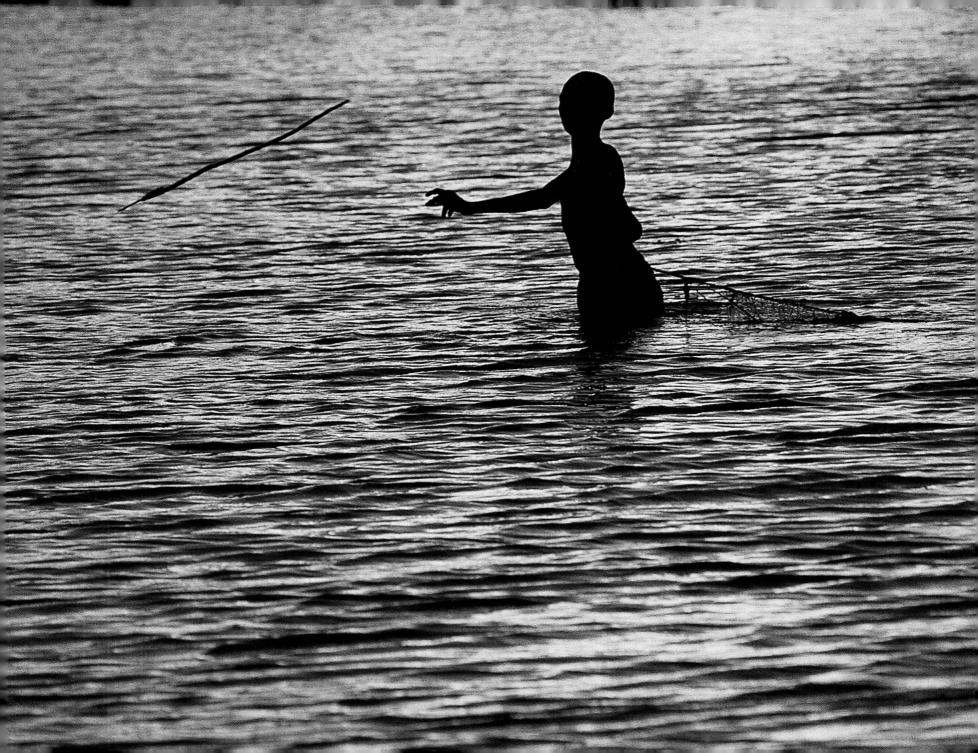

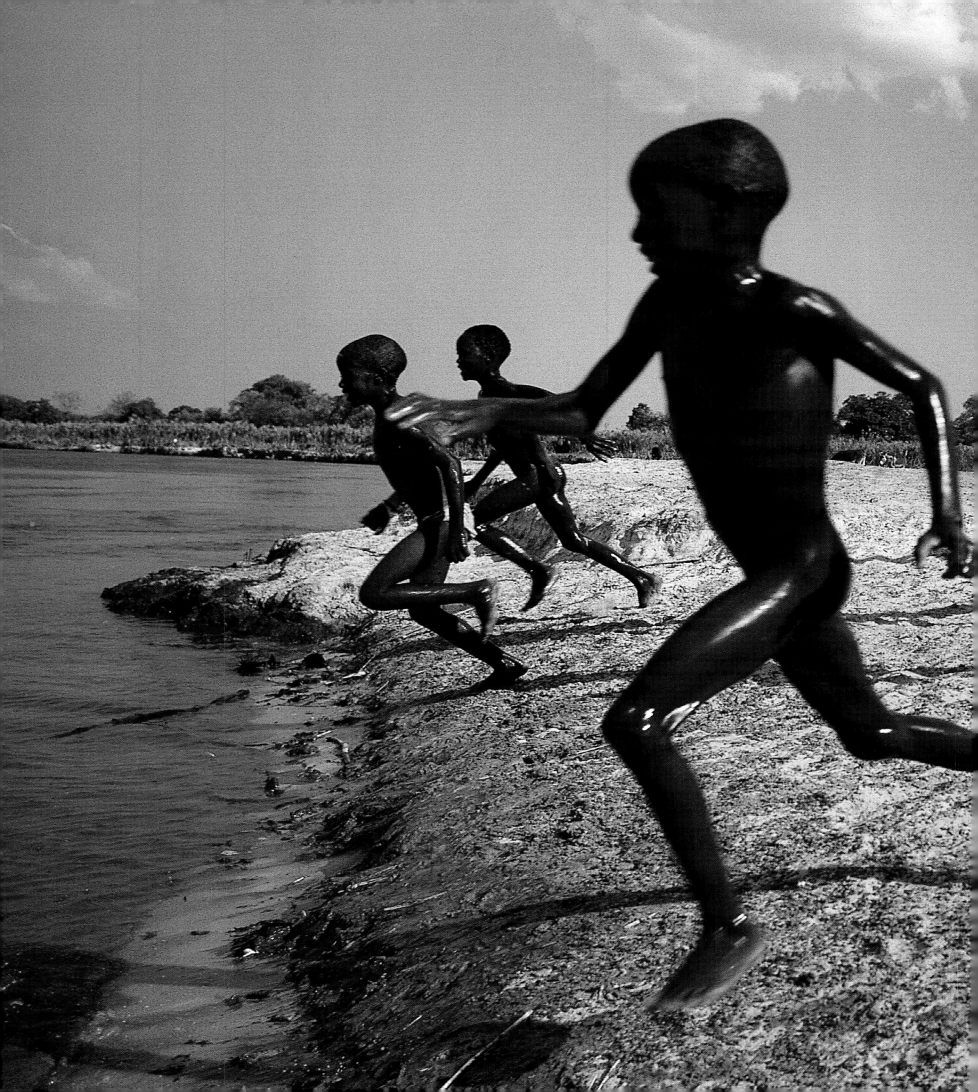

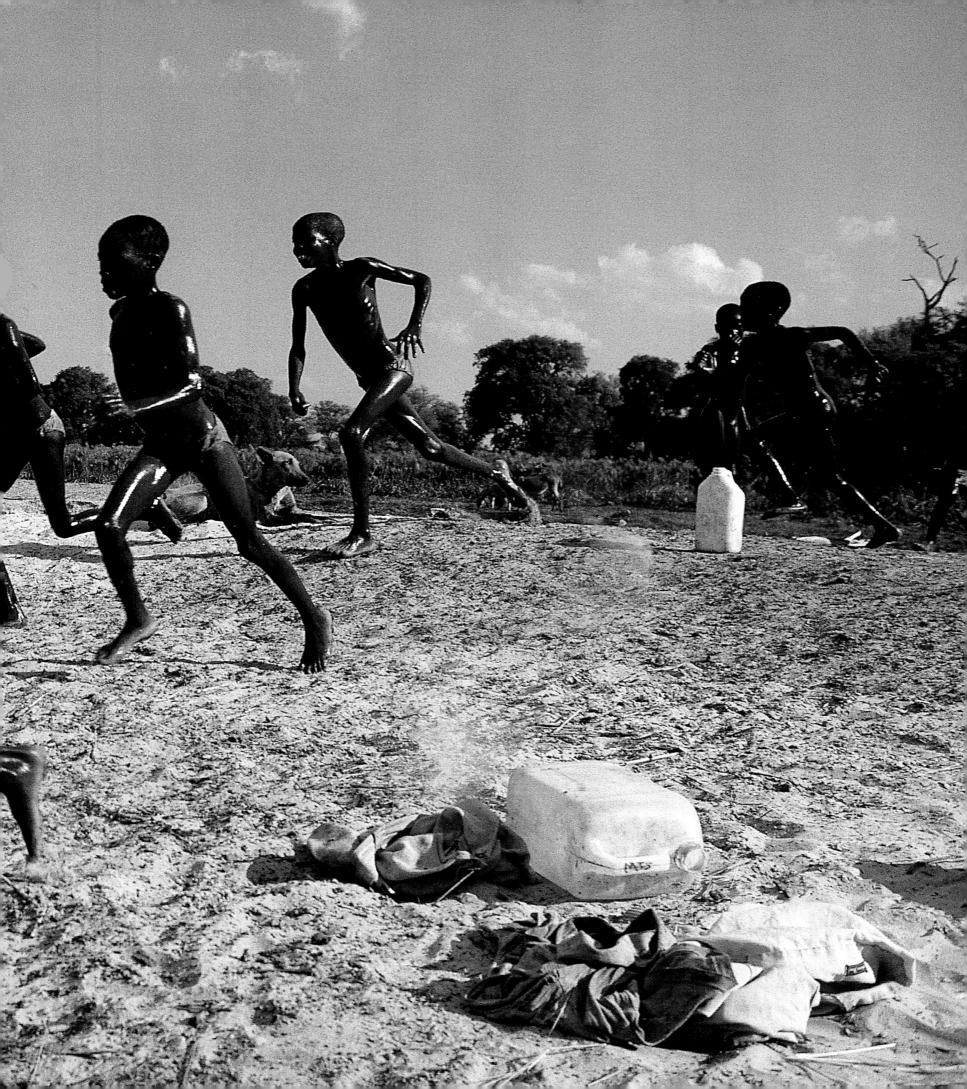

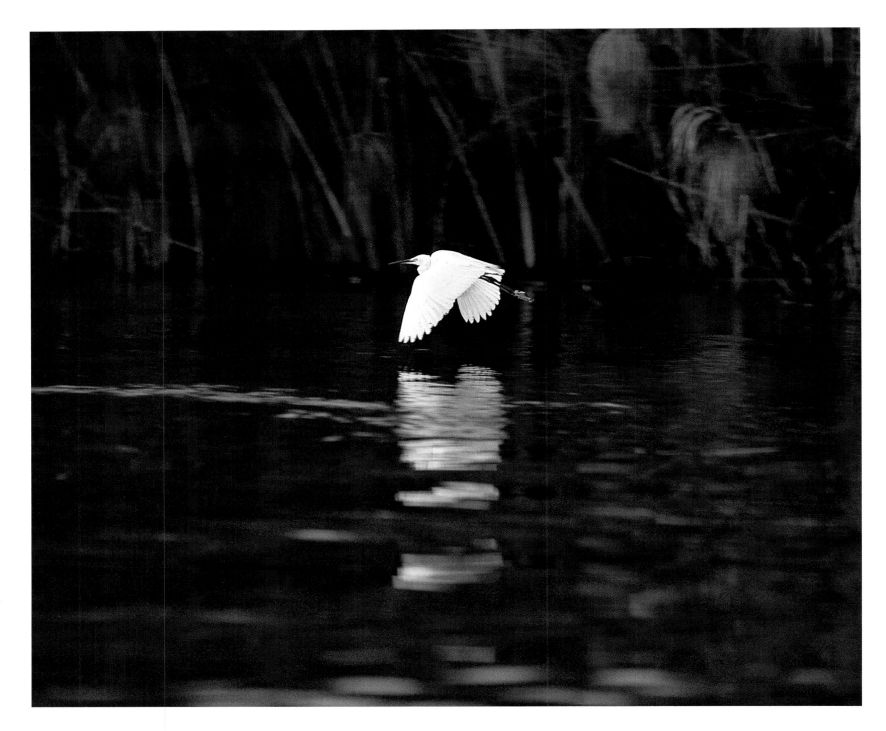

Previous pages:
*Many HaMbukushu live
along the river, and it is their
belief that crocodiles know
them and will not eat them
and so they swim happily
where others fear to tread.*

Above and opposite:
*In September and October
fishermen watch the flight of
egrets which may lead them
to concentrations of fish.*

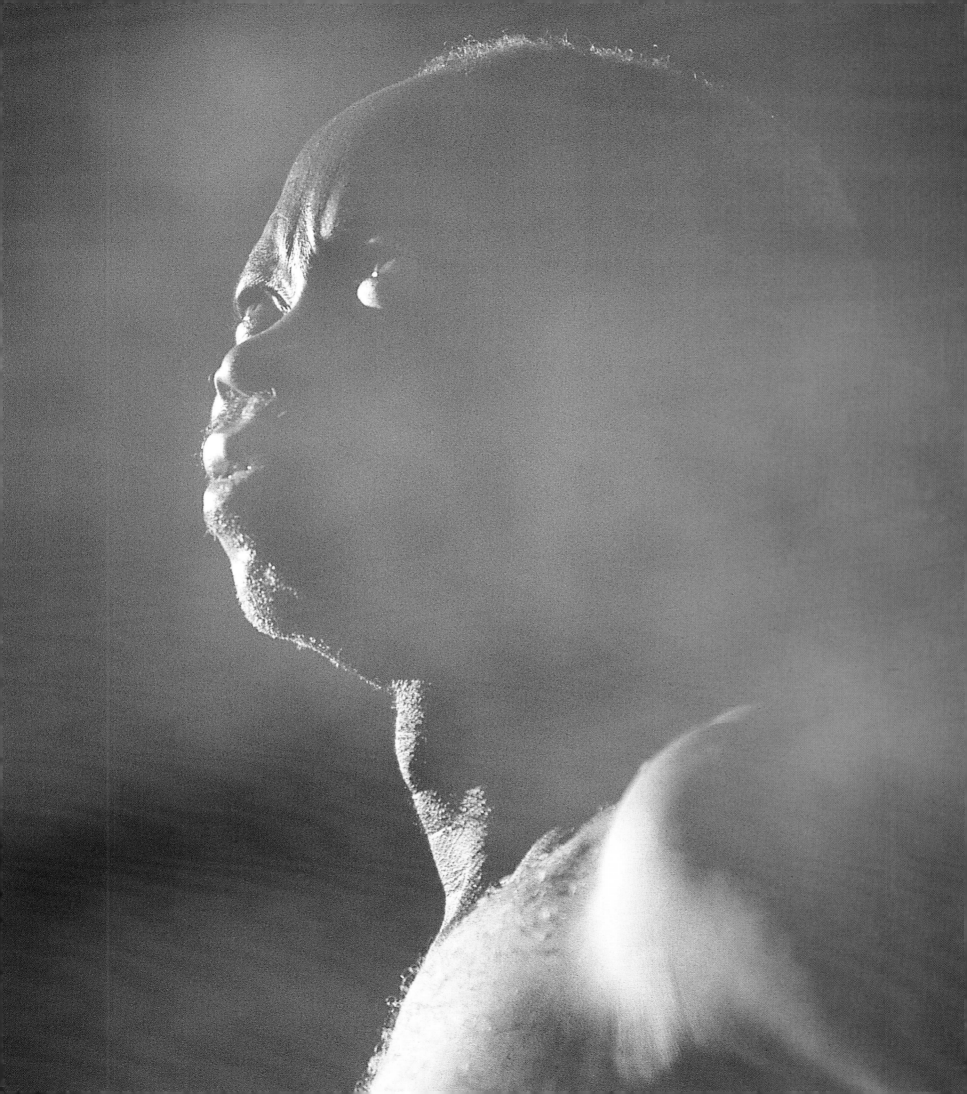

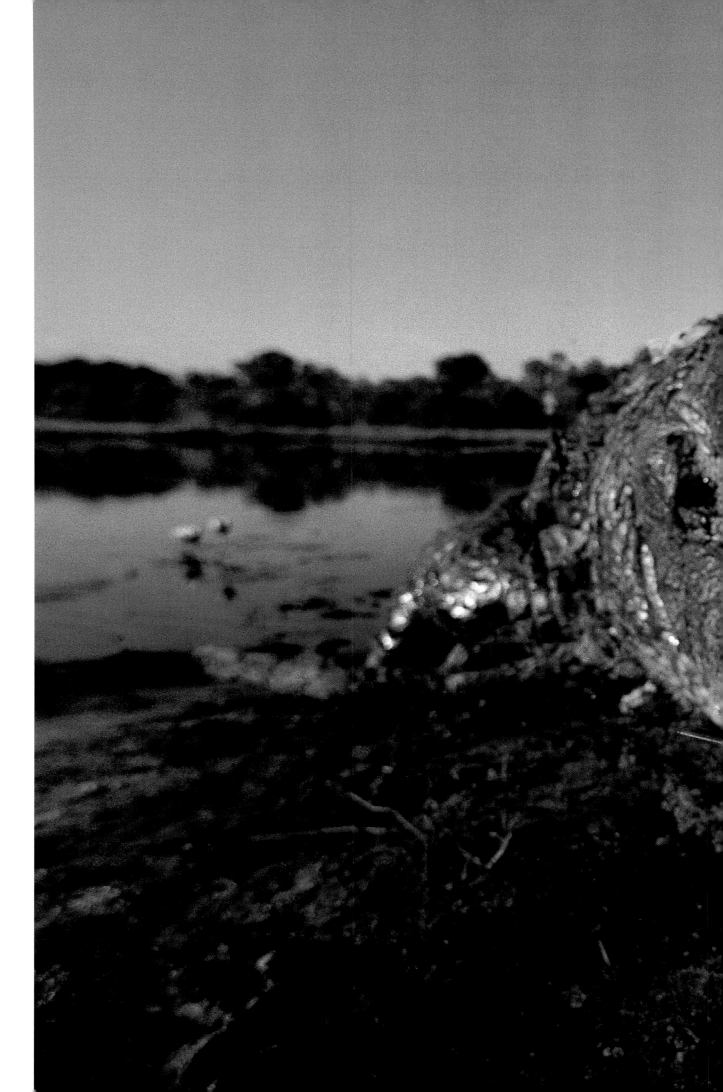

'Canst thou draw out leviathan
with an hook? or his tongue with
a cord which thou lettest down?
 'Canst thou put an hook into
his nose? or bore his jaw through
with a thorn?
 'Will he make supplications
unto thee? will he speak soft
words unto thee?'

Job 41: 1,2 & 3

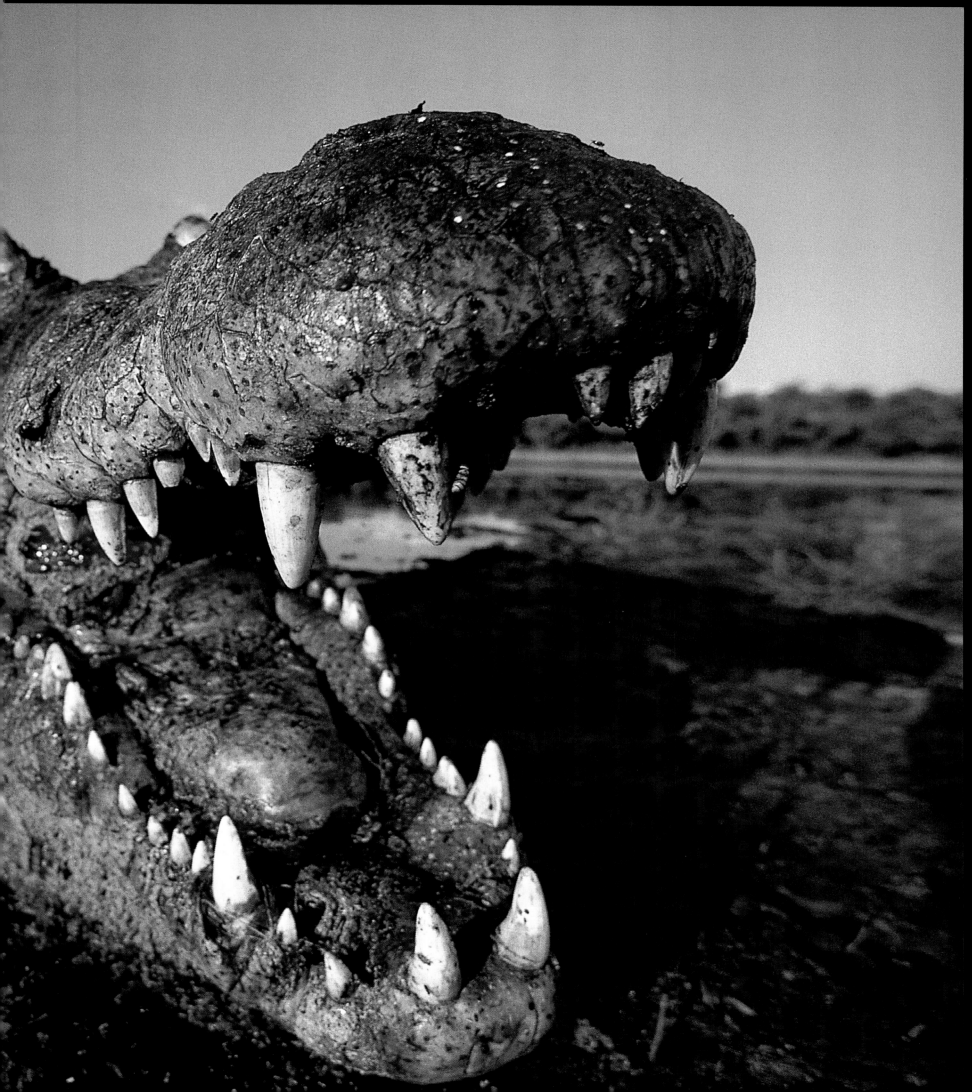

Crocodile Hunting

WILLIE PHILLIPS

*Professional hunter, guide and naturalist Willie Phillips remembers the early days of
crocodile hunting, back in the Sixties. Crocodile skins were highly sought-after fashion items in the
western world, and the hunting of them offered a life of adventure in the wild places of Africa.*

I would spend eleven months in the Delta without coming out. There was no radio communication so I did not know who had died down this way, who had got married, who had babies or who didn't have babies …

We crocodile-hunted on a bonus basis for a South African hide-and-skins company. Some days we shot between twenty and thirty. We hunted at night by spotlight from anything that floated – dugout and boats. The hunter would judge the distance from which to shoot the crocodile, so that the man standing right behind him could get a gaff underneath the crocodile and then hold it up so we could grab it with our hands, otherwise we lost it. We travelled with two skinners who would skin the crocodiles right there and then.

With me it was a case of not being able to swim, which made it pretty exciting. We just hung on to anything that floated. We were chased by buffalo, knocked over by elephant and lion, but I guess no experience is bad so long as you come out of it.

In those days there was no Wildlife Department – you were the king of the bush. If you wanted to eat hippo, you just shot it and ate it.

There was nobody out there, not even police. There was not a single lodge or a single tent; the crocodile hunters did not even have tents. If it rained, we pulled our boat out of the water and slept under that. All we worried about was looking after our bag of mealie meal – that we could not get wet.

*'In our contemplation of the destinies
of crocodiles and men …*

'To begin with we had to ask ourselves a basic question: what is the purpose of knowledge, or the drive to inquire, if it is not to improve one's situation? And it can improve the lot of only those who need more. The biological function of the quest for knowledge is to improve our ability to exploit our environment. Our knowledge of crocodiles ultimately was of potential value only to those far from Lake Rudolf who, feeling overcrowded, needed more resources, more ideas, more space – simply more …

'And what would our increased knowledge of crocodiles do for [the Turkana]? The incompatibility of man and predatory carnivores remains; our findings could not alter that. Knowledge dispels the evil of crocs – for those who bother to acquire it – but our facts would not change the Turkana's outlook. For them the crocodiles remain evil, hostile denizens of the lake. Nevertheless, no Turkana would ever attempt to exterminate crocs. They do not hate them. It takes a civilized, cultured, overcrowded man to hate crocs, or love them, or exploit them, or exterminate them.'

Alistair Graham, *Eyelids of Morning*

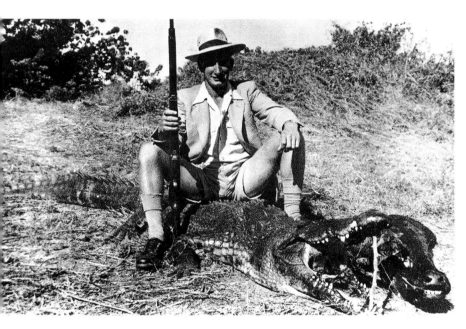

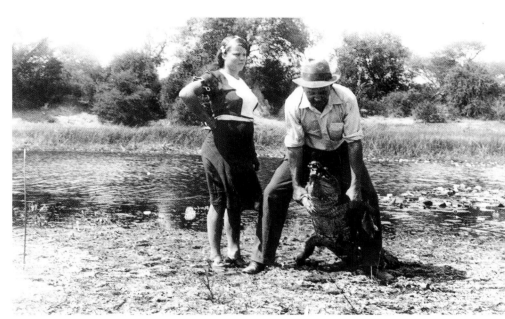

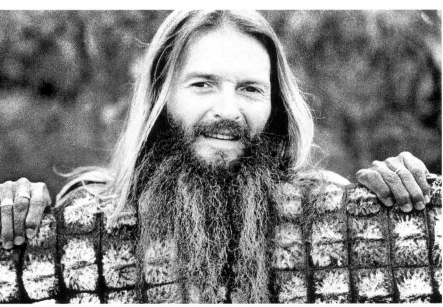

Above: *The hunter hunted.*
Left: *Ian McColl. He lost
his job once for an anti-
hunting principle.*

Overleaf: *In traditional
medicine and witchcraft the
crocodile and its parts are
among the most potent
and evil of ingredients.*

57

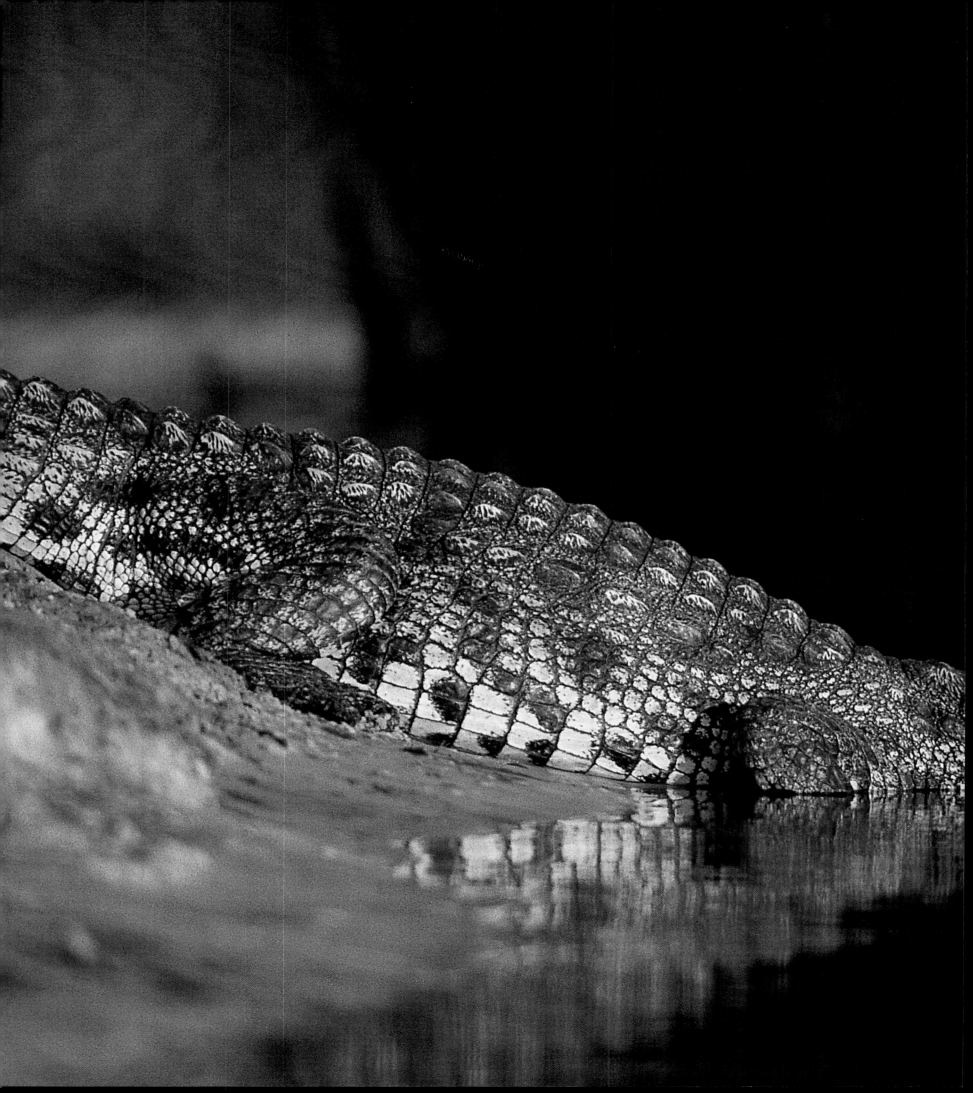

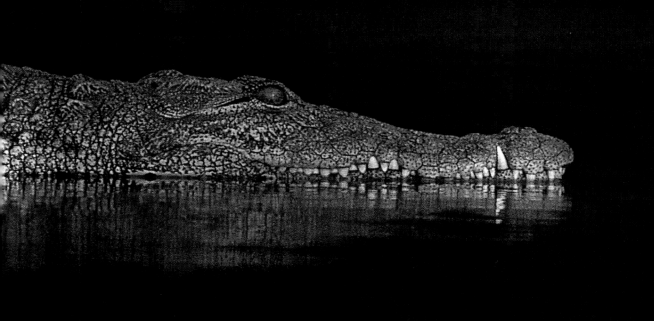

Left: *A journey by* mokoro *is just the rhythm of the* ingushi *and the silence.*
Below: *'He who pushes his* ingushi *too deep, stays with it.'*
HaMbukushu proverb
Opposite: *Smoking fish over an open pit fire.*

Kikaneman the River Bushman

PJ Bestelink has been at Nxamaseri fishing camp for many moons now, and at the close of a busy fishing season, with the rainy season nearly upon them, when the camp closes he decides it is time for a *mokoro* trip south from the Panhandle and deeper into the Delta.

While packing his *mokoro* with supplies for a week or so, PJ decides to add a packet of ground coffee, a small bag of sugar and some tobacco as a gift for his friend Kikaneman, whom he would like to visit if he reaches Xaxaba, quite far south, before the coming of the rains. Kikaneman is a River Bushman who lives on an island called Little Seronga, attached to Xaxaba village and, as he fishes for a living, he is always glad of gifts from the outside world.

The weather is kind to PJ and after a week he arrives safely on the island of Little Seronga and seeks out

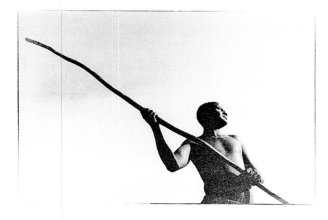

Kikaneman. The River Bushman appears with his usual broad grin and stares into the *mokoro*.

'What have you brought for me, PJ?'

PJ, thrilled to have remembered to bring something, hands him the coffee and tobacco, still miraculously dry.

'Where is the sugar, PJ?'

PJ digs around some more and produces the sugar.

'Such a small packet, PJ!' Kikaneman exclaims.

PJ, looking indignant, explains that he has paddled for more than seven days, coming from as far away as Nxamaseri, and has kept the sugar dry.

'That is nothing,' says Kikaneman. 'I have had people visit me from Japan!'

Later, after sharing a bream for their evening meal and some of Kikaneman's coffee, they sit around the fire in quiet companionship. There is a soft, misty cast to the world as the full moon rises and they are both drawn to watch it loom upwards to reveal itself fully. PJ, perhaps still feeling injured at Kikaneman's perspective of his gifts brought by *mokoro* across many kilometres of water – or perhaps just in search of conversation – remarks, 'There are some very clever men, Kikaneman, who have been to the moon and back.'

For a long time Kikaneman is silent as he watches the moon rise from the horizon. Then he points with his stick to where it appears at the rim of the land. 'Over there,' he says, 'that is not so difficult – fifteen days' paddle, maybe. But when it is up there,' and here he points to the sky above him, 'now that is another thing.'

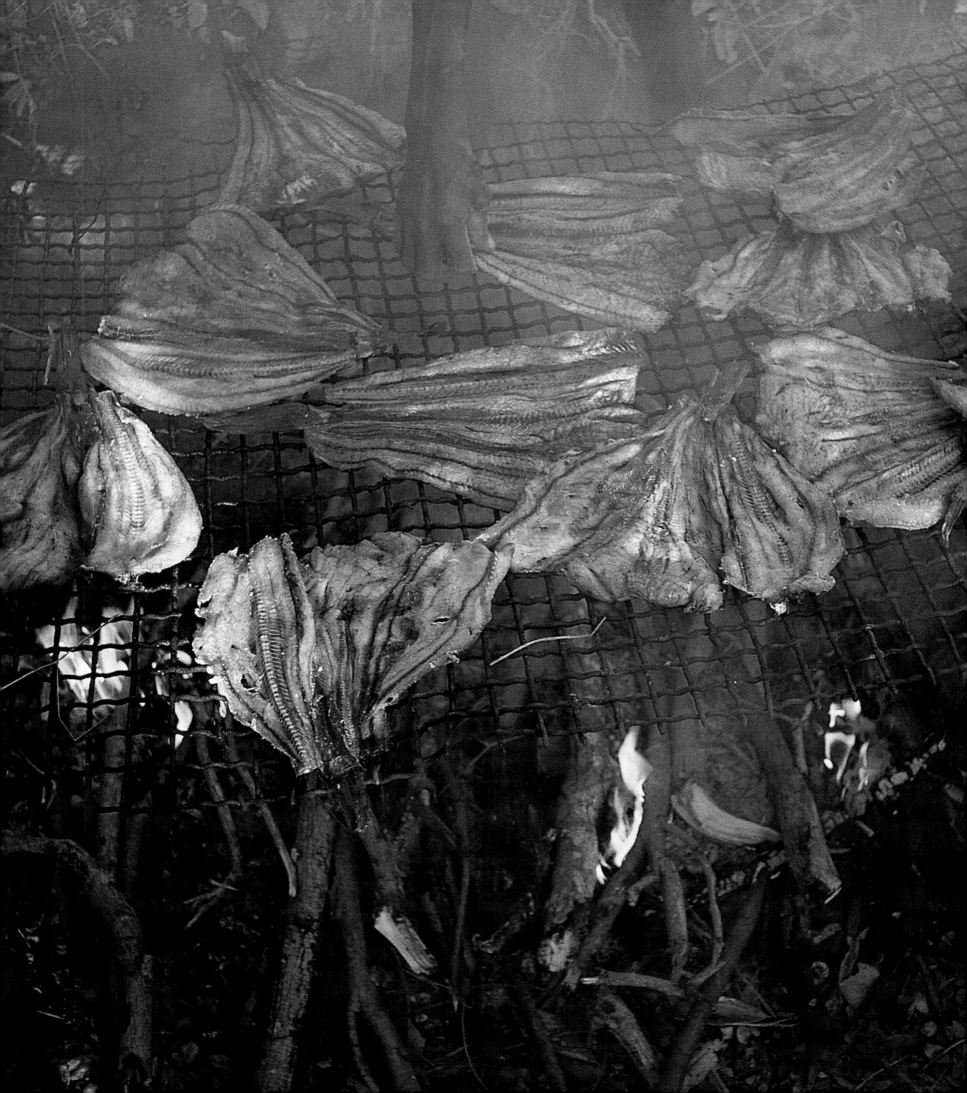

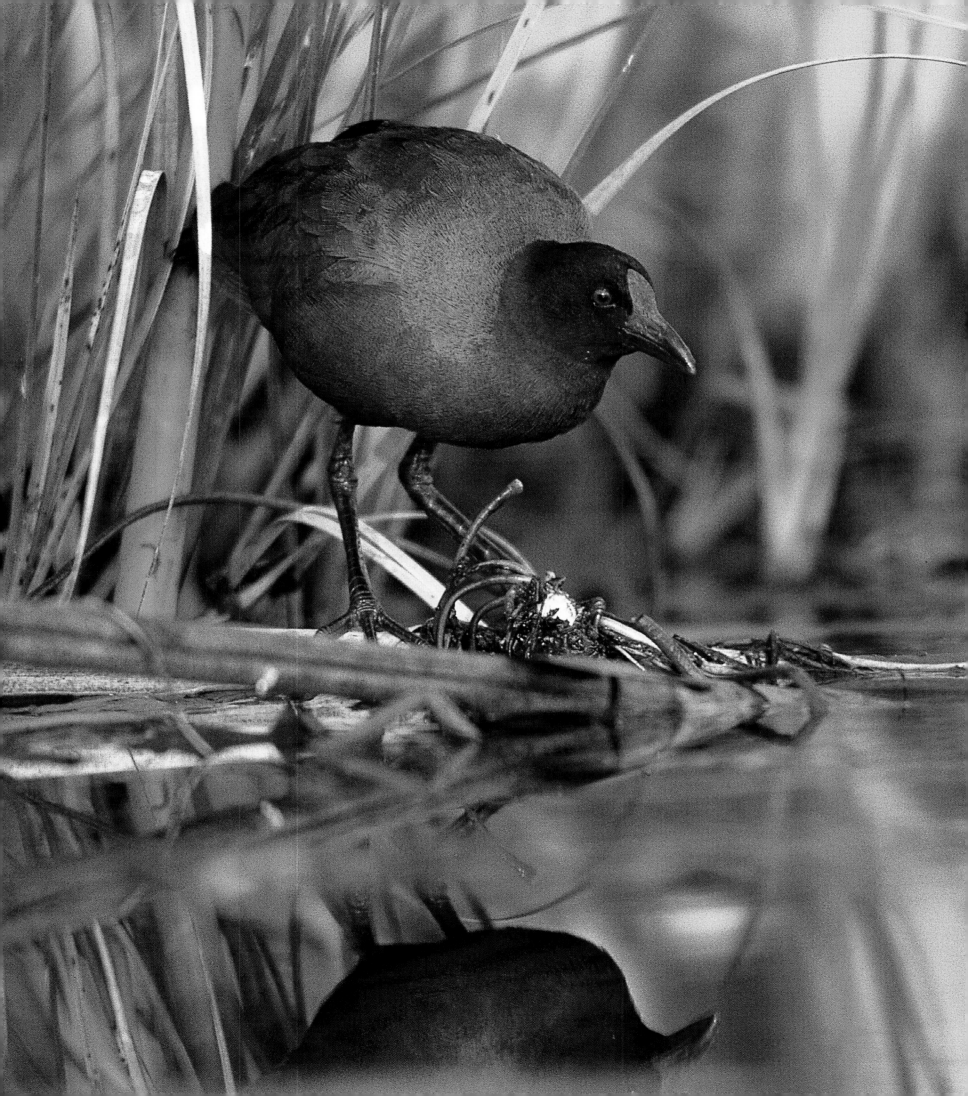

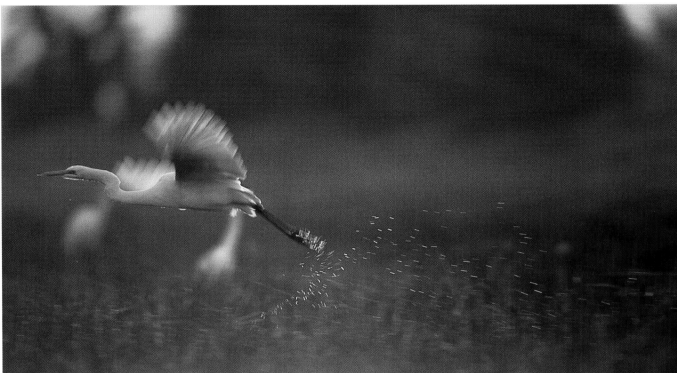

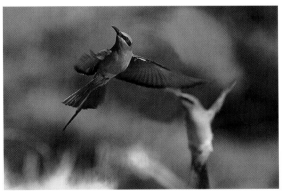

Everywhere here are birds. In and on the water; in the reeds and the trees; on the ground and in the air. Large and small; bright and dull; singly or in flocks that cloud the sky. Some live here permanently while others visit only for the summer and then move on, but everywhere they are present.

Clockwise from left: *Lesser gallinule, great white egret, squacco heron, carmine bee-eaters.*

Overleaf: *African skimmer.*

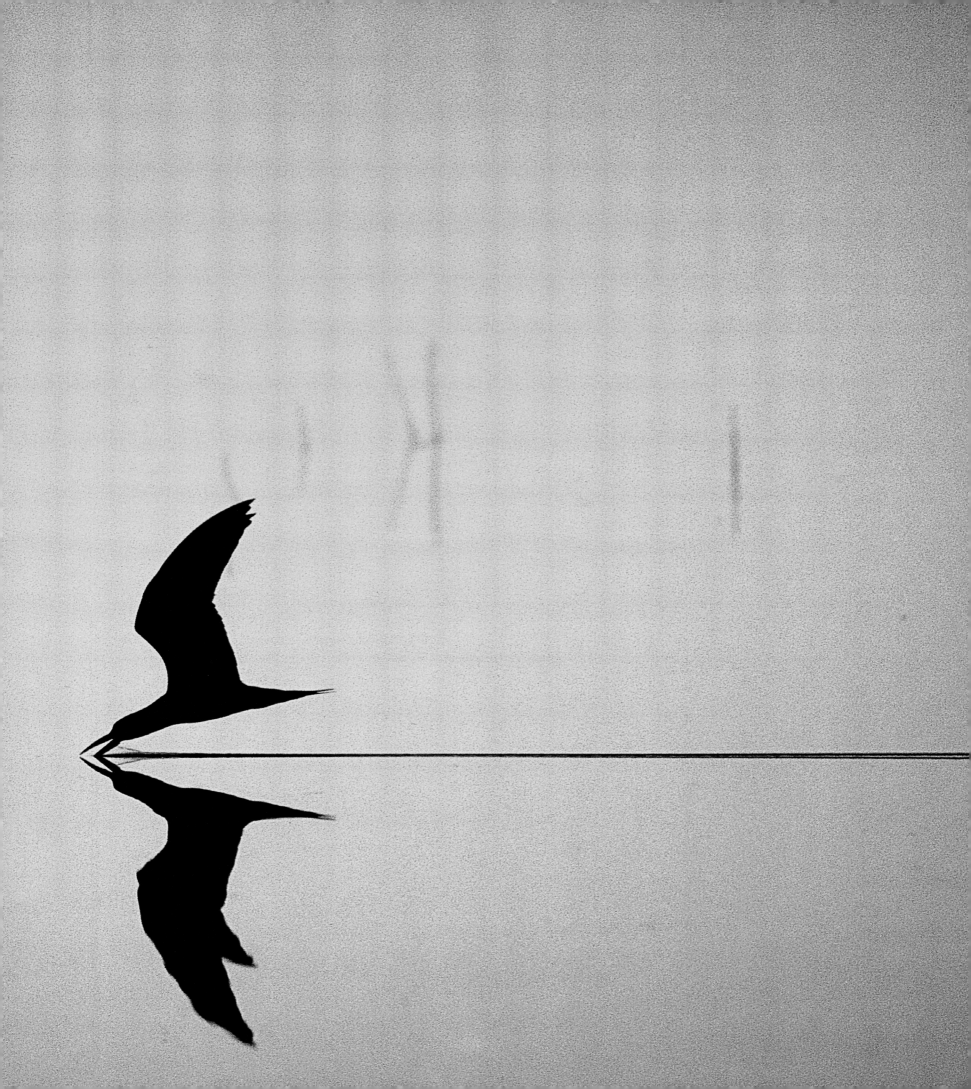

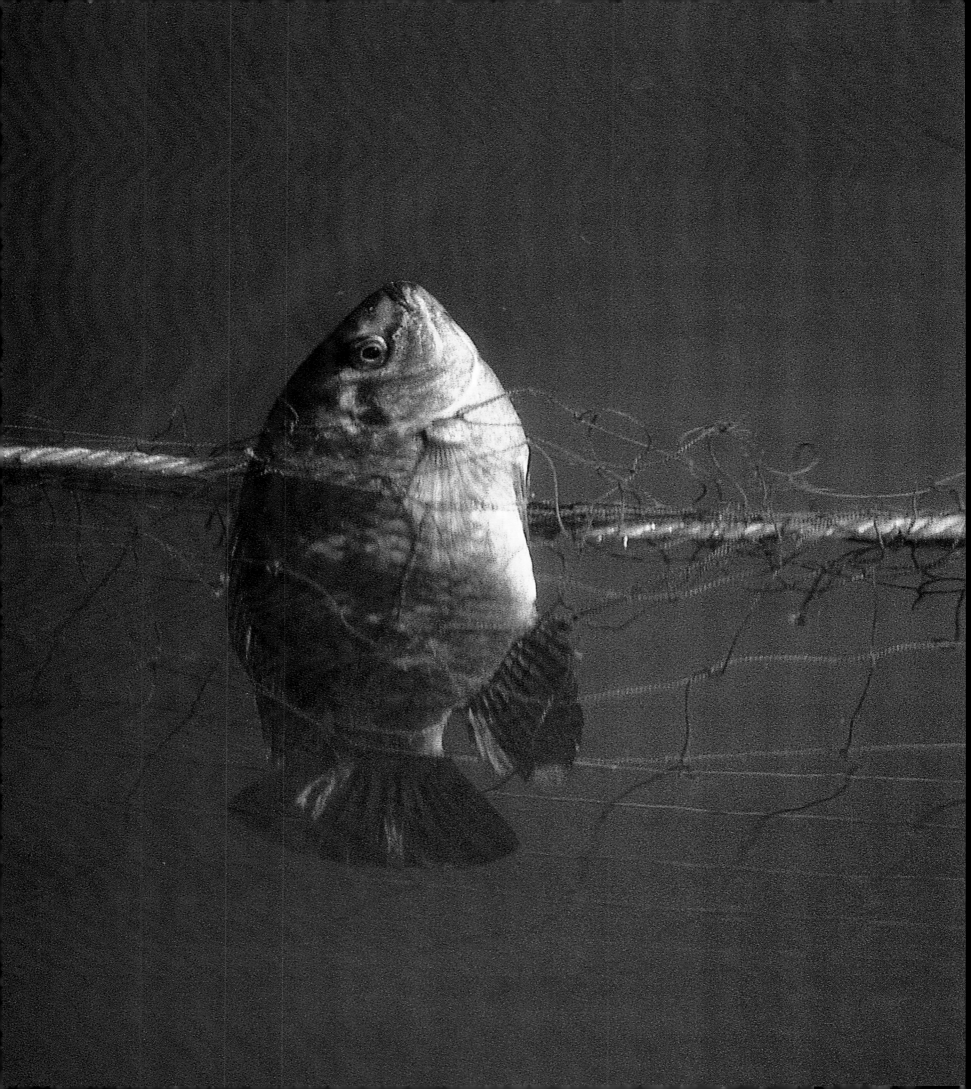

Wilderness

'Wilderness is the raw material out of which man has hammered the artifact called civilization.

'Wilderness was never a homogeneous raw material. It was very diverse, and the resulting artifacts are very diverse. These differences in the end product are known as cultures. The rich diversity of the world's cultures reflects a corresponding diversity in the wilds that gave them birth.

'For the first time in the history of the human species, two changes are now impending. One is the exhaustion of wilderness in the more habitable portions of the globe. The other is the worldwide hybridization of cultures through modern transport and industrialization. Neither can be prevented, and perhaps should not be, but the question arises whether, by some slight amelio-

ration of the impending changes, certain values can be preserved that would otherwise be lost.

'To the labourer in the sweat of his labour, the raw stuff on his anvil is an adversary to be conquered. So was wilderness an adversary to the pioneer. But to the labourer in repose, able for the moment to cast a philosophical eye on his world, that same raw stuff is something to be loved and cherished, because it gives definition and meaning to his life.

'This is a plea for the preservation of some tag-ends of wilderness, as museum pieces, for the edification of those who may one day wish to see, feel or study the origins of their cultural inheritance.'

Aldo Leopold, from *A Sand County Almanac*

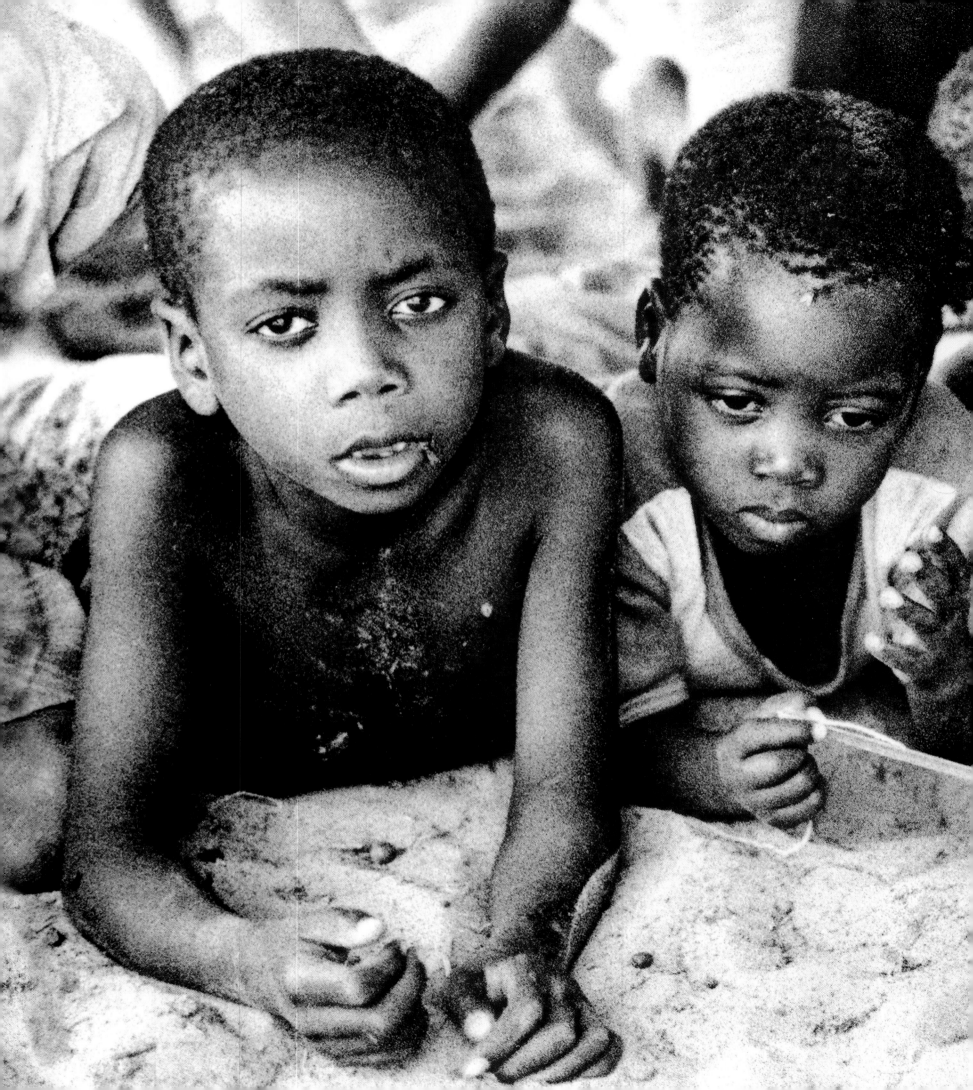

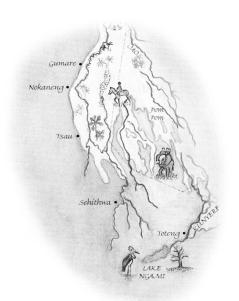

The Fields
OF THE Lord

*'By defending nature man may recover his dignity
and liberty, for the roots of heaven are in the earth.'*
VS Pritchett, *A Review*

*From where the Okavango River begins to spread out, roughly
divided down the middle, the western portion of the Delta is almost
as flat as land can become. The earth's surface here is a series of
vast plates that every so often tilt a fraction of a degree so that rivers
reverse direction from one year to the next. In the dry season, when
the grass is still and yellow and everywhere one's passage raises a
fine grey dust, it is impossible to tell where the flood plains end
and the great expanse of the Kalahari desert begins. Only the
waters of the annual flood reveal it clearly.*

When the dust has been quelled and the footpaths erased beneath the veneer of the water, then it seems that this is where God had his seat when he made his work on the third and fifth days of his Creation. Here, the waters are gathered together and the dry land appears as if freshly emerged, with all that is new and vernal and green. The water brings forth abundantly moving creatures, and winged fowl fly above in the open firmament, and it is good.

It is a place of miracles, too, and nowhere in the Delta is the transformation that the annual flood brings more dramatically exhibited than here. It is a flat land, entirely without hills. It does not, however, appear as a plain, for everywhere the far horizon is interrupted by islands and the continuity is severed and fragmented. In the dry season the islands are little more than rises in the plain, a metre or two above the tablet of yellow grass.

The flat expanses bake beneath the hot sun. Where the grass has been cropped short, the fine grey dust is drawn into the dance of the tight, twisting whirlwinds that skitter to and fro and raise a chatter among the fallen leaves before they die as suddenly as they came. The dust hangs in a shroud over the land and, robbing the sunset of its warmth, leaves a blood-red orb in a bruised sky of deep purple-grey.

And then, on no particular day, the water arrives. You can stand and watch it or walk beside it as it progresses, a thin tendril, no thicker than a finger, that reaches forward into the dry sand, filling the small depressions and growing constantly wider as you watch.

Strangely silent, it is only the soft pop of the bubbles that is audible in the dark as the miracle is performed and, quite literally overnight, the desert is transformed into a sea. Where you drove or walked the day before, now you must wade or use a boat. Everywhere is water, still and blue, as if it had always been like this.

Only where the water is shallow or confined to a narrow passage can the press of its tide be seen. Changing appearance with the cloak of water, the rises magically metamorphose into islands, hundreds of them hatched in unison by this shallow sea; and the slighter rises become the shore.

Some of the islands are small, a few metres around, while others stretch for kilometres. Virtually all are a harbour to trees, their stature exaggerated. Reaching into the sky, they obscure the distance and bring about an intimacy to each moment of this paradise that lies revealed.

But there is – strangely – no peace in it, for in its beauty and magnificence there is constant change, holding you in expectation and exaltation and continually drawing you on. It seems that on the periphery of each scene, behind each island of tall palms, on each distant green shore where lechwe graze, lies another vista of perfection, and the explorer's drive is taxed endlessly and tempted without respite.

With each new morsel of delight revealed, the spirit does not grow content but instead growls with a hunger that becomes ever more insatiable. Perhaps here, between water and earth and sky and stars, our roots are plain and we scrabble to find our attachment, to bond ourselves to all life and all things. Perhaps here is meaning, or purpose, or at least definition. It feels so close, so very near; and its subtle evasions torment our peace.

To know it most closely, you must stand still.

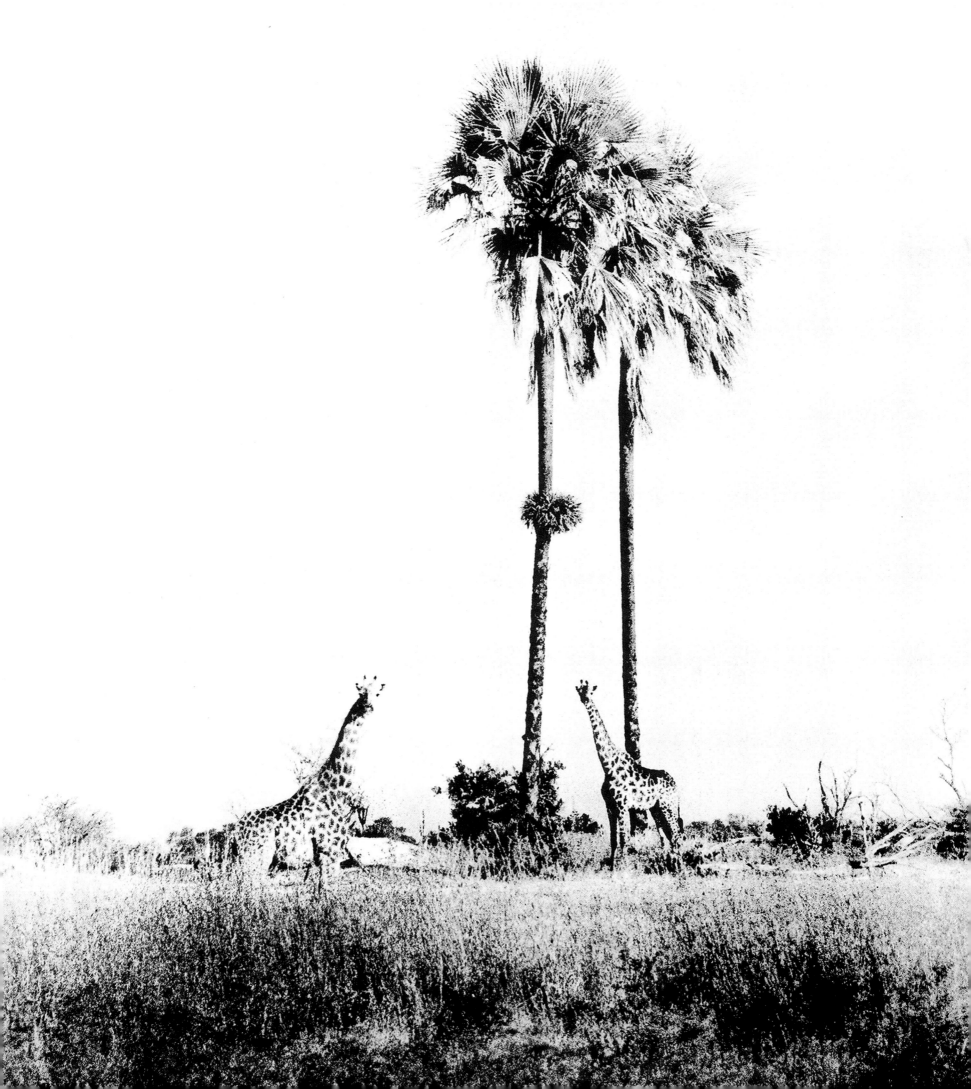

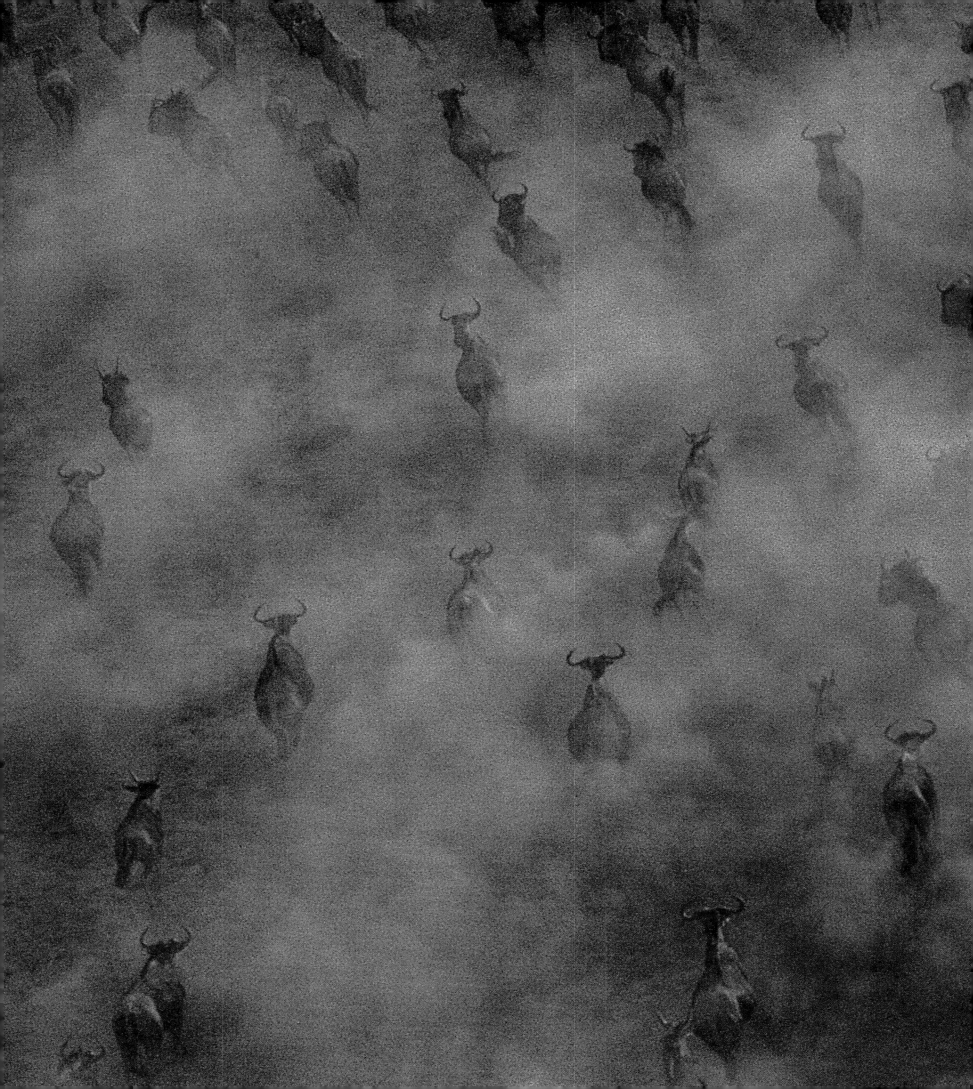

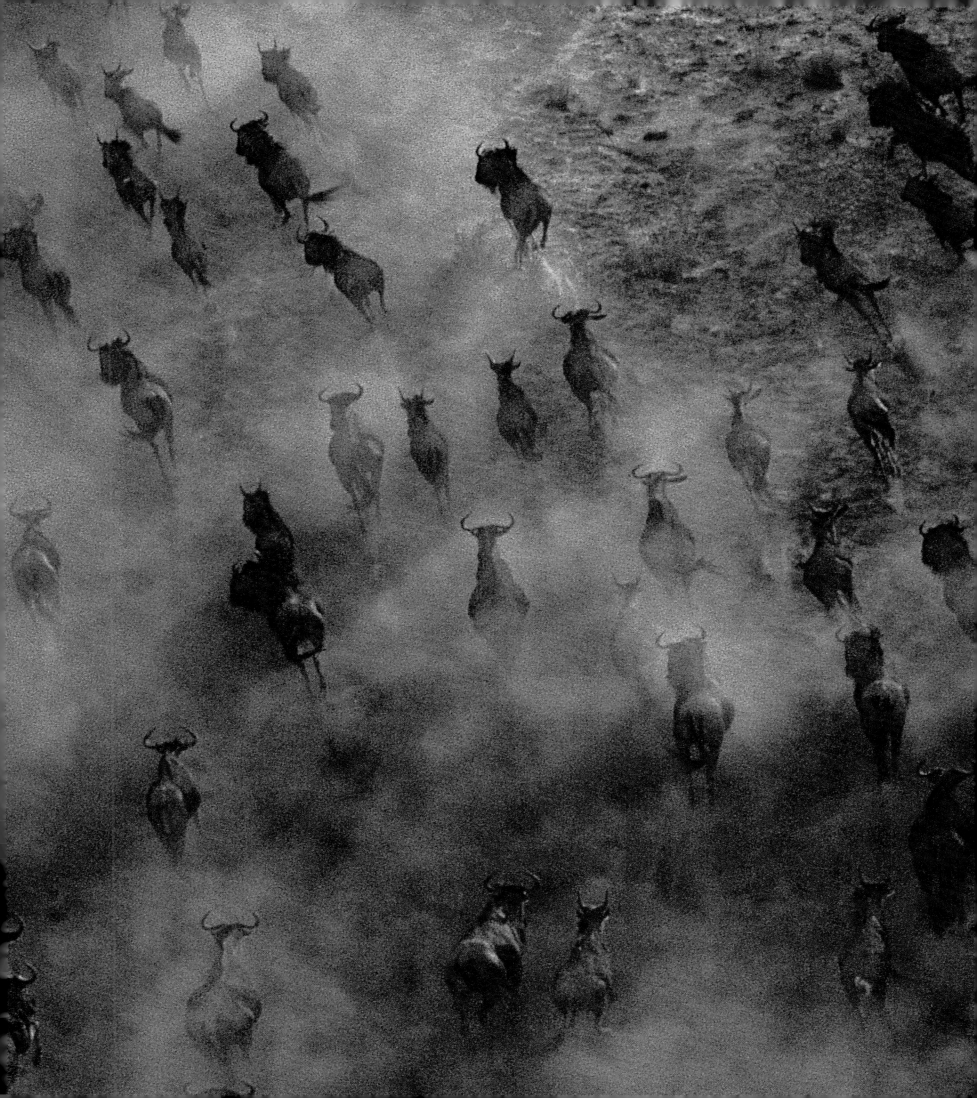

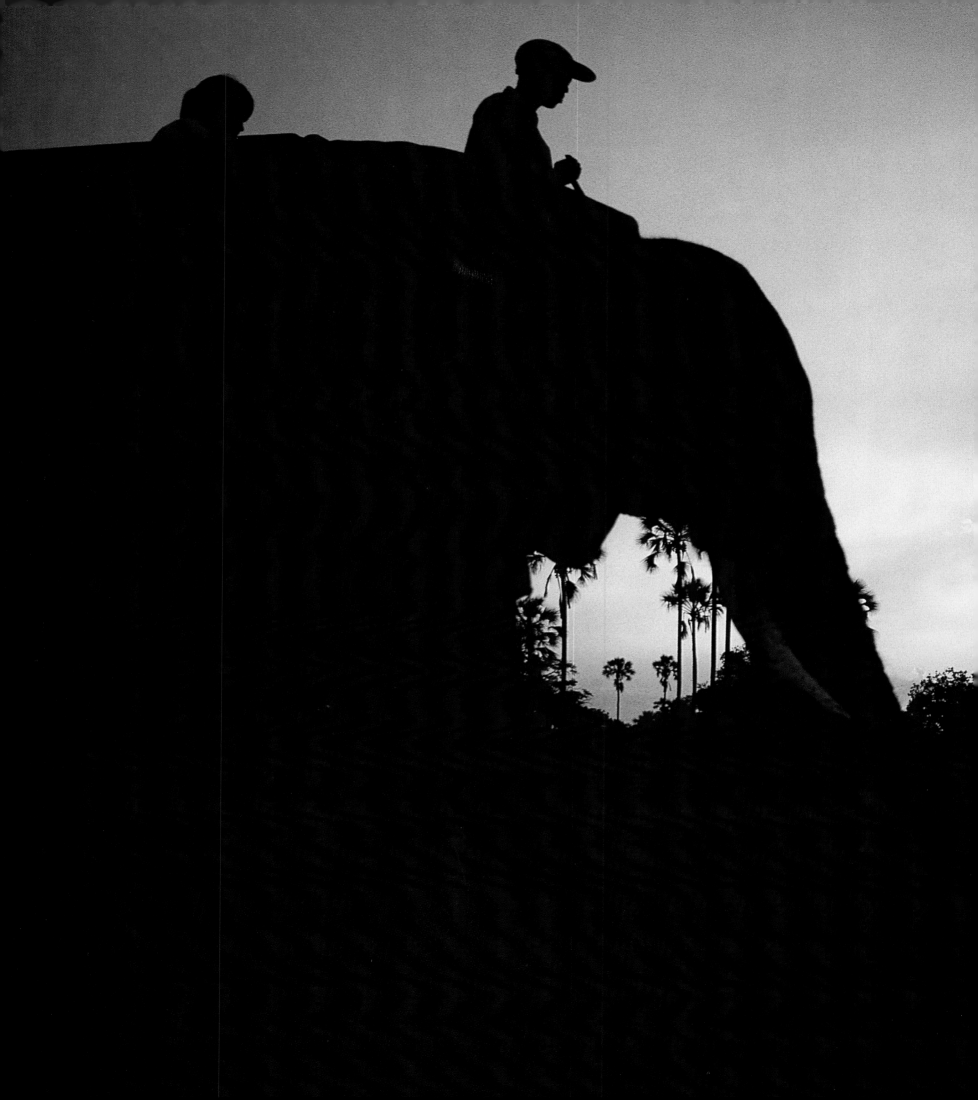

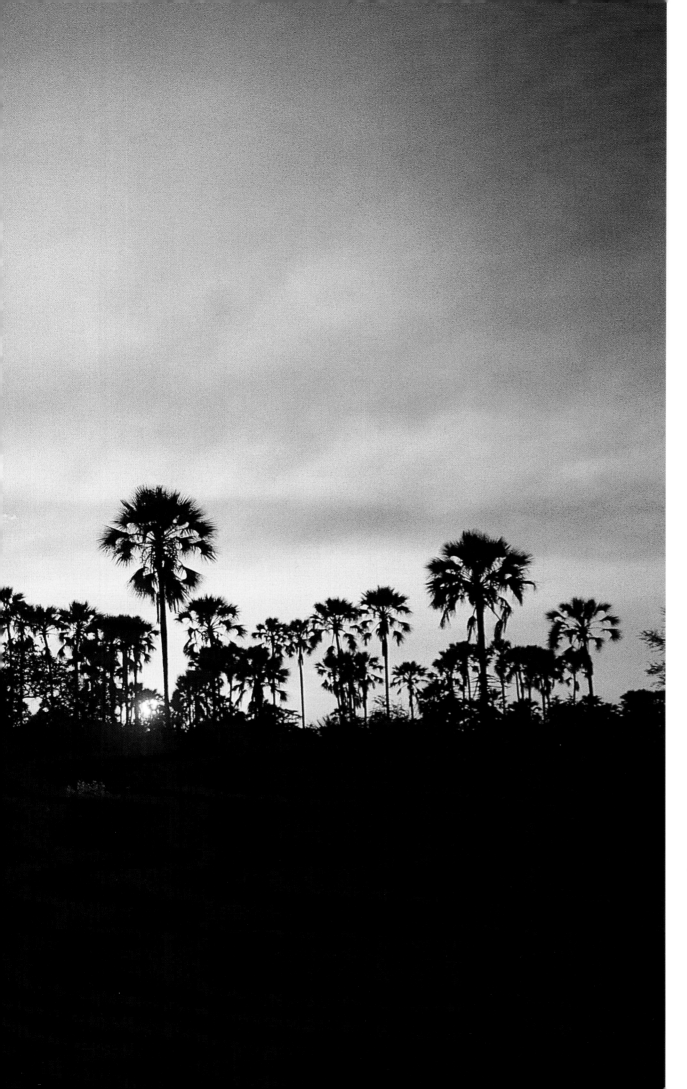

Previous pages: *A galloping herd of blue wildebeest raises a thick cloud of fine dust in the dry season.*

Left: *With pressure from his knees, an occasional light kick behind the ear and softly spoken words, a mahout urges his charge campwards at twilight.*

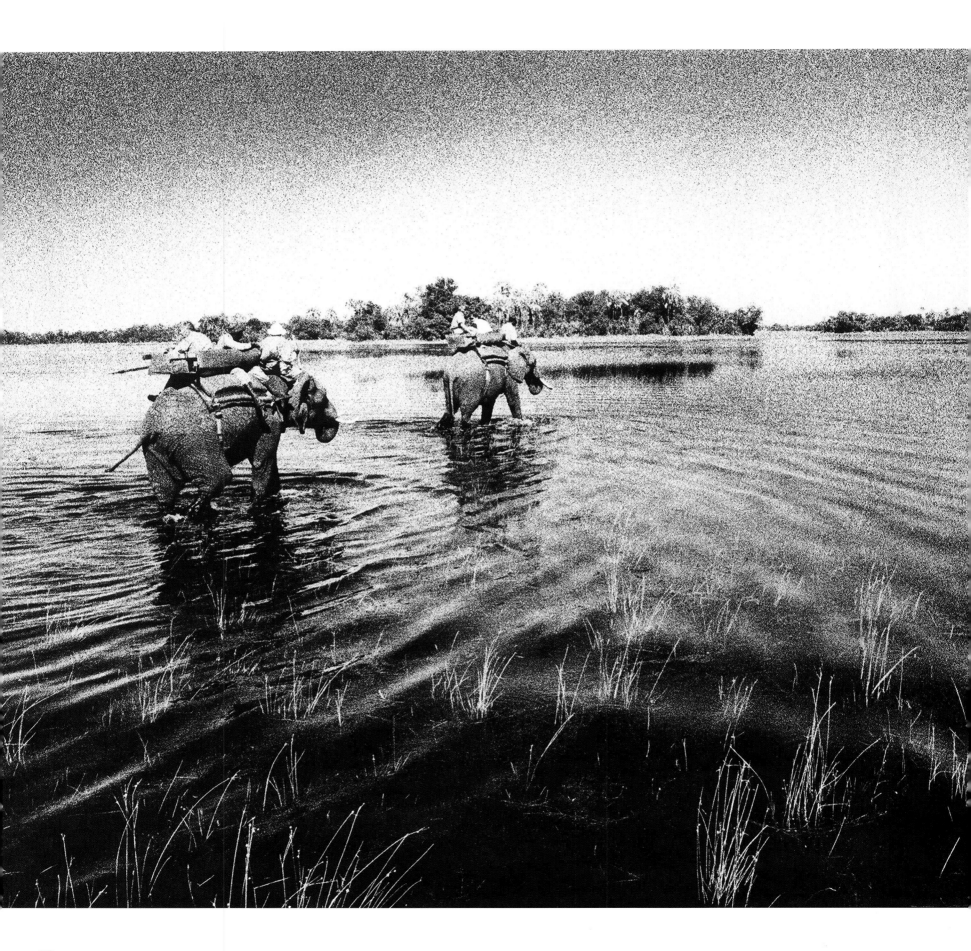

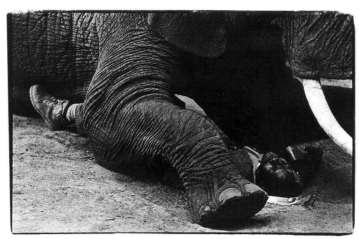

Overleaf: *I imagined the steam that rose about the horns of this trophy lechwe skull as it was boiled clean of the last pieces of flesh, as wraiths of the spirit returning home.*

The Elephant-Back Safari is an opportunity to spend time in communion and association with elephants, to stand close to the intricacies and nuances of their life and, in the intimacy of the contact, to know a little of their complex character and personalities.

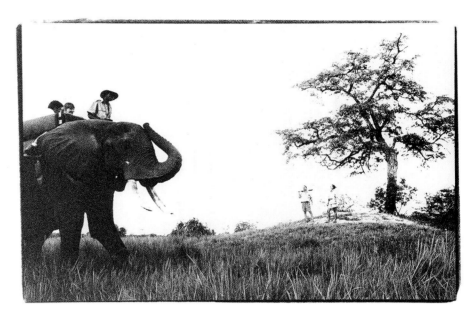

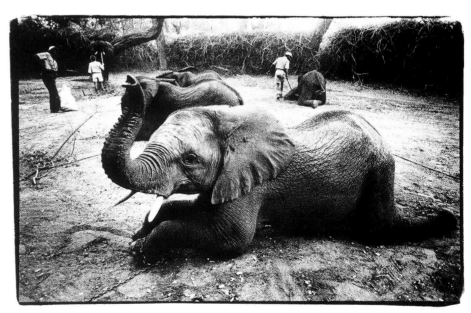

Buffalo Hunting

There is a July chill in the mist-rent morning. The tracks etched by the Landcruiser are sharp and perfect, as they are on only the coldest of dawns. Howard Holly, a client, guided by professional hunter Jeff Rann, and trackers Sable and Othosetswe, leave the hunting camp on the Kiri Channel in search of a *kwatale*.

This is the name given to the oldest, most wily buffalo bulls, most of which have already left the ranging herd, to wander their final days in the wilderness in small bands or alone. Often their choice is in keeping with their natures, since *kwatale* are for the most part battle worn and short tempered. They carry the banner of their survival on their foreheads – an enormous, deeply encrusted boss which gives support to an impressive sweep of horns.

The black and white of zebra stripes move through the tall grass; the erect heads of tsessebe stand out here and there, unceasingly alert. The grassy plains become forests, graced with the spreading canopies of ebonies and strangler figs, and in between dark shadows are cast by the dense foliage of the mangosteen. Reedbuck creep between the trees nibbling at new shoots, while vervet monkeys play above, chattering noisily to warn the forest dwellers of the approaching vehicle.

By contrast, all is silent within the vehicle, the eyes of the hunters scanning the veil of green to see what lies beyond. A sudden movement, a dark shape, a furry texture, eyes perhaps…

As the warmth of the sun bathes the land, lechwe reveal themselves, venturing from their grassy havens. Taking fright, they leap and plunge through the water, throwing up elegant patterns against the sun. A bull elephant turns from his mopane feast, his tusks gleaming white, and shakes his ears, creating for himself a halo of dust. As if in support of the elephant, a herd of blue wildebeest takes up the head-shaking, developing the farcical display into a series of bucks and prances, then dashing wildly away in a helter-skelter of disarray.

Jeff tests the wind, running sand through his fingers to be certain. He surveys the terrain for cover and decides to drive in a half-circle around the buffalo to be in the most advantageous position. This done, the vehicle is left in the shade of an ebony and the hunt begins.

Othosetswe leads, followed by Jeff, carrying a Holland and Holland 500-465, then by Howard, armed with a Dakota .375. Sable has his second rifle, a Bruno .375. The walk will be long. They remove their jackets to minimize sound.

Quietly the hunting party moves in the direction of the buffalo. Wherever possible, the cover of trees, bushes and termite mounds is used; where the grass is short, the hunters bend double or crawl. Sign language is

Othosetswe and Sable study the tracks on the ground for the story of the night. Picking up lion tracks, they point with their sticks. Conferring in low tones, they nod in agreement – it is females and cubs, and they laugh in enjoyment of this.

Sable looks to the horizon, squints his eyes and points with his stick. He softly says, 'Phologolo,' and nods his head. Othosetswe narrows his eyes and studies the growing cloud of dust. The hunting party is too far away to have startled the animals into a run. The cloud of dust billows higher, but not as it would if the animals were on the move.

The trackers, seated in the back of the vehicle, tap the windscreen, and Jeff stops and steps out to investigate the dust through binoculars. Through the dust, he discerns the definitive black bulk of buffalo, slowly moving and grazing; the dust cloud indicates there are many.

used, decisions made quickly and smoothly. Sometimes Jeff or Othosetswe will raise his hand and the party will stand dead still for long minutes and wait.

For more than an hour the stalk progresses until, from between the fronds of a date palm, a herd of approximately 150 buffalo becomes visible. It is time for the age-old secret of the successful hunter to come into play: all motion must be easy and gentle, as any ill-timed movement will alert the game of something amiss.

It is Howard's first buffalo hunt and his mouth is dry with excitement. His hands, clutching the rifle, shake slightly. The hunters rest on their haunches as Jeff carefully searches the herd, looking for a *kwatale*, a trophy bull. The minutes creep by while beads of sweat, from both heat and tension, form on the hunters. Then Jeff makes his choice. Estimating the distance, he indicates the most suitable rifle and bullets for the shot.

Above left: *The trophy room.* **Above:** *Hanging from a block and tackle, a trophy buffalo awaits the skinner.*

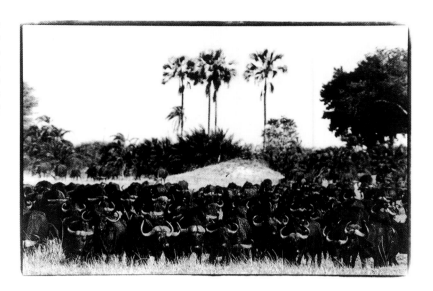

Although when gathered in herds the buffalo tends to be retiring, the determined ferocity of the individual is legendary and deserving.

Waiting for the correct moment to shoot, according to the movement of the buffalo, more long minutes pass; the targeted animal must move far enough away from the rest of the herd for a clean shot. The hunters change position to behind a large termite mound, more to the right of the buffalo and closer in. Again time passes and the hunters wait and watch. Howard's knuckles on his rifle are white with anticipation.

Finally, the moment is right. The oldest bull moves out from the front of the herd as it grazes. Immediately Jeff instructs Howard to rest his rifle in the fork of a tree. The tension of the moment suspends time, before the sharp crack of the rifle carries far across the plains.

The herd thunders away in a single dark mass, enveloped completely in the thick grey dust of the powdery soil. The chosen buffalo is left alone, standing motionless; it has not fallen. Jeff searches for the bullet wound through the binoculars; the hunters wait. The buffalo has been hit just above the shoulder.

Gathering its strength, the buffalo trots behind a termite mound which is spread with creeper-draped bush. The hunters leave their cover and, their eyes never leaving the termite mound, cross the open terrain. The strain is plain on their faces.

As soon as the great head and shoulders of the buffalo appear, with its magnificent sweep of horns, Jeff instructs the hunter to shoot again. In fluid response, Howard's rifle comes up. He aims and shoots.

Again the buffalo is hit but does not fall. It runs into a thicket of croton bush and creeper. The hunters run up the termite mound and scan the bush around them.

The buffalo waits silently in the thicket. The hunters' shirts cling stickily to their backs. All is eerily still.

A slight movement, a sound, then the buffalo reveals itself through a gap in the thicket. Howard fires. Hit once more, the buffalo stops in its tracks and turns. Lifting its head to scent the wind, it stands absolutely still. Howard changes rifles.

Jeff knows the buffalo is waiting for the hunters to move close enough for it to charge. Slowly, with soft treads, the hunters close. They can taste the adrenaline in their mouths.

The buffalo comes, launching its enormous bulk directly towards the hunters in a final thrust of power. A moment passes, then Jeff's rifle is up and two shots are fired in rapid succession. At a range of twelve metres the buffalo is not stopped by a bullet in the side of its head; at six metres, it falls in a shroud of dust, a bullet in its brain.

The world is strangely silent as the hunters look down at the fallen buffalo. Blood seeps from its wounds and froths from its nostrils to mix with the settling dust.

The hunters shake hands. This one came close – very close – and it is some time before their nervous laughter gives release to the pent-up tension and excitement. Othosetswe and Sable are jubilant.

It is an hour or more before the buffalo is loaded and the hunters return to camp. They are weary; perspiration and dust clog their pores, blood and dirt stain their hands. Their expressions are serious but serene, their thoughts caught up in the distance of the African plain.

This scene was lived out in the winter of 1995. Man has hunted from the beginning of time, but the place of the hunt in the life of modern man is no longer certain. What is there to gain and what to lose by hunting? Is hunting a privilege or a right?

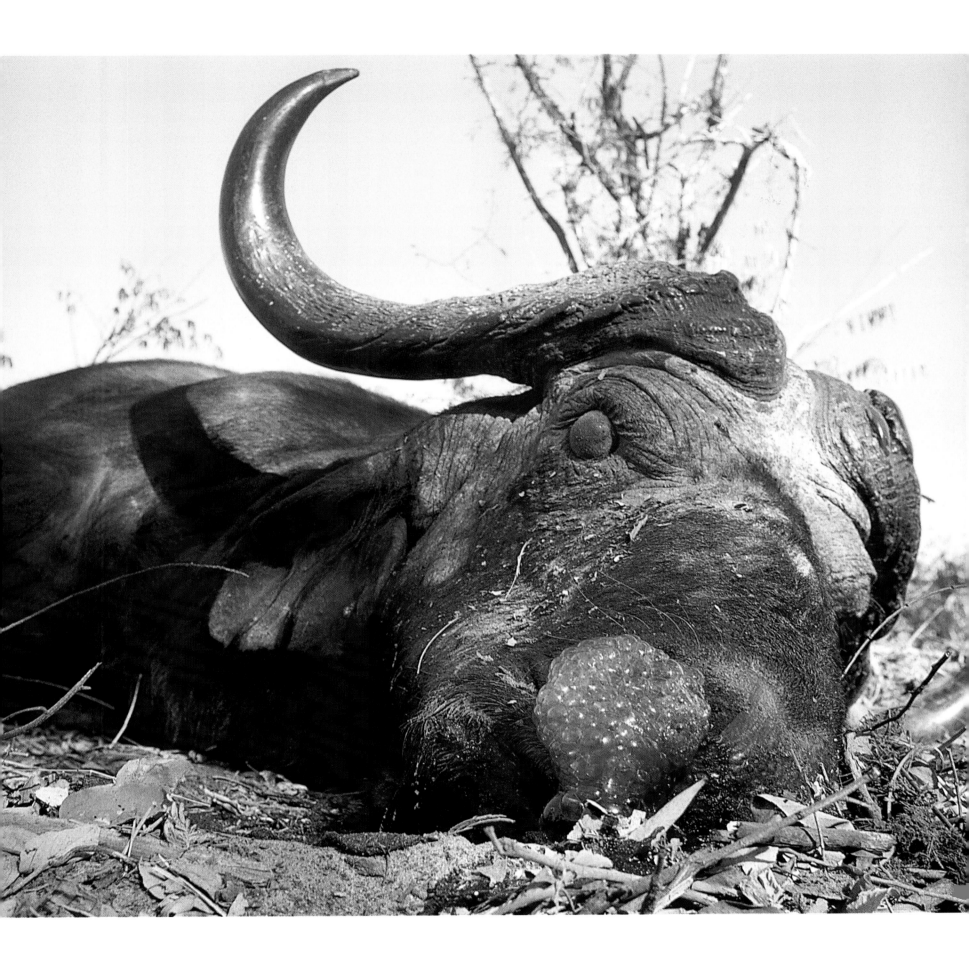

Penalties and fines of the new Wildlife Conservation and National Parks Act, 1992

excerpted from an article in The Okavango Observer, *Friday 26 February 1993*

Botswana has taken a major new step towards the conservation of its fragile wildlife by imposing a new set of penalties and fines, especially with regard to its rhino and elephant populations.

Anyone convicted of an offence under this Act which is punishable by a fine of P2 000 or over will have any weapon, trap, animal, vehicle, aircraft or boat used for the purpose of or in connection with the commissioning of the offence forfeited to the State. Anyone convicted of an offence for which the penalty prescribed is P1 000 or over will have his or her licence, permit, authority or permission cancelled.

P100 000 and
15 years' imprisonment

• If you kill, hunt or capture a rhinoceros unlawfully.

• If you kill a rhinoceros by accident while hunting and do not report it within seven days.
• If you kill a rhinoceros and do not produce its horns to a licensing officer within seven days; or if you are found in possession of a rhino horn which has not been produced in accordance with the provisions of the Act.
• If you have in your possession, transfer, or in any way deal in rhinoceros horn.

P100 000 and
10 years' imprisonment

• If you discharge any weapon at or towards a rhinoceros, drive, stampede, disturb or approach it nearer than 200 metres to hunt or capture it from within or on a vehicle, aircraft or mechanically propelled vessel.

P50 000 and
10 years' imprisonment

• If you kill, hunt or capture an elephant unlawfully anywhere in Botswana.
• If you kill an elephant by accident while hunting and do not report it within seven days.
• If you discharge any weapon at or towards an elephant, drive, stampede, disturb or approach it nearer than 200 metres to hunt or capture it from within or on a vehicle, aircraft or mechanically propelled vessel.
• If you kill an elephant and do not produce its lower jaw, tail and tusks to a licensing officer within seven days; or if you are found in possession of tusks which have not been registered.
• If you import any ivory or any tusk into Botswana, or acquire it in Botswana, without a certificate

of ownership, and do not produce it to a licensing officer within seven days; or if you are found in possession of any ivory or tusk and cannot produce any reasonable proof of lawful importation or possession thereof.

P10 000 and
seven years' imprisonment

• If you kill, hunt or capture any animal in any of the four National Parks.
• If you hunt or capture any protected game animal unlawfully anywhere in Botswana.
• If, from or on a vehicle, aircraft or mechanically propelled vessel, you discharge any weapon at or towards, capture, drive, stampede or disturb, or hunt from less than 200 metres, any game animal. Exceptions are made if this is done in self-defence, if the animal

Left: *Dispatching a wounded spurwinged goose, destined for the dinner table, with a blunt instrument.*

Right: *Waiting.*
Below right: *The Holland & Holland side-by-side rifle.*
Bottom: *Skinning a leopard.*

is causing or threatens to cause damage to livestock, crops, water installations or fences, or if one does so to drive the animal away from any licensed aerodrome or emergency landing strip.

P5 000 and five years' imprisonment

• If you hunt or capture any animal in the six Game Reserves and in Maun Game Sanctuary; or hunt or capture any wild birds other than game birds in the two bird sanctuaries.

• If, having wounded an animal, you do not take all such steps as may be reasonable in the circumstances to kill the animal at the earliest opportunity or, in the case of a dangerous wounded animal, do not or cannot destroy it and do not report the incident.

• If you hunt or capture any game animal by night or use any dazzling light for the purpose of hunting or capturing any game animal, unless you are the holder of a valid permit which specifically authorizes you do to do so, or if the animal is causing or threatens

to cause damage to any livestock, crops, water installations or fences, or if done in self-defence.

• If you sell or otherwise deal in or manufacture any article from any trophy that has not been lawfully imported into, or which has not been obtained from, an animal lawfully killed or captured in Botswana.

P2 000 and five years' imprisonment

• If, without lawful excuse, you are found in possession of, or kill, hunt, injure, capture or disturb any animal or take or destroy any egg or nest in a National Park.

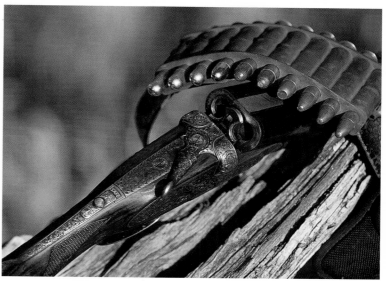

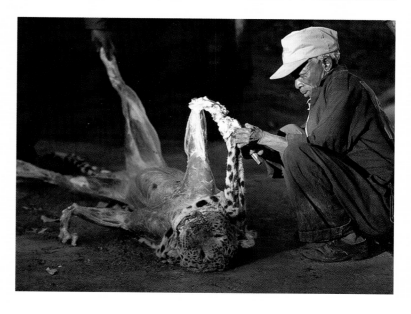

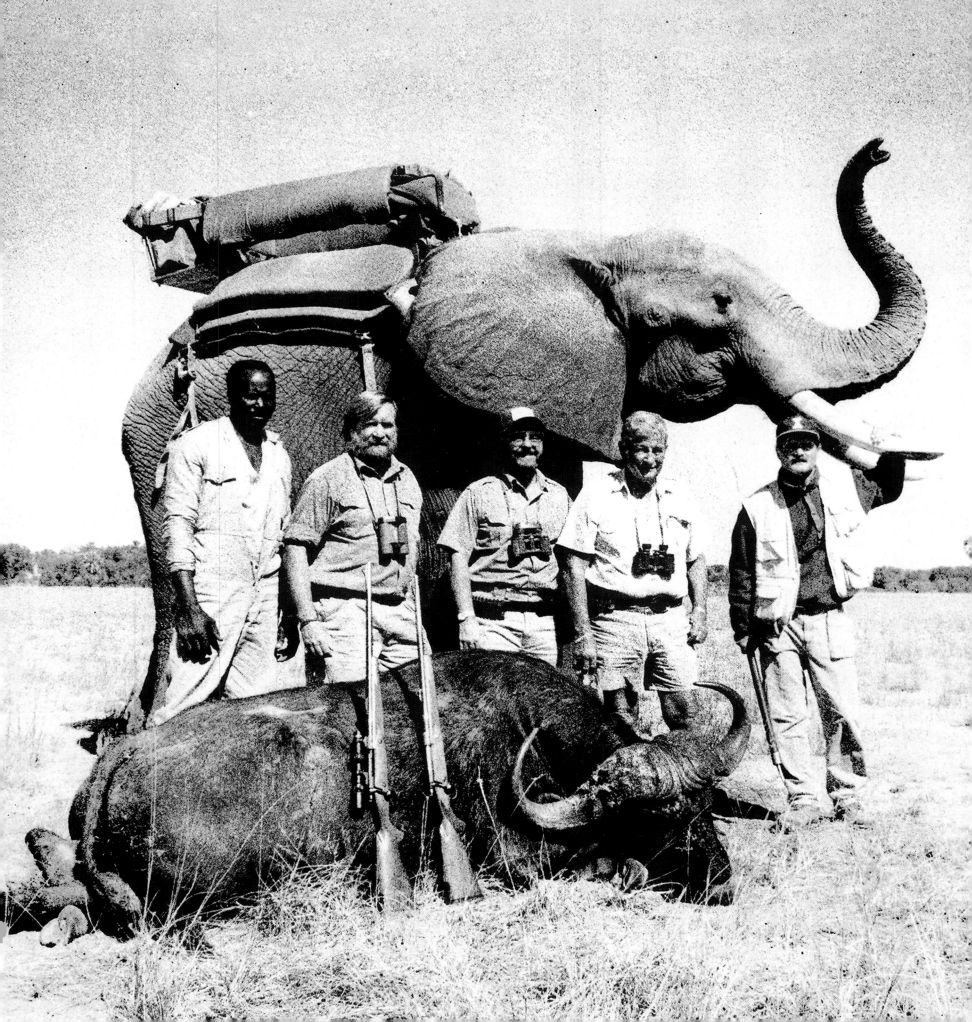

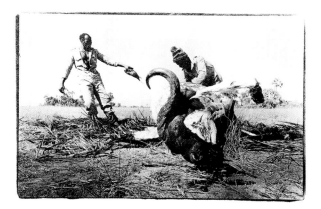

Elephant-Back Hunting Safari

There is a timeless scene unfolding on an African flood plain in the western Okavango Delta. Long fingers of blue water stretch across a canvas of dry, golden grassland to form intricate channels and shallow lakes. The coming of the flood promises renewed life, heralded by the arrival of the wattled crane and followed closely by vast herds of lechwe.

Traditionally, this is the season of the hunt. Under the cool, breezy shade of mature real fan palms, African elephants are being saddled, and in the khaki safari tents, hunters oil their rifles. As the sun gently slips above the horizon, eight regal, swaying elephants leave the haven of the island camp, bearing a hunting party. Moments later a group of young elephants bring humour and lightheartedness to the formality of the procession, as they emerge, frolicking and trumpeting, into the open of the plain.

There is a genteel air to this safari, as man and beast combine their talents and resources in ancient custom in the pursuit of wild antelope for the camp table. Each elephant is ridden by an experienced African or Sri Lankan mahout, whose leg tapping and quick commands add rhythm to the silent elephant walk. The safari is led by a unique combination of individuals: accomplished elephant trainer Randall Jay Moore and professional hunter Harry Selby.

There are two hunting clients in the party, who share a longstanding friendship and love of hunting in the African wilderness. Fifty years of professional hunting and experience in the bush distinguish Harry Selby in the hunting world; in his still, clear, blue eyes there is a sparkle in anticipation of the hunt. Also present are the trackers, whose remarkable eyesight and bush lore are both an essential and a romantic addition to the hunt. Bringing up the rear is the family of one of the hunters, sharing the mood and the unfolding of the day.

The elephants pass through the dense foliage of an island, gently pulling leaves from branches and feeding them into their soft mouths. When the leaves are succulent and sweet they stop and tear whole branches from the trees; the mahouts struggle to move them on.

On an island the trackers discover the well-defined spoor of buffalo. They study the spoor for further information, and establish that a large herd moved across the island only hours before. The hunting party proceeds after a time – it had taken a buffalo the previous day. Today's quarry is red lechwe. To find them they must reach the area where the new floodwater lies, and this is yet some distance away.

Once past the island, the elephants return to the flood plains, where they wave their trunks right and left over the grass to select choice pieces here and there. The long, patterned necks of giraffe turn momentarily in the direction of the elephant procession, then, with blinks of their extravagant eyelashes, return to their chosen browse. The elephants pass right by them and a group of kudu, sharing their meal of new acacia leaves. The hunters, as one with the elephants' silhouettes, are able to approach closer to game than ever before, without the necessity of creeping and ducking behind the cover of bushes. Tsessebe barely raise their heads as the elephants approach; blue wildebeest, always keen to

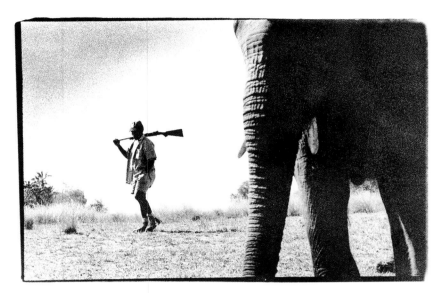

Overleaf:
'I shall be telling this with a sigh
'Somewhere ages and ages hence:
'Two roads diverged in a wood, and I –
'I took the one less travelled by,
and that has made all the difference.'
Robert Frost, *The Road Not Taken*

dash off frantically at the slightest cue, watch the tsessebe for a reaction and, seeing none, are content to stand and stare.

After many hours the elephant-back riders are still mechanically scanning the horizons, when a male lechwe, prominently horned, happens out from behind a palm-studded island. Randall Moore gives the signal and the mahouts guide the elephants around the island. The hunters sit upright in their saddles, reach for their rifles, unsheathe them and wait.

Before them, the grassy flood plains disappear into a world of shimmering silver and blue. Land becomes an island-scattered sea, and it is with immense excitement that the hunters, on the elephants, are carried into the water in pursuit of the spectacular male lechwe which has now joined its herd of females. To reach the island the elephants must cross deeper, darker water.

Tentatively, the mahouts urge them on. The elephants plunge forward, trunks raised, into water that comes to just below their saddles. The subadults are uneasy, but follow closely the steps and actions of the adults. The baby elephants swim, keeping as close to the walking adults as they can. The mahouts allow the elephants their natural and instinctive reactions in getting themselves and their mounts to safety.

The hunters sway to and fro as the elephants draw closer to their quarry. The deep water crossed, the elephants appear once again in full silhouette. The lechwe, now familiar with the presence of the elephants, barely raise their heads. The hunting party crosses a very shallow flood plain scattered with the patterns of fresh green grass; the clear water grows murky with its passage.

Slowly but surely the gap between the elephant procession and the lechwe closes. When the hunters are still quite a distance from the lechwe, Harry Selby gives the signal to stop. One of the hunters and a tracker dismount, keeping on the far side of the elephants and behind their cover, and select a rifle and bullets.

Bent double, with the tracker out in front carrying three hunting sticks tied together to form a tripod, the hunters, moving slowly and quietly, wade closer to the quarry. Randall Moore gently edges the elephants away. The male lechwe looks up in their direction, but does not seem to notice the hunters, who immediately stand stock still. As the lechwe once again lowers its head, the hunters resume their stalk. Within minutes Harry Selby judges the distance to be right. The tracker sets the hunting sticks and the hunter places his rifle on these. Although the hunter is a veteran, the thrill of the hunt and stalk still describe some of his most

treasured moments and have imbued in him a deep love and respect for the wilderness.

The shot tears harshly through the tranquil scene. The male lechwe is thrust into the air with the impact, and falls instantly. The herd of females raise their heads and, still unable to perceive any danger, trot a few metres away. The hunters check through binoculars to make certain that the lechwe is dead. They shake hands and touch each others' shoulders while they quietly confer as to the nature of the shot.

Wading across the flood plain, through alternating waist-deep and shallow water, the hunters approach the dead lechwe. The herd of females, now seeing the human shapes, dash off, spraying water as they go, to disappear behind another small island. The hunters admire the graceful, tapering spread of horns of their

trophy, and, turning it over, find the bullet wound through the heart. Blood seeps to mingle with the water.

Harry Selby signals to Randall Moore to bring the elephant-drawn sleigh. The trackers load the lechwe and tie it down with strong twine. The hunters remount and, with Randall Moore leading the procession, the elephants move back across the flood plain, once again negotiating the deep channels to the dry land.

With the hunt behind them, a lechwe in the bag, the wet and weary hunters are content to succumb to the lulling, ambling pace of the elephants. As the sun cools and sinks below the horizon, the elephants and the hunters disappear back into a palm-shaded island. The only sign of their passing are the giant, veined footprints on the flood plains and a softly falling sheen of dust caught in the last light.

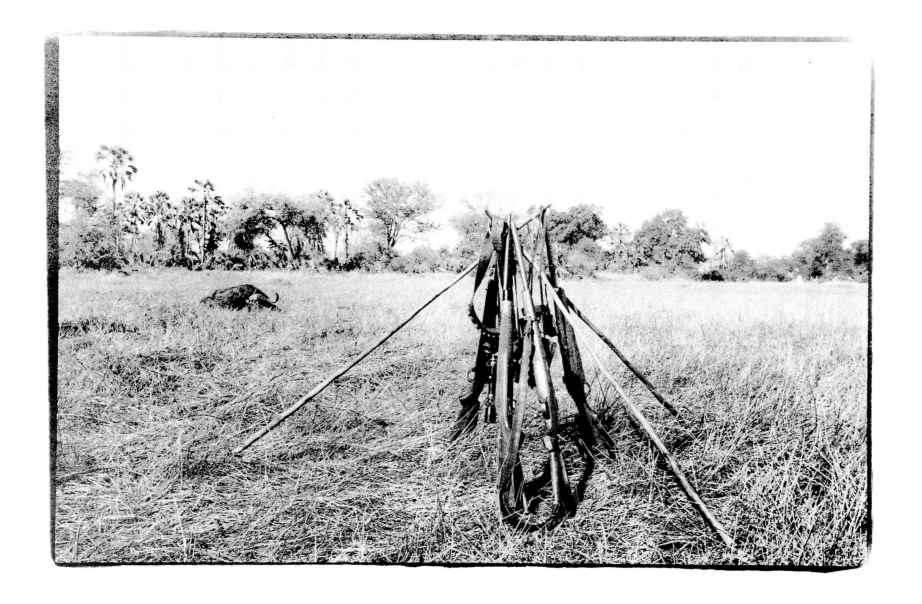

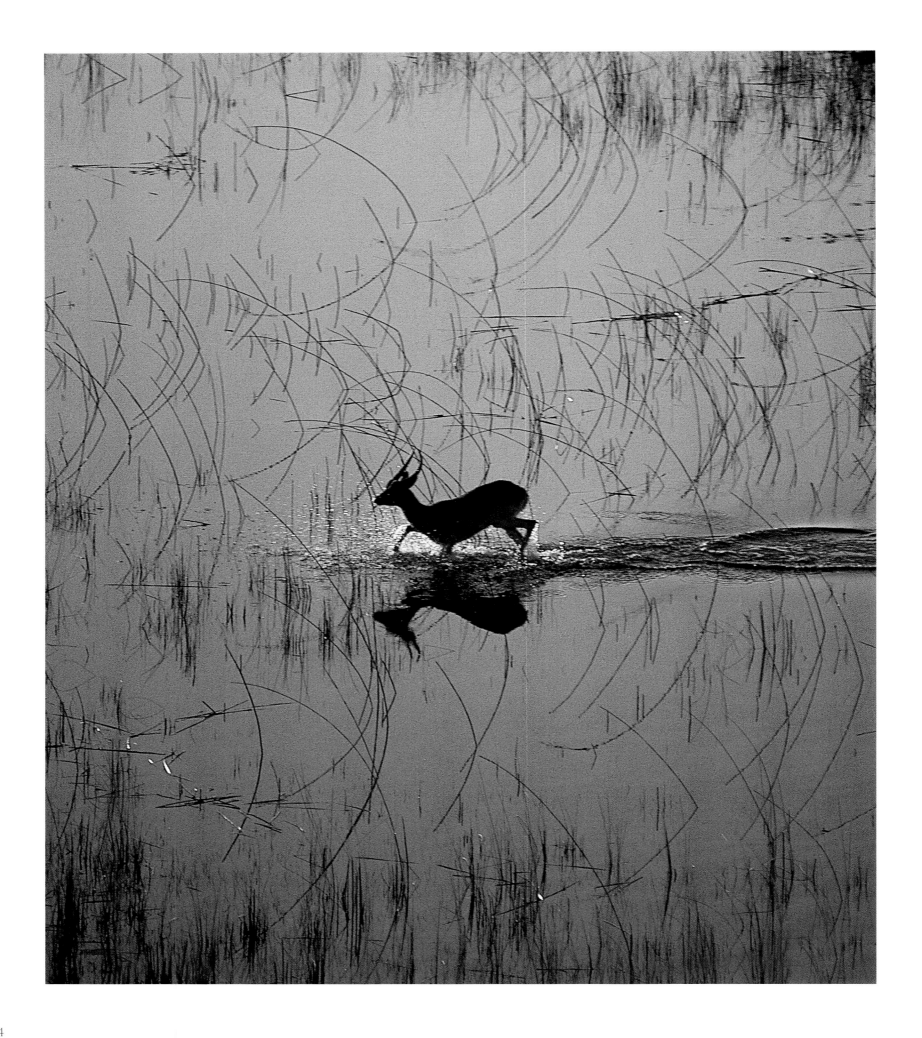

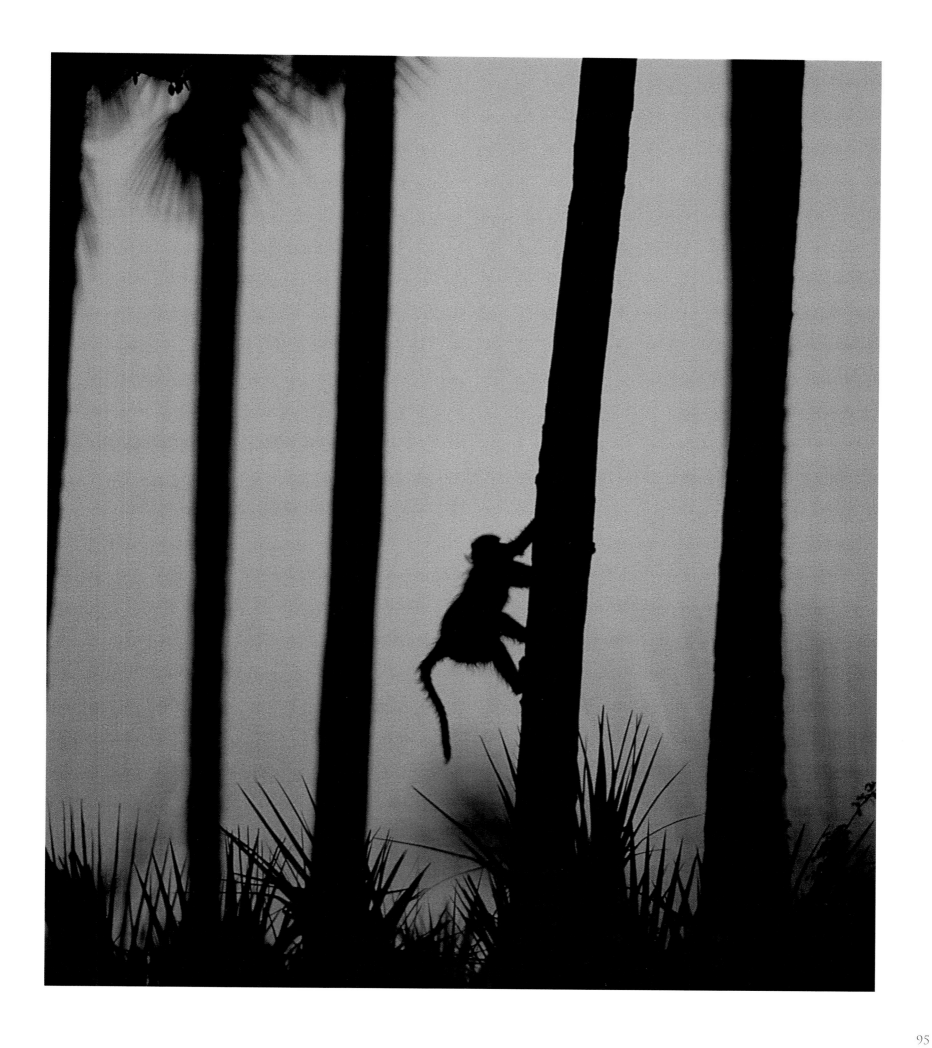

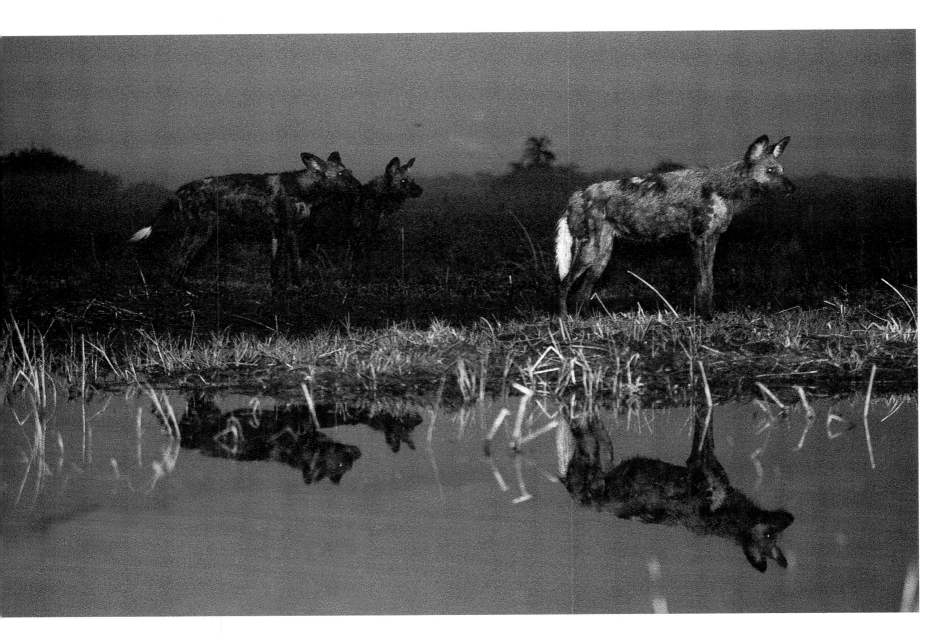

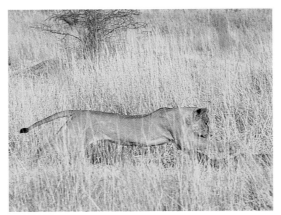
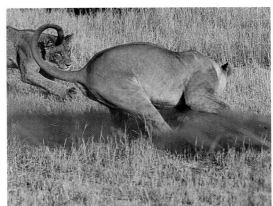

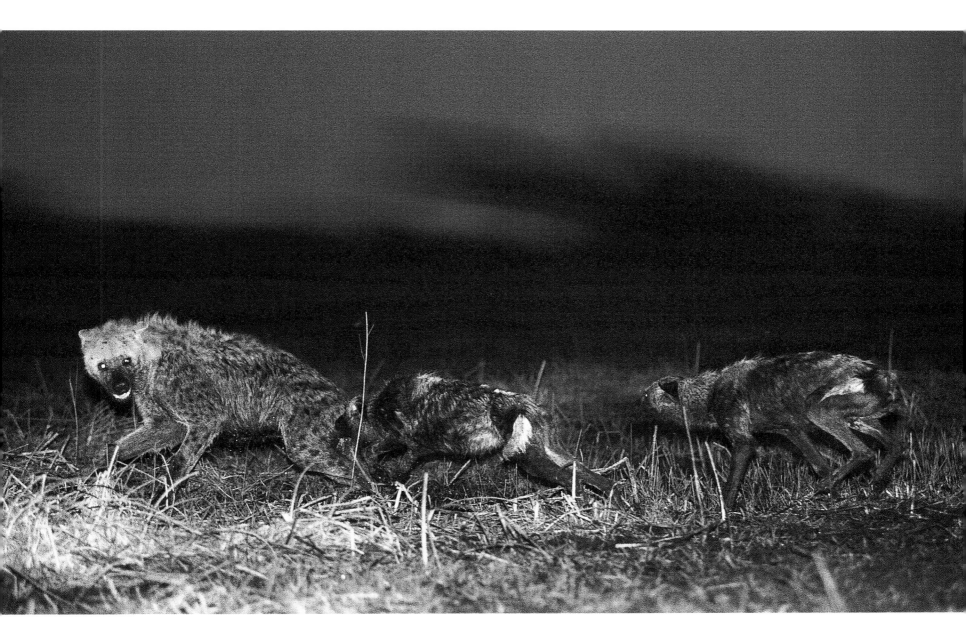

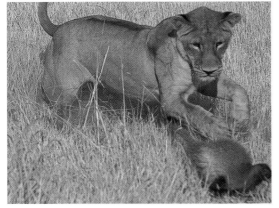

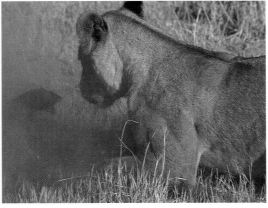

Above: *For wild dogs on a hunt there is a constant tension, for they are haunted by the inevitable arrival of hyenas.*

Left: *Miraculously, the water mongoose escaped this attack by two young lions.*

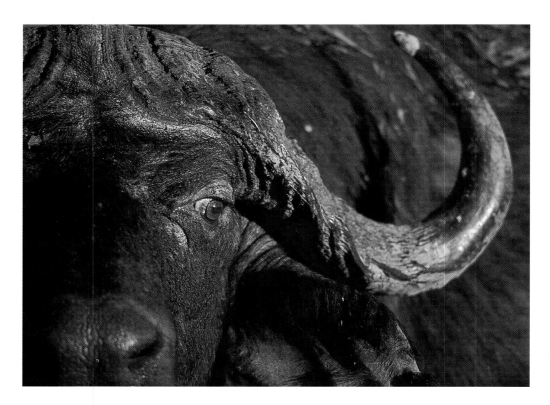

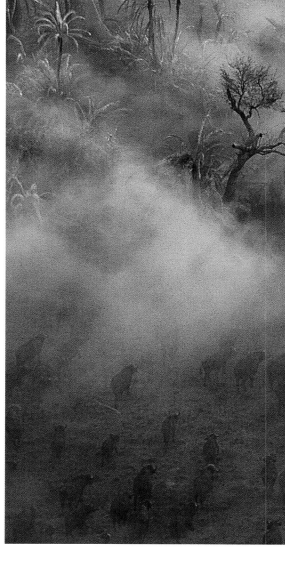

'I had seen a herd of buffalo, one hundred and twenty-nine of them, come out of the morning mist under a copper sky, one by one, as if the dark and massive iron-like animals with the mighty horizontally swung horns were not approaching, but were being created before my eyes and sent out as they were finished.'
Karen Blixen, *Out of Africa*

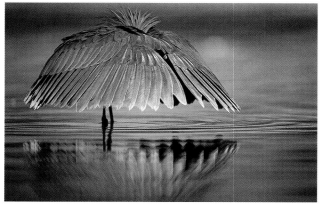

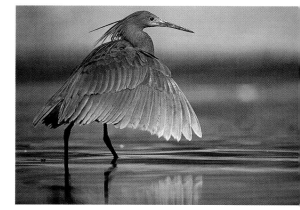

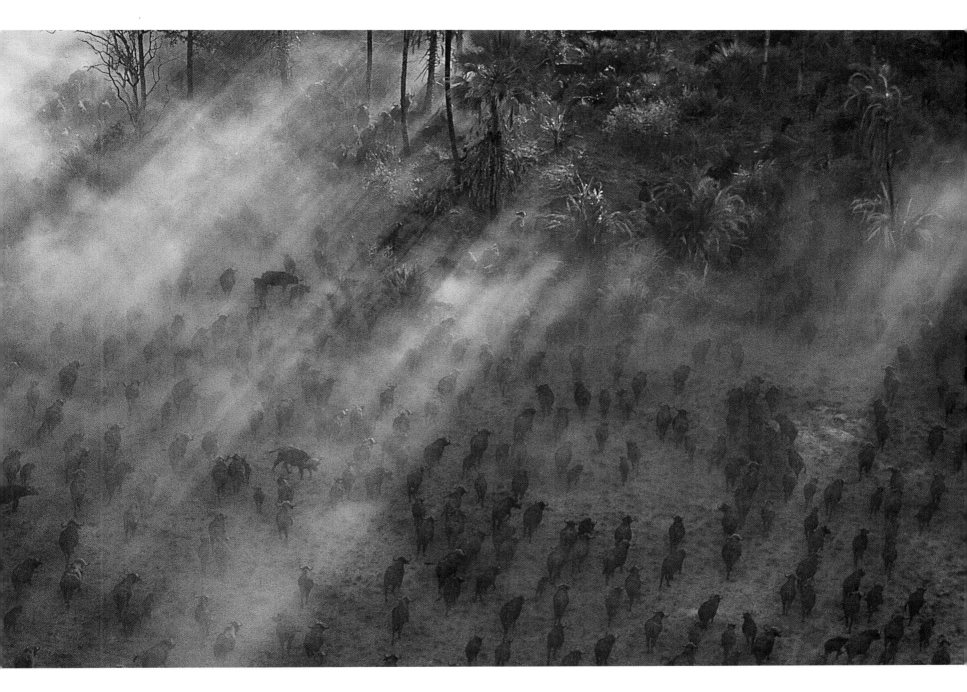

Left: *A black egret hunts beneath its self-made canopy of shade.*

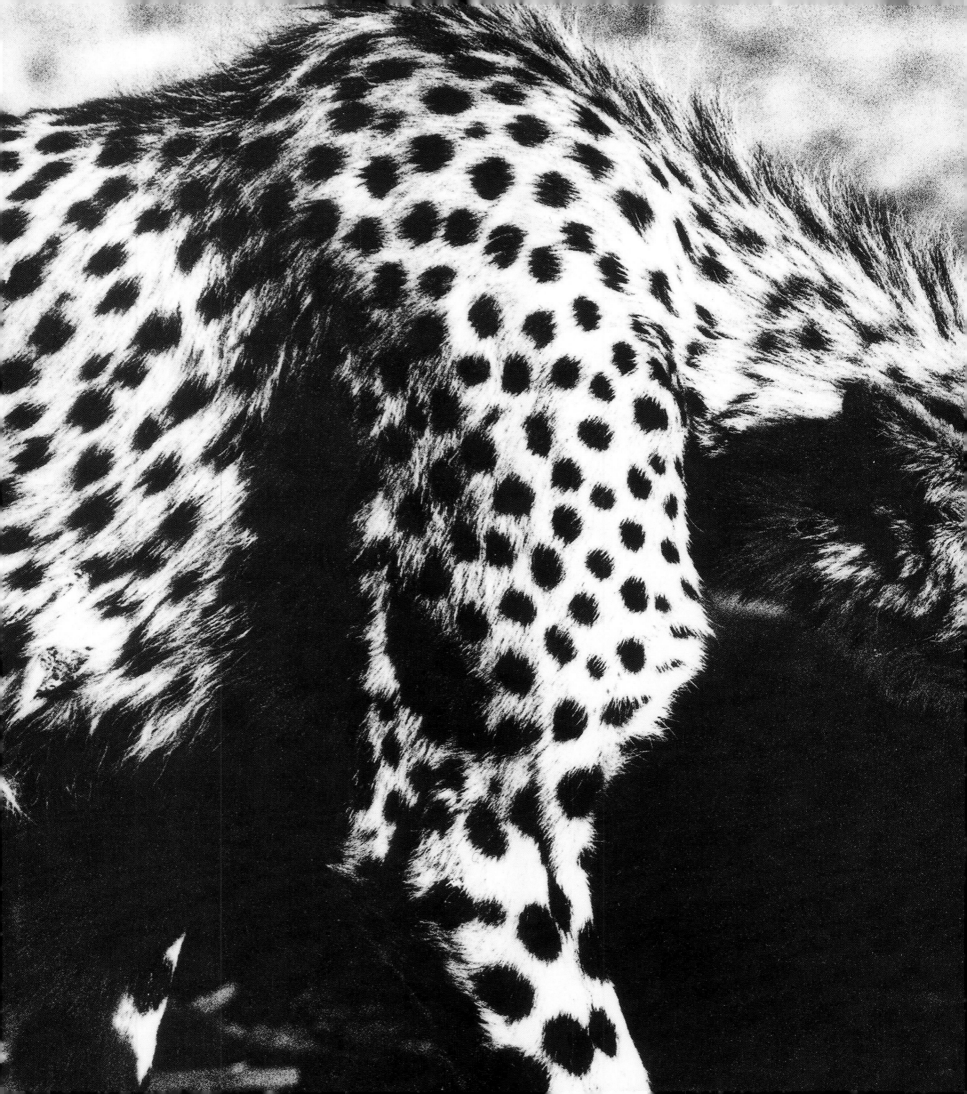

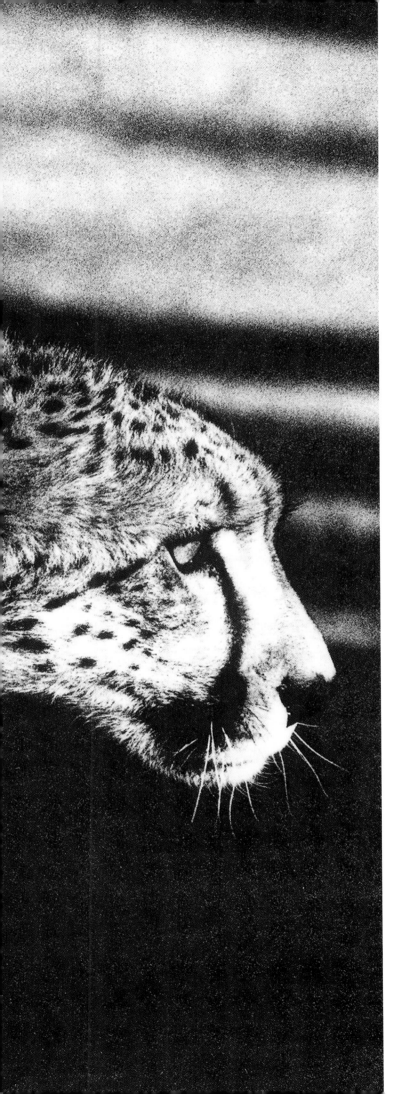

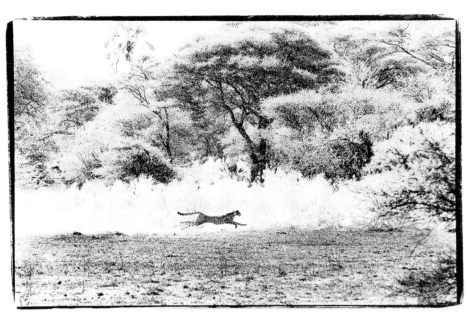

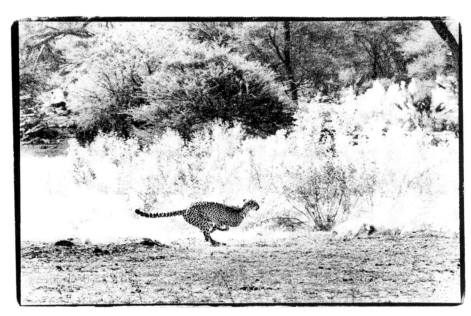

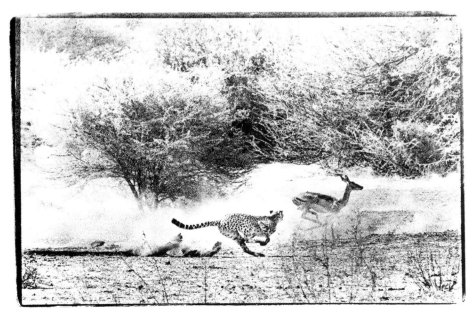

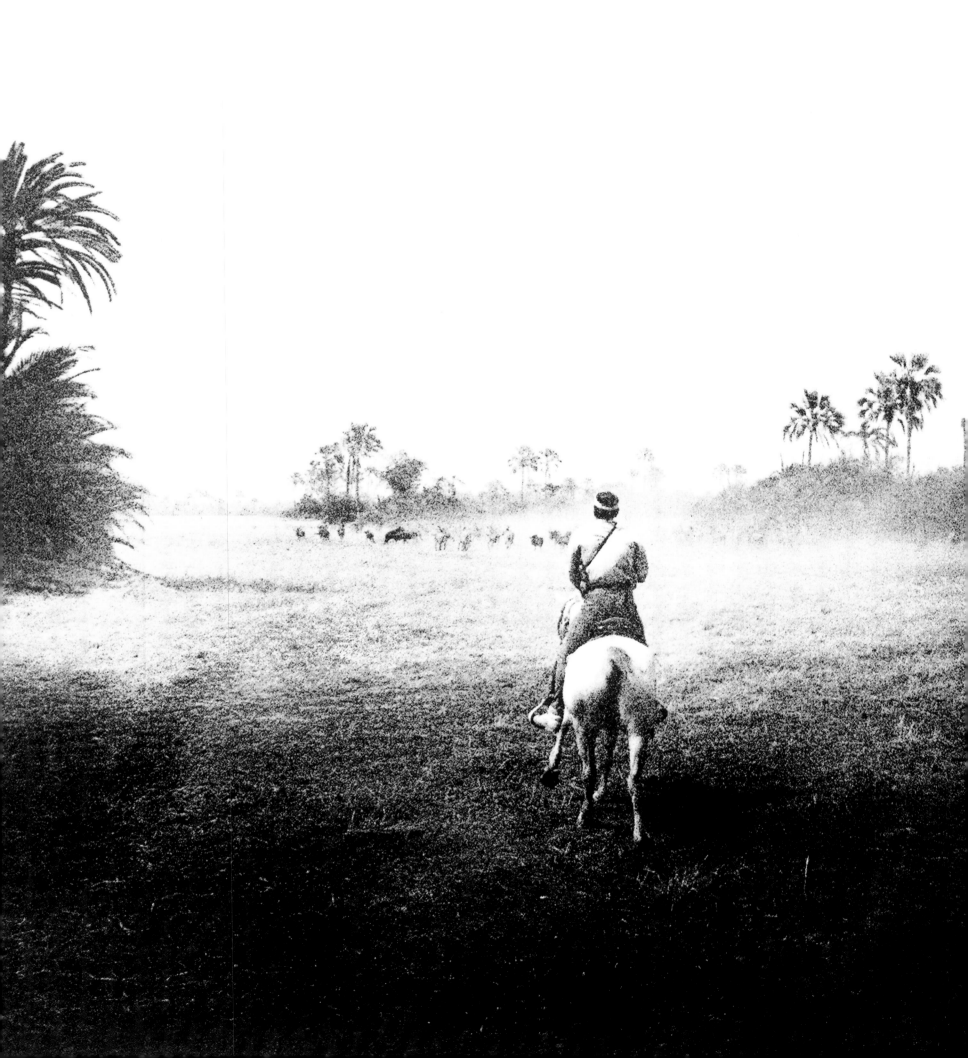

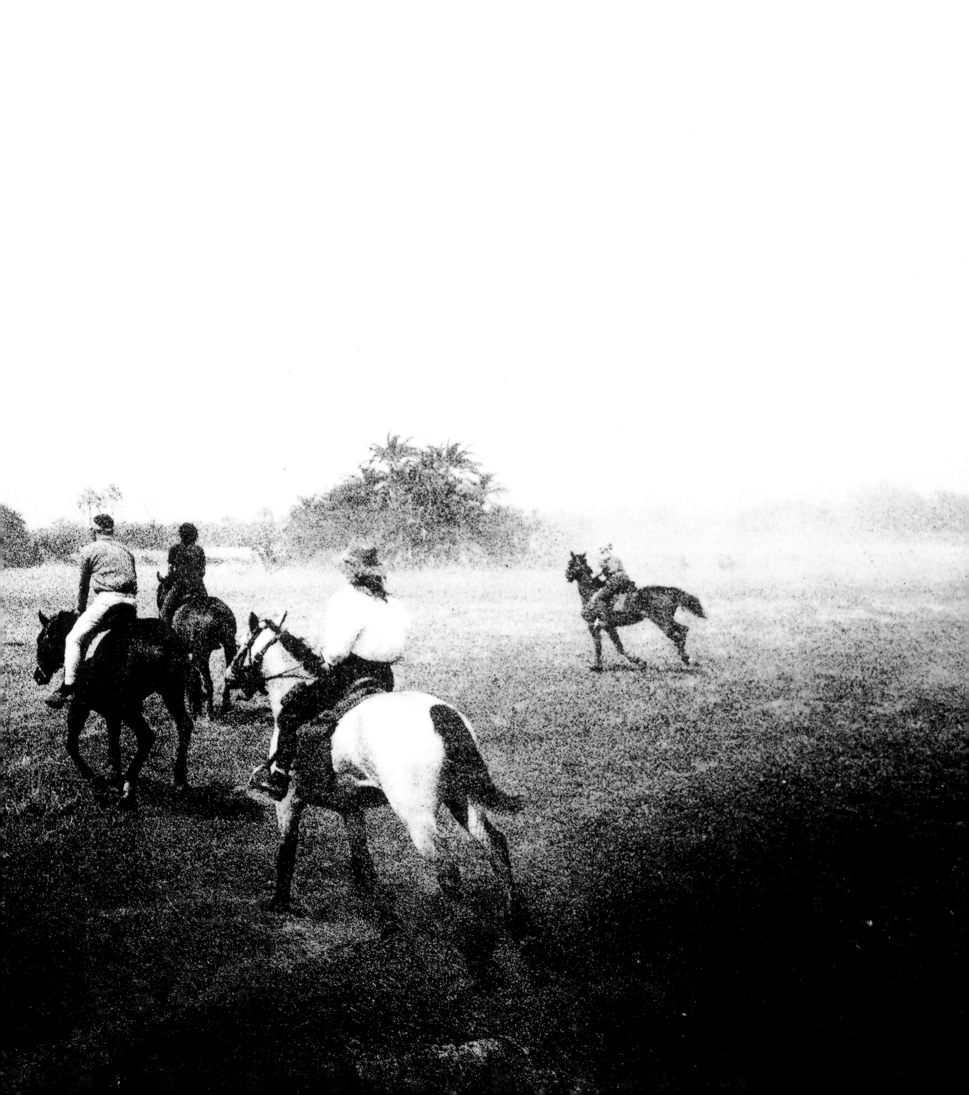

Horse-Back Safari

The horse-back safari base camp lies deep in the heart of the Delta. As darkness closes, the glow of a distant fire becomes visible between the trees. Around a bend, the camp: a large mopane-wood fire, a candle-lit table splendidly decked for dinner, gleaming saddles off to one side and warmly extended hands.

The way to the tent is lit by paraffin lamps. The showers, open to the stars, are steaming hot, the water supplied from a bucket on a pulley. Later, cocktails are sipped around the fire. Now and then the pleasant scent of horses wafts by, or a rumbling snort breaks the silences between laughter and conversation.

The safari is led by naturalists PJ Bestelink and Barney Bestelink, whose sense of adventure, wild spirit and love of horses combine to create this safari. The horses, stabled in a lion-proof tin shed, are for the most part the sturdy breeds of the desert: pure Arab, Anglo-Arab, American Saddle-bred, part thoroughbred, Kalahari and Kalahari-cross. The horses' names – Moremi, Katima, Linyanti, Quando, Nxebeca, Talkwe – conjure up images of the places for which they are named.

Left: *After a day riding among the wild animals, with siestas in the shade of small palm islands, PJ Bestelink leads the riders into a fly camp at dusk.*

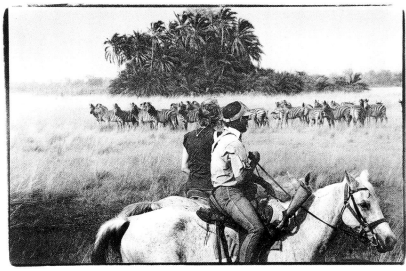

Mount-up is at dawn. As the soft light filters through, Barney turns her American Saddle-bred, Lamu, in the direction of the day. The horses test the cool air of dawn and follow Barney's lead into the sun. PJ, having checked all stirrups and girths and carrying a .375 rifle, mounts his Anglo-Arab, The Silver Smous, and brings up the rear.

The horses cross a shallow, flooding area. Water lilies bend to and fro as the movement of the water disturbs their wispy stems. Pygmy geese snap off water-lily buds where the water deepens into a channel. A pair of yellowbilled ducks announce their indignation at the intrusion into their watery domain.

On the next island, the riders disappear into a band of shade where the path is damp and silent; then they're

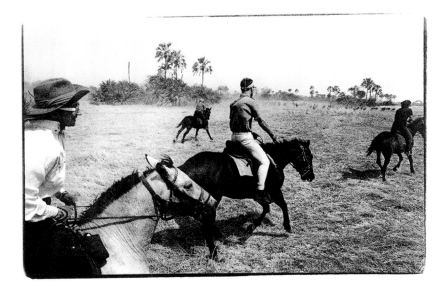

Opposite: *A leopard's call, although not as imposing as that of a lion, is deeply guttural and reverberating and can be likened to a coarse saw on heavy wood.*

out again, touched by the warmth of the sun, to trot easily through the long, spindly grass.

Barney suddenly stops and holds up her hand. Ahead, across a channel, between the long green grass, like an ancient carving, stands the black hulk of an impressively horned male buffalo. The wind carries the scent of the horses and riders away from the beast, out over the plains, and the buffalo remains calm. The silence is, however, heavy and uncertain, as primordial adversaries watch each other for long moments before moving on.

The regal brown and white of the fish eagle appears, to follow its shrill, far-carrying call. The large, unmistakable, veined spoor of an elephant is superimposed on the forked hoofprint of a lechwe. All too often the imposing paw of a lion has left its mark, and sometimes hyena, and the riders try to piece together the story left by the spoor.

The islands are parted by a many-channelled flood plain where several flocks of wattled crane wave their graceful white necks about in dance and aggression. A few, close by, disturbed, take to the air, propelling themselves upwards to the accompaniment of their croaking calls.

The temper tantrum of a scolded young elephant in the distance begins a long hour of tracking elephant. Island after island is rounded; the riders stop and listen, waiting for the cracking of a branch or a trumpeting or the sound of a burst of water … but there is nothing. With ghostly stealth and quiet, the breeding herd of elephant has slipped away through the dense bush.

The riders are weary from concentration, so when a distinctive shape suddenly appears, they are taken by surprise. A lion, about thirty metres away, emerges from the bushy edge of an island, to stand alert; it is joined by another two. PJ and Barney urge the riders into a tight group, then remain dead still. Delicious minutes pass and adrenaline runs freely. Slowly, the horses back off – they know the procedure; they are familiar with the scent of lion. Once a safe distance away, Barney moves into a trot. The riders follow, reigning in the urge to gallop unchecked, wildly away.

It is breakfast time, and Barney leads the way to a shady island. The riders lie on their backs, while far above vultures, both whitebacked and hooded, find thermals in the sky. As the heat of the day begins to lull the scene, the call of a Burchell's zebra is carried by on the wind and, with this, PJ and Barney rouse the riders.

Following the zebra's calls, the riders soon emerge onto a vast, open plain. Dust is kicked up by teeming herds of blue wildebeest, Burchell's zebra, impala and tsessebe, all moving tensely, pacing this way and that. In deep concentration, watching and responding to the movements of the animals, PJ and Barney lead the riders towards the herd of zebra. The herd divides; Barney rides into the gap. The zebra move; the horses, caught in the tension of the moment, break into a gallop, and soon the plain disappears beneath a single galloping melee, dust streaming up between black and white stripes. Time stands still while for magic moments the riders are carried by the spirit of the wild herd. And then, as if by some prearranged signal, the animals quieten down and, in the settling dust, the riders and their horses stand among the zebra.

Calmer now, but uncertain, the zebra walk slowly off to where instinct leads them, leaving the riders, animated yet thoughtful, to return to camp.

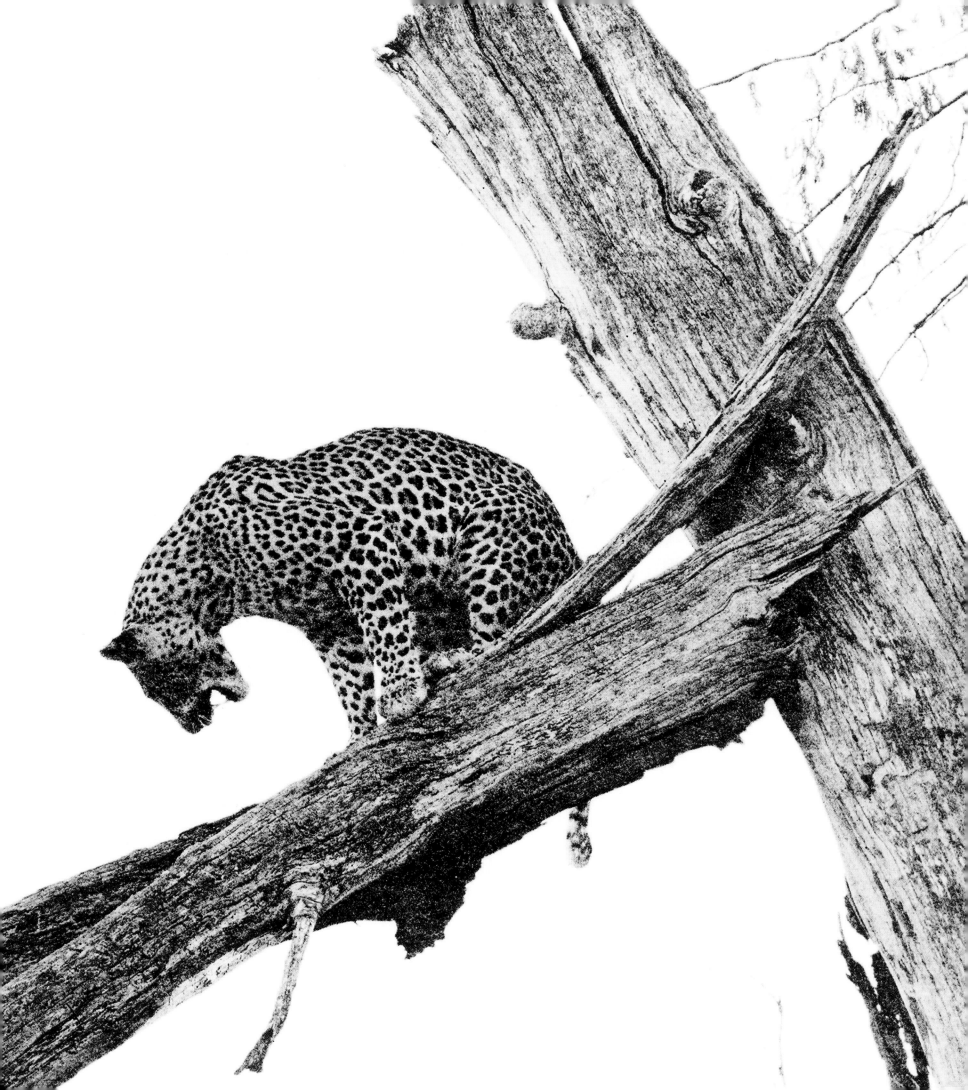

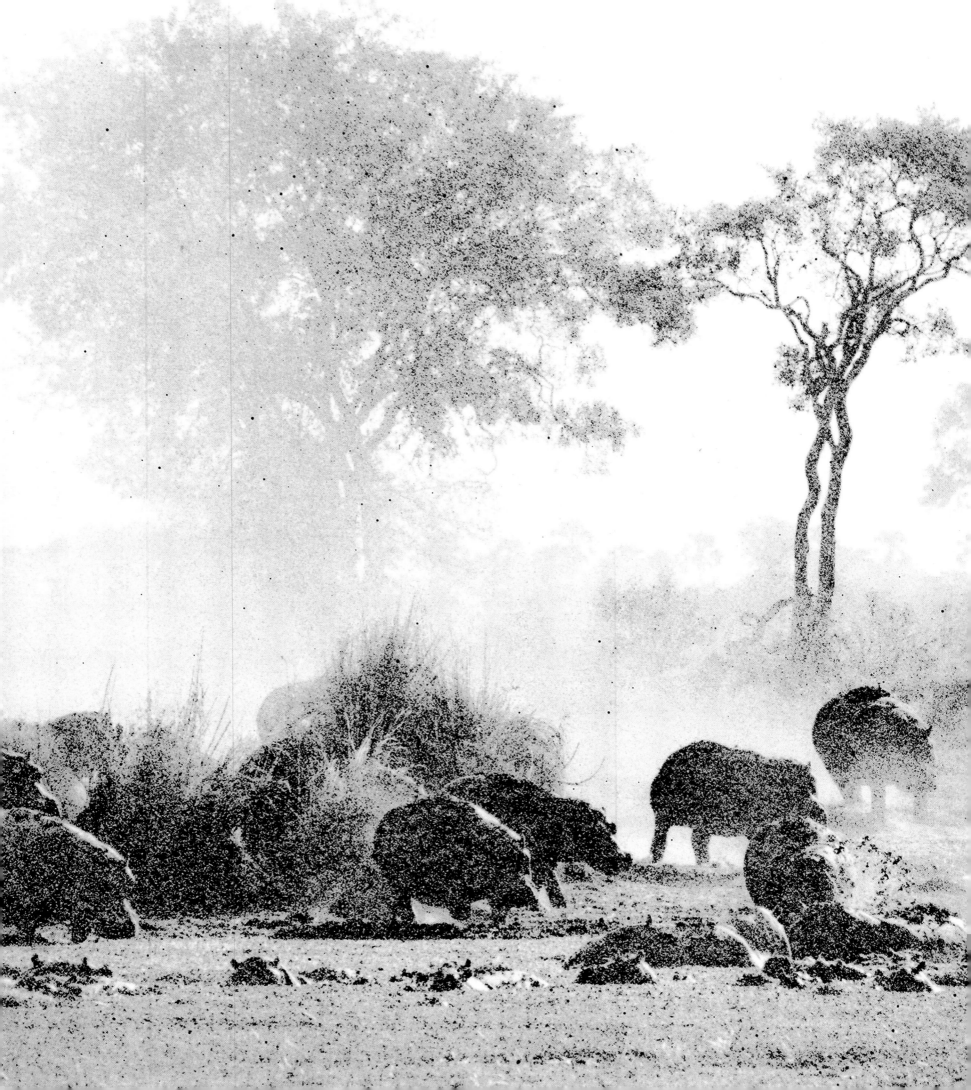

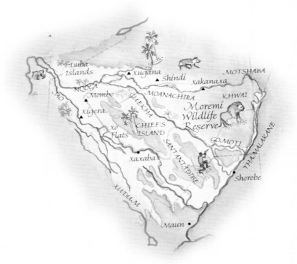

The Realm OF THE River Horse

*'It's absolutely essential that man should manage to preserve
something other than what helps to make soles for shoes or sewing
machines, that he should leave a margin, a sanctuary, where some
of life's beauty can take refuge and where he himself can feel safe
from his own cleverness and folly. Only then will it
be possible to begin talking of a civilization.'*

Romain Gary, *Les Racines du Ciel*

*The eastern portion of the Okavango Delta is dominated
by the sand spit of Chief's Island, which reaches up from the
mopane forests in the south and stretches two thirds of the way
into the Delta. The bulk of the island falls in the Moremi
Game Reserve, an African paradise teeming with wild
creatures, but there are people here too.*

109

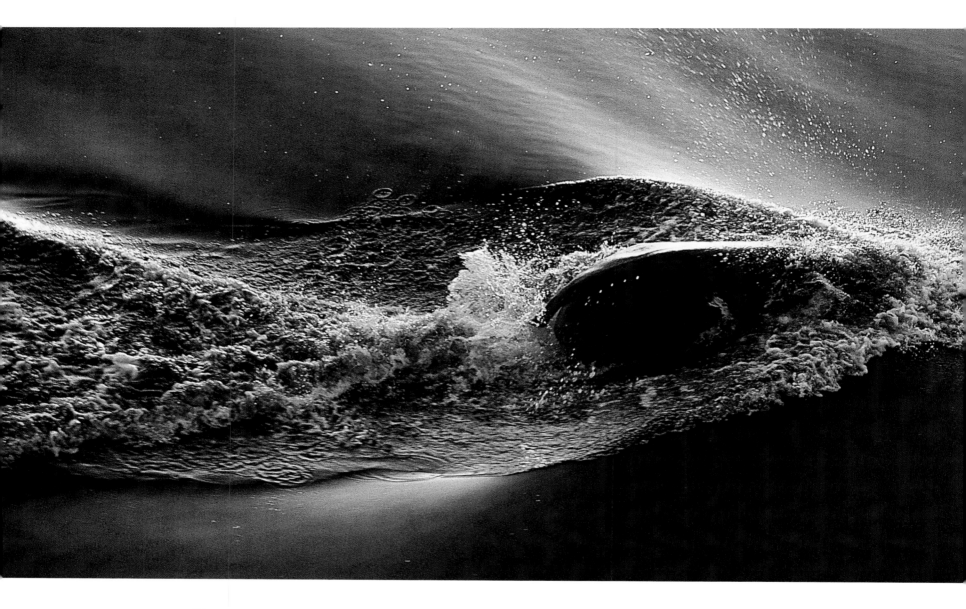

*I*t is certainly not cheetah or wild dogs, and it isn't elephant, lion or leopard either. So is it buffalo, hippopotamus or crocodile that kill the most people in Africa every year?

But does it matter? Is the question important? Is not each story, each anecdote, merely an embellishment of the African legend? The myth of Africa, the dark continent, is intrinsically linked to its proliferation of wild beasts that would attack and savage us … and sometimes eat us.

In Khwai, Xaxaba and Kiri, small dusty villages of neat, round huts baked to a sleepy stillness, the question is unimportant and unweighed, for it matters only that it is a part of life. These villages are beyond the buffalo fence, beyond Maun with its frenetic, frontier-town bustle. Tied instead with content resignation to a slower turning, it is geared at the very cog of life. The villagers seem to be in life itself, in the very moment of it – not in opposition to it, or at a distance from it – and they make our questions seem

superfluous. For here, to kill or be killed is much like the trees and the grass: not a question but a fact. Here, the people walk together with all things, of which they know they are a part.

The wilderness begins upon their threshold and radiates out all around. The land is higher here and stands against the waters' advance, confining it to channels, with occasional wide pools between the ever-present press of trees. From the south, where water and sand stand forever opposed, staging their annual ritual of advance and retreat, rises the great sand tongue of Chief's Island, reaching two thirds of the way north across the Delta. In the dry season, its western shore is a torpid place where the flood plains lie, beaten dormant and grey by the sun, and its haggard countenance appears ancient.

It is hard to reconcile this visage with the fresh, painted face of youthful serenity that is its transformation as the waters return to revive it once again. Everywhere there are long peninsulas, or wide

At sunrise, after a night of feeding, a hippopotamus lunges through the shallows towards the sanctuary of deep water.

bays or coves beset by dense, shady trees, the blue expanses of which are pinned to a stillness by the myriad straight, green shoots that spear the surface.

The channels, too, with the waters' advance, bring a flush of life. Some are short, petering out in a shallow, bowl-like flood plain or small lagoon, while others, like the Piajo, nearly sever the land right through. They are for the most part narrow and, as a result, you come upon them quite unexpectedly.

In the middle of the island, with its incessant forest and shy creatures that appear briefly and then are gone as if they had never been, the trees end with an abruptness and there before you lies the narrow green swath of a channel. To the left and right its close path meanders off between the trees, and at the centre its water is often deep.

To the east, between Chief's Island and the land, is a place of many rivers and permanent deep water, a vast wilderness of reeds and papyrus punctuated by lagoons and laced together by twisting channels. The water here is too deep for most animals; this is the home of the tigerfish and the bream, the hippopotamus and the crocodile, the shy sitatunga and a host of birds. Here, too, are a myriad tiny painted frogs whose united voice is a liquid chime of crystal bells in the close, warm darkness of the night. It is this deep water that wraps around Chief's Island and separates it from the rest of the Moremi Reserve.

As the water moves southwards, so it is met by the insatiable thirst of the sand, and its strength is sucked from it. Nowhere is this more evident than on the eastern edge of the Moremi. From Xakanaxa a spear of deep water pierces the land, but this grows forever narrower and shallower until the wide mopane-pole bridge at Khwai spans only a fetid, warm, brown stream which the baboons cross quite easily in a single leap. It is only in years of an exceptional flood that the waters press on into the Mababe Depression, or into Shorobe, or into Maun.

It is interesting to note that the tide of western influence seems to move against the flood for there is, in moving from Maun to Shorobe to Shukumukwa to Ditshipi to Zankuyo, and on to Khwai, Xaxaba and Kiri, more than a physical progression. It seems that with each step onwards you slowly strip yourself of the comfortable distance with which you usually conduct your voyeurism until, almost by default and quite by surprise, you find yourself standing before reality.

It is then, like that – in a sense almost naked – that we can ask the question. Is it just the raw beauty, the natural state of this wilderness, that is its attraction to us, or is there a darker magnetism here too? To stand before the wild beast and in our fear to know, however fleetingly, the vitality of the immediacy of life.

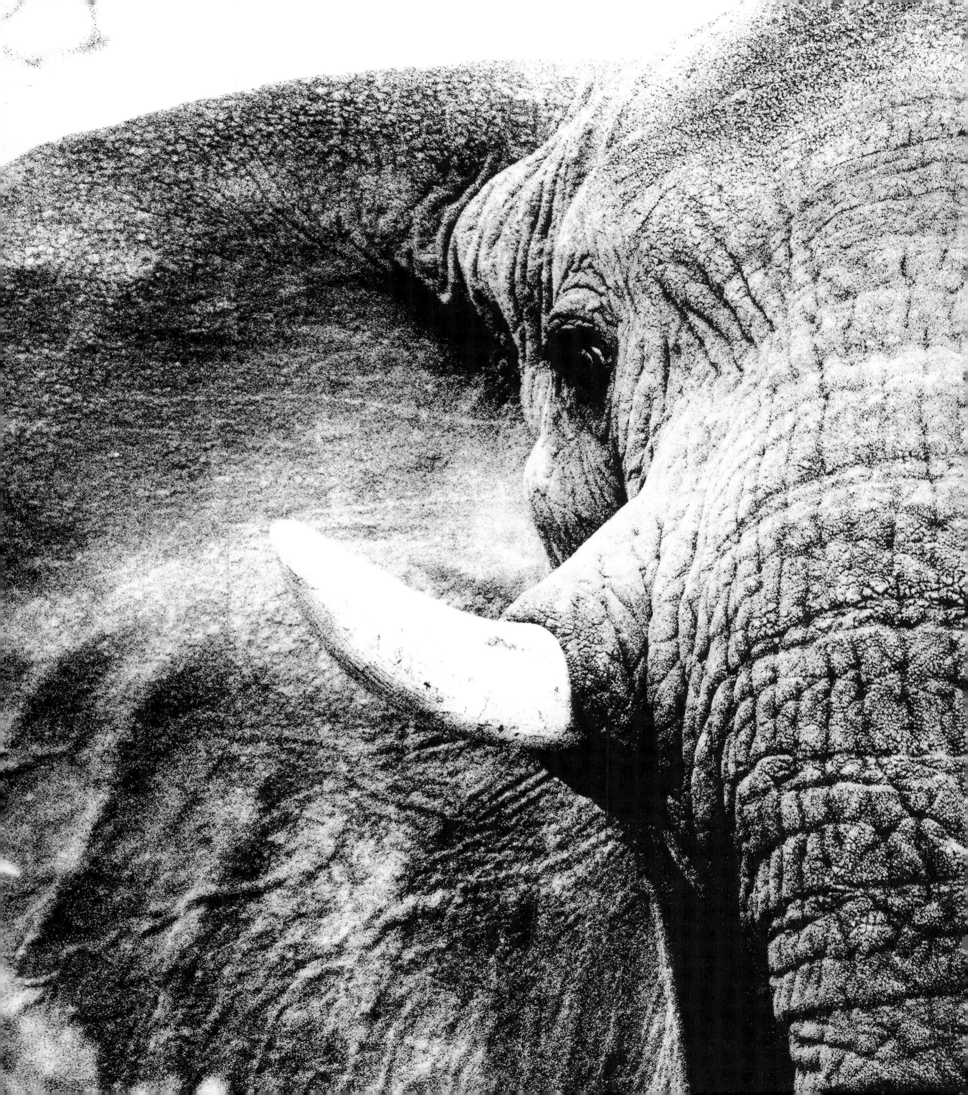

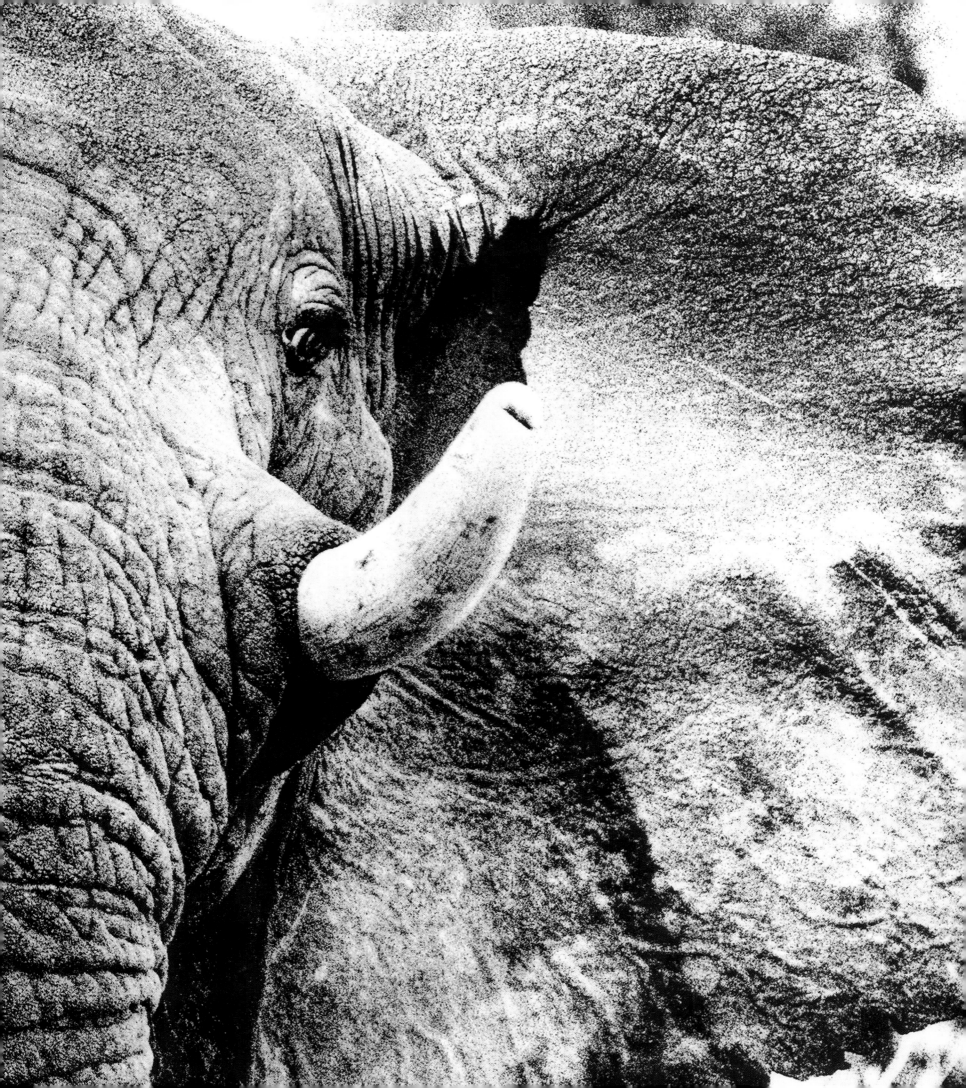

Elephant Birth
on Chief's Island

On Chief's Island, near Mombo and close to the Boro River, lies a series of pans. To those unfamiliar with Africa they look like large, barren, empty stretches of sand. They are surrounded by palm islands, so called because they are clustered with tall, statuesque real fan palms, and shorter, more densely fronded wild date palms. These palm islands hug and divide the pans, creating between them a maze of jungle and desert.

It was while exploring the solitude of these palm-edged pans in our vehicle that we came upon a group of elephants at the edge of an open area. The elephants, silhouetted by the thinly setting sun of a hazy afternoon, stood shrouded in dust. At our approach, they bunched more tightly together and lifted their trunks in unison to test the nature of the intrusion. As if bound by some ancient pact, not a single elephant gave the usual alarm trumpet, or made any effort to either confront or run away from us.

Trunks raised high and swaying in the light of dusk, the elephants remained strangely, eerily silent and still. There was an apparent nervousness and tension between them, and while still quite a long way off we killed the motor. As the intrusive sound faded, they relaxed a little but remained tightly bunched. They seemed unwilling to move, unwilling to break the silence; out in front, an old female rolled her bulk slowly from foot to foot.

Suddenly, without warning, the reason for this unusual and remarkable display was made plain. Blood gushed from between the legs of a cow, to mingle with the dust and form a dark red pool on the ground. Then there was a deep thud, and a small cloud of dust floated up between the legs of the elephants. A baby lay spread-eagled on the ground, born before our eyes.

The attendant herd remained immobile, seemingly caught in the spell of the moment. The mother cow moved as if in a dream as she turned and searched for her baby under its mask of afterbirth, while the strange, swaying ceremony of the elephants in attendance continued. It was as if this was the only way to release some of the tension of the enormity of the moment, without disturbing the newly born baby.

Reaching down with her trunk, the mother sniffed at her baby; then, gently and tentatively, with one of her

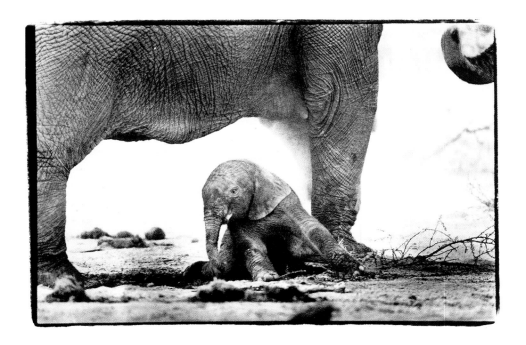

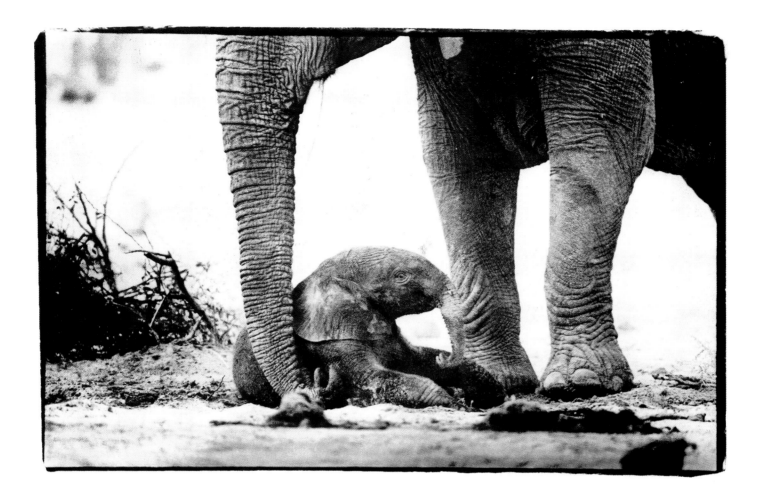

enormous feet, she prodded it. The baby lifted one of its forelegs in its first sign of life and the mother showered it in fine grey dust with her trunk. She moved around the prone form of the baby, alternately showering herself and the baby with sand, every now and then trying gently to nudge it to its feet with her foot or trunk.

The baby lifted its head. Spluttering and sneezing with its first breaths, it tested the discovery of its tiny, wiggling trunk. The mother lifted it upright onto its belly. A few minutes later, with legs splayed, the baby made its first attempt to stand, only to fall sideways into the dust. Lifting its head, it gamely tried again. For seconds it remained upright, legs spread in all directions, belly only centimetres from the ground, but its waving trunk overbalanced it and it fell forward into the sand.

The mother urged her baby up once again: lifting its head with her trunk, she placed her foot under the baby's belly as if to tempt it into this new position. Long minutes passed as the baby was continuously coaxed and lifted, gently and tirelessly, by the mother's trunk and feet.

Finally, with enormous, directionless effort, the baby stood. Its legs were still not erect, but rather propped up its body. It peered wide-eyed as its mother covered it, then the afterbirth, in shroud upon shroud of dust. The entire twilight scene was masked in grey as the light faded from the sky. The other elephants conspicuously relaxed their vigil and gave the mother space.

About ten minutes after the baby's birth, the breeding herd began to move away to stand under the nearby trees. None of them moved entirely out of sight or hearing, and all their movement was curtailed and very quiet, as if not to disturb the mood of the event or disclose their whereabouts.

The mother tossed the afterbirth aggressively above her head several times before slamming it into the dusty earth as if she sought to destroy it. Eventually, satisfied, she hurled it into the closing darkness and focused all her attention on her struggling baby.

Lifting her trunk to test the air for danger, she continued her ceremony of dusting and urging her baby to stand in its new and foreign world. Just before

nightfall, as if in confirmation of the mother elephant's deepest concern, the full-blooded roar of a male lion reverberated across the pans.

The baby's little trunk, helpless and worm-like, seemed to have taken an interest in its mother's belly, although most of the time it ended up between the hind legs instead of the front legs, confusing and disorienting the mother. Turning around and backing up to reposition herself, she momentarily lost physical contact with the baby, at which it fell off the shaky support of its new, wobbly legs.

Eventually, after forty minutes or so, the baby stood more readily and learnt that if it leaned against the sturdy bulk of its mother's leg, it could rest more easily than if it lay on the ground. Twice, more by coincidence than design, the baby found its mother's nipple and suckled very briefly before it lost its balance again and fell away.

This soundless, urgent struggle for survival was suddenly disturbed by a fast and stealthy movement between the bushes. The mother's trunk went up; she raised her head and flared her ears. Her every instinct must have willed her to trumpet out in fear and anger at the intrusion, yet she remained silent. She stood over her baby, who, probably in response to the urgent tension of its mother and its own deep, as yet unexplored instincts of danger, remained standing. A male leopard, crouching low to the ground, revealed

itself momentarily, claiming the afterbirth for itself. The dark rosettes of its fine coat were visible briefly before it vanished back into the undergrowth.

The baby stood more steadily now. The elephant cow moved a short distance away. The baby took a few tentative steps and then fell again. The mother, becoming harsher in her intent, stood farther and farther from her baby, encouraging it to follow. She returned to its side only when its will floundered and it sagged to the ground. It seemed she knew she must return to the security of the herd for her baby to survive the long night ahead.

Two hours later only faint traces of blood remained on the calf as, grey and finally elephant-like, it scrambled obliquely after its mother. Every now and then sheer uncontrolled momentum would force it to stop and rebalance itself on its splayed, unreliable legs. Then it would set out once again after its mother, its disobedient trunk snaking about in search of something promised but not yet known.

The night closed in as the exhausted but ever-vigilant elephant cow and her calf rejoined the breeding herd, waiting not far off, calmly and quietly, among the trees. As soon as she was once again part of the herd, they surrounded her and her calf, as if to envelop them so they became unseen. Then, solemnly and purposefully, the herd edged into the darkness.

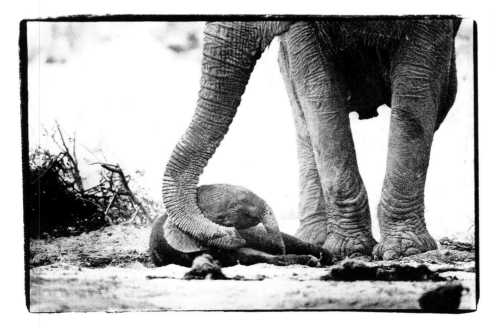

Right: *Snarling, a leopard revealed itself momentarily to steal the afterbirth.*

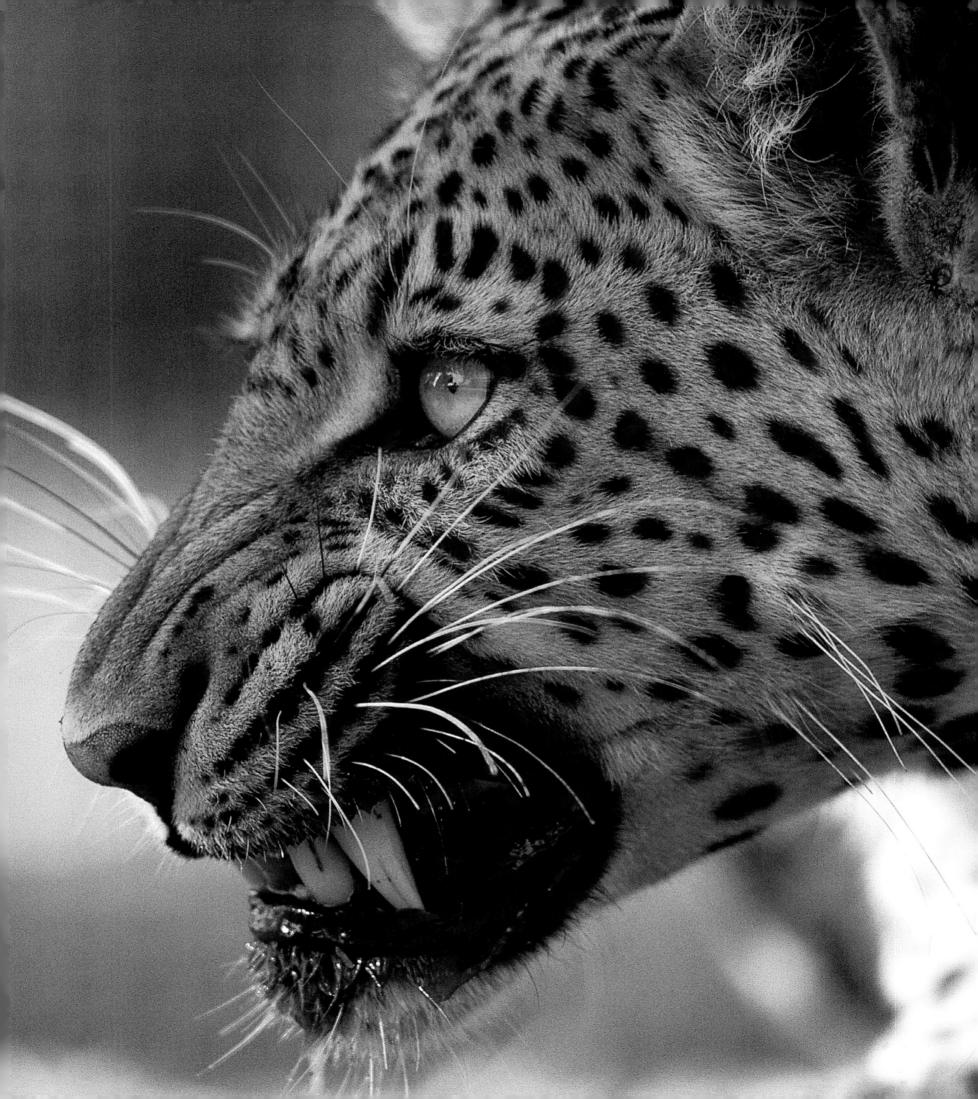

Store sign in Khwai village.

The Bushman Stories

GIRAFFE

as told by Boikhutsu Phuti a Basarwa

'I went early in the morning to hunt the giraffe, with my spear. I started chasing the giraffe. I chased it the whole day, and while I was chasing the giraffe it started to rain. It rained heavy rain – "do, do, do, do". It came down so heavy that I spent the night up in a tree.

'In the morning when I woke up I found the giraffe again. After chasing the giraffe, on my way back, I got lost. When I was lost I went far away.

'I got my way the following day. When I realized my way back, I saw a sour palm, a ready sour palm, and I started to eat, because I had eaten nothing on my whole journey. I ate a lot – "oo, oo, oo, oo" – and at last the seeds were full in my stomach.

'When I arrived at home, people could not recognize me, because of my two days without food. I was very thin. I ran away, but the people chased me and grabbed me. I could not recognize people and they were going to kill me. The hunger had made me mad.'

LEOPARD

as told by Thagiso Raditsela, of Bayei and Moyei origin

'I went hunting with my father. When we were hunting, all the time there was an island we walked around, as we could not get inside this island.

'One day while we went hunting, my father asked me to go in front and hold the rifle. He said, "Today we have to go inside this island."

'But inside the bush there was a female leopard with cubs. My father took the rifle and held the rifle like this, with the wooden back towards the leopard, and he said to the leopard, "See, leopard, I am not hunting leopard, I am only collecting firewood," then he dropped the rifle.

'When the leopard attacked, my father ran away, and went up a tree. I could not climb because I was young, so I just ran around the tree, crying.

'When the leopard left with her cubs, my father came down. He fell on top of me at the bottom of the tree and thought I was the leopard, and he cried too. Then I said to my father, "I am your son, I am not the leopard." My father stood up and we went off.'

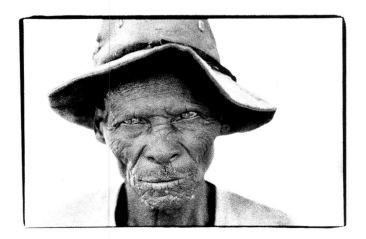

LION

as told by Zibeso Kwarako a Basarwa

'One day in 1985 I left home to go hunting. While in the bush we found a place to camp.

'In the afternoon we left that camp and went hunting. We found nothing, so came back to the camp, slept, and in the morning we went in the other direction. We found lion spoor. We tracked that but it was very hot so at midday we decided to go back to the camp.

'The following day we followed the same tracks and fortunately that day we met two lions. When the lions saw us they ran away. We tracked them. When we came close to them they ran away and crossed the river, and after crossing the river the other one dashed, and we followed only one lion. We followed that lion and not far away we saw him and we shot him. After hitting him he got into a thick bush. We went around the bush and he was still there. Then we started to go back because it was dark.

'In the morning we woke up again and went to the bush where we had left the broken lion. When we arrived there he was left. We followed his tracks. We started to see the blood – that means the lion is now getting tired. He got inside the thick grass and slept.

'While we were looking at the blood, the lion was near. On that pile of grass, he was sleeping there. We did not know that he was there, because it was open. The other men went the other side and I went on the left-hand side. When the lion heard the other men on the right-hand side, he stood up and saw me, just close to him, and the lion grabbed me. I put my arm on his throat. I hit him with my fist and gave him a kick. I grabbed him with his mane and pulled him towards me. The lion slapped me with his tail on my thigh and picked me up. I pushed it away.

'The lion came again. He grabbed me with his claws and I moved backwards slowly, slowly … I put my foot in a hole and fell down. As I fell down he started to bite me on my thigh. Here is the scar.

'The others started to shoot the lion. I was screaming underneath the lion, just screaming. On the other shot they hit the lion in the right place. It died and they carried me home, and I came through to the hospital in Maun.

'For many years I could not use my right leg.'

PYTHON

as told by Okganetswe Masupatsela a Basarwa

'I was with my father, my mother and my grandmother on the way from Beetsha to Khwai after visiting relatives. We were walking and my father carried a spear and I carried a dish with honey. My mother and grandmother carried the blankets.

'We met lions with cubs. The lioness left the cubs and the male and ran towards us.

'We stood and looked at the lioness. She just stood in front of us, looked at us, then went back to the cubs.

'While we were watching the lioness in front of us, I started to scream loudly. The male one came again, came very close, to attack us.

'My mother threw the dish with the honey at the male lion. It sprayed on the lion's face.

'When my mother threw the dish on the lion's face, then my grandmother screamed too, and she took just a short stick from the ground and threw it at the male lion. It hit him and he moved backwards. When my grandmother screamed, the cubs started to cry and came towards us. That's when the whole pride attacked.

'So my father now started to defend us from the lions with the spear. He ran at the lions with his spear, shouting at them. And with the screaming, the lions began to run away.

'When the lions were running away, I ran the other side and I fell down and broke my tooth. Look, here it is. When I lost my tooth I also was hit by a stick, a piece of wood on my leg. Here, on my leg. I screamed, calling my mother and father.

'After I fell down and was hit by the wood on my leg, my father took me and we went to a termite mound. In that termite mound there was a python. My father killed that python and we had lunch.'

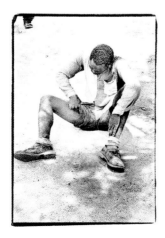

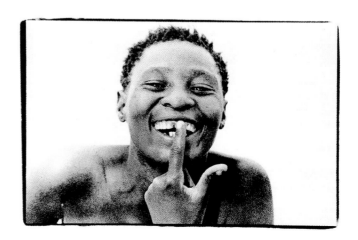

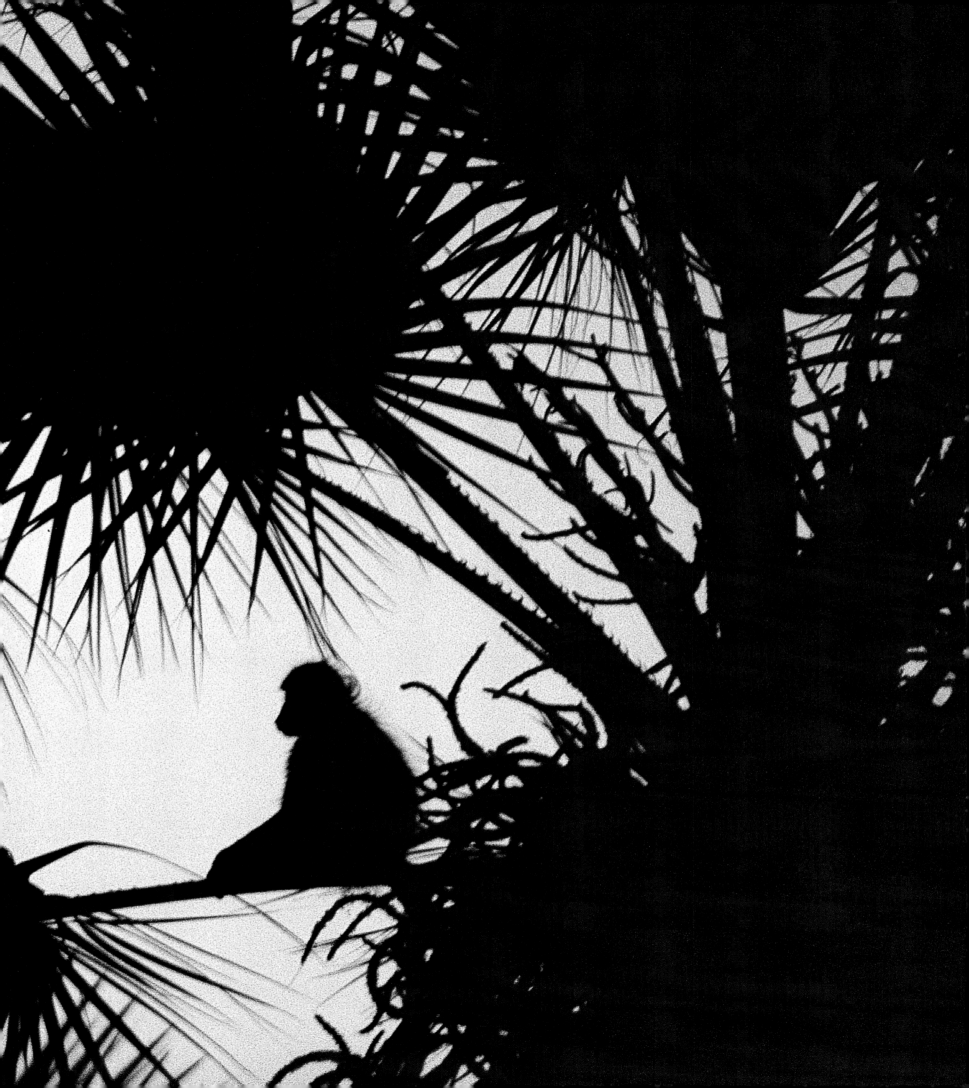

Previous pages:
*A chacma baboon
in repose among
real fan palms.*

Right: *Two men
of Khwai butcher
an elephant.*

BUFFALO

as told by Jewe Diako a Basarwa

'I was out hunting in Khwai holding a rifle, when I encountered buffaloes. In the evening, on my first shot, I killed one and broke one buffalo. I took the meat of the buffalo I killed to the camp and then in the morning I tracked the broken buffalo.

'While following the broken buffalo I encountered lions following the same buffalo. The buffalo attacked me. Then the lions killed the buffalo while I was trying to kill it. The male lion of the same pride then attacked me and I shot this lion and killed it.

'After this I went away and saw another herd of buffalo. With my one bullet left, I killed another buffalo. It was dark now and I decided to go back to the camp.

'When I came to skin my buffalo the following day, I found the same pride of lions eating my second buffalo. When I arrived, the lions charged, so I had to shoot again and killed another lion. After shooting this lion the old lion charged, so I ran away and climbed a tree and watched the lions. After a time he went off and I went to the camp.'

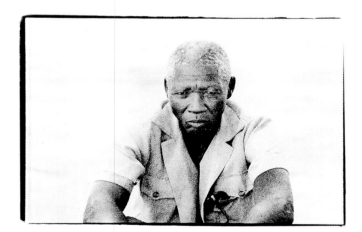

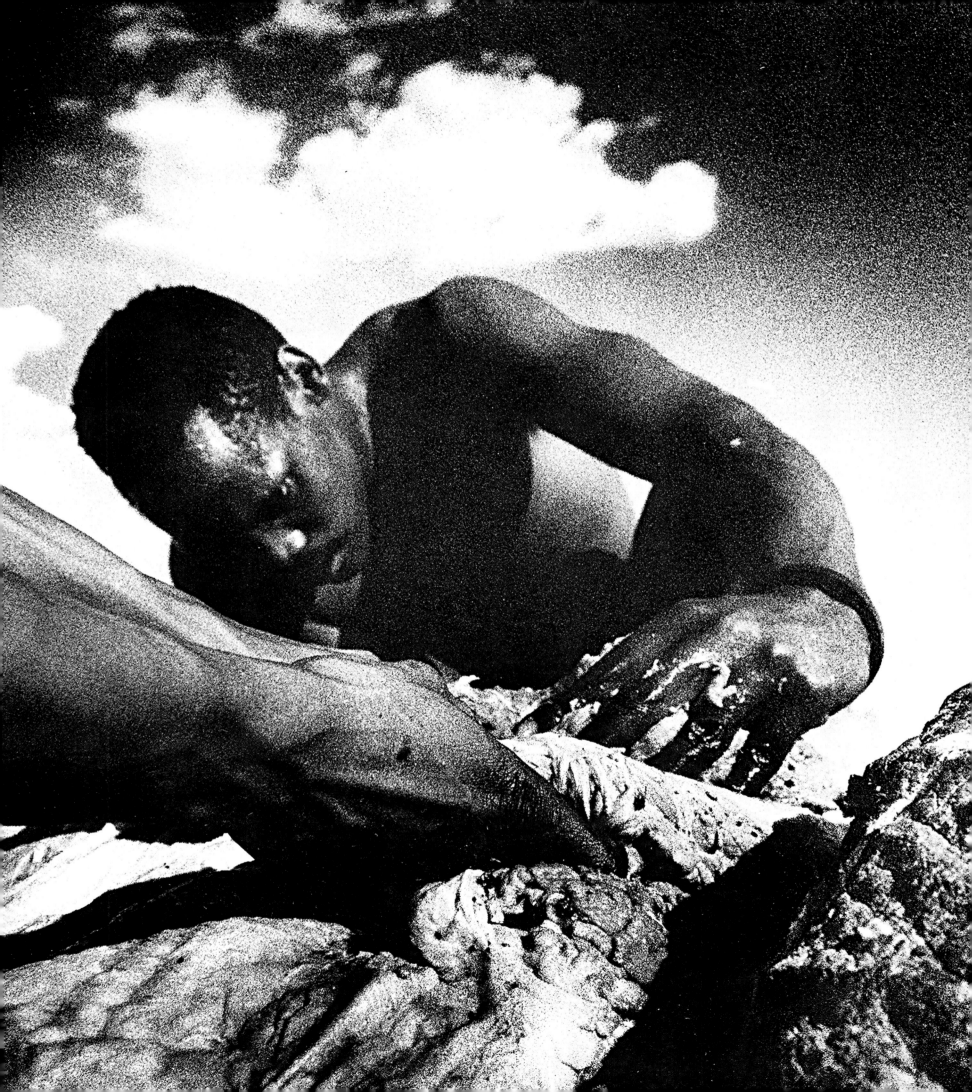

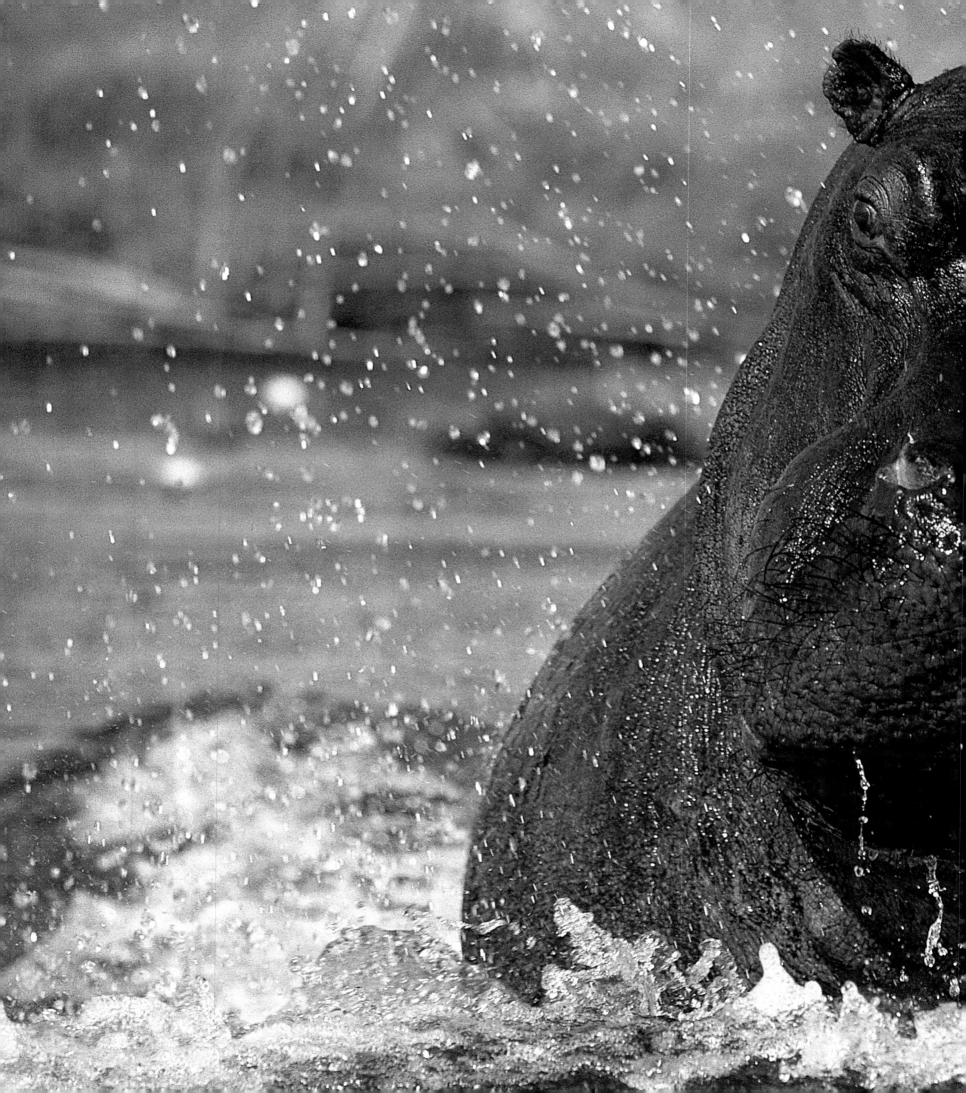

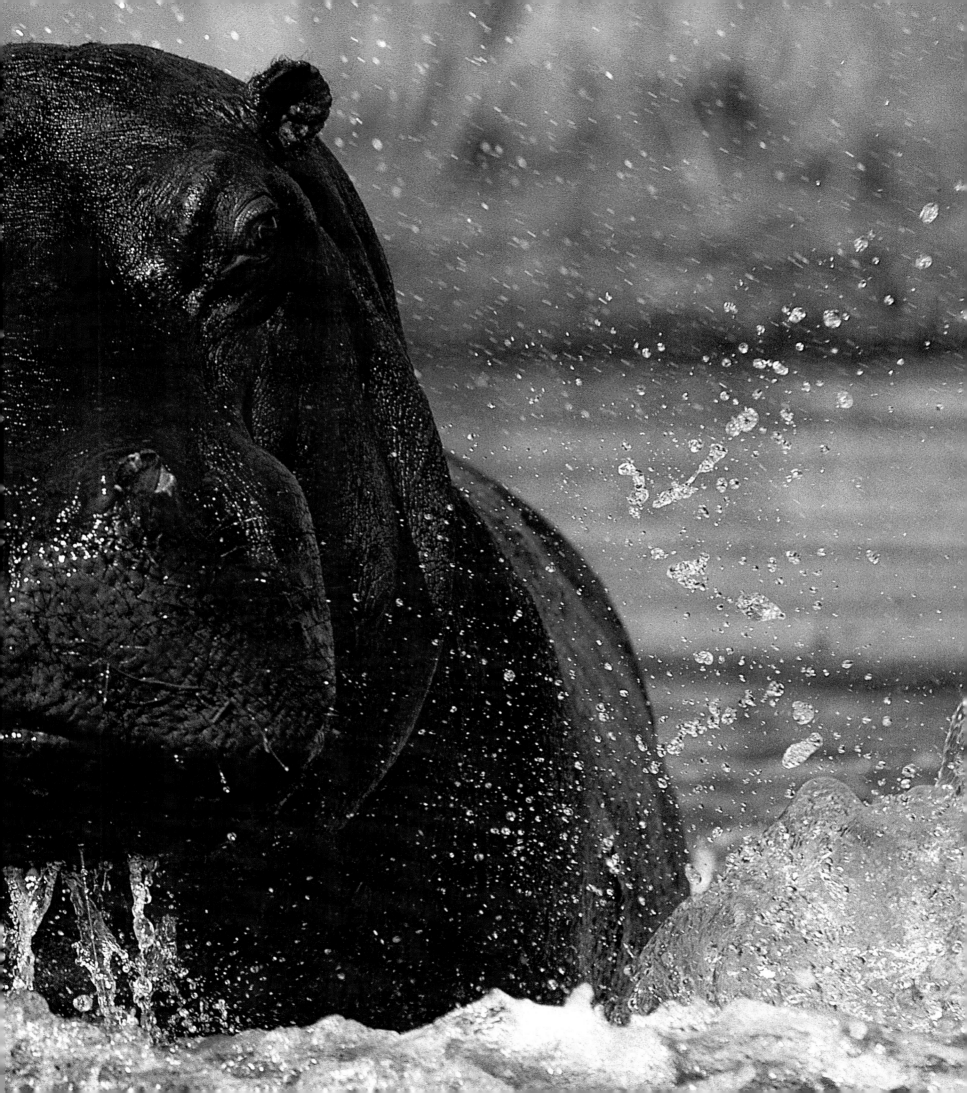

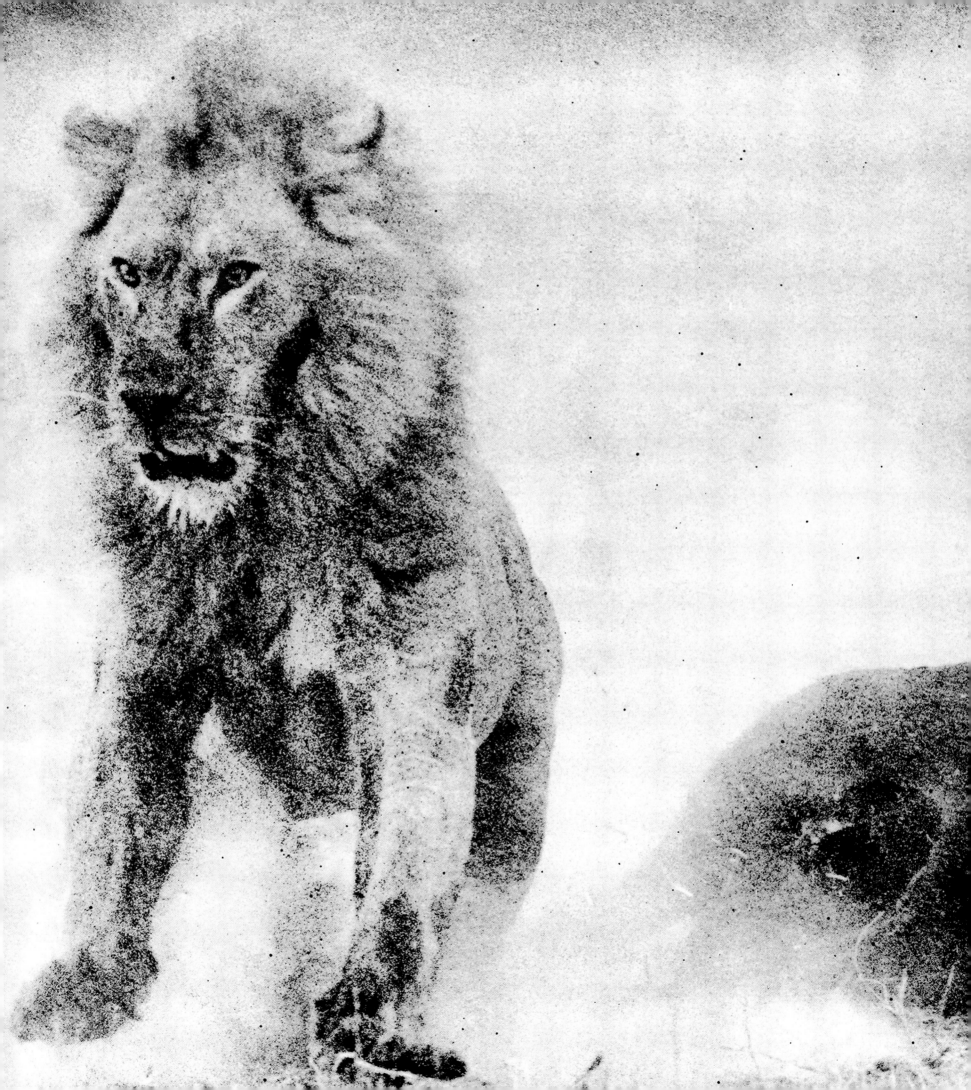

Previous pages:

It seems at times that the very essence of the lion – its power and ferocity – is reduced and held in the two flaming orbs of its eyes.

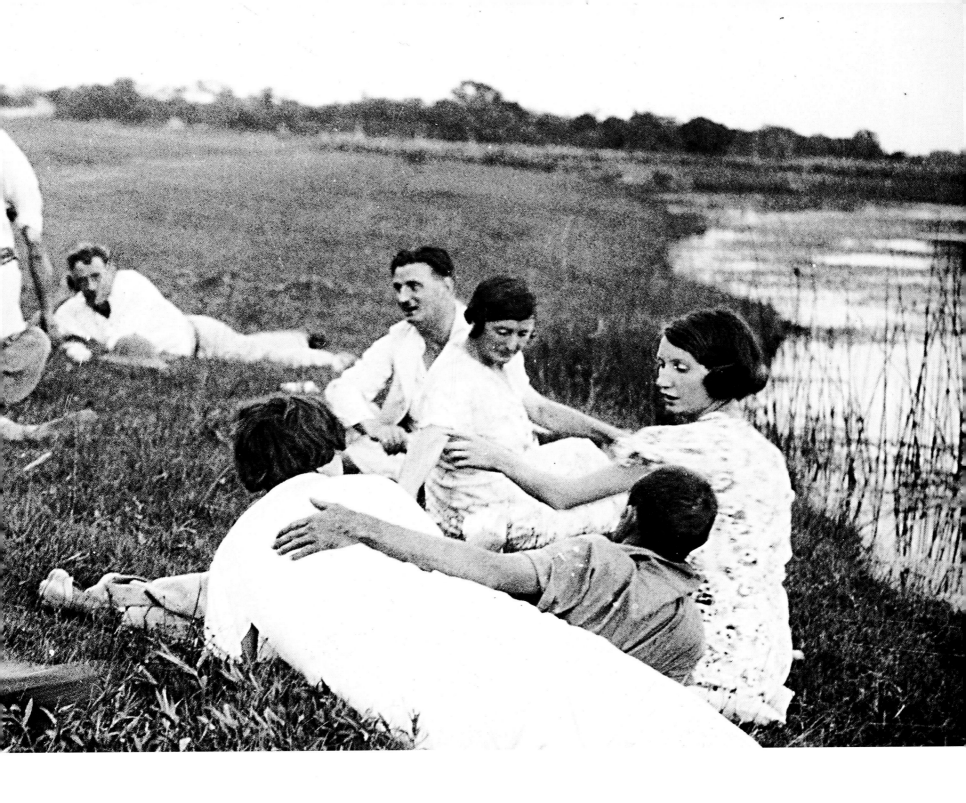

Above: *A ukelele and a banjo serenade a '50s Maun picnic.*
Far left: *Waiting for the store to open.*
Left: *Restaurant on the road to Nata.*
Right: *A hubcap becomes a car.*
Far right: *Herero child.*

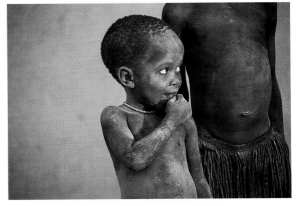

129

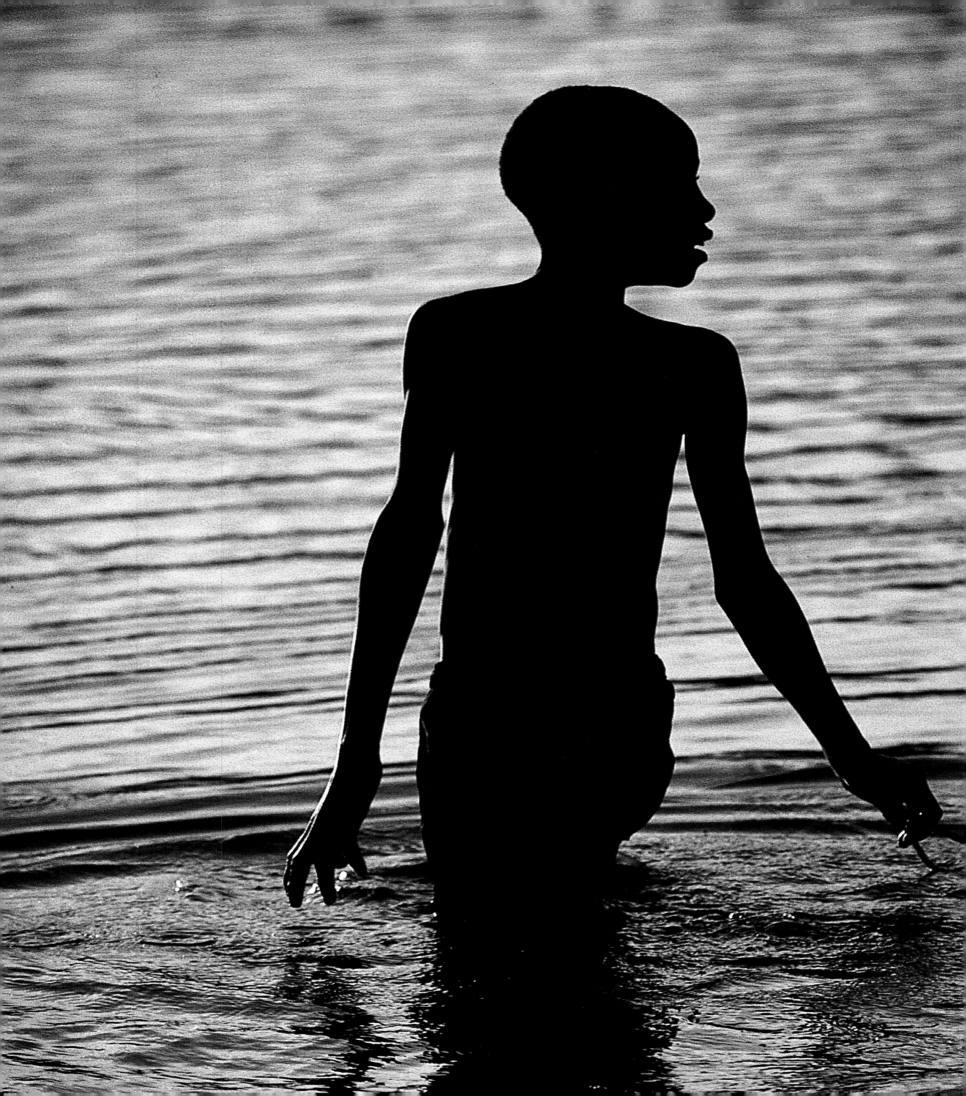

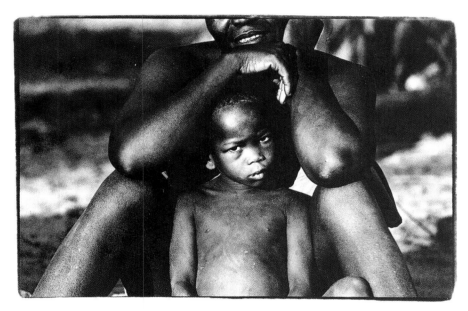

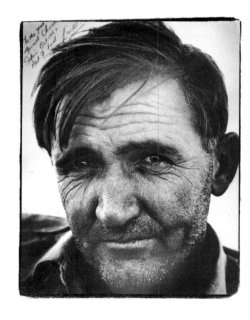

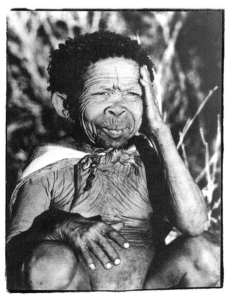

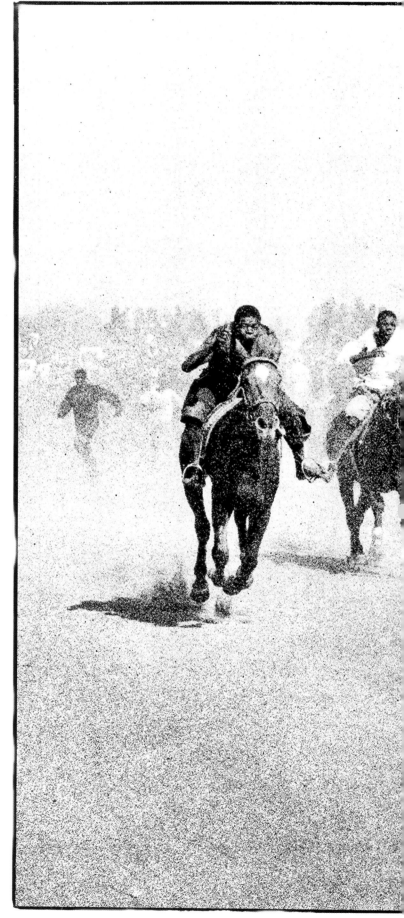

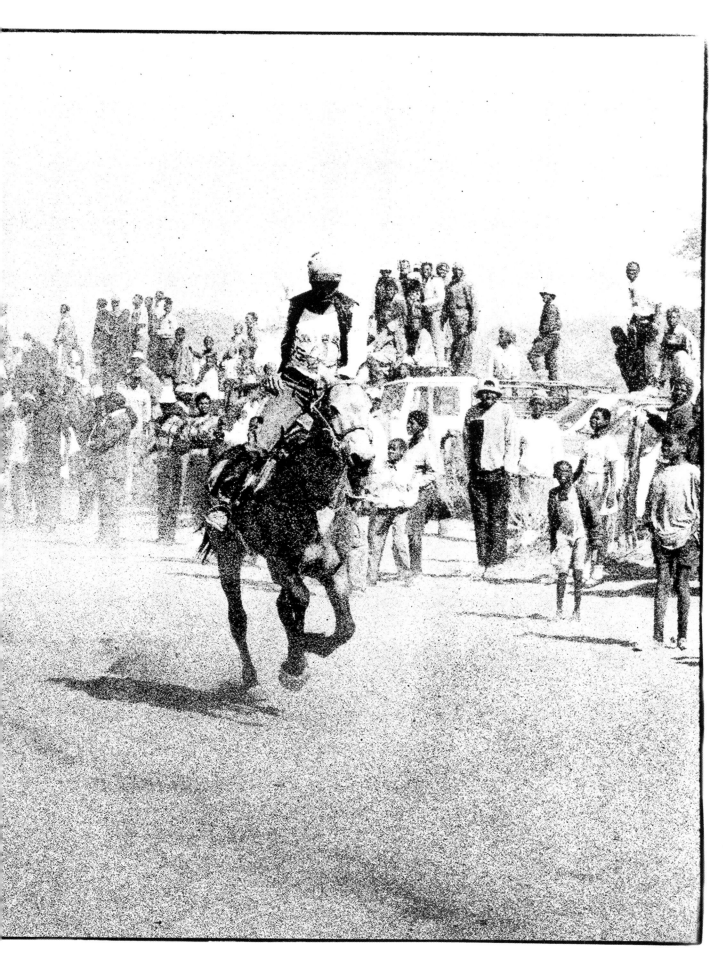

Previous pages: *'Perhaps they were in life itself, within their own element, such as we can never be, like fishes in deep water which for the life of them cannot understand our fear of drowning.'*
Karen Blixen, *Out of Africa*

Far left, top: *Water was a necessity during the hot days of the inaugural festivities.*
Far left, middle: *A mother and child wait for the bus to Toteng.*
Far left, bottom left: *Lionel Palmer.*
Far left, bottom right: *A Bushman photographed in the earlier part of this century and thought to be a Pygmy.*

Left: *Horse races for the inauguration of the Paramount Chief were held without a start or a finish line.*

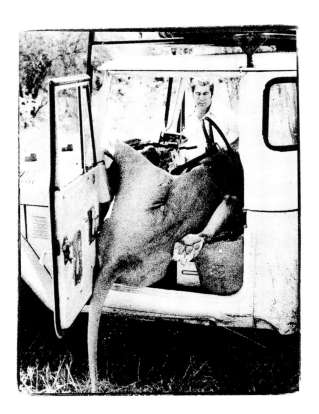

Lion Hunt for the Paramount Chief

It is a late winter afternoon. We are sitting around a leadwood-log fire with a group of Motswana men who are animatedly discussing the morning's lion hunt.

The last hunt of this nature was in 1964, when the previous Paramount Chief, Letsolothebe II, was inaugurated. Now Chief Tawana II has come of age and will soon be inaugurated and assume his duties. It is for this reason that we are in search of a mature, black-maned lion, which must be hunted by the regiment of the Paramount Chief of the Batawana tribe. The skin must be taken and worn by the incoming chief at his inauguration ceremony.

Peter and I, just returned from a bow hunt, had been chatting to Willie Phillips on the dusty streets of Maun when we learnt of the forthcoming traditional hunting safari. Peter had immediately put our request to join the hunt to the Maun *kgotla* (group of elders), and I was granted the great privilege of being the first woman to accompany so significant a hunt.

The following morning, presenting ourselves for the 8 am departure, it had distressed us somewhat to see nothing resembling a safari vehicle, camping gear or guns in the vicinity of the meeting party. This had proved to be simply another lesson in the laws of African time, however, for, four hours later, the first safari vehicle, a Bedford truck, arrived. A considerable crowd had gathered by that time, and stood scattered about, smiling and relaxed. Just before dusk we had been joined by a Land Rover, vehicle three of the safari. Finally, with the sun setting behind the dust trail of the vehicle ahead of us, we had set out, joined by Soleilwe and Mutuku, who had decided they liked our vehicle – 'No wind in the ears,' they said.

Hours later, around an enormous, noisy campfire, twenty Motswana men had bedded down on the ground. We had done similarly, keeping a respectful distance, and, weary from the day, had closed our eyes to the sound of husky voices and lions roaring to the north.

This morning, after tracking various crisscrossing spoor for hours in the freezing cold, we had finally come

upon a spectacular black-maned male in the company of five lionesses. As expected, the male had separated from the others and disappeared into the tawny grass. We had driven for a time in the direction in which we thought the lion had gone, then eight men with rifles had leapt off the Land Rover and given chase.

Peter and one of the men of the regiment, Gaorongwe, had chosen to remain in the vehicle as they felt the men had gone in the wrong direction. Suddenly there was a shuffling in the grass and the huge lion had appeared from behind a termite mound and ambled off. Gaorongwe, seizing his rifle, had sprung from the vehicle, circled a bush and shot at the lion. From a hundred metres away and obscured by bush, his aim had been bad and he had missed hopelessly.

In a fervour of released adrenaline, twelve men, their rifles loaded and safeties off, had hurtled after the lion. Peter had grabbed a camera and zoom lens and sprinted after the melee. Chief Meno and I had remained sedately in the Land Rover, making getaway and rescue plans – his English and my Motswana improving greatly with necessity! An hour had passed before Peter returned, the excitement around the loaded guns eventually getting the better of his sensibilities.

Now, four long hours later, all of us, hot, exhausted and dehydrated, have returned to camp. A conference ensues in the Motswana style, each expressing his views. The self-appointed leader of the hunt, Bing Westcob, is feeling frustrated. Standing amid steaming pots of mealie meal and boiled meat, he attempts to lay down the law, trying to make himself heard above twenty voices all talking at once.

The conference finally decides that it would be better to return home, jubilant, with a lion skin, than have to admit to a failed expedition. The competitive nature of the riflemen – each striving to be the one to shoot the lion for the Paramount Chief – must be sacrificed for the success of the safari. Bing Westcob, who owns the Land Rover, and three of the best riflemen head out alone in an attempt to conduct the hunt in an organized fashion. Peter and I are granted permission to go along but, seeing the crestfallen faces of the younger men of the regiment who have to remain behind, I decide to stay with them.

Sitting at the fire I write fitfully in an attempt not to think about the fate of Peter, the four riflemen and the black-maned lion. I wonder which is the more difficult for the young men: forgoing the excitement of the hunt or forgoing the opportunity to prove their manhood and marksmanship in this age-old tradition.

As it grows dark and the cold of the winter night settles, the hunting party returns, subdued. Peter comes to the fire and, warming his hands, describes his afternoon spent following a lioness and cubs with the hunting party, both in the vehicle and for long hours on foot. The hunting party had felt the lioness may have led them to the male lion they so desperately needed for the success of the hunt.

Peter is exhausted and together we decide to leave the hunt the following day, and so retain the image of a magnificent, black-maned lion in its prime, dissolving into the African night with its pride.

Above left: *A hunting incident.* **Below:** *'Tau! Tau!' The prey is seen.*

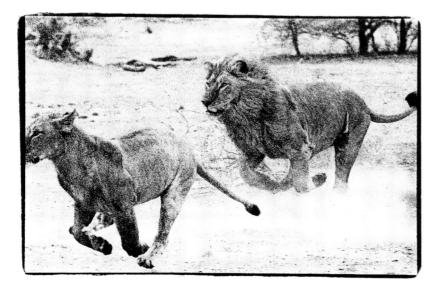

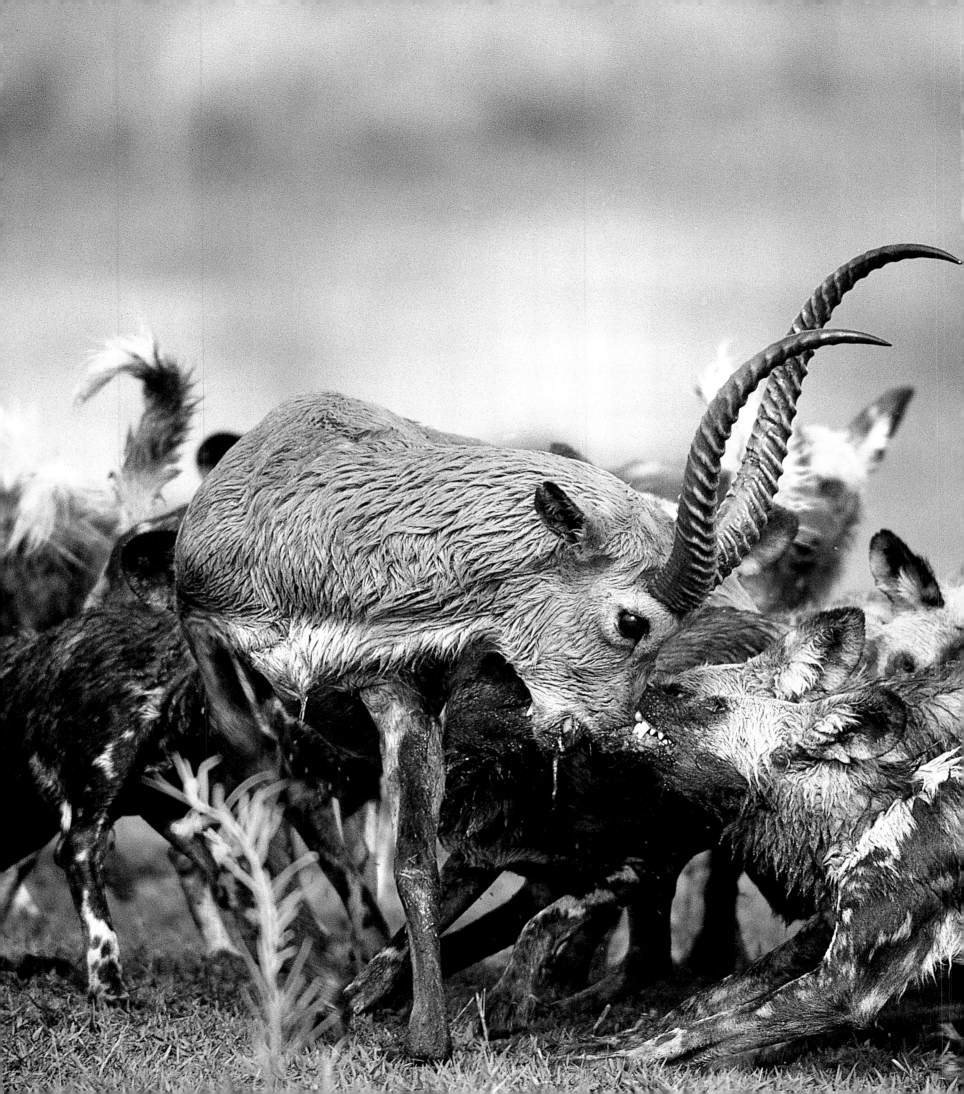

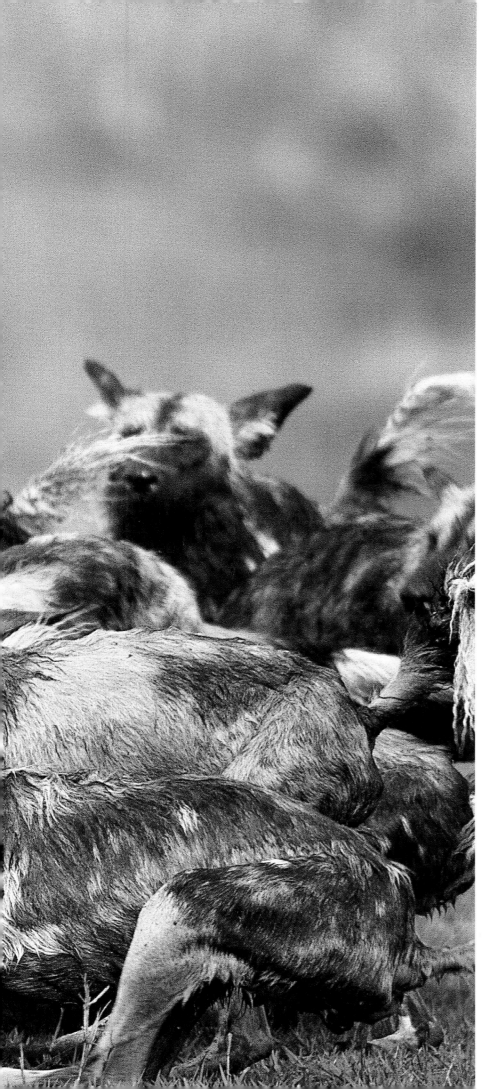

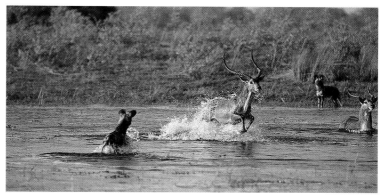

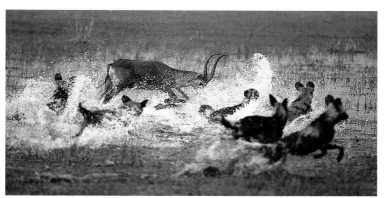

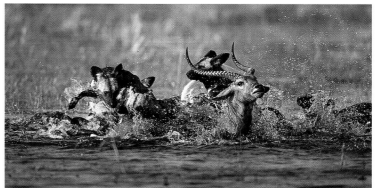

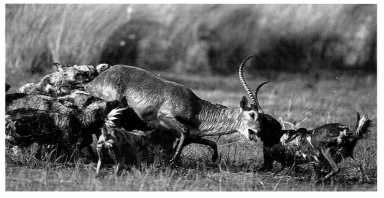

In the Okavango, wild dogs often drive their prey to water, where they surround and overwhelm it.

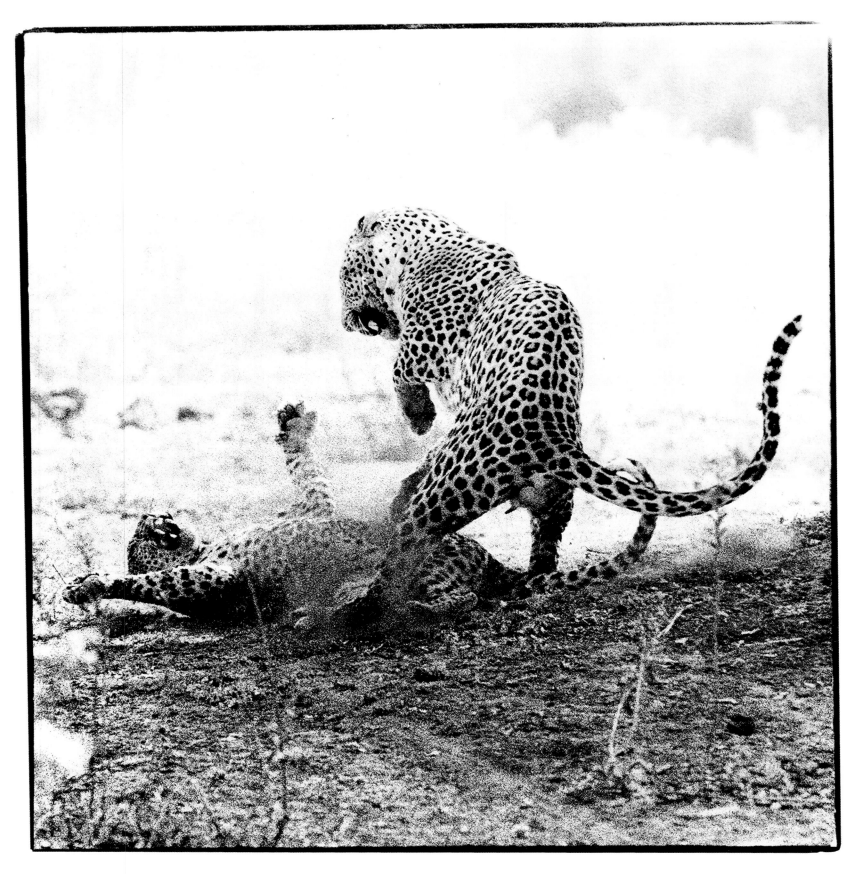

A leopard dismounts after mating.

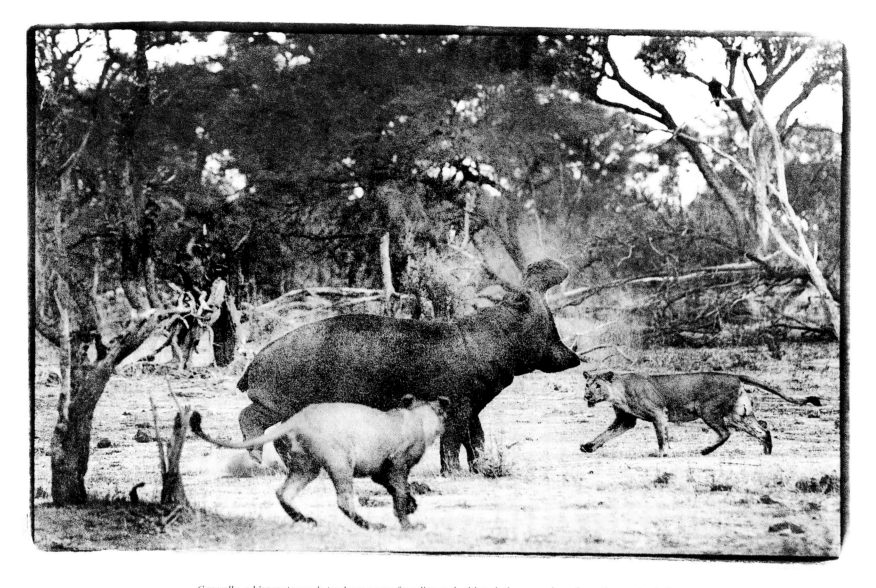

*Generally, a hippopotamus is too large a prey for a lion and, although they may chase them, they are too bulky
to bring down or throttle, and their huge, tusk-like incisors are too formidable a weapon to oppose. In Botswana, only
in Selinda have the lions learnt to jump on the back of the hippopotamus and, by biting through the exposed ridge
of the spine, paralyse the back legs. The crippled animal, surrounded by lions, then dies of shock.*

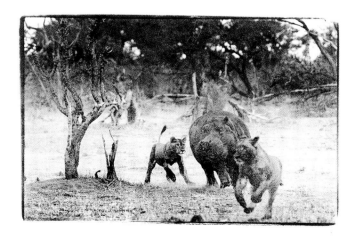

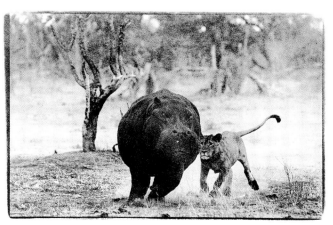

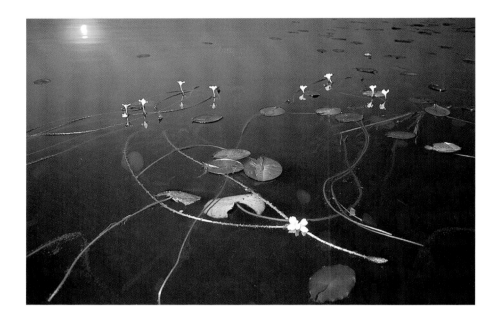

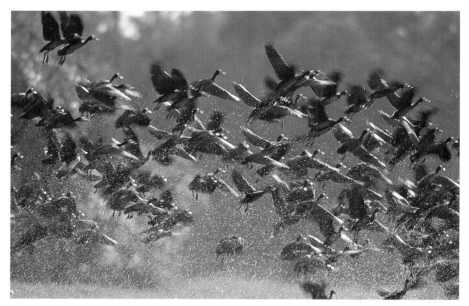

There are times in the wilderness when one is so completely overawed by its spectacle that one seeks neither to analyse nor to understand, but remains rather, for a while, wholly absorbed by the moment.

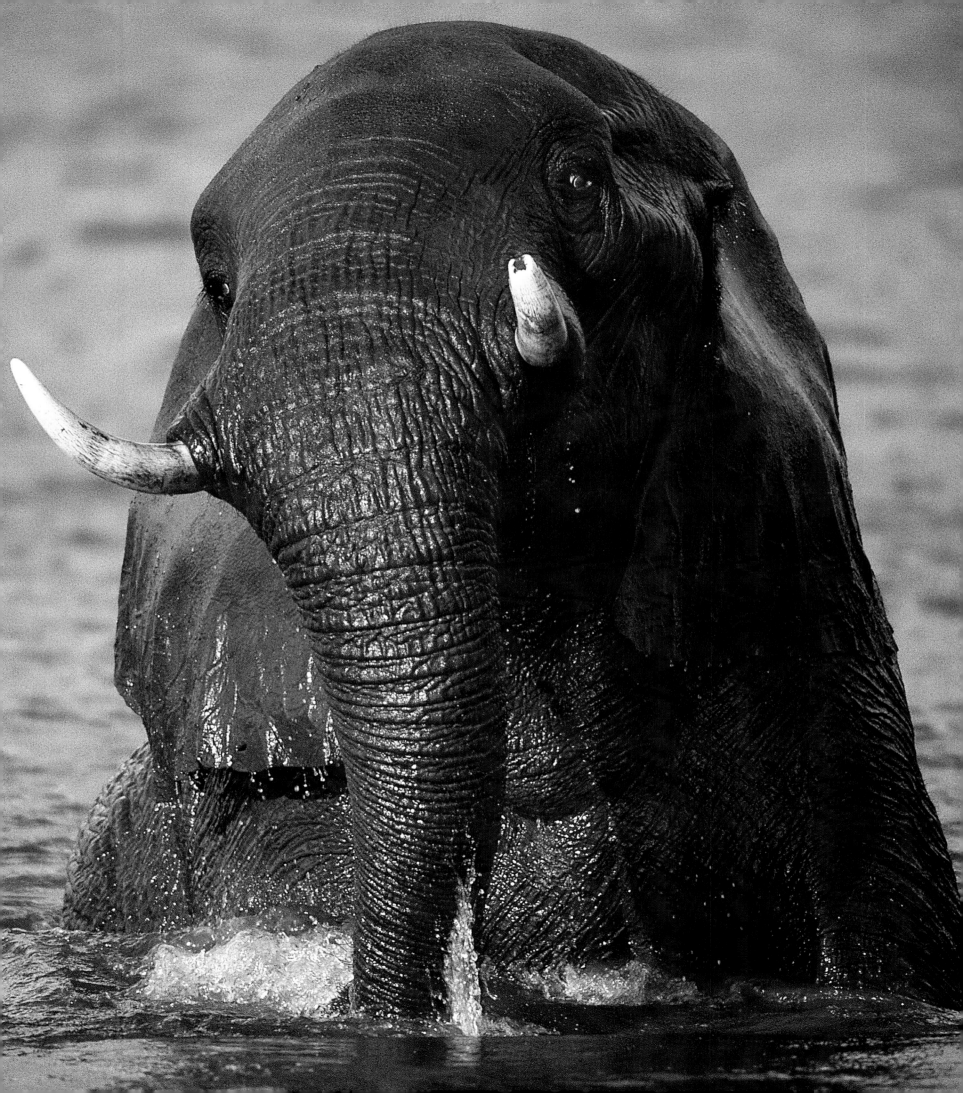

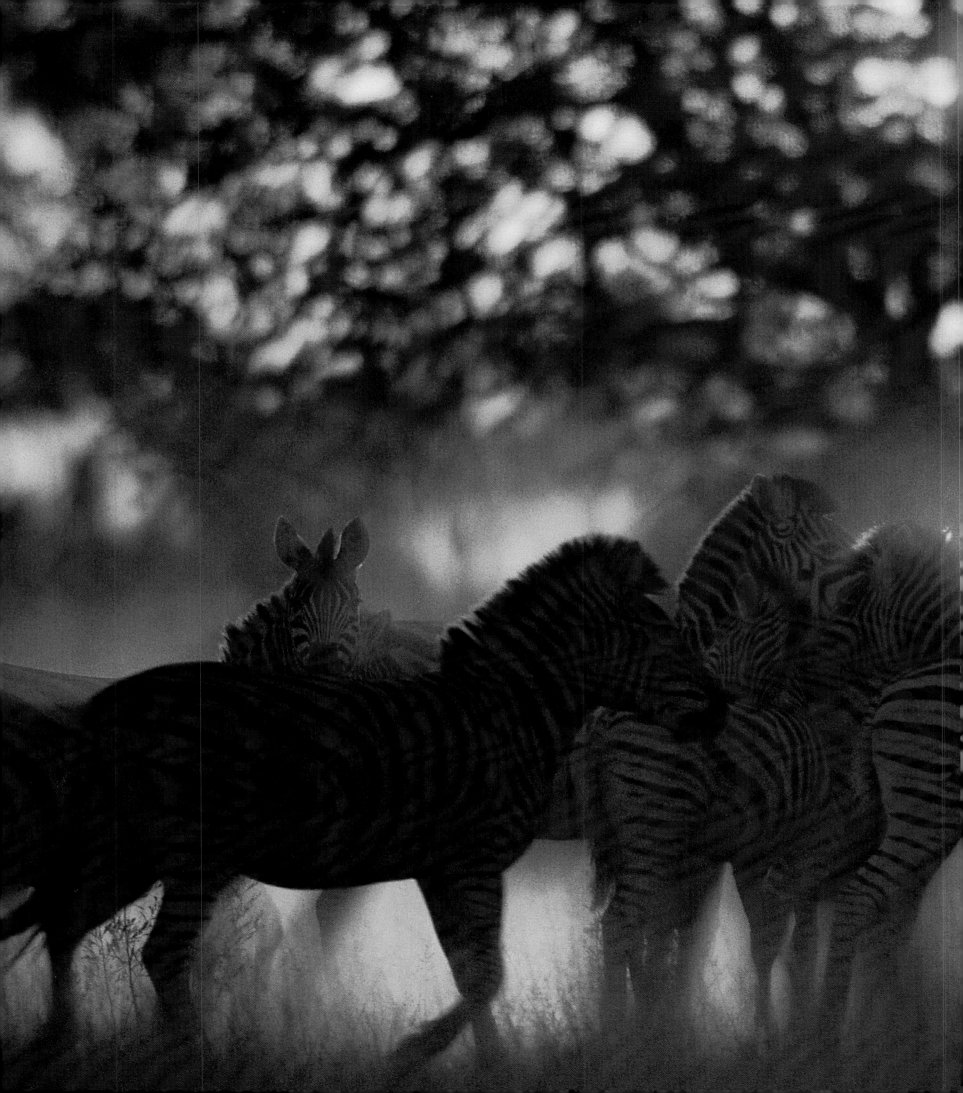

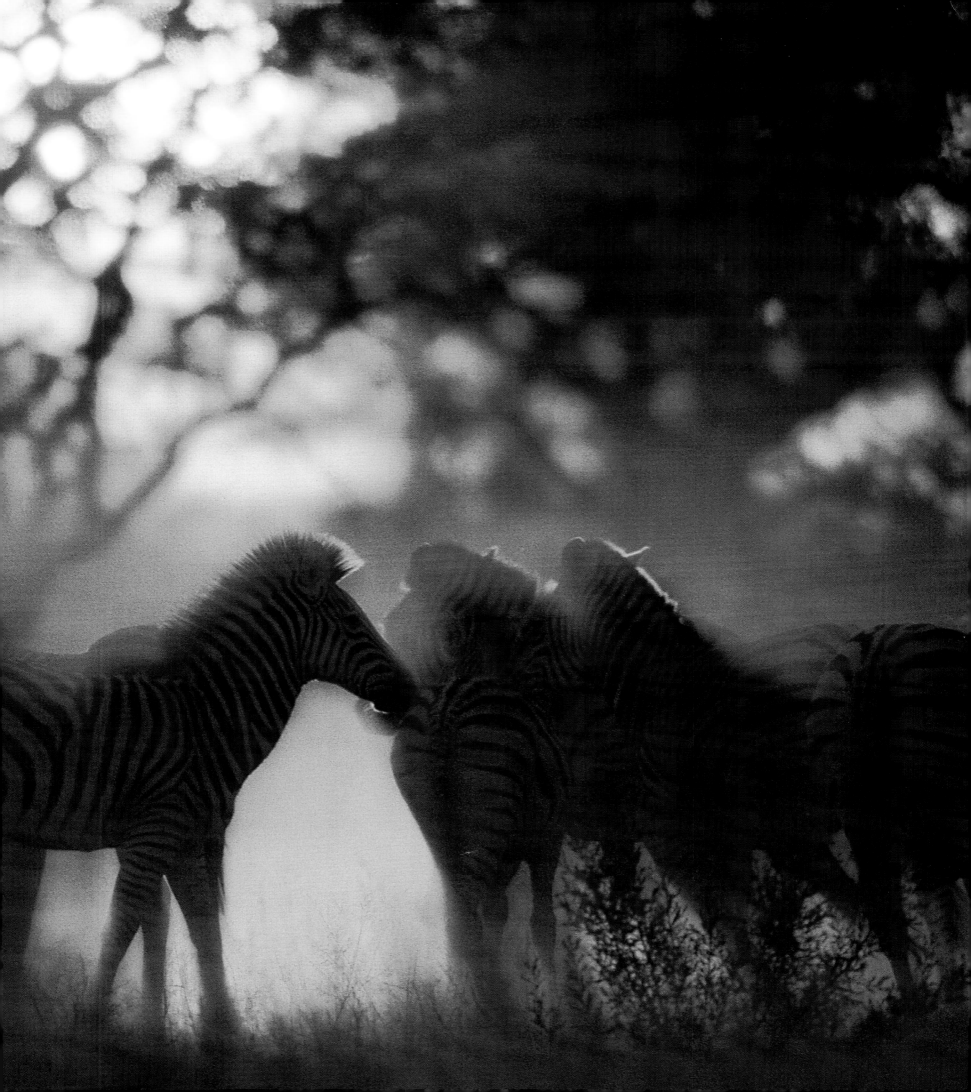

A Thirstland Crossing

'I have learnt there was no past that
was not part of our own time.'

Mike Nicol, *West Coast*

A few notes and observations made by Stanley and Livingstone,
and more detailed information, with some paintings and sketches,
by Thomas Baines, are virtually all the annotated history that exists
of the vast area of dry land that stretches from the Makgadikgadi
Pans, north through Nxai Pan, the Mababe Depression and Savuti,
and up to the Chobe forests. However, if you walk alone in the great
quietude that lies upon this place, then it may come to you that this
is only contemporary history. Here, you become a part of all time,
both past and future, for it is quite obviously an ancient land
that has long been steeped in the brew of Africa.

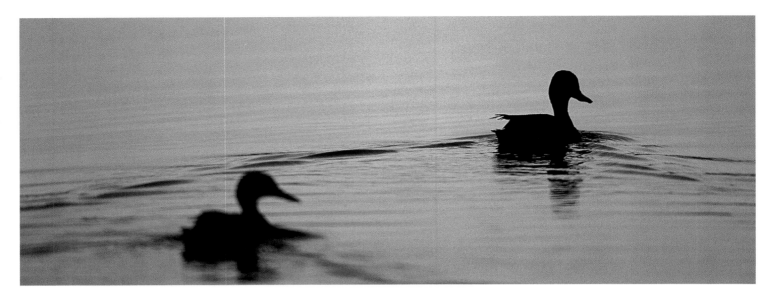

And if, in your walking, your footsteps follow the dry shore of the Makgadikgadi Pans, you will be privy to yet more ancient historical notes. The chronicles of this history are not written in words but in rock, for here, in this desolate place, lie arrowheads and blades and spearpoints knapped to sharpness by ancient man. To bend down and, dusting the light white shroud of sand from its surface, lift an ancient axe head from the earth, is to know that this day, and one thousands of years before, are in fact the same.

While staring through the bright white glare to the distant dancing mirages, it is not difficult to envisage a hunter of old walking carefully, crouched low. Sitting like this, alone, you may also perceive that you and he are the same, for he was clever then, as you are now. It is not you or your specific days, but the earth and, caught in the vastness of eternity, the life upon it, that is the whole.

In this wide wilderness there seems little life, for everywhere is nothing that breathes. In the sand, between the grass and the still trees, are perhaps a few scant tracks of those creatures that can live without water, but nothing else. This is a vast thirstland; nowhere is there a spring or a pan or a seep where water is guaranteed, and men and animals that have wandered unwittingly into its grasp have left their bones behind.

In summer, when the thunderclouds boil and twist and their heavy, pregnant, grey bases join together to bring a premature darkness to the day and lightning cracks its white whip, the water comes in a deluge to this place. Then, the dust of the arid months is washed away, and the dry parchment loses its brittleness to become supple, soft and green, and smell new and fresh again. In the black clay soils of the Mababe Depression a myriad pans form, and in the soporific, clammy heat the cicadas gather in the trees at their edges and shrill their incessant song. The dry riverbeds may flow again, and to the pools they leave behind come black turtles with sharp claws.

Some of these rivers empty into the Makgadikgadi Pans and, if it

rains long and hard enough, the pans become once again a vast, shallow lake. It is then that one of Africa's most eloquent mysteries occurs: out of the sky the flamingos come, thousands of them on a rain of scarlet wings, to feed on the shrimps that hatch in the new water, and to build their curious mud-tower nests and breed before the water recedes and they too move on. No-one knows what stimulus it is that lures them here, but in the dry years they do not come.

On the ground, following the green paths made by the rain, appears the game. From the Chobe in the north they pass through the forest and out onto the wide sand face that is covered with tall grass and short, scrub-like thorn trees. From the Linyanti, too, they are drawn on their pilgrimage, over the soft sand ridge, through the Savuti Marsh and on. In the Okavango, below Khwai, tracks appear in the slippery black mud between the trees, headed south and east into the Mababe Depression and a land where they will leave man behind. Mostly blue wildebeest and Burchell's zebra, it begins as a trickle, a few groups here and there; but as the rains continue the press becomes more urgent, until hundreds or thousands of animals may be seen together, their heads bent to feeding as they move steadily on. Elephants, small groups of giraffe and herds of springbok and gemsbok walk out into the pathless vastness of this thirstland, following the distant grey blades of the falling rain. And trailing the game come the lions.

I remember as a youth being caught in a truck between Nata and Maun in the dark, in a herd of zebra that we could not drive through. For half an hour we tried, but there were too many and their press was too tight for them to give way. Stopping, we camped beside the track as the herds parted around us and joined again on the far side. We breathed their dust and fell asleep to the soft sound of their hooves on the hard gravel of the road. In the morning they were gone. It dawned on me then that I had been privy to a history more ancient than any that is written down.

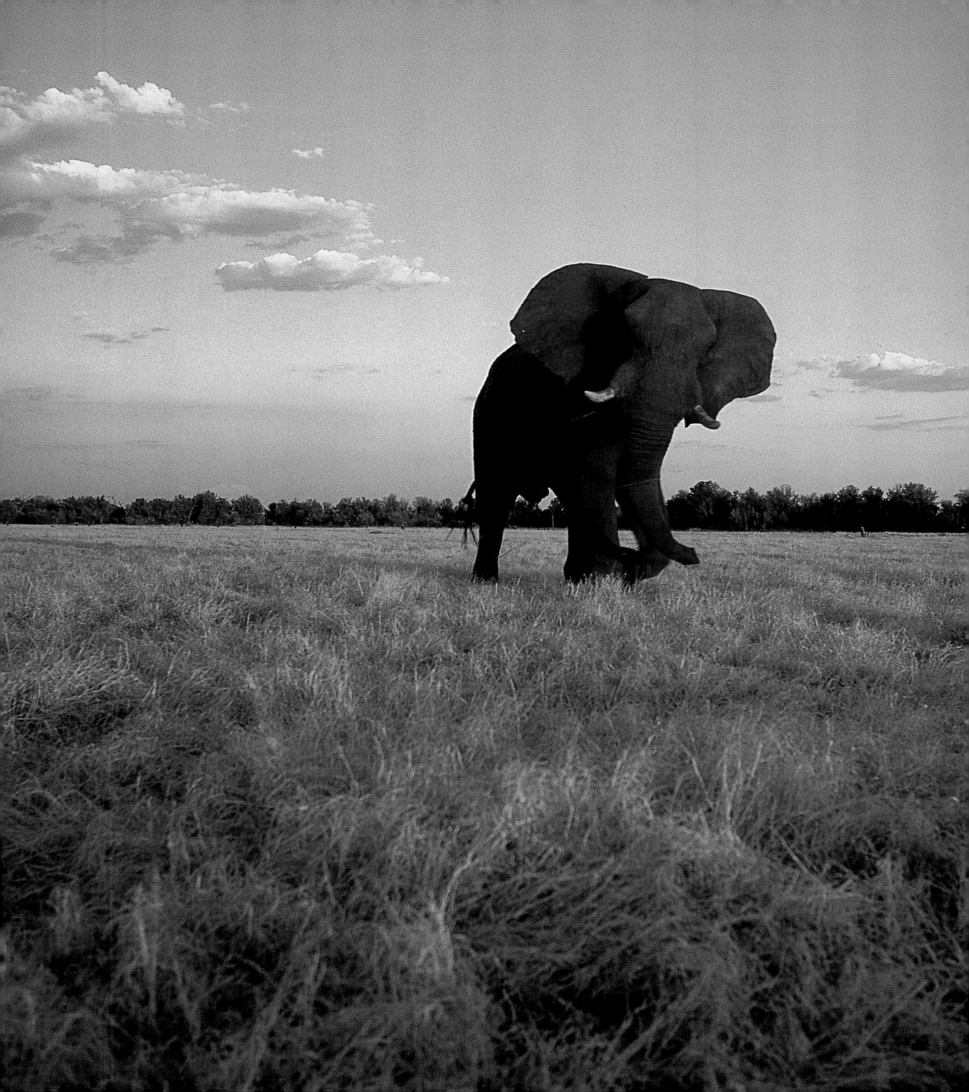

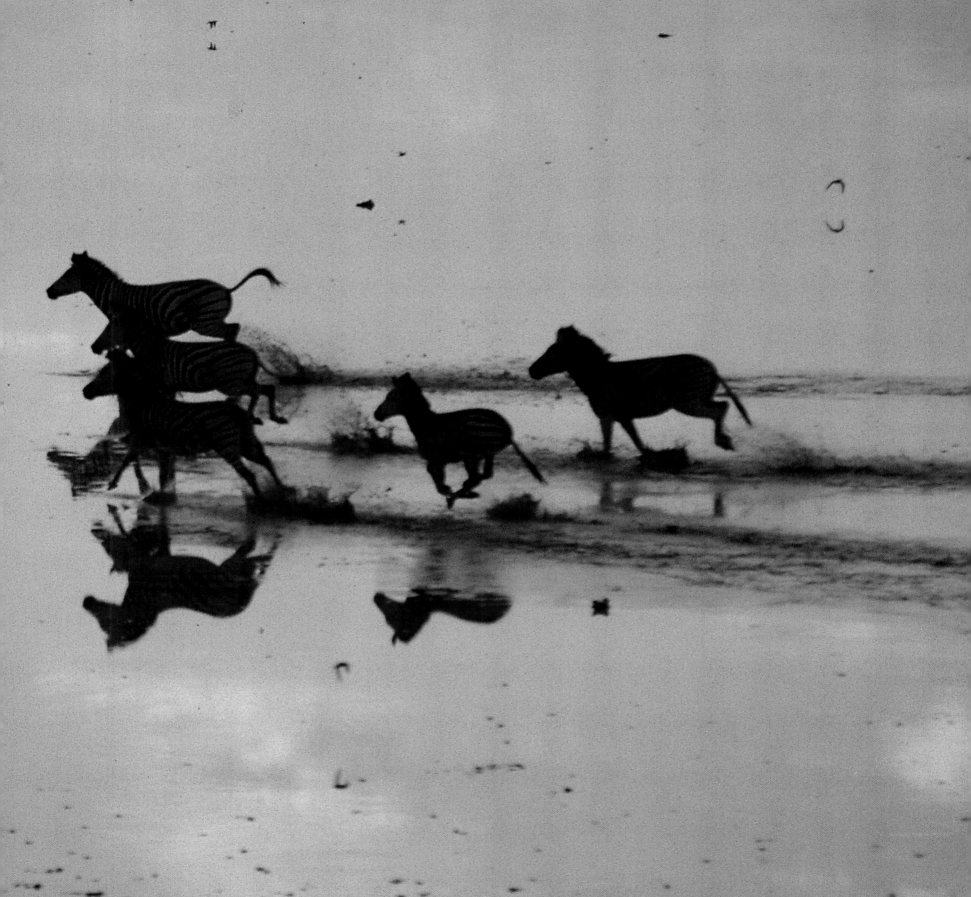

Ngamiland in 1928

excerpted from The Okavango Observer, *Friday 23 April 1993*

From The Farmers Weekly,
19th September 1928
Ngamiland in 1928: Potentialities
and Future; A Great Cattle Country.
MT Kays, of Maun, Ngamiland,
via Livingstone, writes:

A great deal of attention has of late been drawn to Ngamiland. I therefore give some particulars of a country which some years ago was accessible only with the greatest difficulty and which was always described as 'the white man's grave'.

The Depleted Lake

In 1887, Lake Ngami was a vast sea; today it contains only one-sixth of the water it contained in those days. It has been only partly refilled for the last three years. The Okavango River flows right through Ngamiland, a part empty section of Khama's country, where it disappears in the sand at Rakops, some 250 miles from here. The reason Lake Ngami completely dried up and remained so for years, I ascribe to the fact that the channels carrying the water down to the lake became silted up, were overgrown with reeds, 'komo' and papyrus (parchment could be manufactured out of the latter), and turned into what are to this day described as the Okavango swamps and marshes.

Were it not for the Okavango River coming out of the highlands of Angola, some 1 600 miles distant from here, all this country would be practically uninhabitable.

Suitability for Ranching

The country is, as a whole, pre-eminently suitable for cattle ranching and has for many years been free from such contagious diseases as pleura pneumonia,

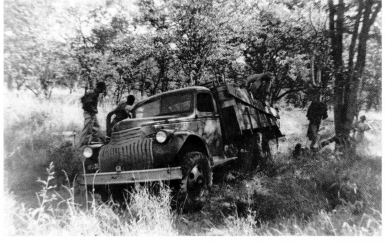

redwater, East Coast fever, etc. Hence, there are enormous herds of cattle, owned by the Batawanas (a migrated branch of the late King Khama's people) and the Damaras (who fled here from South West Africa after they had risen in rebellion against the Germans). The latter, who arrived here with nothing, are very rich today, proof in itself of the suitability of the country for cattle raising. The Makobas, the original owners of the country, also own cattle, while some of the Batawanas own as many as 5 000 to 8 000 head.

Agricultural Prospects

The agricultural prospects of the country are great. Large quantities of rice and wheat could be grown in the swamps, where there are vast tracts suited to the growth of the former. Cotton could also be grown with, I am sure, very good results. Some years ago a merchant at the former capital, Tsao, experimented with cotton, which proved successful without irrigation.

A few years ago it was intended to form the Ngamiland Irrigation Cotton Growing Syndicate, the purpose being to restore the water into the lake and then to obtain rights from the Chief to grow cotton for a number of years on either the north or the south side of the lake. The Chief was quite agreeable, but a paternal government turned down the scheme.

No proprietary rights of land were sought, and it would have become a great asset to the country, the natives and the British Empire. Some day this scheme must certainly become an accomplished fact.

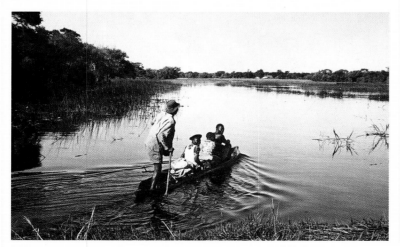

Minerals and Timber

The mineral concessions for the country were years ago obtained by Mr Isaac Bosman, now of Steerstroom, CP, for the Chartered Company. I am given to understand that these rights have now lapsed. I have no doubt that minerals will ultimately be found.

The country is well wooded. There is very good timber growing, out of which wagons are built, no imported timber being required.

Game

There are still to be encountered vast herds of game of every description, from elephants down. Lions are still numerous and occasionally one can hear them roaring at night. As the Chief has full sovereign rights, should he give permission one can shoot what number he gives permission for. We do not consider royal game here, as this can only be where the sovereign has domination rights, and this is a foreign country. It is mandated territory, administered by the Bechuanaland Protectorate, and

our status as defined by Mr Mercer, an authority on International Law, is that of 'foreign visitors'. Even the government officials are 'foreign visitors'.

Advance of Civilization

There is a magistrate here, the present one being Captain Tim Reilley; a police officer; a qualified doctor; an LMS Missionary, the Rev Mr Sandilands, and his wife. A school for white children has been established with a European lady teacher. There is a native church with a native minister, also some evangelists; a native school with four teachers; four large stores. There are four motor cars in the country and two more coming; several outside country stores; a few outside

police stations; a veterinary surgeon; and some stock inspectors.

The Europeans pay income tax or 2 pounds per annum poll tax. The store keepers pay licences in addition. Should anyone desire to open a business, or to buy cattle, he must first obtain written permission from the Chief. The natives pay 1 pound 3 shillings per annum hut tax, which is collected by the Chief, who receives ten per cent. Many natives, however, evade this tax by concealing

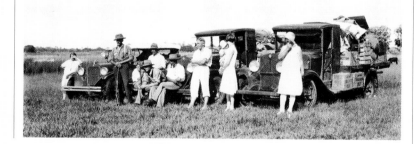

themselves and living on small islands and in the swamps.

We have a wireless receiving set and a rifle club has been started. The Government is establishing mechanical motor transport between here and Livingstone (from where we are 306 miles distant), and other parts, and has ordered or intends ordering two motor tractors. The licence to carry a gun costs 10s per annum.

The Tsetse Menace

A great drawback to this particular part where we are at present is the tsetse-fly belt, in extent some 25 miles. The country has lost thousands of cattle through the fly, but a new road for wagons and oxen has lately been made which completely circumvents the fly belt. Maun is distant about 16 miles from the nearest fly. It is to be hoped some remedy may soon be discovered whereby the fly can be exterminated.

Railway Prospects

There is one thing everybody is anxiously looking forward to, and this is the time when we will see the iron horse running through Ngamiland from South West Africa to Southern Rhodesia. We cannot form any conception of what it will mean to this country as our present transport system is very slow and dreadfully expensive.

Inexhaustible Fibre

I should add that the finest fibre grows in this country in inexhaustible quantities. The Bushmen make rope out of this, with which they catch the very largest antelope. It had been reported on before the Great War on the London and Berlin markets as second to none. Mr Weatherilt, a member of the Advisory Council for the Protectorate, ordered some very expensive machinery from England years ago, but unfortunately the machinery was wrongly constructed and the knives cut the fibre to pieces.

The Lion Hunt

as told by Joseph Tekanyetso

'My name is Joseph Tekanyetso. I was born in the country called Rakops in the Kalahari desert. This is my true story.

'In 1985 I was working in Safari South company. I was working as a tracker. I was working with a man called Soren Lindstrom for 11 years; he was my professional hunter. I was working with a man called Teko Mbwe; he was my friend.

'In 1985 there was a lady called Sissy Levin; she was an American woman. She came here to Botswana for hunting with her family. One of her family, he was looking for a lion.

'First of all we took these people into the Kalahari desert for bird hunting. We spent four nights in the

Kalahari. The following day we came back to Maun. We spent one night in Maun.

'From there we went to a camp called Four Rivers Camp. In that camp we stay only four days, looking for a lion. It was very dry all over, no lion tracks at all.

'After four days Soren sent a message to the Maun office to tell them that he wanted to move from that camp. From there we took a fly camp to Kapuruta. In our fly camp we stayed for only two nights.

'The third day we wake up at six o'clock in the morning. We pack our coolbox and lunchbox. At seven o'clock we begin our hunting.

'At nine o'clock we saw some zebra. Soren asked one lady to shoot the zebra. That lady, she just shoots

one shot; the zebra, it was already down. We came around the zebra, helping the lady because she shoot a nice shot.

'From where we kill the zebra we then drive for 30 minutes. We saw a female lioness with four cubs. I used my long, thin stick to tell Soren: the lioness, it just ran into the thick bush. We drive into the thick bush, looking for the male's track.

'We saw a big male lion heading under the mopane trees. I picked up my long, thin stick to tell Soren. Soren called Mr Coke to be ready to shoot, because Mr Coke, he was the one now looking for the lion. The American boy, he begins to shake. His first shot, he just shoots up in the air.

'The big male lion runs way. We shout to him, saying, "Shoot again, shoot again!"

'The big male lion runs into the thick bush. Soren drives around the bush. Then the lion came straight into the Land Rover; it just came straight inside the Land Rover, at the back.

'All of us, we begin to shout. We were seven inside the Land Rover. Soren drives away fast and the lion begins to fall down. He asks the people if they want to go back and try to find the lion tracks again but the people refuse to follow the lion.

'Soren finds a big leadwood tree and puts these people up in the tree. Soren, Teko, Coke and I go back to where we last saw the lion. We drive around and around inside the bush but we don't find the lion again.

'We try to look for the tracks. Soren is holding his .458; ourselves, we were just walking without a gun. Then the lion charges us. It comes straight into Soren. Soren tries to shoot the lion. He just misses and the lion comes straight for him and grabs his right arm. Soren begins to cry, calling his god, saying, "Oh please, my God, help me, please, my God, help me!"

'I see the lion's tail hit me on the legs. I grab the lion's tail and try to look for Soren's gun. The lion jumps onto me, begins to grab my right arm. It grabbed me four times on my right arm.

'By that time Teko was up in the tree. He shouts and calls the American boy to bring the Land Rover. Coke tries to drive the Land Rover under the tree so that Teko can jump inside.

'After that he drives between me and the lion. Coke walks around and picks me up and puts me inside the Land Rover. He drives away. Teko shouts, "Stop, stop! We must try to shoot this lion!"

'Coke refuses to stop the Land Rover. He drives away, and when he is near the tree in which his mother was

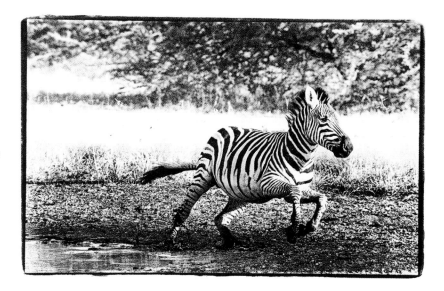

in, he begins to shout and cry. His mother, up in the tree, made a big noise. They just dropped themselves on the ground and ran into the Land Rover.

'We find that Soren is full of blood everywhere. I am full of blood everywhere too.

'Everybody begins to cry. Teko sends a message to the Maun office to tell them that we have had an accident in the bush. We waited there for an hour and a half.

'Lucky we just stayed there. There was a man called Mr Tim, he was the one who tried to find us in the bush.

'Myself, I spent two months in Maun Hospital. Soren spent three and a half months in Johannesburg Hospital. The two of us are still alive.

'After a week another professional, Harry Selby, found the lion and killed it.'

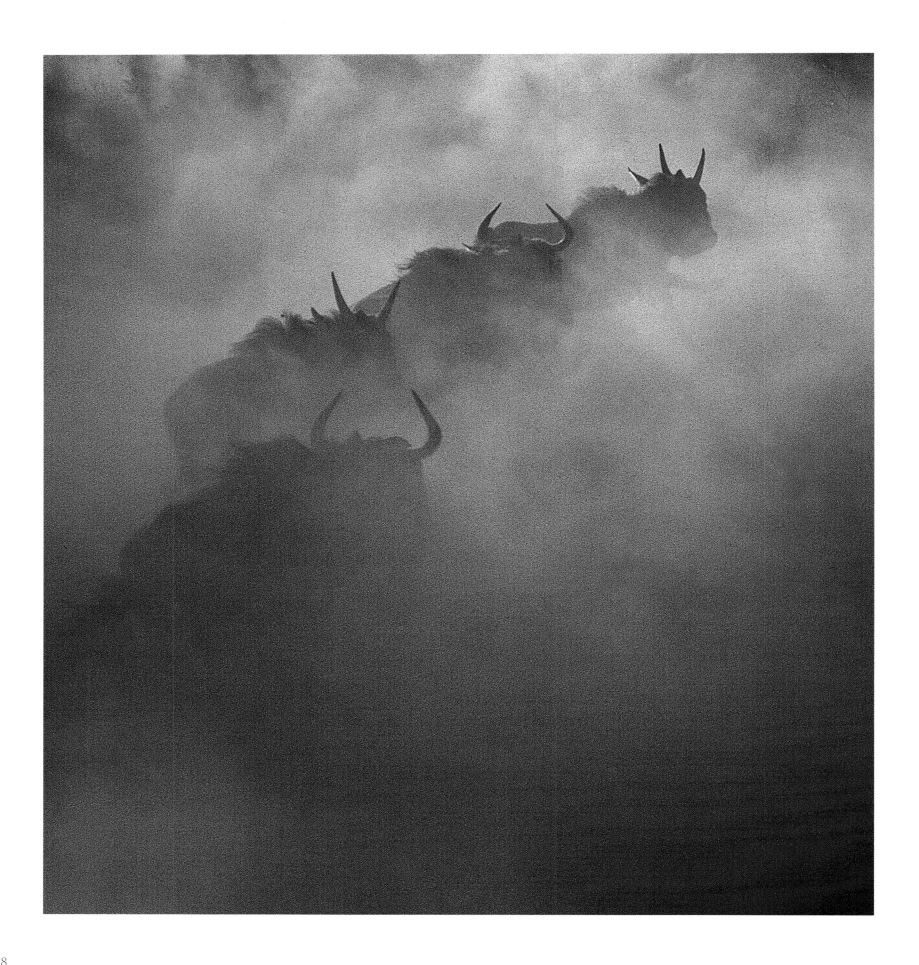

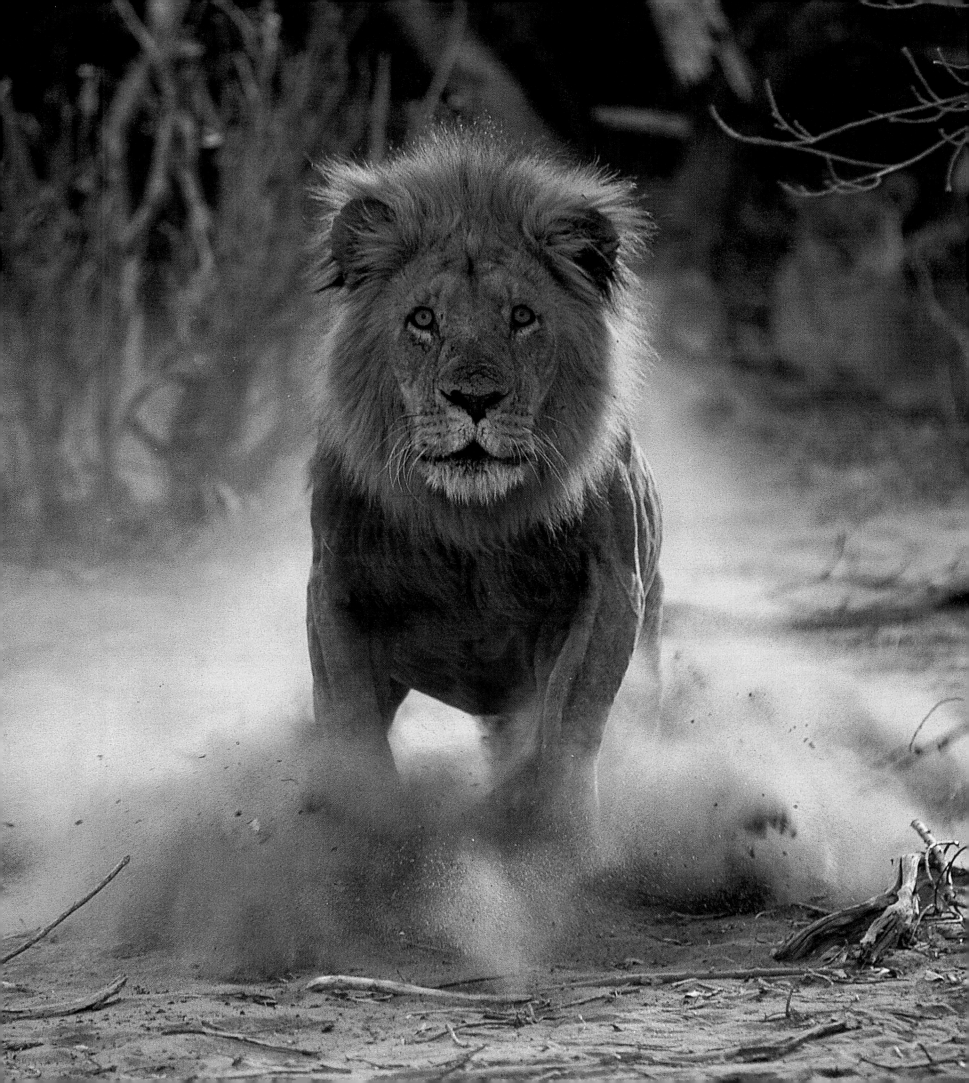

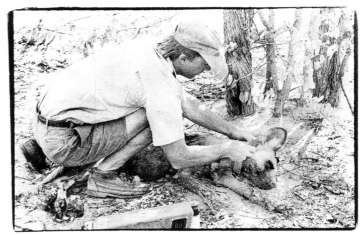

Carling – an African Wild Dog

by Tico McNutt

Dr J 'Tico' McNutt is a resident researcher
of wild dogs in northern Botswana.

Above: *Tico draws a few vials of blood and fits a radio collar to the dominant female of a newly formed pack.*

I located Carling in the middle of Chitabe, about 20 kilometres from the centre of the Santawani Pack home range. It was the first time in two years that she was outside of her home range and alone.

Twenty kilometres is not an unusual distance for an African wild dog to travel, but this time was different: Carling had been missing from Santawani for at least two weeks, and, having disappeared alone, I had hoped she might have joined some new males. Having spent the previous two years as the subordinate and, consequently, unreproductive female of the Santawani pack, I reasoned she might have been looking for an alternative arrangement in which she could dominate and thereby directly determine the fate of her offspring. So I was surprised to find her alone and looking very haggard.

She was so thin that her skin was stretched tight over her ribs. Worse than that, she was limping badly on her right front leg, which was swollen like a lemon at the wrist. It was an injury identical to the one as a result of which her mother, Amstel, had died two years earlier.

Amstel was limping the first time I saw her in April 1990. She was managing to stay with the pack mainly because they regularly waited for her. Eventually they became separated and Amstel, unable to hunt for herself, rapidly grew weak. After the first week it seemed every day could be her last. But she continued, demonstrating the will to live that has come abstractedly to summarize for me the nature of wild dogs. She refused to give up to her inevitable fate, limping after impala as fast as she could.

After several more days without food, Amstel eventually died when a lion casually snapped her spine. I found her body the following day. She was furiously clutching a clump of grass in her jaws, as if reflecting her commitment to life even when literally in the maw of death. Now it looked to me as though the same laboured and tragic end was facing Carling.

The first night after I found her, Carling travelled more than seven kilometres, in a straight line, towards her old home range. I knew what she seemed to know: that she was beyond hunting for herself and that her only chance was to relocate her pack, her family. I also knew that the Santawani pack, whose range was over 450 square kilometres, could be anywhere. Wild dogs travel an average of five to six kilometres a couple of times a day in seemingly unpredictable directions. The chances seemed slight that Carling would relocate them before growing too weak to travel. But she carried on.

On the second day, having rested through the heat of the day, she set off with renewed determination in the cool evening light. I followed her into darkness.

By nightfall she was in her old range and beginning to cover familiar ground; somewhere in those

450 square kilometres was her pack and her chance to survive. She would stand and hoo-call, sending her plaintive expectancy into the darkness. Then she would listen optimistically for some reply, and, hearing nothing, would hobble, three-legged, for about 200 metres before lying down again. She seemed to be wearing out, running out of energy, able to neither walk far without stopping nor put much into her calls.

Her voice was scratchy and breaking when I left her for the night. At the time, I was reasonably certain she couldn't continue travelling like this for more than another day, and then only if she was fortunate enough not to run into lions.

At first light the next morning I went in search of her. About five kilometres from where I had left her the night before, I heard a hoarse contact call. It was unmistakably she. She had made it through the night – a stroke of luck in her favour, I thought to myself. Waiting for more hoo-calls while brooding over the philosophical aspects of my role in this natural drama, I thought I heard another call, from a slightly different direction and in a stronger voice. I waited and after a few moments heard Carling's hoarse call – then it was answered by a more distant but stronger call.

As I drove across the dry, broken flood plains in the direction of the calling, I saw in the distance four wild dogs running away from the area where I expected to find Carling. All four were strong. None of them was Carling. This was not what I expected, so I turned to follow them, wondering who they were, why they were running away and what had happened when they found Carling. I quickly imagined the worst: an aggressive encounter with new dogs.

After a brief and unsuccessful attempt to locate the unknown wild dogs, I started back towards where I thought I might find Carling. There had been no calls for several minutes, but then came a distant call. She was still moving. Then she was answered again, by calls from several dogs coming from the same direction. I knew the gap was closing and that the dogs answering her were now coming to her.

When I caught up with her, Carling was already reunited with the Santawani pack. I felt like celebrating – or sobbing a sigh of relief – and assumed I would see something analogous in the dogs' behaviour. Instead, there was a quick, subdued greeting from her nephews and nieces, then the others, after which Carling collapsed next to her sister, Harp, the dominant female. She looked like an arrangement of bones covered with a thin skin.

I was overwhelmed by her drive and spirit – and by the coincidence. Was it a coincidence? Could she have known where to go? How could she and her pack have happened to coincide in an area, close enough to hear Carling's weak and desperate calling? They could have been almost anywhere in their range, and certainly unable to have heard such pathetic calling from more than one or two kilometres away.

Leaving them, I noted to myself that even if she died now, at least she had managed, against all the odds, to get home and back with her family. I knew that because of her injury she could become separated from them again, and that if she did not eat soon she would fade very quickly.

I found the Santawani pack again three weeks later and was surprised to find Carling looking stronger and putting on weight. Remarkably, four months later she was strong enough to give birth to a litter of pups. These, for the first and only time during her life, she was allowed to keep, and she reared them with help from the rest of the pack.

And so it has been, and continues to be, in the unbearably unpredictable life and tenuous times of Africa's last wild dogs.

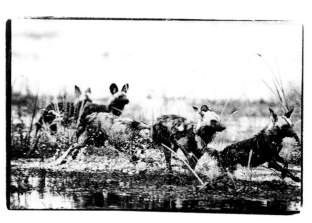

Far left: *On the front seat of Tico's Land Rover.* **Left:** *African wild dogs – painted wolves.*

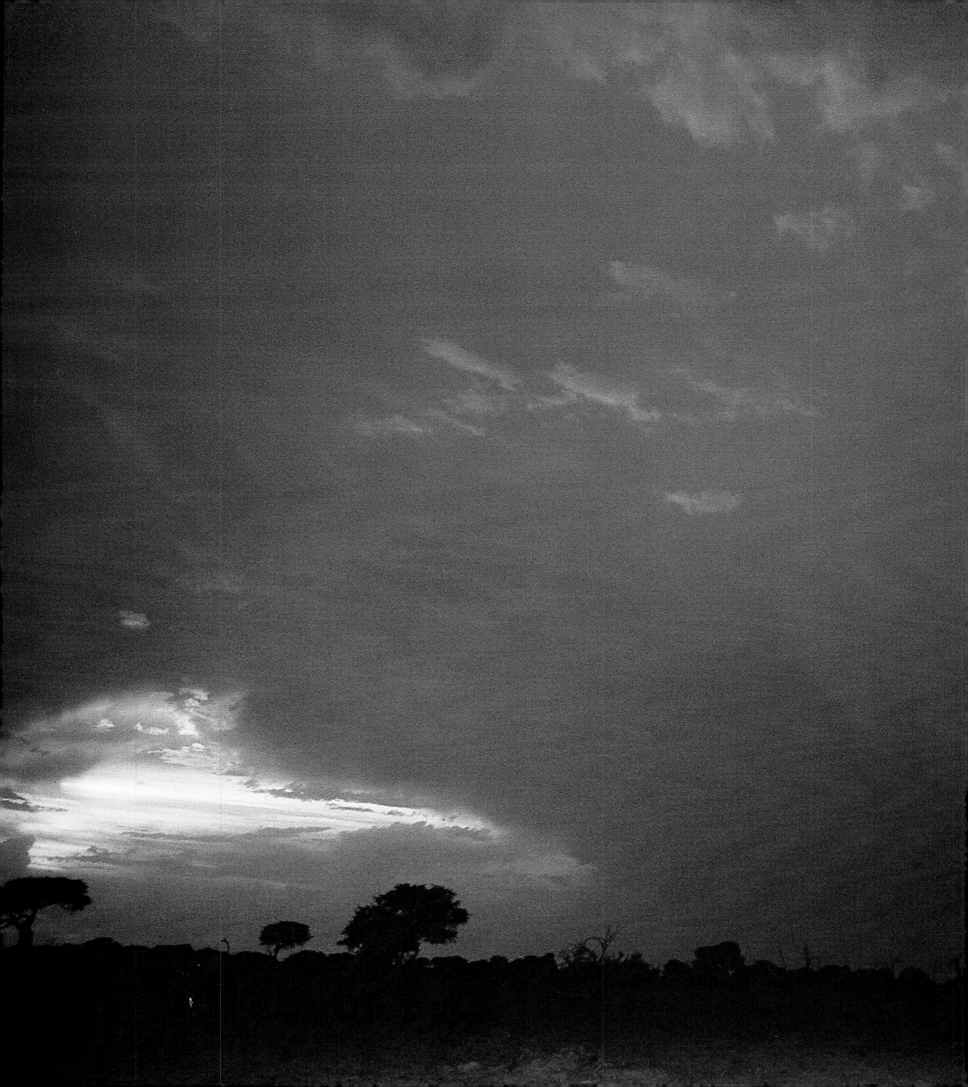

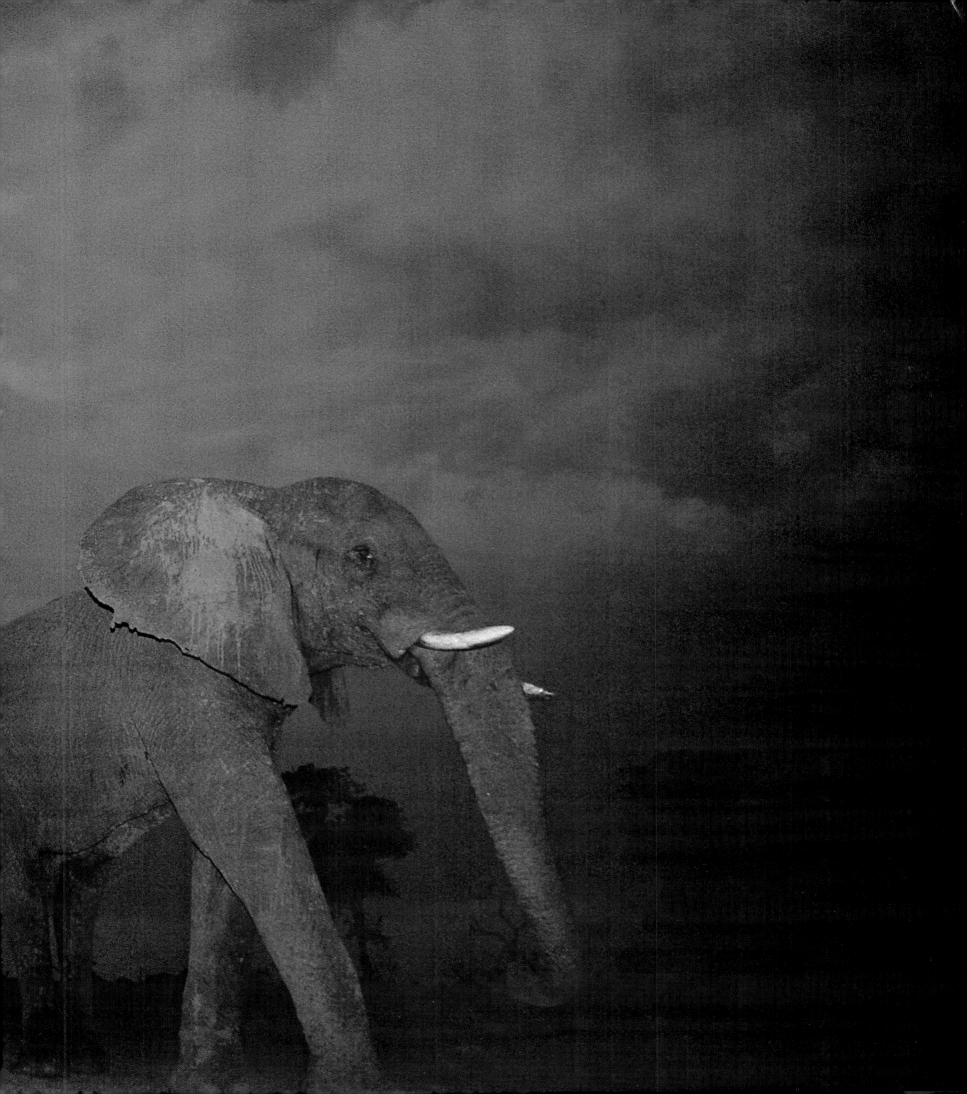

Previous pages: *'What progress requires inexorably of human beings and of continents is that they should renounce their strangeness, that they should break with mystery; and somewhere along that road is inscribed inexorably the end of the last elephant.'*
Romain Gary,
The Roots of Heaven

Above: *In the dry season doves gather in their hundreds at the waterholes.*

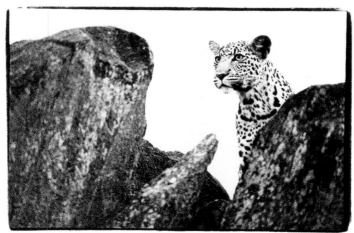

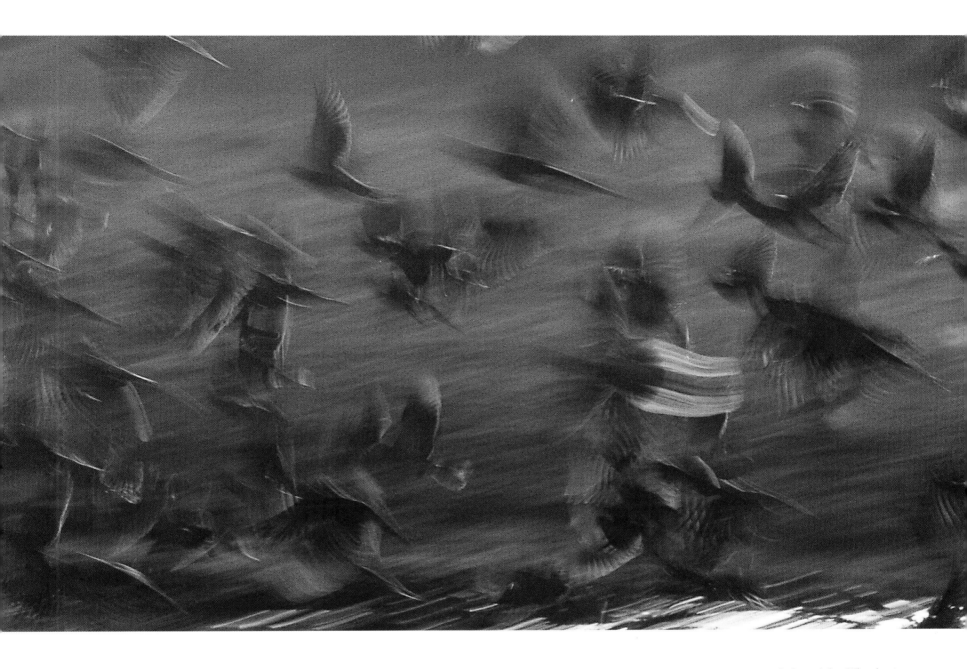

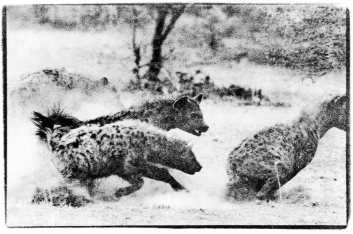

Left to right: *When hunting, a leopard is as still as the rocks of Tsonxhwaa; 'You will remember a curve of a track in the grass of the plain, like the features of a friend, (***Karen Blixen,** Out of Africa); A redbilled hornbill brings food to its mate imprisoned in the nest; Hyenas' disputes are settled by weight of numbers.*

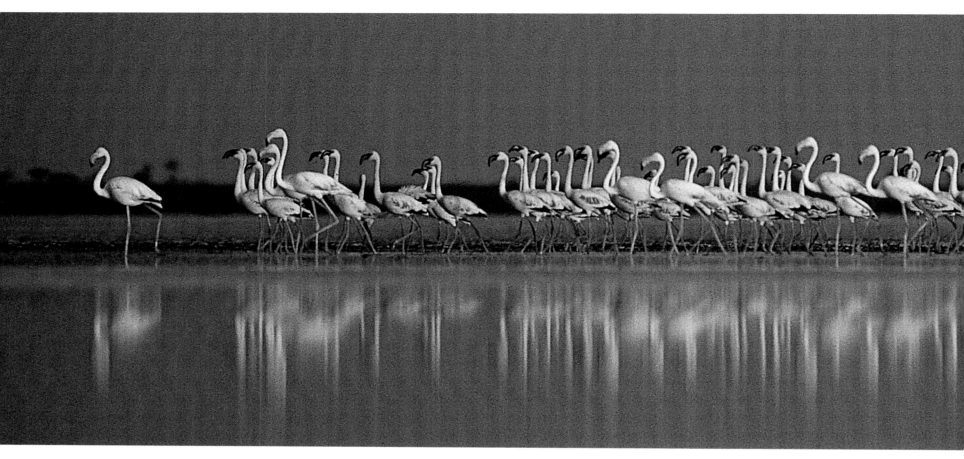

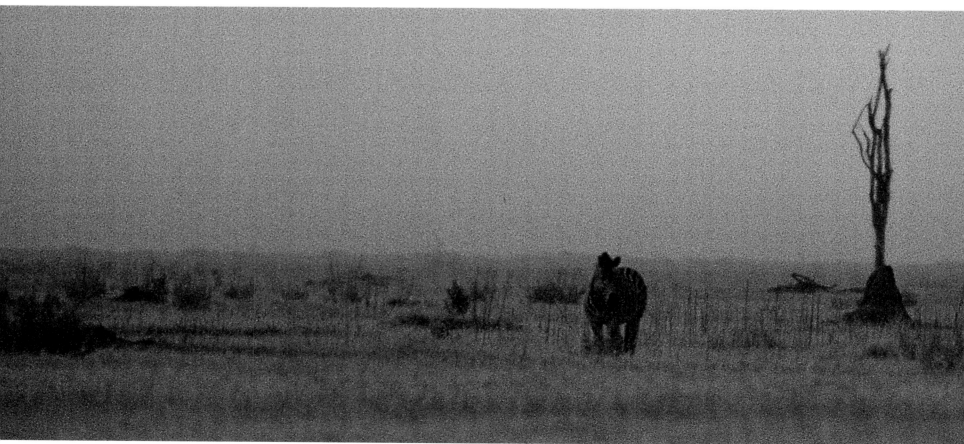

Above: *In the vast expanses of the Makgadikgadi Pans and the Savuti Marsh, Africa stretches endlessly before one, its ancient rhythms distilled to a stillness under the arc of a wider sky.*

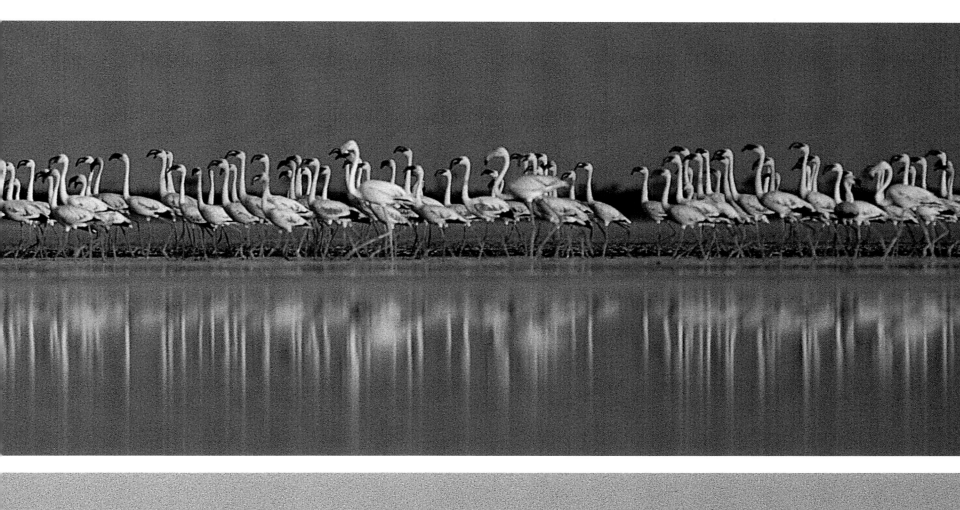

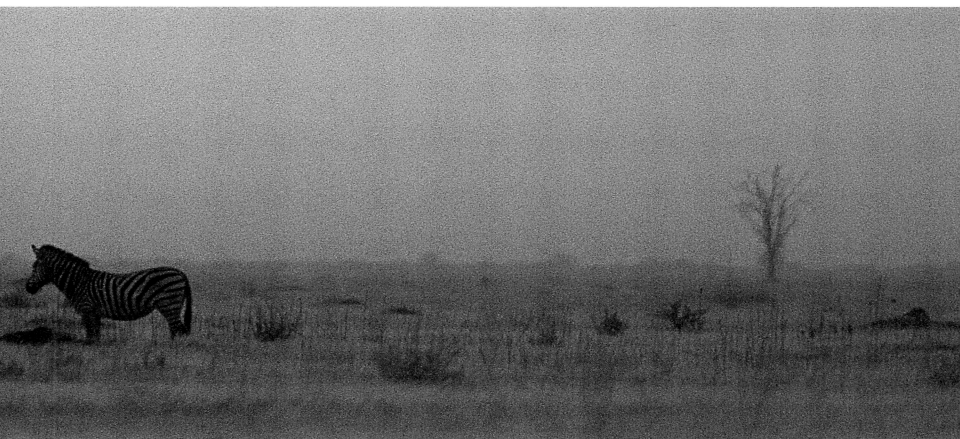

Overleaf: *'And in the moonlight on the iron-grey plains/ Zebra herds graze, small spots of light/ Like tears on the cheeks, shooting stars run down the sky and disappear'* **Karen Blixen**, *Out of Africa*.

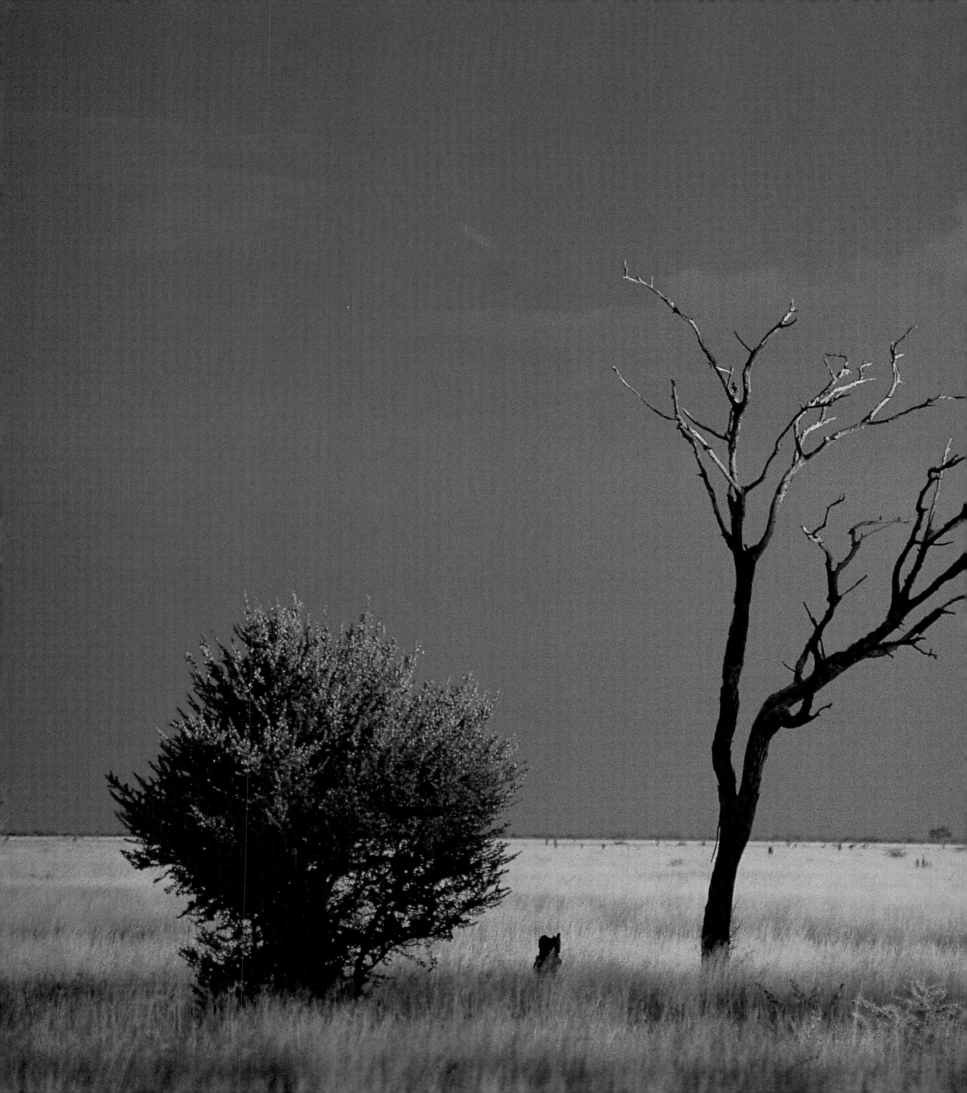

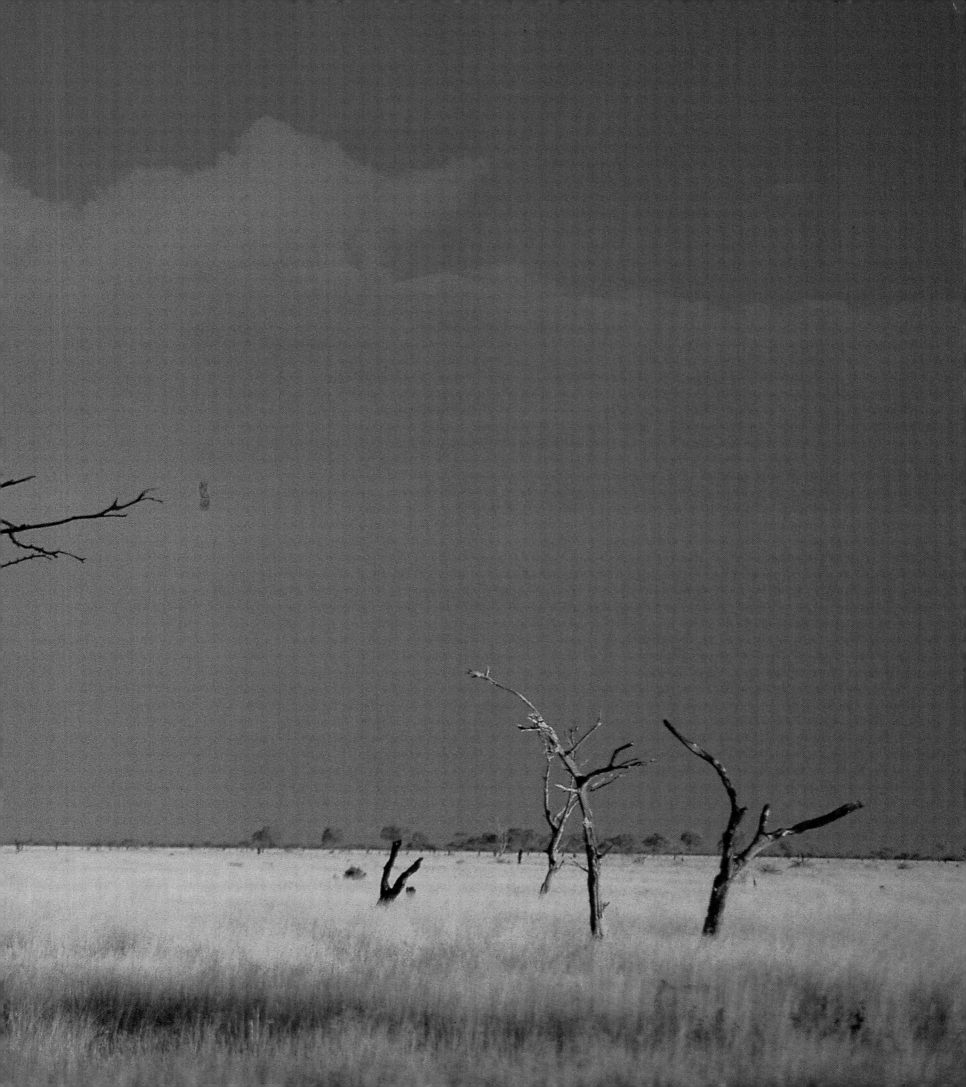

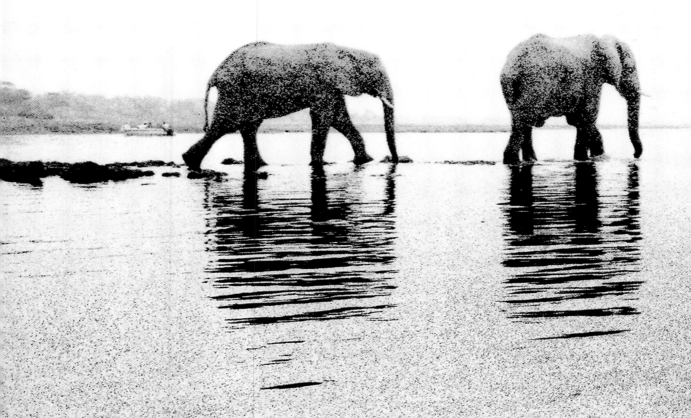

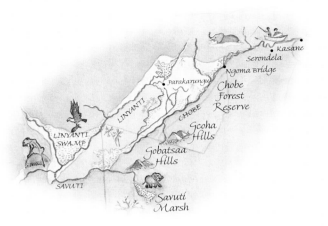

AN Elephant Tide

'In the very old days the elephant, upon the roof of the earth, led an existence deeply satisfying to himself and fit to be set up as an example to the rest of creation'

Karen Blixen, *Out of Africa*

On the main road to Ngoma Bridge, a large articulated truck crested the rise of the Sidudu Valley. As it started down the incline, dust boiled out in a thick cloud behind it, swallowing the trees. Inside the cab the thickset driver turned to smile at the young woman to whom he had given a lift. She was buxom, squeezed tightly into fresh, clean clothes, and her face and hair shone with cream and oil.

Out of the corner of his eye the driver saw a movement up ahead, beside the road. He reached up for his air horn but it was already too late: the young elephant had stepped into the road and was being followed by others.

Right: *The great African spectacle.* **Opposite:** *Elephants drink from the Linyanti Channel at dusk.*

As the brakes bit, the truck skated on the gravel. The driver's heavy forearms bulged as he wrestled the wheel and the cab veered sideways. The dust enveloped them, closing out the world, and then the juggernaut was still.

Through the thick dust, right before them, an irate elephant cow charged, her ears flared wide, to within a few metres of the truck. She screamed before following the rest of the herd into the trees at a shuffling run.

Elsewhere, at the Chobe gate, the attendant stood coated in a light film of dust beside his raised boom and watched the last of the afternoon game-drive vehicles disappear around the corner and into the reserve. Back up the road, towards Kasane, three bull elephants emerged tentatively from the cover of the trees and crossed the road, lumbering down the steep bank to the river. Lowering his boom, the gate attendant smiled to himself, for he too was weary of the press and pressure that this northeastern tip of the Chobe endures.

Here, when the rainwater pans have dried, the great African spectacle squeezes into the thirty-odd kilometres west of the Chobe gate. Elephants roll incessantly out of the hills, and the buffalo are massed dense and black on the long-grass plains of the river. Lions sleep in the shade; crocodiles bask on banks beside pods of wallowing hippopotamus. You can see it all in the space of a three-hour game drive, and it draws quite a crowd.

Beyond the Chobe gate, on the open flood plain, rises a tall army observation tower beside which the Botswana flag flutters in the breeze – a blatant statement against Namibian pressure to claim Sidudu Island as its own. Below it, a bevy of boats plies the river back and forth to flock about the game that comes to the water. On the land a squadron of safari vehicles scours the roads and, like hungry vultures, squabble and jockey for position about moments of excitement. In their wake, along the banks of the river, lie a jumble of hotels, lodges and camp grounds to accommodate the inrush of people, and they in turn draw a further pack of people to work in them, and a throng of trucks to supply them.

One morning, entering through the Chobe gate, we drove down Watercart Road. There we found two lions lying sleeping. Beside them were sixteen safari vehicles containing a total of 167 people. Unlike the lions, we fled. At the end of the Nanyanga flood plain we seemed finally to be on our own. I took my fly rod and scrambled down to a side channel where fish occasionally moved beside a bank of waterweed. I frightened a big crocodile that was lying on the bank about a hundred metres distant and it slid noiselessly into the water. I had not yet thrown a line when its eyes and nostrils quietly breached the surface about eighty metres away. As soon as I started fishing, it vanished and then reappeared, closer still. It was only when it slid beneath the surface and reappeared with great stealth about thirty metres away that I realized it was stalking me. I reeled in my line and scrambled back up the bank.

I found myself breathless and elated, for in my fear I had acknowledged the crocodile for what it is – the quintessential predatory beast.

That night we camped by ourselves on the Kabolebole Plain and heard a poacher's shot between us and the rise of hills to the south. The next morning, as I sat across the desk from Mr Morake, the warden, to report the shooting, I found myself glad that I was not in his shoes. To him fell the delicate task of reversing an ingrained trend, and he would have to tame and regulate the tide of people while ensuring that the tide of elephants remained wild and free.

I was sure too, that he had no inkling of the fevered pitch that the battle would reach, for, like all conservationists, he would be opposing the savage ferocity of greed, armed only with principles and a belief.

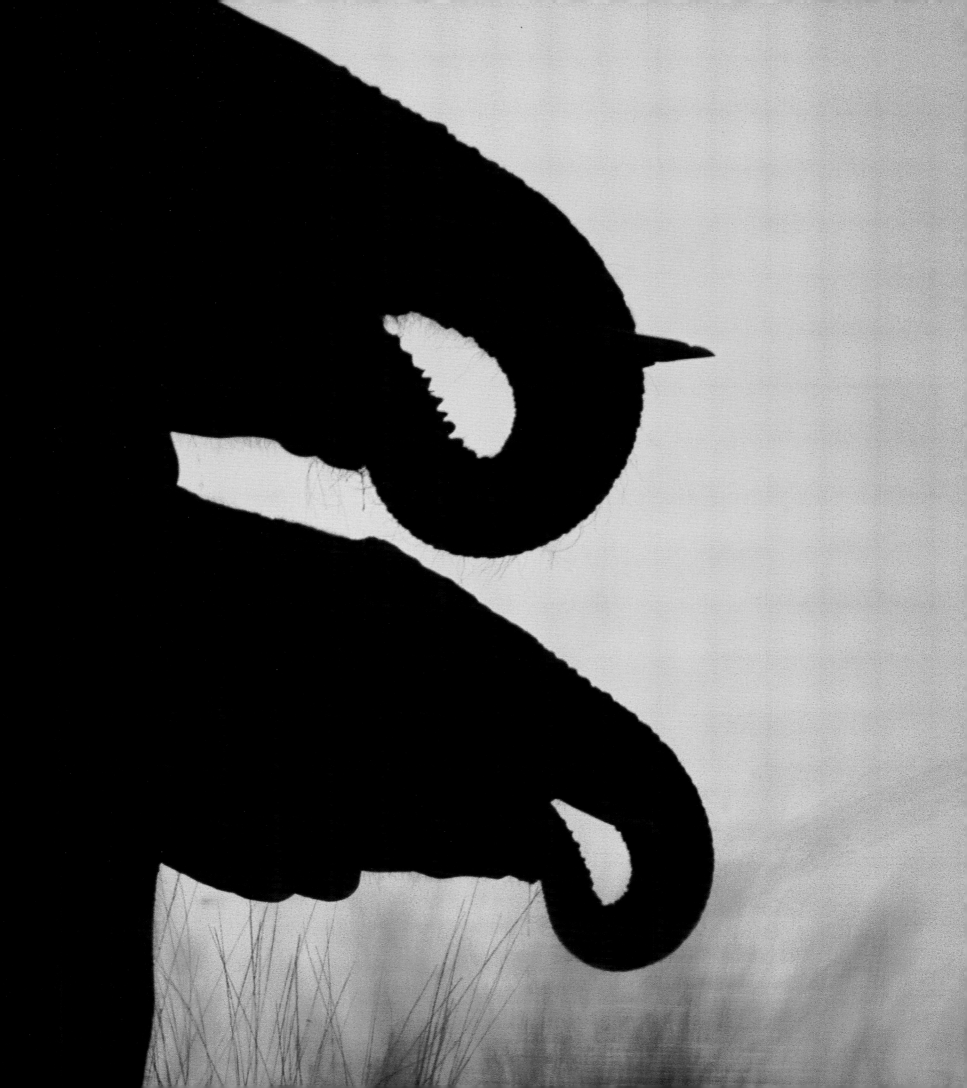

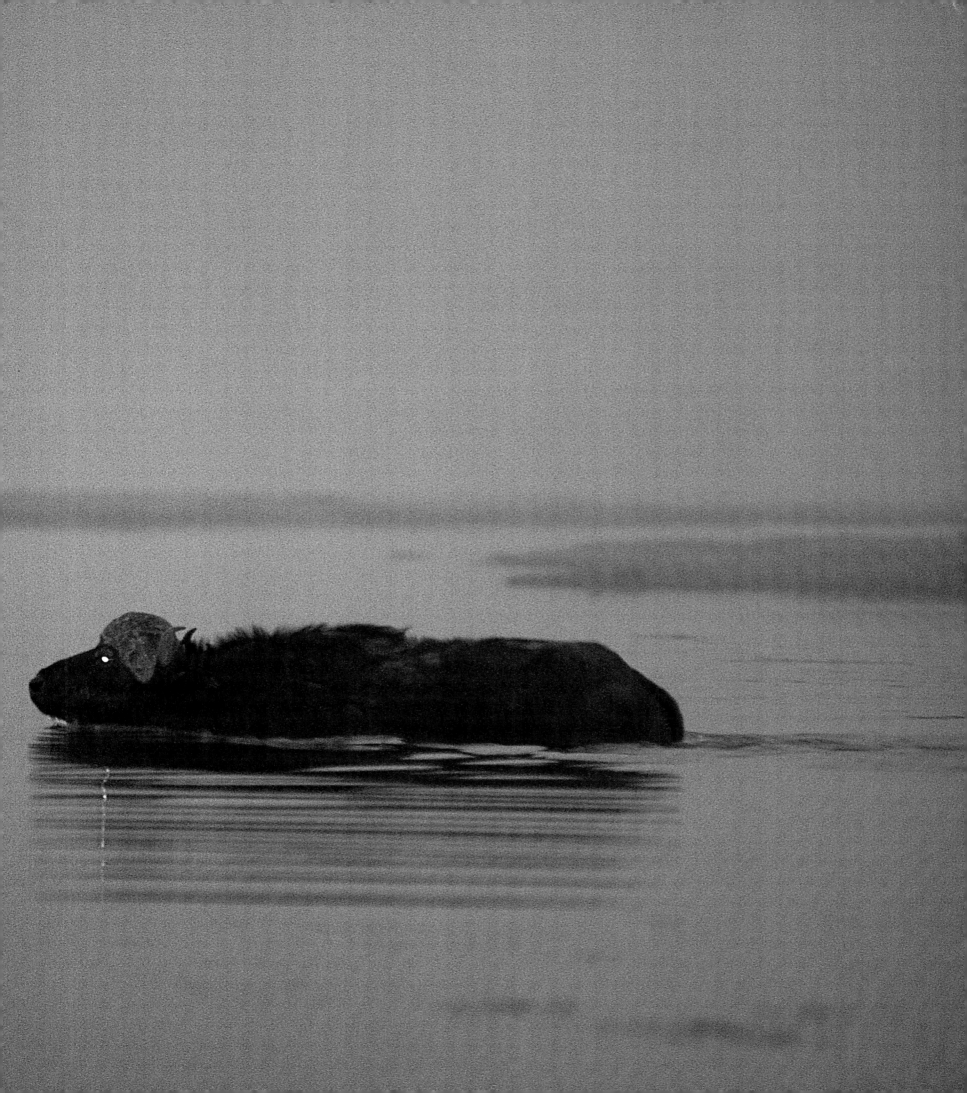

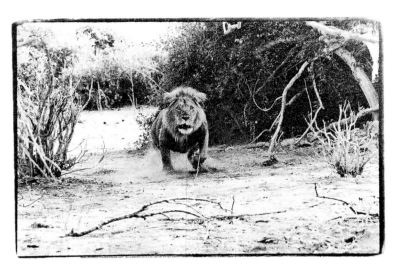

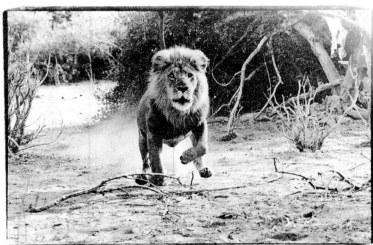

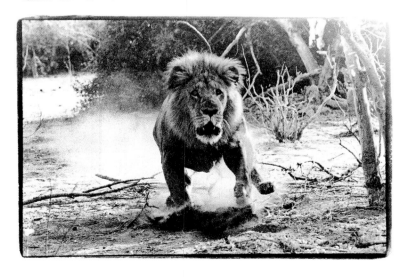

*A lion charge: there is no time for
fear; you simply know, through
some long-forgotten instinct, that
if you move you will die.*

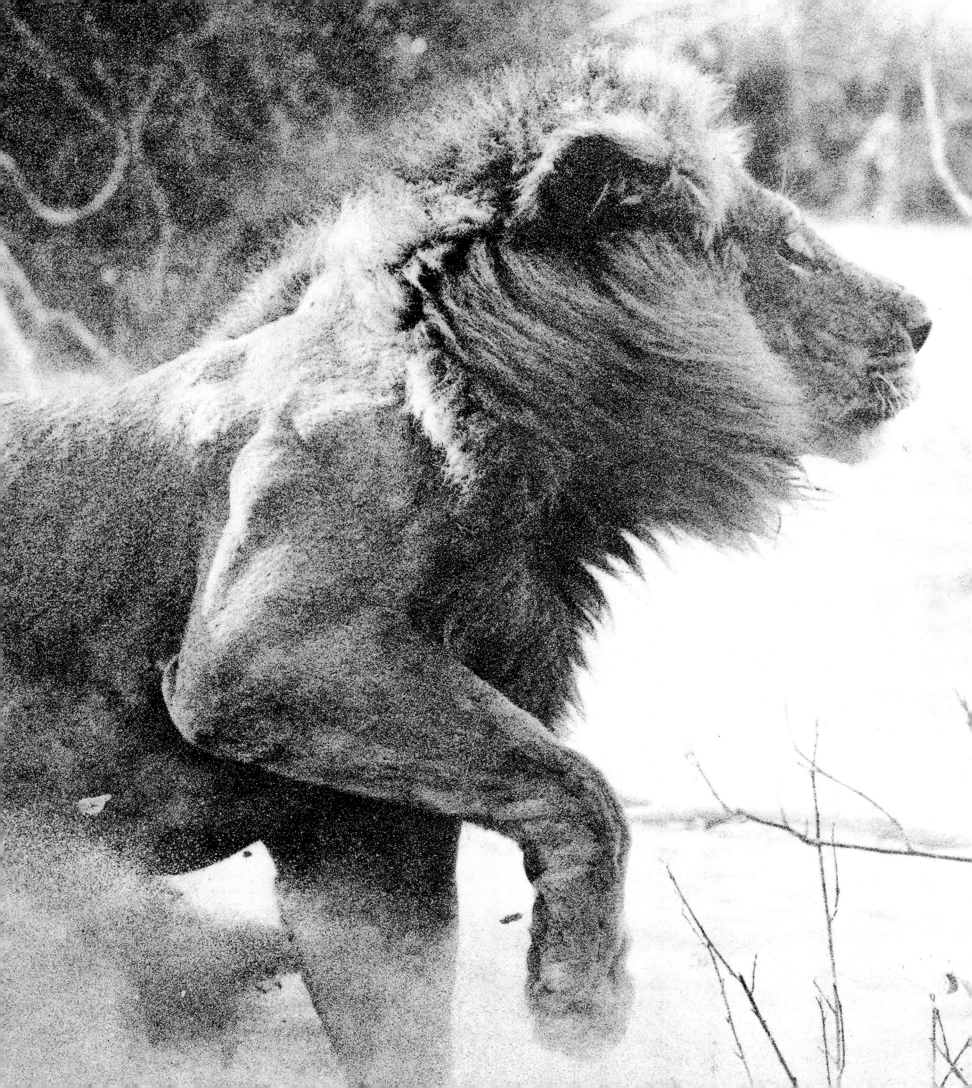

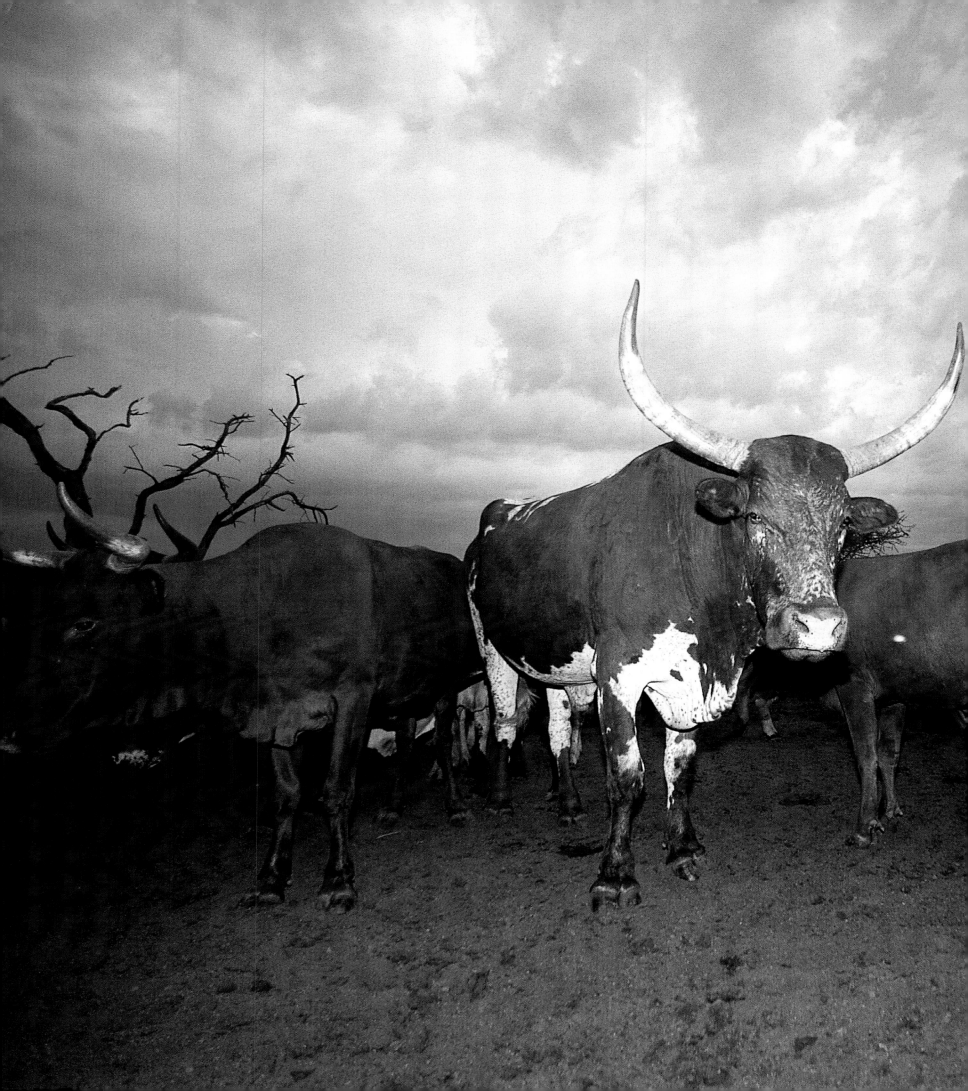

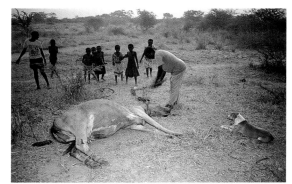
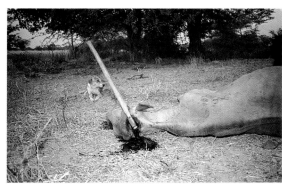

'And that is why it is so dangerous to turn an animal into a machina animata, a cow into an automaton for the production of milk. By so doing, man cuts the thread binding him to Paradise and has nothing left to hold or comfort him on his flight through the emptiness of time.'
Milan Kundera, *The Unbearable Lightness of Being*

Willie Phillips on Hunting

'You could say that I am one of the people who started the decline of the Okavango, when I started hunting crocodiles in 1958. When I first came here it was very poor, but we were quite happy and we survived. We had no fridges; a warm drink meant nothing; now, I could never do that.

'Progress is something you cannot avoid. People have to live, but the mistake currently being made is that the present situation of wildlife being deliberately destroyed continues as it did when we started. Now we should know better, and the destruction is more so now than ever before.

'Citizen hunting is largely to blame. It is very difficult to intervene when an outsider is hunting outside of the regulations and licences and stands to lose his car, his guns and licences, and pay heavy fines, when our own citizens are hunting illegally all the time. They should be setting the example.

'When I was young here in the Okavango, people hunted to eat; today, they hunt to sell the meat. Now, that is wrong as far as I am concerned.

'I disagree with those who say that the drought situation, or bad flood years and poor rains, are a major cause for the dwindling wildlife populations. The large unflooded areas provide a greater refuge for the animals, whereas a big flood will flood the islands and force the wildlife to the outer edges of the Delta where it will be more accessible to the hunters. The game moves out first and the predators have to follow. Also, in a high flood many more areas are accessible: you can go anywhere a vehicle cannot go with a dugout.

'There is a particular area in the Delta where you still find large herds of buffalo, for example. The reason for this, up until now, is that during the cold months of the year when the buffalo congregate there and the local people are able to make biltong, there has not been enough water to get dugouts into these areas. When the buffalo start moving out of these areas towards the end

of winter, there is enough water for the hunters to go in, but the animals have by then moved out farther to be able to migrate north when the rains start. The only way in is on foot. It is hard work and you can only carry so much, so those who go in there only shoot one animal then get out.

'Out hunting one day with a cattleman, a client, we walked into this area, island hopping. We set up camp with a flood plain in front of us, easily three or four kilometres long and a kilometre wide. A herd of buffalo came down one morning at about nine or ten o'clock, and we were actually hunting buffalo. The hunter said there was no way he could shoot animals like this, here, so close to us.

'As far as the eye could see were between two and three thousand buffalo, all in just one herd. They remained there until about four in the afternoon. The client was amazed that there remained a place that was hunted that looked like this. But these sights are very few and far between today.

'You would probably not believe that I shot my first buffalo just the other side of the Shashe River, right here in Maun. This was before the Makalamabedi Fence went up in about 1954.

'Unfortunately, there arose the subject of money, the making of a quick buck. Traditionally, the Bushmen were the truest conservationists because they hunted only for subsistence. They hunted only to live, as where would they get P3 000 to buy a rifle? If one has P3 000 to buy a rifle, one has money for food and does not need to subsistence-hunt. Until this is realized by the authorities, our wildlife is doomed.

'Another situation that exists with professional hunting is the gratification of clients. Recently I have heard reports of lion sightings of 35 and 57 on one hunting trip, but the question that arises – and it is one the hunters should ask themselves in support of their argu-

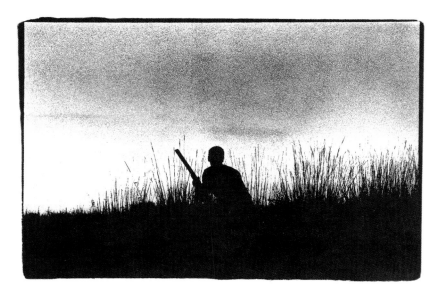

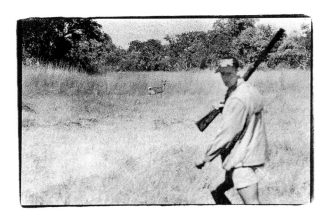

ment for more lion-hunting licences – is how many of these were trophy males? Perhaps three or four?

'Professional hunters earn a good salary and have an independent lifestyle. They have the privilege of spending much of their time out in the bush, in relative freedom, and must remember that they make the decision of what to do and how to do it. Some of the clients are extremely wealthy but they still have to listen to the professional hunter, whether they like it or not. Sometimes it is difficult, as the client imagines he is still in his multimillion-dollar corporation, shunting people around, but sooner or later, without abusing the situation, the professional hunter must take control.

'With all of the hunters, the in-dealing of licences must stop. With trophy hunting one must never forget that one is always shooting off the best breeding stock. The quality of trophies in Botswana has been on the downgrade for the last decade. It is the individual concession owners who must take responsibility and be answerable for the areas they control. They must control who hunts there and the species that are being hunted. Money must take second place to the correct utilization of the area.

'I am a professional hunter and I will not stop hunting. I will hunt a species that is plentiful, since there are species that are plentiful. There is no harm in doing it properly, as long as there are ethics involved. You must shoot the animal as quickly and efficiently as possible; you do not leave a wounded animal.

'I do not think it is necessary to actually stop hunting, but it may be the only solution to get people to realize that there is some authority behind it. Hunting should be properly controlled. At the moment it is not.'

185

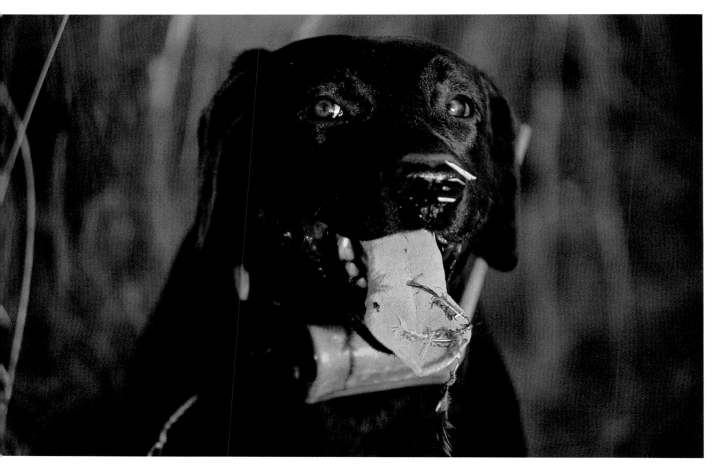

Left: *Ruger, a working black labrador.*

Together with these men I tested the wind, inched forward through the dry grass and lay flattened against the earth in pursuit of wild beasts. Ants bit my chest, sweat trickled down my back and the adrenaline tasted hot and sour in my dry mouth. I concluded then that it is not hunting that is the emotional issue, but killing. The dilemma lies in the fact that it is only the killing that makes the hunting real.

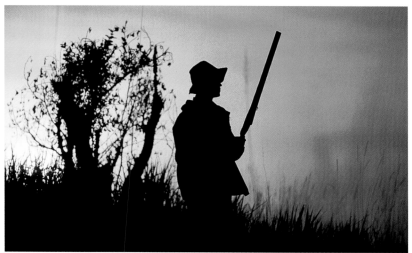

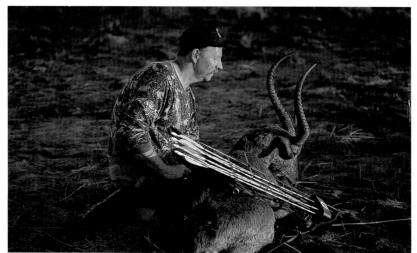

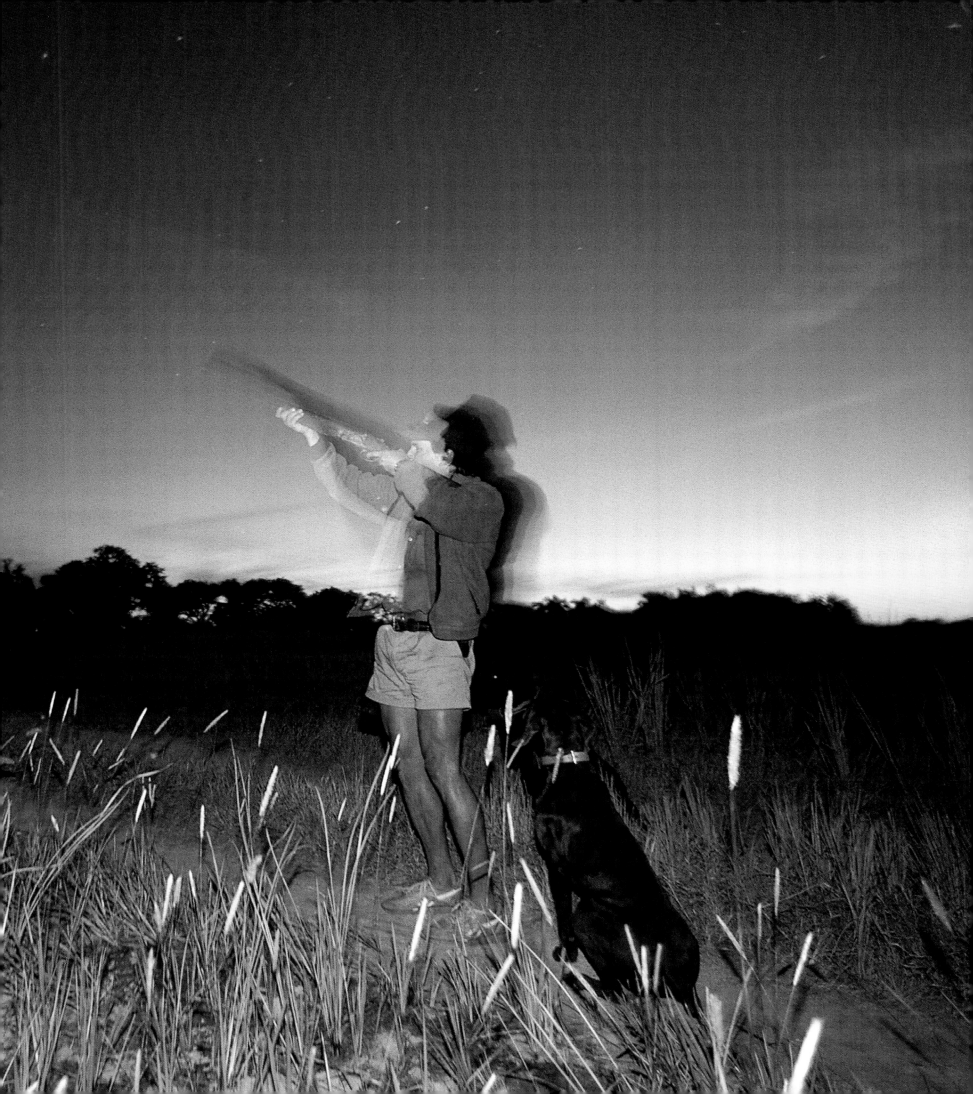

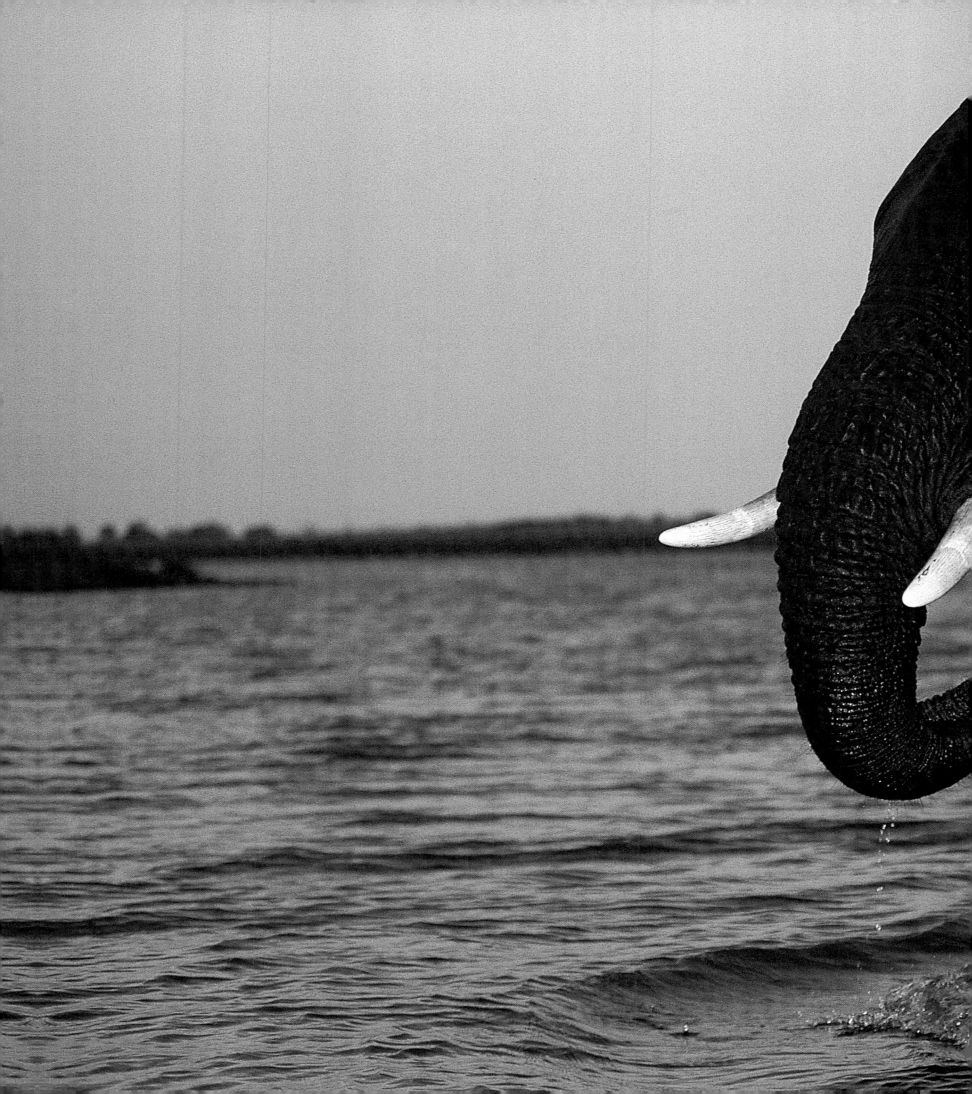

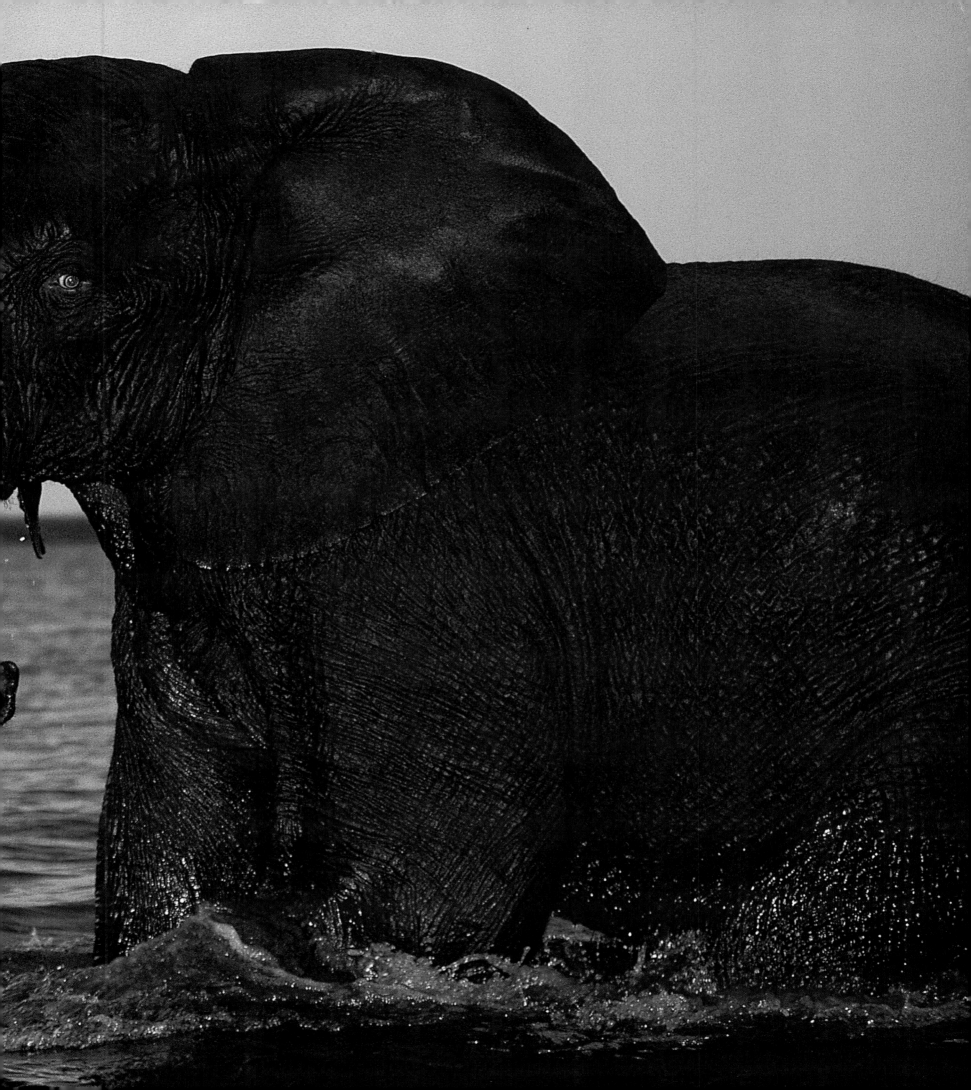

Chobe Elephant Confrontation

At the end of the long dry season, as the days became longer and hotter before the coming of the rains, the only surface water to be found for kilometres in all directions for the elephants of the Chobe was the Chobe River. It appeared to us, as water took on this heightened significance, that when the elephants came to drink, it was more a celebration than a mere quenching of thirst.

At any time, from the approach of midday and on into the night, elephants came to the river: lone bulls and all manner of groups; bachelor herds and breeding herds; some gatherings small and apprehensive, others large and made bold by years of contact with man.

The older bulls, the ones with cracked and broken tusks, would drag their trunks wearily across the dusty roads, often waiting behind thick bush for the passing of a vehicle before crossing. The younger ones dashed excitedly through the trees, making an unseemly amount of noise. The more cautious breeding herds chose the remotest of crossings, to appear suddenly like ghosts at the river's edge, where thirst then overwhelmed all other instincts. The largest and most unwieldy herds, undeterred by anything, trooped in single file down ancient paths to their favourite pools,

where they remained ensconced for hours on end.

One stormy evening, with heavy, black skies hanging overhead, the Chobe River dark and ominous, we slowly passed through Serondela and out onto the flood plains. It was more a moving on, a restlessness arising from the disquiet of the approaching weather, than an earnest photographic sortie. The road was rutted and the going extremely slow, and as a result we rounded a deep bend unnoticed by a herd of elephants scattered on the plain. Something was afoot; many trunks were upraised, curled, testing the air. We switched off the engine and watched.

For a few minutes the tableau remained exactly as we had found it, and we began wondering if the approaching storm had made us apprehensive and if we were simply imagining the tension between the elephants. Then, suddenly, without warning, a huge bull charged past a few metres from us, directly at a younger bull. Completely oblivious of us, or choosing to ignore us, the bull was engrossed in its primeval challenge.

The younger male dropped its trunk, stood with its legs planted apart and waited. The charging elephant turned, avoiding confrontation at the very last moment. Two more bulls waited in the wings, cement-like in the

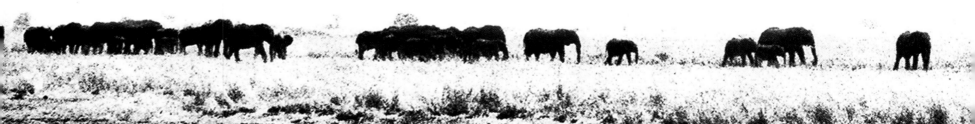

pale evening cast, with trunks pointed to the wind.

In the background elephants dotted the plains; some, vaguely interested, turned towards the action, while most continued calmly plucking clumps of grass, from which they shook the soil before eating them. It was a strange indifference, somehow, knowing that life would continue whatever happened.

The two elephants stepped towards each other. The huge bull raised its trunk, and the younger raised its too; the larger elephant lowered its trunk, and the smaller lowered its. Was the younger copycatting the older bull to infuriate it, or was this the dance of the gladiators, the bowing of opponents? Finally, they met with trunks up, and both stood absolutely still for long, long moments. Then they locked trunks, each trying to twist its trunk into the topmost position and push down on the head of its opponent.

The younger bull, pulling free, then sideswiped the elder with its trunk. The older bull stepped back and lowered its head. This may have been a sign that it was going to charge, but instead it stood stock still. The younger bull moved off to the side, where it turned and waited, as if it knew it had overstepped the mark. As if all this were not enthralling enough in itself, the clouds then parted and a shaft of light cut through the ominous grey to illuminate the elephants, first one, then the other, with those surrounding and dotted about lit gently by the glow.

Undaunted by the intrusion of the light, the two elephants began to chase each other, the one close on the tail of the other, until a certain point, when the front one would turn and seek revenge, also up to a certain point, just before contact was made, when the tables would be turned once more.

The saga was finally explained when one of the bulls, waiting patiently and without apparent interest in the wings, saw its chance and sidled up to a female standing nearby. It sniffed the female with its trunk.

The young bull, caught in one of its turn postures, noticed the elephant's trunk uplifted next to the young female and quickly strode directly over to them, taking care not to venture too close to its chief opponent. The young female, obviously in oestrus, was soon surrounded by four male elephants. The behaviour of the bulls in the company of the female became quite different. The tensions shifted; the trunk-lifting, trunk-throwing and stepping towards and away from the female were no less tense, but much gentler, more controlled.

The advancing darkness was laying its cloak over the elephants, and we could no longer see them clearly, but we were given one final vision as a bright flash of lightning momentarily lit up the scene. In slow procession, the elephants were leaving the plain and making for the shelter of the forest. We saw the young female, too, with the four males in close attendance, taking the final chapters of this drama into the night.

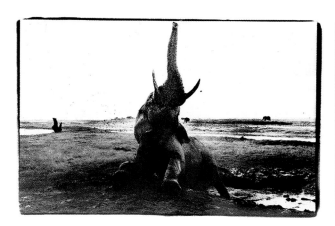

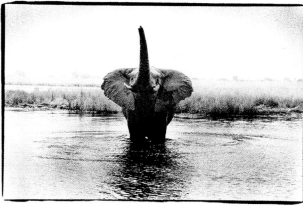

Overleaf: *Agile and silent, the leopard can at times seem a living ghost.*

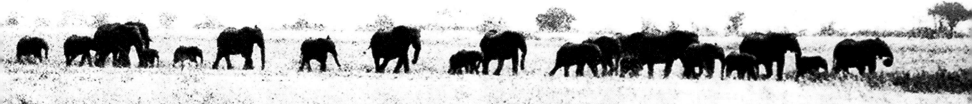

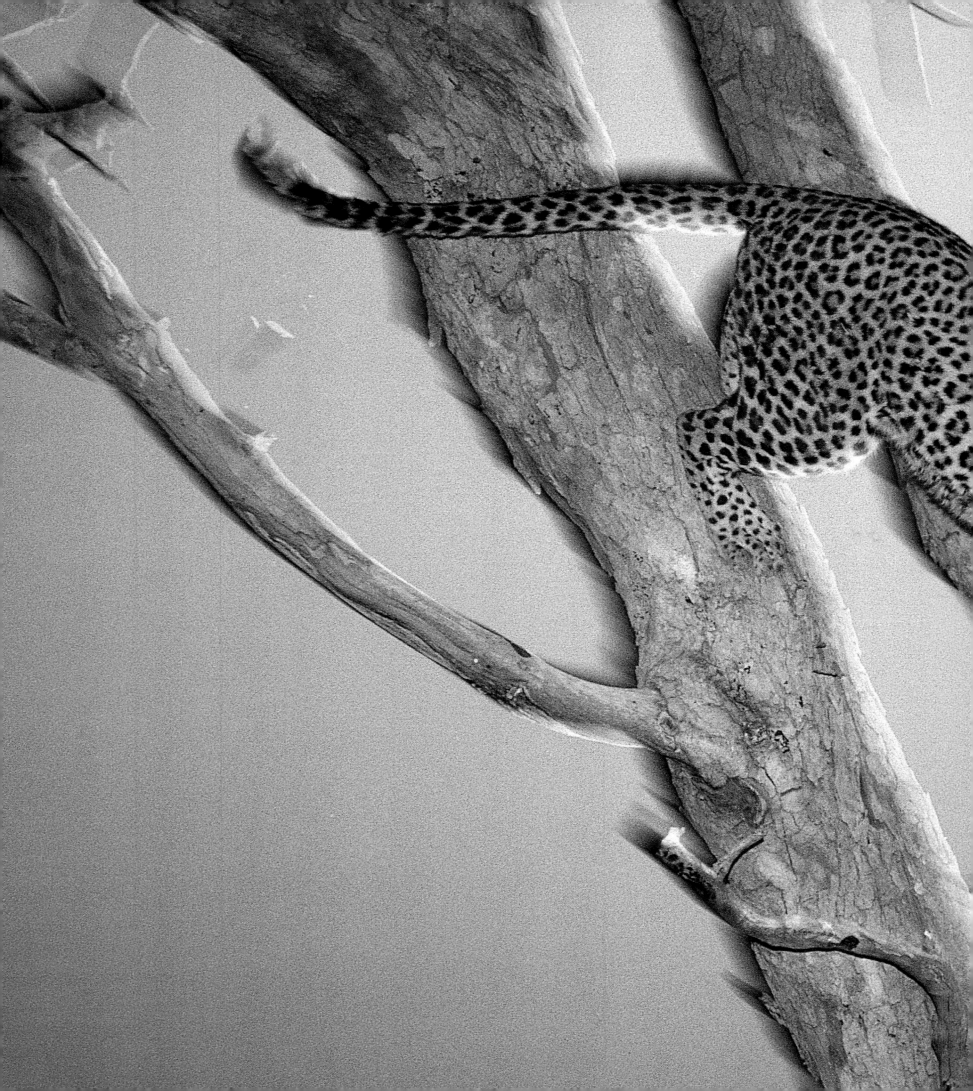

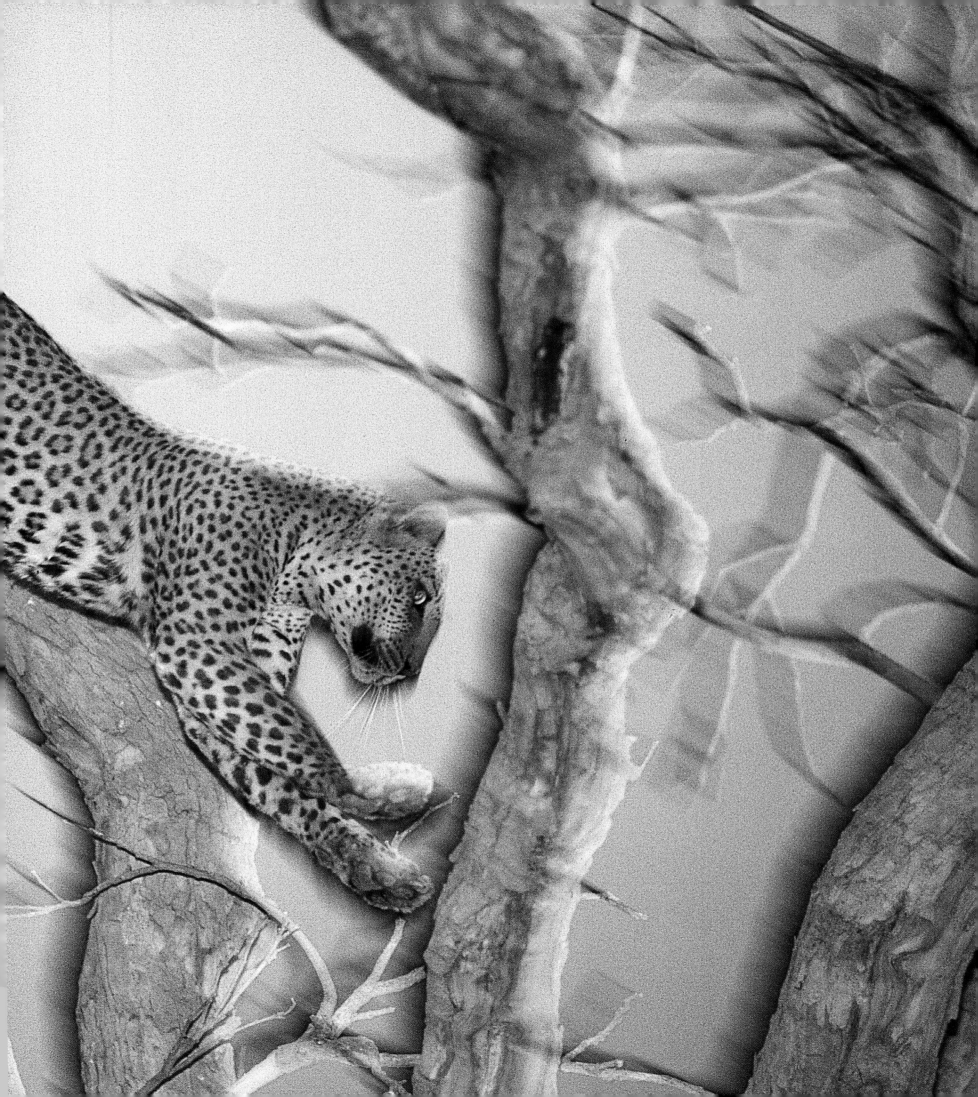

Conservation by Karen Ross

*Dr Karen Ross is the head of Conservation International in Botswana
and author of* Okavango, Jewel of the Kalahari.

When, one hot, dusty day, Peter and Beverly Pickford walked into our small offices and asked me to write a piece for their book on why I work in conservation, I was stopped in my tracks. Good question!

On the tip of my tongue was the simple reply, 'Because I believe in it,' but since then I have paced backwards and forwards, retracing thoughts and going in circles, mulling reasons around in my head. On a bad day, with a vehicle stuck in the bush, no money in the bank, and reports coming in about yet more wildlife declines, I do wonder: why do we do this? Why go on dealing with the frustration? Why do we who care, carry on caring? But in the end I always came back to the same simple answer: because we believe in it.

The overall mission of the organization I represent, Conservation International (CI), is 'to conserve the earth's biodiversity, and to demonstrate that man and nature can live in harmony'. This is a move away from the idea of putting great emphasis on single species (the panda, the tiger, the elephant), which makes sense, because if you protect entire ecosystems, you protect the vast array of species within them. Most importantly, you conserve their home. Without their natural habitat, most species will become extinct, while others will be doomed to a future in zoos and man-made habitats.

Our mission in Botswana is the conservation of the Okavango Delta. It was once said that a picture paints a thousand words, so by just looking at the photographs in this book you can see the beauty of the Delta, and the great array of species (which is what is meant by 'biodiversity') within it.

For more than ten years I have worked in the Okavango Delta, and its satellite village called Maun, and this extraordinarily lovely wilderness has been an inspiration. When I was first sent out here from London to do research for a BBC documentary series, it took my breath away. The Okavango's magic is as subtle as the whisper of a breeze; you can't quite put your finger on it. The tranquillity, painted in a thousand shades of blue and green, cut by the brilliant colour of a diving malachite kingfisher. The reflections of water lilies and reeds, clouds and trees, like a Japanese silkscreen. The night sounds of bell frogs, silenced by a lion's roar. The torpid stillness of noondays broken by birdsong, the splash of rising fish, or the thunder of a thousand flying hooves. A wilderness distilled through time. A fairy-tale place, removed from the world of modern man, that never fails to draw wonder from those who see it.

The Okavango is perhaps the least spoilt and most fragile wetland on Earth, in the heart of a desert, on a subcontinent thirsty for fresh water. Within its small, brave heart are the representatives of almost all of Africa's biodiversity, from fish to fowl, from herbivores to an array of carnivores – and, most significantly, a tribe of people who still live in harmony with them.

Yet the Okavango is one of the least protected

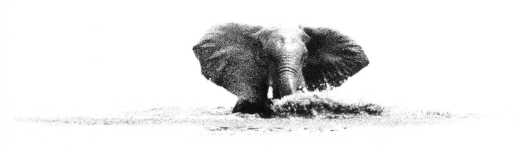

'*Our individuality is all, all that we have. There are those who barter it for security, those who repress it for what they believe is the betterment of the whole society, but blessed in the twinkle of the morning star is the one who nurtures it and rides it, in grace and love and wit, from peculiar station to peculiar station along life's bittersweet route.*'
Tom Robbins, *Jitterbug Perfume*

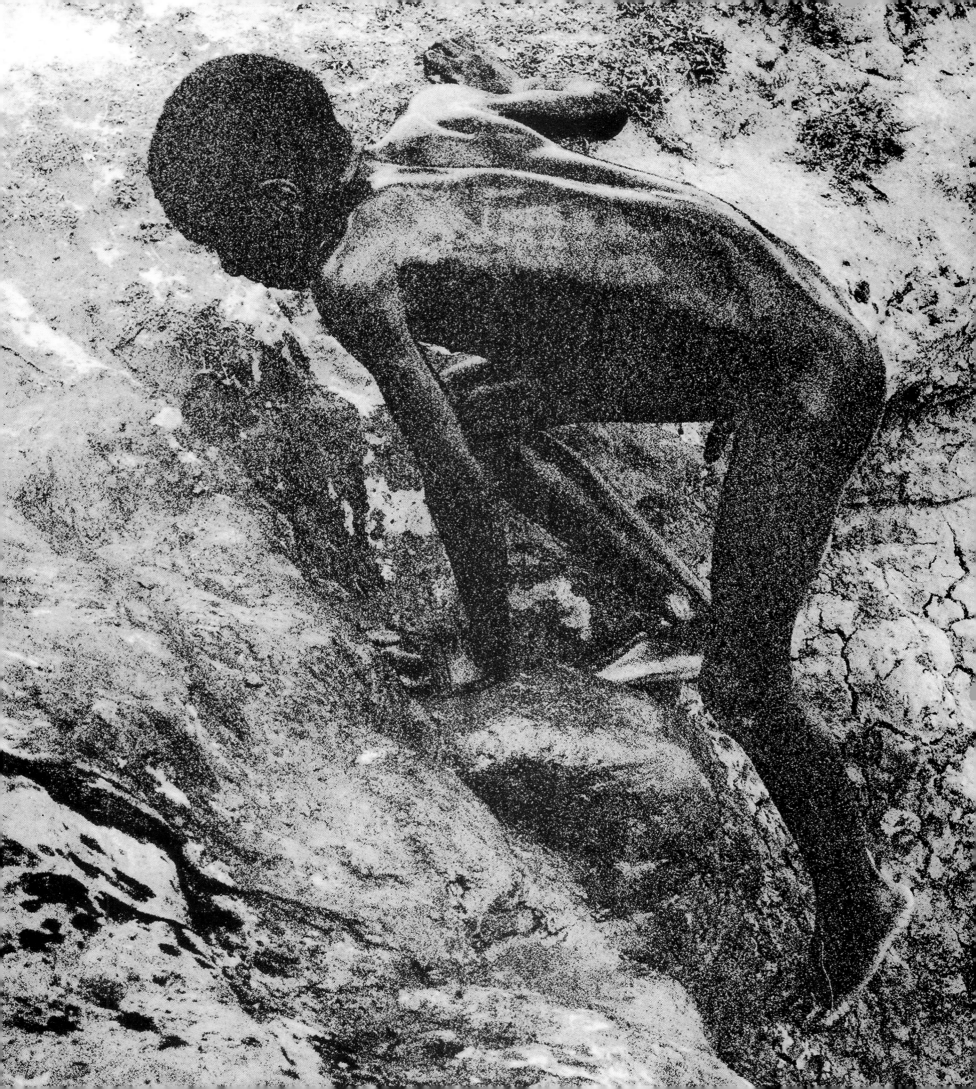

wetlands in the world. It is thanks only to the indigenous people of the region that it has any legal protection, through the Moremi Game Reserve. Why?

Why, when many of us really love nature, is there so little wilderness left? Few of us have the time, opportunity or even desire to fight to save it. So professional conservationists, who dedicate their lives to this work, are necessary. And 'fight' is the operative word. More and more, I have come to believe that today conservation is a real fight; it is a battle to hang on to what is left of the world's wild places and extraordinary diversity of life. Conservation has moved into the high-risk game, into the international arena, where it is serious business. We need to play at the same level as the forces that cause the environmental damage.

There can be little doubt that the Okavango is worthy and needful of conservation. However, there are probably many people out there who see the region as merely a development opportunity, its richness an avenue for growth and wealth. People's needs have to be catered for, which makes the second part of CI's mission – 'to demonstrate that man and nature can live in harmony' – significant but hard to fulfil.

As a child I felt very connected to animals. My feelings haven't changed. What have changed are my feelings for humans. In time, I have learnt to love my fellow man much more, and now I believe that

conservation is for humans, by humans. We all need the variety and wonder of the natural world, for medicine, materials, food and spiritual renewal. Wiser civilizations than ours knew this; the Mayans, the American Indians, the Bushmen all lived in harmony with nature, and respected life on the planet. This is not to say they did not hunt or eat meat. They did, but they did so with respect, so there was not the misuse and abuse that today we have come to accept as the norm.

Many have said that conservation is a rich man's indulgence, a western world's luxury. Not true, especially for our children! CI's programme in the Okavango has put a great deal of emphasis on education. Through our work I have seen that children have an innate love and wonder of animals and nature; our environmental-education work around the Delta has brought us into contact with hundreds of indigenous children, passionate about the wild. Perhaps it is the hard realities of life, or the lack of leadership, parental guidance or hope, that makes our children lose this instinctive wonder and respect for nature. Whatever it is, the challenge is to find it again. And if we can't find it through adults, surely we can through children.

What does conservation really mean these days? The term itself means different things to different people, from animal rights to sustainable utilization. Sadly, it

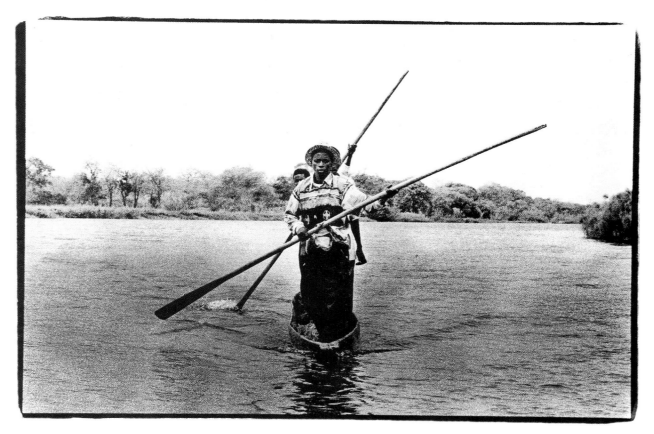

Opposite: *Their bulk swallowed by the immensity of the scene, elephants swim across the Chobe River.*
Left: *In the deep waters of the Chobe, long paddles replace the ingushi used in the shallow waters of the Okavango.*

seems to be fashionable to knock conservationists: governments are suspicious of us, developers and industrialists consider us a threat, the 'utilization' lobby considers us bunny huggers. Certainly, I am not working to satisfy sceptics and critics.

More than simply loving nature, most conservationists feel that the environment must have representation in today's world. Without a voice, a bank account or a vote, how does the environment have its needs represented? I want, and have always wanted, to be a voice for the environment, and consider myself privileged to have the chance to work in conservation.

And not only do I believe in conservation, I *have* to do it. We need conservation so that humans can survive. Developers would like us to fall into the trap of thinking that conservation and development are opposing forces. In reality, that is not the question. It's whether or not development and conservation can grow together. We need to find a way for both of them to prosper. If they don't prosper together, they will die together.

Each year more of the natural world is lost. In Africa, poverty and overpopulation grind away at her fantastic natural bounty, while cattle and goats replace her great natural spectacles. The conservation picture in Botswana

is as gloomy as in many other parts of the world, despite our apparent advantages of high per-capita wealth (mainly from diamonds) and low population density. At a symposium in Gaborone in December 1995, the government's own senior research biologist, Dr Crowe, analyzed the Department of Wildlife's existing aerial-survey data and told us the chilling news: in Botswana, in the past twenty years, wildlife has suffered massive declines. In southern Botswana in the order of 95 per cent of the wildebeest, 90 per cent of the hartebeest and 50 per cent of the eland populations have been lost; in the north there have been 50 per cent declines in buffalo and zebra, and significant declines in roan, sable, tsessebe and others. The only population to have increased are the elephants, and the main departmental discussions are about how to cull them!

How could we have got it so wrong? Why did we get into the mess we are in now? Why has man done this to nature? Losing respect, losing touch and losing knowledge all play their parts. We forgot that we are here as guardians of the natural world, and suddenly got it into our heads that we are the masters, that we have domination over earth's creatures. At the same time, we lost respect for our fellow man, respect for life.

Sometimes, living in Maun, one forgets what is out

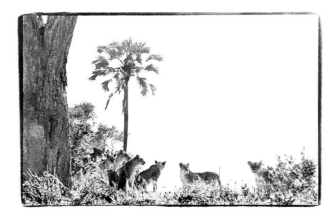

there. When the tar road came through, it brought with it cars, crime, money-makers and chainstores selling tempting goods no-one could afford. Within a few months, the frontier had become a part of the real world. But beyond Maun, just an hour into the Delta, one can still see a pristine environment supporting all of Africa's great wildlife species, including representatives of nearly every carnivore known on the continent.

So much to do, so little time! The task ahead is so great that even significant conservation groups, like CI, openly admit that the job, even in one location, is too great for any single group to tackle alone.

It's a crazy world out there. Highways, freeways, planes, boats and trains; neon lights, skyscrapers, fast food and television. It's all so invasive; life is so demanding. But the consequences of inaction, as we all know, will be catastrophic. We *must* change. Humans need to rediscover who they really are: custodians, not masters, of the earth. Since we humans are the problem, we are also the solution. Humans need to regain a respect, a trust, of life and nature.

The conservation movement will, I believe, make a difference. Even if the loss of wilderness is currently happening at a rate faster than our progress, we can at least acknowledge that human consciousness is expanding, and this is vital.

Anyone who lives a life with love and respect in their hearts is a conservationist. If you care about plants, respect animals, worry about your rubbish, think about things, and try in any small way to make things better, you are making a difference.

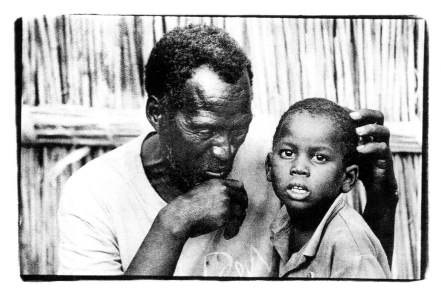

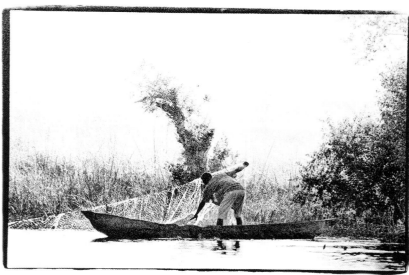

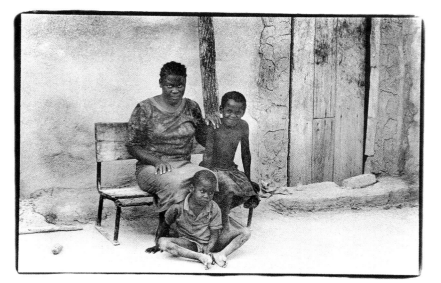

'In every place today the human mind is mockingly starting to lose its awareness of the fact that a person's true security consists not in his own personal, solitary effort, but in the common integrity of humankind.'
Fyodor Dostoyevsky,
The Brothers Karamazov

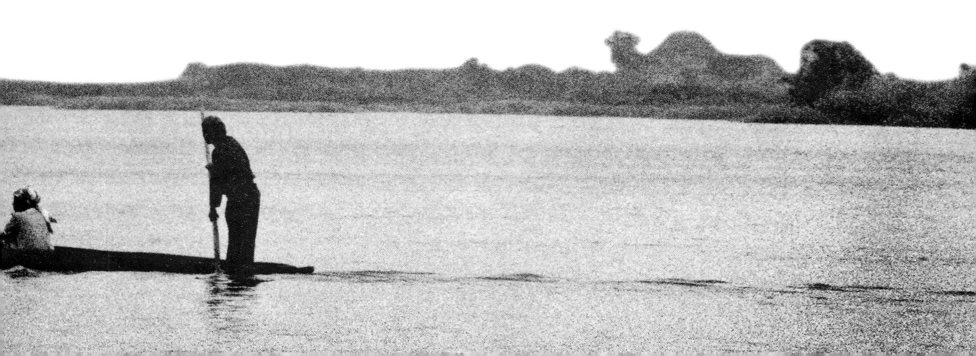

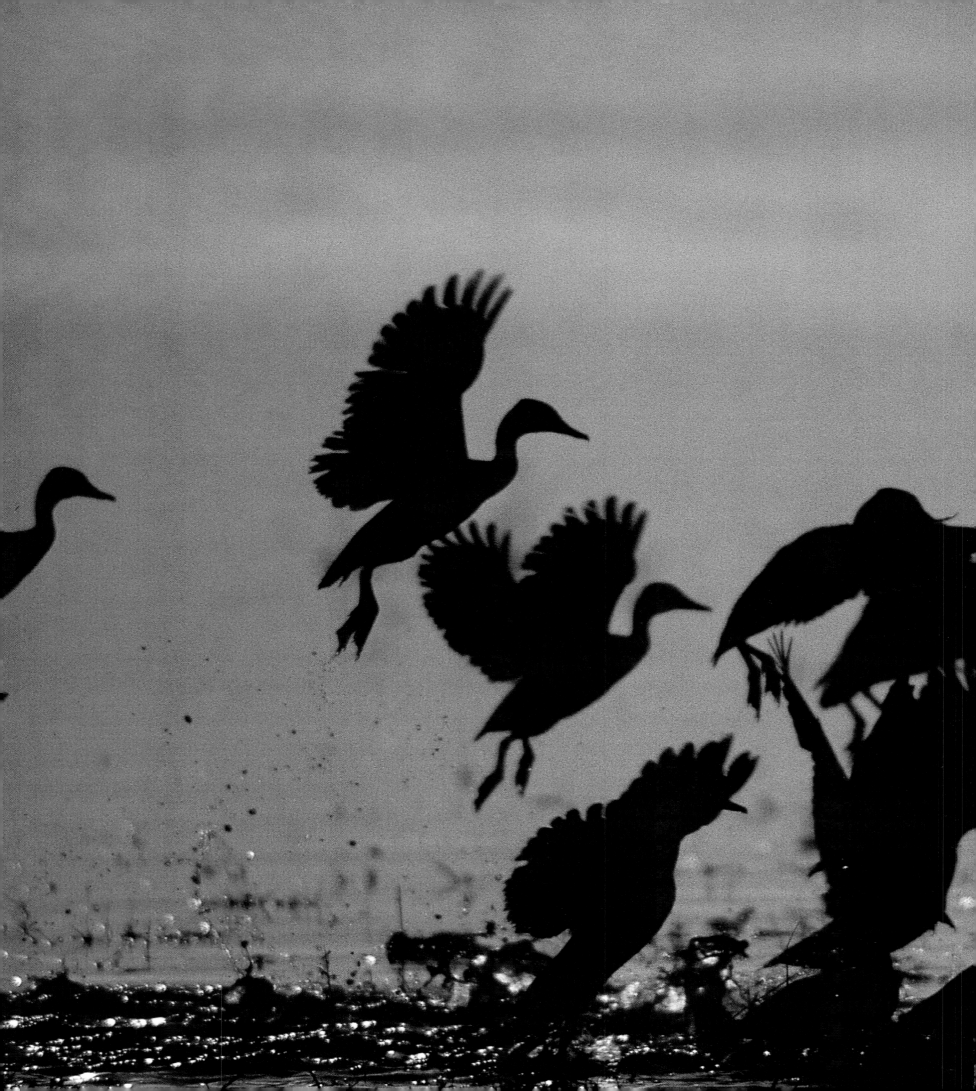

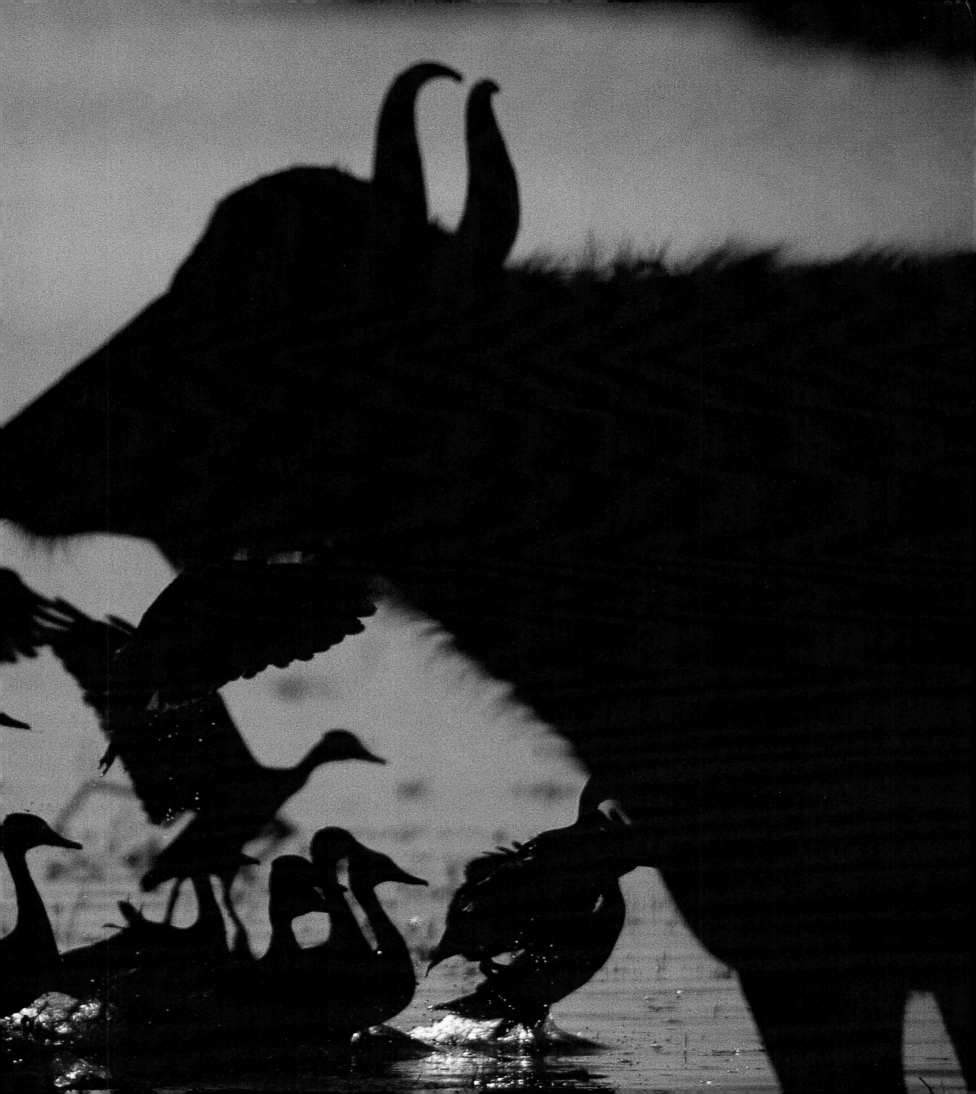

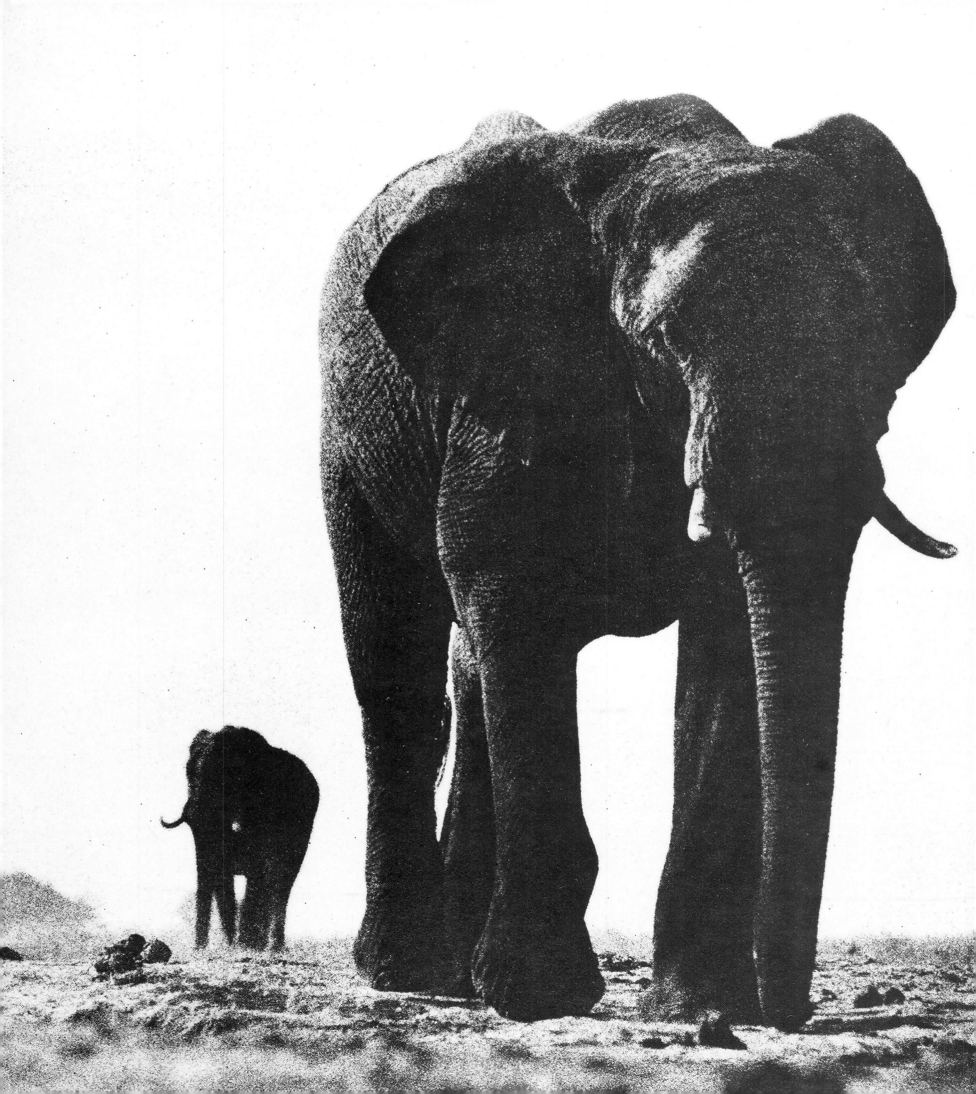

ACKNOWLEDGEMENTS

Every book is the effort of a combination of people, and *The Miracle Rivers* would not be what it is without the input of every single one of these people, and others whose paths met ours more briefly. For all that was given, and the friendship imparted by those who have made the rivers the heart of their lives, we are indebted and sincerely grateful.

The project began on a high note as we were warmly welcomed to the Delta by PJ and Barney Bestelink, Ian Michler and Britt Simpson, and invited to begin our project at Nxamaseri and to ride on an Okavango Horse Safari. They have remained a cornerstone and a home throughout. Thanks, too, to their tireless staff.

To Hennie and Angie Rawlinson, whose friendship paid dearly and did not count the cost, for giving us a home in Maun and much more; to Dave Hamman and Hélène Heldring, for sharing so much so selflessly; and to Jeff Rann and Cathy Rann, for opening your camps and your home to us and for your warm and generous friendship.

To Chris Kruger of Wilderness Safaris, who endorsed our project and opened the first door; and to Colin Bell, Chris and Karen McIntyre, Alan Wolfromm and the rest of the dynamic team of Wilderness Safaris, for the good times, good humour and vast experience.

To the inimitable Randall Moore and his OC Michael Lorentz, and their ever-friendly and helpful workforce, for the unforgettable days on the Elephant-Back Safari and nights at Abu.

To two very special women, Win Harrison and Mary Seselamarumo of Travel Wild, who sat beside the radio and telephone, making it all possible.

To Tico McNutt and Lesley Boggs, for their unique bush hospitality and sharing of ideas.

To Tony and Rose Hardwick, for hospitality and a home in Kasane.

To all at Lloyd's Camp, whose love and enthusiasm for the bush have not paled after all the years, but rather become greater still.

To Barry Clarke, who accommodated himself as a pilot so willingly and enthusiastically to our ends.

To Neil and Susie Lumsden, for the Makgadikgadi flight and for flying supplies out to our strange outposts.

To Willie Phillips, for his insight and honesty.

To Barry and Elaine Price of Shakawe Fishing Camp, for unwaning enthusiasm and assistance.

To Tim and June Liversedge, for much that was shared and given.

To Lionel and Phyllis Palmer of insatiable spirit, for a wonderful collection of photographs and the tales that they tell.

To Arden Moolman, Mike Penman and Angie Bunyard, and Karen Ross, for all that was so easily given.

To Bev and Dereck Joubert and Daryl and Sharna Balfour, for company and hospitality in the bush.

To 'the musketeers' – Map Ives, Dan Rawson and Mike Watson – for the laughter and the tales.

To the guides of Afro Ventures, who never passed us by without a greeting of some sort and telling us where the game was happening.

To Patrick and Heather Penstone of Penstone Safaris.

To Brian and Jan Graham, and the warm staff of Linyanti Explorations, for the opportunity to work in Selinda and for the hospitality and company.

To Dougie and Di Wright.

To Chris Preuyt of Khwai River Lodge, who gave so easily.

To Cairn Patrick of Mowana Lodge, who shared all his sightings at Chobe with us – sometimes even seeking us out to do so.

To Pauline MacManus, for her exercises in frustration on our behalf.

To John Gibson of Chobe Game Lodge, for his support.

To Harry Selby, Frank and Jane Lyons and Joe Coogan, for welcoming us on their safari, and to Howard Holly and Neil Summers for the same.

To Peter Holbrow, for spirit and wit; to Brian, for some ideas we still don't understand; and to Craig and Nola.

To the 'Zululand Gang', for the adventures and laughter.

To Janis Lorentz and the 'Okavango Observers', for assistance and for making the newspaper available for use in the book.

To the Kays family, for making their old family photographs available, accompanied by stories from the past; also to Ronnie Kays, for the introduction to the Maun *kgotla*.

To Chief Tawana II, for granting us permission to accompany the lion hunt in honour of his inauguration; and to Mr Letsholathebe, for making it possible.

Thank you all!

Finally, none of this would have come about were it not for President Masire and the Office of the President, where our project was first condoned and encouraged.

The Department of Wildlife, Nigel Hunter, Mr Peacock and Mr Modise granted us permits which made our work possible.

In the reserves and national parks, the assistance we received and interest in our work was invaluable. Thank you, Jomo Bontshetse and Jackson Thupeng of Khwai, Moremi; Moksweetsi Komoki and Jim Eves of Savuti; Cyder Mulanwa and Biki France of Linyanti; and Mr Morake and Mr Matumo of Chobe.

Water Affairs helped us out of a number of fixes, especially Maybe Mabe, Government Merapelo and Lecco Letota.

The Department of Immigration was always patient and helpful.

The October family generously gave us the use of their cottage at Quoin Point, to write the text.

In the production of the book, Dennis da Silva of Beith Laboratory lent his expertise and assistance, Dennis Sprong of Creative Colour Laboratory accommodated our impossible needs, and John Rivett spent long hours in the darkroom.

Kodak, South Africa sponsored the bulk of our film, and thanks are most especially due to John Creighton for his commitment to our project.

A special thank you to our publishers, Basil van Rooyen and Louise Grantham, who had the courage to tackle (in their own words) 'this challenging book', and to our talented and patient designer Alix Korte and editor Tracey Hawthorne.

Lastly, thanks to our 'faraway' family, and family of friends, who were always there!

This book was photographed using Kodak film and paper.

LAST WORD

We have heard people regretting that Africa and its wilderness has and is changing; and that what is now, is not what used to be. We have no doubt that they are right, but change is change and it will eternally be with us. We can fight it but not avoid it.

We have also heard those who wish that they had known the Africa of earlier times. This we do not understand, for wishing merely fills us with envy, and we deny ourselves the opportunity to acknowledge that that which surrounds us is still quite magnificent.

We are deeply happy that we have had the opportunity to live now, to inhabit a world where we could still find silence and wilderness, where we could still be utterly, frighteningly alone. We are quite sure that we are of the last generations that will be able to enjoy this privilege, and we will treasure it as a most special gift.

There is no way to explain it, no adjectives that will quite touch its wild heart, and we unashamedly confess that we have shouted out loud with the overwhelming joy of having known it.

Left: *'I had seen a herd of elephant travelling … pacing along as if they had an appointment at the end of the world.'* **Karen Blixen**, *Out of Africa*

DIRECTORY

International dialling code for Botswana: +267
International dialling code for South Africa: +27

CAMPS AND SAFARI COMPANIES

DESERT AND DELTA SAFARIS
Chobe Game Lodge, PO Box 32, Kasane, Botswana
tel: Kasane 65-0340 fax: Kasane 65-0280/65-0223

GAMETRACKERS
PO Box 100, Maun, Botswana
tel: Maun 66-0302 fax: Maun 66-0153

GUNN'S CAMP
Private Bag 33, Maun, Botswana
tel: Maun 66-0023 fax: Maun 66-0040

HARTLEY'S SAFARIS
Private Bag 48, Maun, Botswana
tel: Maun 66-0528 fax: Maun 66-0528

KER & DOWNEY
PO Box 40, Maun, Botswana
tel: Maun 66-0211 fax: Maun 66-0379

LINYANTI EXPLORATIONS
PO Box 22, Kasane, Botswana
tel: Kasane 65-0505 fax: Kasane 65-0352

LLOYD'S CAMP
PO Box 37, Maun, Botswana,
PO Box 2490, Fourways 2056, South Africa
tel/fax: Johannesburg (11) 462-5131

MOREMI SAFARIS
Private Bag 26, Maun, Botswana
PO Box 2757, Cramerview 2060, South Africa.
tel/fax: Johannesburg (11) 465-3779

OKAVANGO TOURS AND SAFARIS
PO Box 39, Maun, Botswana
tel: Maun 66-0220/339 fax: Maun 66-0589

UNCHARTERED AFRICA SAFARI CO
PO Box 173, Francistown, Botswana
tel: Francistown 21-2277 fax: Francistown 21-3458

WILDERNESS SAFARIS:
PO Box 78573, Sandton 2146, South Africa
tel: +27-11-883-0747 fax: +27-11-883-0911

SPECIALIST SAFARIS

AFRO VENTURES
PO Box 323, Kasane, Botswana
tel: Kasane 65-0119 fax: Kasane 65-0456

ELEPHANT-BACK SAFARIS
Private Bag 332, Maun, Botswana
tel: Maun 66-1260 fax: Maun 66-1005

HARRY SELBY HUNTING SAFARIS
Private Bag 332, Maun, Botswana
tel: Maun 66-0362

NXAMASERI FISHING LODGE
Private Bag 23, Maun, Botswana
tel: Maun 66-1671 fax: Maun 66-1672

OKAVANGO HORSE SAFARI
Private Bag 23, Maun, Botswana
tel: Maun 66-1671 fax: Maun 66-1672

PENSTONE SAFARIS
PO Box 330, Maun, Botswana
tel: Maun 66-0351 fax: Maun 66-0571

RANN HUNTING SAFARIS
PO Box 248, Maun, Botswana
tel/fax: Kasane 65-0433; Maun 66-1323

OKAVANGO WILDERNESS SAFARIS
PO Box 78573, Sandton 2146, South Africa
tel: +27-11-883-0747 fax: +27-11-883-0911

AIR CHARTER SERVICES

DELTA AIR
PO Box 39, Maun, Botswana
tel: Maun 66-0220/339 fax: Maun 66-0589

SEFOFANE AIR
Private Bag 159, Maun, Botswana
tel/fax: Maun 66-0778

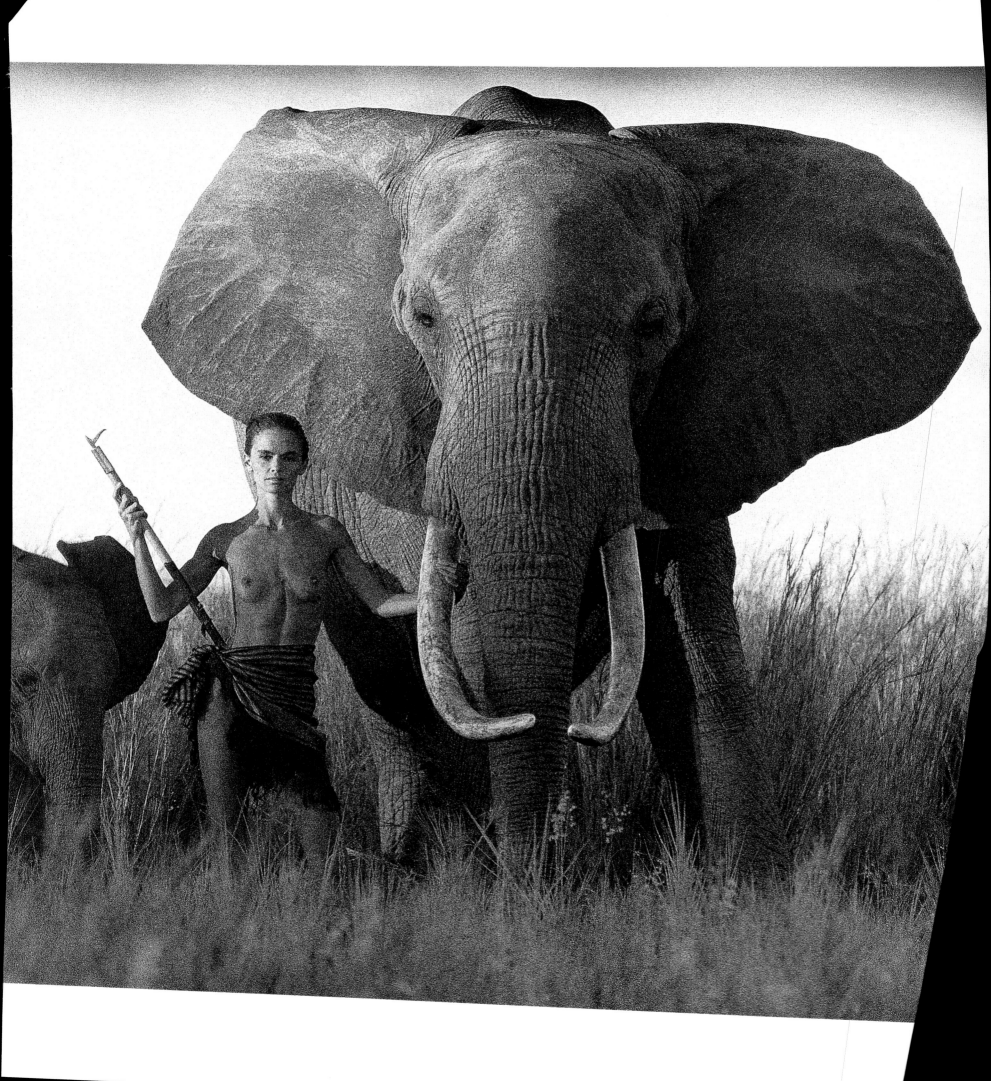

ISBN 1 86812 755 9
First edition, first impression 1999

Published by
Southern Book Publishers (Pty) Ltd
(A member of the New Holland Struik Publishing Group)
PO Box 3103, Halfway House, 1685

Cover design by Alix Korte
Cover photograph by Peter and Beverly Pickford
Maps by Tessa van Schaik
Edited by Tracey Hawthorne
Designed and typeset by Alix Korte t/a Design Dynamix
Set in 8.5/13.5pt Stone Serif
Reproduction by Hirt & Carter Repro, Cape Town
Printed and bound by Tien Wah Press (Pte.) Ltd

SOURCES OF QUOTATIONS AND EXCERPTS

Okavango Observer (local Maun newspaper)
Blixen, Karen. *Out of Africa*, Putnam & Co, London, 1937
Dostoyevsky, Fyodor. *The Brothers Karamazov*, Penguin, London, 1993
Frost, Robert. 'A Road Not Taken'. *Mountain Interval*, Henry Holt & Co, New York, 1920
Gary, Romain. *The Roots of Heaven, Les Racines du Ciel*, Librarie Gallimard, Paris, 1956
Graham, Alistair. *Eyelids of Morning*, Chronicle Books, San Francisco, 1990
Kundera, Milan. *The Unbearable Lightness of Being*, Faber & Faber Limited, London, 1984
Leopold, Aldo. *A Sand County Almanac*, Oxford University Press, New York, 1949
Lopez, Barry. *Arctic Dreams*, Pan Books, London, 1987
Matthiessen, Peter. *The Tree Where Man Was Born*, William Collins Sons & Co Ltd, London, 1972
Nicol, Mike. *West Coast*, Struik, Cape Town, 1991
Pritchett, VS. *A Review* (A Paris book review)
Robbins, Tom. *Jitterbug Perfume*, Bantam Books, New York, 1984
Robbins, Tom. *Skinny Legs and All*, Bantam Books, New York, 1990

PHOTOGRAPHIC CREDITS

The Pickfords' photography is available through
Focal Point tel: +27-11-463-5853

Lionel and Phyllis Palmer page 28 left; page 57 right; page 132 bottom left
The Kays family page 28 right; page 29; page 57 left; page 128/129 top;
page 152 top and bottom; page 153 middle and bottom
Douglas Wright page 134
Horst Klemm page 207

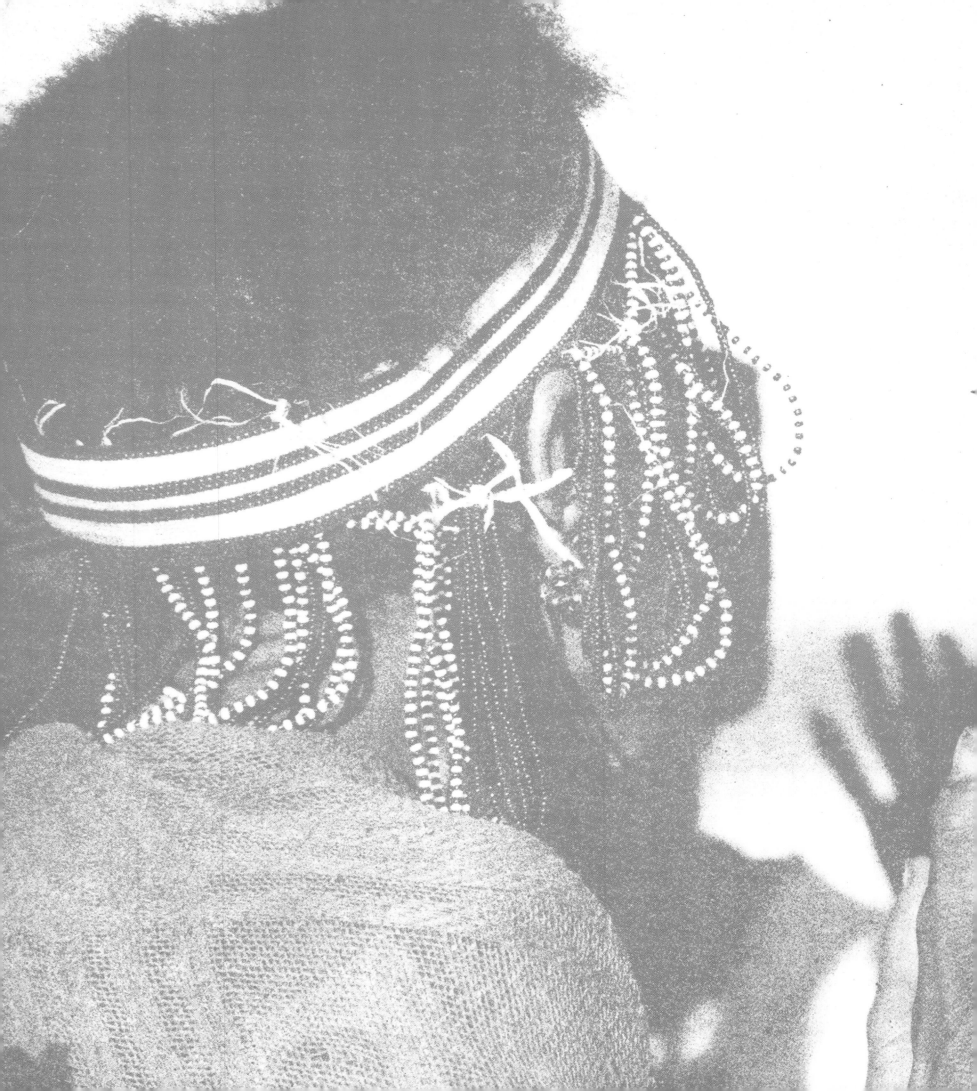